HOUSTON

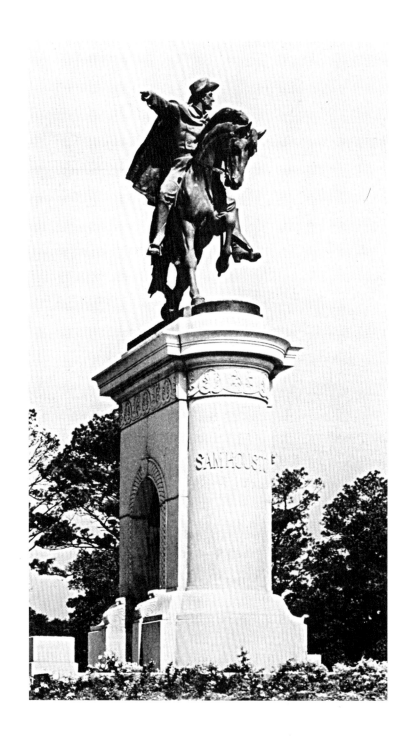

American Historical Press
Sun Valley, California

HOUSTON

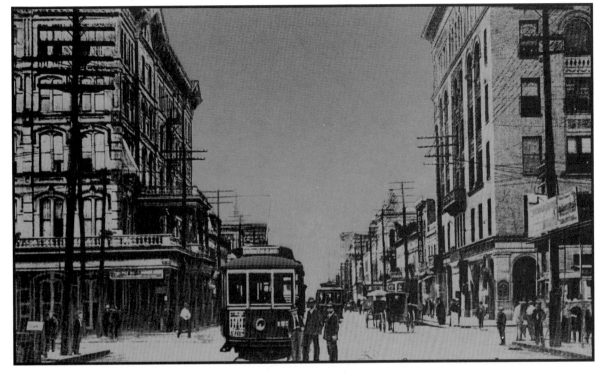

A CHRONICLE OF THE BAYOU CITY

STANLEY E. SIEGEL & JOHN A. MORETTA

Photos attributed to Maps Collection, Texas State Archives,
courtesy Texas State Library and Archives Commission.
Photos attributed to *Harper's Pictorial History of the Civil War*,
1866, courtesy Random House, Alfred H. Guernsey, author.

CONTENTS

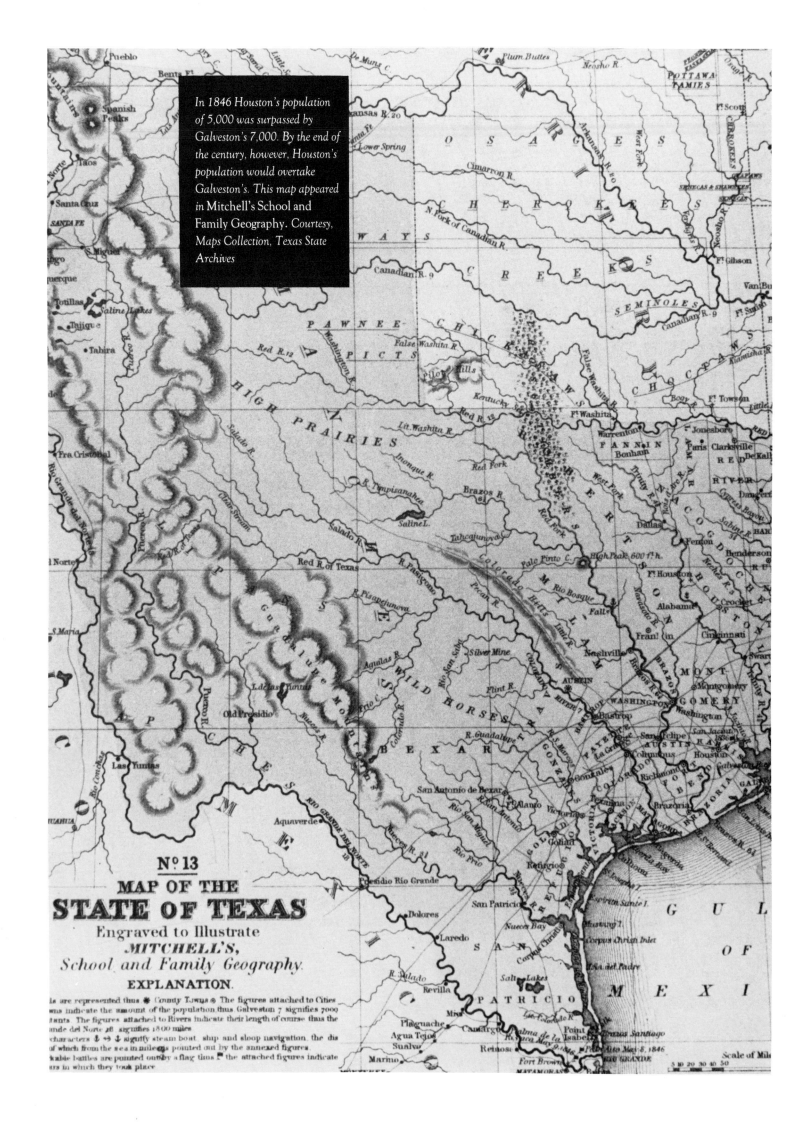

In 1846 Houston's population of 5,000 was surpassed by Galveston's 7,000. By the end of the century, however, Houston's population would overtake Galveston's. This map appeared in Mitchell's School and Family Geography. Courtesy, Maps Collection, Texas State Archives

N.º 13
MAP OF THE
STATE OF TEXAS
Engraved to Illustrate
MITCHELL'S,
School and Family Geography.
EXPLANATION.

PREFACE

This work seeks to acquaint the general reader with the history of a unique city, Houston, Texas. Founded in the immediate aftermath of the Texas War for Independence and named for the conquering hero of that struggle, the city prospered as the first capital of the Republic of Texas. Annexation culminated in statehood and, facilitated by railroad construction, the city emerged as a leading trade and market center. Spared Union invasion during the Civil War, Houston adapted to Yankee occupation during the postwar Reconstruction era. Symbolically, the final quarter of the century culminated with the fabulous Spindletop oil discovery, which cast the future of Houston in the present century.

The completion of the Houston Ship Channel in 1914 marked the fulfillment of a dream that had commenced virtually with the founding of the community. Direct access to the Gulf of Mexico and the attainment of "deep water" in time placed the Bayou City among the five leading ports in the nation. Two World Wars fueled even greater economic advancement, and by 1950 Houston had become the major petrochemical center in the country. Perhaps it was only inevitable, given its past record of growth and development, that the Houston-Harris County area would be chosen as the space exploration capital of the United States.

Houston however, was destined to be more than just "Space City." Using such status, city boosters in the 1970s and 1980s embarked on an aggressive campaign to make Houston one of the most attractive, modern, and dynamic cities of the "New South" if not the nation. Ironically, helping Houstonians accomplish that vision, at least for a while, was the economic hardship experienced throughout the rest of the country, which suffered a severe recession—stagflation—in the late 1970s and early 1980s. Most affected by such hard times were the states of the Northeast, Mid-east and Midwest—regions which had once been the centers of America's heavy industrial production. As the steel mills closed in Pennsylvania; as the car manufacturers' curtailed production in Detroit; as the textile mills in Boston closed; the unemployed of those areas packed up their belongings and headed south, to the "promised land" of Houston's oil and energy rich economy. By 1982, 10,000 of such dispossessed Americans entered Houston weekly, all looking to start a new life. Few were disappointed as the majority found work, becoming "naturalized" Houstonians and Texans in the process. In less than a decade Houston's population grew by 600,000 people.

The boom times however, unfortunately did not last. By 1986 the drop in oil prices finally took its toll on the city, ushering in

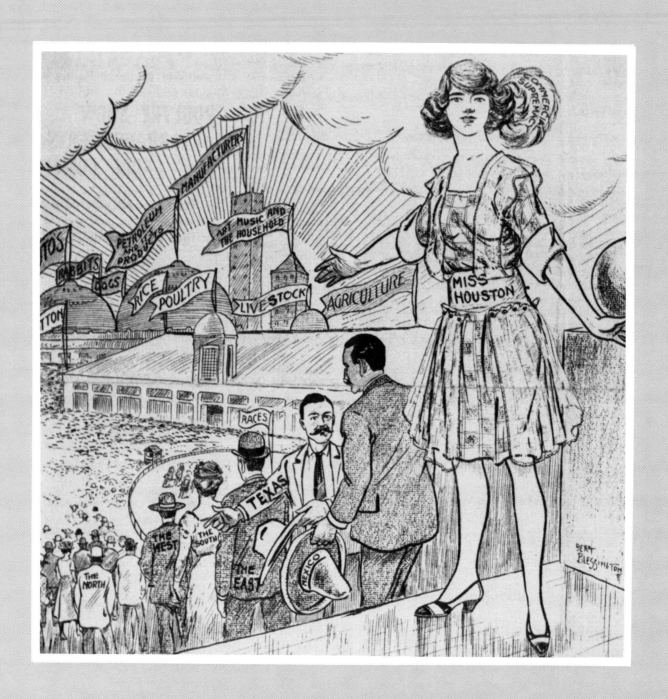

a five year downturn, one of the worst in the city's history. But as this book will show, Houstonians are never down and out for very long, rebounding both in spirit, perseverance, and audacity, diversifying their economy and back on top of urban growth by the early 1990s. Along the way, Houstonians realized that it was also time to take stock of the quality of their lives, and thus in the 1990s, Houstonians for the first time in decades, put forth a concerted effort to make their city as aesthetically pleasing to both visitors and residents as they possibly could. The result, by the end of the last century, Houston no longer was a city known only for its "cutting edge" gigantic skyscrapers or petrochemical plants and refineries, or home of the Eighth Wonder of the World, the Astrodome, or where one came when destitute to find work but quickly moved on to more pleasant environs once they had sufficient means. Surprising to many, those who came stayed, finding a better overall quality of life in Houston than they imagined possible; indeed in many instances better than anywhere else in the country, particularly when it came to home ownership. Perhaps more important, Houstonians poured money, time, and effort into revitalizing and renovating their city, especially its downtown district, which had been an eyesore for decades, transforming the area into one of the most vibrant performing arts centers in the nation, in many capacities rivaling that of New York City. As Houstonians look back on the last 25 years they can be proud of their achievements, ranging from creating one of the most impressive urban skylines in the nation; to rebounding from a recession, emerging with even more confidence and vitality; to being one of the most affordable cities in America; to being a city recognized for its outstanding contributions to the visual and creative arts.

While the above constitutes an enviable urban record of accomplishment, there have been problems along the way. Only relatively recently has adequate attention been devoted to the artistic and cultural side of city life. Also, standards of public education languished somewhat, and the city was guilty of evasive and delaying tactics on the issue of integrating the public schools. The text of this work describes the earlier second-class status of blacks and Hispanics in Houston, and later the hard won gains in civil rights and political expression that have been realized. New minorities are present today and appear to be more easily welcomed into the mainstream of community life.

Finally, some attempt has been made to forecast Houston's role in the future. Certainly if the next 150 years are anything like the previous period, the results will be noteworthy, even by Texas standards.

Stanley E. Siegel
John Moretta

The Houston Fair and Exposition of 1921 was intended to demonstrate Houston's modernity to the world. The symbol of the fair, Miss Houston, was dressed in the latest costume. inviting the country to see all that her city had to offer. Courtesy, Special Collections; Houston Public Library

The territory that would encompass Houston and Harris County was a part of the grant made to Stephen F. Austin by the Mexican government. Austin worked to maintain his colony, although his travels left the development of the colony in the hands of his secretary, Samuel May Williams. Austin attempted to solve the problems that grew up between Mexico and Texas, but eventually decided to support those who favored the break. Courtesy, San Jacinto Museum of History

ON BUFFALO BAYOU: THE TURBULENT ERA

In 1519 the Spanish governor of Jamaica commissioned a navigator to explore the west coast of Florida and map a possible route westward. In pursuit of this commission, Alonzo Álvarez de Piñeda mapped the Texas coastline for the first time.

After sailing up the west coast of Florida, Piñeda proceeded to map the northern Gulf Coast. He discovered the mouth of the Mississippi River and also sketched the coastline, bays, and rivers of the Gulf of Mexico all the way south to Tampico. Returning from Tampico, he landed at the mouth of a river that he named "Rio de las Palmas," generally believed to be the Rio Grande.

The first recorded impression of the Houston vicinity and its inhabitants was left by explorer Alvar Núñez Cabeza de Vaca. Left shipwrecked on the Texas coast in November 1528, he was captured by Indians on Galveston Island. Cabeza de Vaca managed to escape and travel to the mainland, where he became a trader among friendly Indians in the future Harris County vicinity. These Indians have been identified as Karankawas, a ritually cannibalistic tribe that inhabited the marshes and inlets of the Gulf of Mexico for thousands of years prior to the coming of the Americans. Other Indian tribes that roamed the area of the future city of Houston included the Bidais and the Orcoquisacs, a tribe of hunters and primitive farmers who spent the winter in small villages along Spring Creek in what is now northern Harris County.

Settlers from the United States began to migrate to Texas in substantial numbers following the Panic of 1819 in the United States. A few were already there, having crossed over illegally from the "neutral ground" between Spanish Texas and American Louisiana, their presence winked at by Spanish authorities in San Antonio and Nacogdoches. However, the economic dislocation occasioned by the depressed financial conditions in the United States prompted the heavy migration of the early 1820s. State and federal statutes sanctioned imprisonment for indebtedness, so for those in debt a new start in Mexican Texas was particularly attractive. "G.T.T." scribbled

on a farmhouse door informed the local sheriff that he had missed out on a foreclosure and that the former occupant had "Gone To Texas." Also, as a result of the nation's first major depression, the United States Congress decreed that land could no longer be purchased on time, but only for cash. While the American price of $1.25 an acre was not excessive, it was beyond the reach of most who dreamed of getting on their feet again on new land, and free land was available for them in Texas.

Fortunately, the intensive desire of Americans to move to Texas coincided with Mexico's willingness to receive them as colonists. Attaining its independence from Spain in 1821 after 10 years of bitter civil war, Mexico felt that the time was now propitious for the settlement of its outlying provinces. Where Texas was concerned, Mexican leaders felt particularly secure since in 1821 Spain had ratified the Adams-Onís Treaty with the United States. Negotiated by Secretary of State John Quincy Adams and Spanish ambassador to the United States Louis de Onís, the agreement defined the Sabine River as the northeastern boundary between Spain and the United States, indicating to Mexico that it had nothing to fear from American frontiersmen.

Mexico also sought to attract European immigrants. French, German, and British colonization schemes were proposed, but with few concrete results. Then the Imperial Colonization Law of 1823 was passed. Foreigners were invited to settle in Texas if they would become Mexican citizens, accept the Roman Catholic faith, and agree to defend Mexico against all enemies, internal and external. Grants of land could be secured by applying to the local *ayuntamiento* (town council) or by employing the services of an empresario licensed by the Mexican government. The maximum grant of land was the traditional Spanish "league and a labor." In stark contrast to the United States policy at the time, the land was free, subject only to nominal empresario fees.

The correspondence of Stephen F. Austin, the leading empresario in colonial Texas, reveals the concerns of the early

DOMINGUEZ' GRANT.

 No _____ **4428** 120 English 1000 acres.

I, JOHN DOMINGUEZ, OF THE CITY OF MEXICO,

Do hereby certify, That under and by virtue of a certain Grant of Land in TEXAS, made to me by the GOVERNMENT OF THE STATE OF COAHUILA AND TEXAS, with the approbation of the SUPREME GOVERNMENT OF THE UNITED STATES OF MEXICO, on the 6th day of February, A. D. 1829, for the purpose of colonization as an Empresario, I do hereby authorize and empower ⸻ of ⸻ to locate for his own use and benefit, and to receive a title therefor, and to hold the same to himself, his heirs, executors, administrators and assigns, in accordance with and subject to the terms of the said Grant, so made to me as aforesaid, and to the laws of the United States of Mexico and of the state of Coahuila and Texas, one SITIO of land, within the limits of the said Grant, which are as follows, viz. :

Commencing on the RIVER ARKANSAW, at that part which is crossed by the twenty=third degree of longitude west from the CITY OF WASHINGTON, which is in fact the boundary line between the MEXICAN REPUBLIC and the UNITED STATES OF NORTH AMERICA; thence the line runs to the south, along the said twenty=third degree of longitude or boundary line, a distance of FORTY LEAGUES ; thence the line strikes TWENTY LEAGUES to the west, which is the limit of the reserve referred to in the Colonization Law of the 18th of August, A. D. 1824. From the point at which the said last mentioned twenty leagues terminate, a line is to be drawn to the north parallel with the said twenty=third degree of west longitude from WASHINGTON, till it reaches the said RIVER ARKANSAW, which forms the boundary line between the MEXICAN REPUBLIC and the UNITED STATES OF NORTH AMERICA. Thence the said grant runs along the western bank of the ARKANSAW for TWENTY LEAGUES, till it comes to that part at which it is crossed by the before mentioned twenty=third degree of longitude west from the CITY OF WASHINGTON, which is the place of beginning.

The rights and privileges hereby conveyed, may be assigned and transferred by delivery of this CERTIFICATE, after its indorsement by the original holder. ⸻ Dated November 11th. 1831.

John Dominguez

By his Attorneys

A. L. Davis

C. V. Shane

The lands to be located by the Agent of the Empresario, who will reside upon the premises.

Texas pioneers. Succeeding to the grant originally held by his father, Moses Austin, Stephen went to Mexico City in 1823 to receive reassurance that Mexican officials were serious in their intention to settle Texas. Once back north of the Rio Grande, he informed all those who wrote to him that the colonization laws did not prohibit slavery. Also, while admitting that conversion to Roman Catholicism was a formal requirement, he doubted that adherence to that religion would be vigorously enforced. Their fears eased, Austin brought the "Old Three Hundred"—the 297 original colonial families—to Texas, and located them on choice lands between the Brazos and Colorado rivers.

Between 1823 and 1835, on the eve of the Texas War for Independence, some 25,000 Americans settled in Texas. Most settled between the Sabine and Colorado rivers. Confined to what would today be the eastern and Gulf Coast sections of the state, they endured Comanche raids from the west and the depredations of Karankawa Indians along the coast. In time, Austin was forced to recruit a militia company of colonists to fight off the Indians, and many Texas' historians believe that this mounted corps constituted the beginnings of the famed Texas Rangers.

One disappointment encountered by migrants to Texas was the absence of broad and deep rivers for transportation. Texas rivers tended to drift leisurely to the Gulf Coast where they dropped their silt deposits, creating dams across their mouths and sandbars that effectively blocked passage. The Brazos River, for example, which seemed to be the natural waterway to Austin's colony, was rendered virtually useless by a sandbar at its mouth.

By contrast, the harbor leeward of Galveston Island was the best in Texas. Austin had an official survey made of the island and harbor, and Mexico designated Galveston as an official port of entry. Buffalo Bayou ran deep and wide from Brays Bayou to its confluence with the San Jacinto, which then emptied into Galveston Bay. In 1828 J.C. Clopper, an early pioneer, recorded his impressions of the waterway:

. . . this is the most remarkable stream I have ever seen—at its junction with the San Jacinto is about 150 yds. in breadth having about three fathoms water with little variation in depth as high up as Harrisburg —20 miles—the ebbing and flowing of the tide is observable about 12 miles higher the water being of navigable depth close up to each bank giving to this most enchanting little stream the appearance of an artificial canal in the design and course of which Nature has lent her masterly hand.

Unlike most Texas waterways, Buffalo Bayou ran east-west. What was thought to be the head of navigation on the bayou was only some 20 miles from the center of the fertile Brazos agricultural region and less than 40 miles from the capital of Austin's settlement at San Felipe.

The area's commercial and trade possibilities excited the imagination and initiative of John Richardson Harris, who had first moved from New York to Missouri and then settled in Texas in 1824 as a member of Austin's original colony. From the Mexican government Harris received a league and a labor of land at the juncture of Buffalo and Brays bayous in the vicinity of modern-day Houston. At that site, in 1826, he plotted a small town called, not surprisingly, Harrisburg. Harris then erected a steam-powered sawmill, and Harrisburg became known in colonial Texas as a "timber town."

With the help of his brother David, who followed him to Texas, John Harris then established a trading post at Bell's Landing on the Brazos River. Their sloops and schooners plied between Texas and New Orleans; one, the *Rights of Man*, carried 84 bales of cotton to New Orleans in 1828. However, the principal business of Harrisburg was as a supply depot for the colonial settlers in the Galveston Bay area and at San Felipe. Trade with Austin's colony was further facilitated when in 1830 Mexican officials permitted the laying out of a primitive overland road from Harrisburg to San Felipe. Finally, on

December 30, 1835, the revolutionary Provisional Government designated the town as the "place for transacting the judicial and municipal business . . . and for the deposit of the Archives of the Municipality of Harrisburg." Unfortunately, John Harris did not live to see the little prominence his town achieved. While on a trip to New Orleans to purchase equipment for his sawmill, he contracted yellow fever in that swampy city, leading to his death on August 21, 1829.

The fortunes of Harrisburg, like those of all the burgeoning communities in colonial Texas, were tied to the winds of political change. Repeated and persistent attempts on the part of the United States to relocate the Texas boundary further to the south fed a growing apprehension in Mexico that an American invasion was imminent. To combat this possibility, Mexico instituted the Law of April 6, 1830, which barred further immigration from the United States, increased the complement of Mexican soldiery throughout Texas, and located customs garrisons at points along the Gulf Coast to ensure the collection of taxes.

One such garrison at Anahuac was commanded by John Davis Bradburn, a Kentuckian serving in the Mexican military who was despised by the local settlers for his oppressive measures. When he arbitrarily arrested attorneys William Barrett Travis and Patrick C. Jack in mid-1832, the thoroughly alarmed American community reacted in two ways. At Brazoria a peaceful demonstration took place and a call for a protest convention was issued; at Velasco bloodshed resulted when American colonists seeking to sail back up along the Gulf Coast to Anahuac clashed with Mexican troops blocking their way.

Fifty-eight delegates representing all of the American colonists in Texas convened at San Felipe in October 1832 to discuss a response to the Mexican measures. Meeting in the capital of Austin's colony, it was fitting that the delegates chose Austin as their presiding officer. A cautious revolutionary at best, he counseled moderation and respectful protest. The delegates passed resolutions urging repeal of the ban against immigration, a reduction in taxes, and use of the English language in judicial and commercial transactions in Texas by wide margins. Then, in defiance of Austin's moderate course, the "radicals" led by William Wharton and William Barrett Travis demanded separate statehood for Texas. This measure carried, but had no practical effect, since it was studiously ignored by Mexico.

The period from October 1832 to April 1833 was one of tranquility, the altercations at Anahuac and Velasco seemingly forgotten. However, in January 1833 another convention was called to meet on the first of April at San Felipe. Those who wished to move more rapidly in the direction of independence or at least separate statehood pushed for this assemblage, and the election of radical William Wharton as presiding officer reflected their strength. One of them, recently arrived in Texas and elected from the Nacogdoches district, was Sam Houston.

In a real sense the history of Texas from the Independence period through the Civil War is the history of Sam Houston. Perhaps only the growth and future prospects of his namesake city can rival the story of his colorful life. Born in Virginia in 1793, Houston moved to Maryville, Tennessee, in 1807. Young Sam's formal schooling was brief; he preferred to live among the Indians and as the adopted son of a Cherokee chieftain took the name the "Raven." A lifelong friendship with Andrew Jackson developed when, in 1813, he enlisted in the United States Army under Jackson's command. He subsequently practiced law and then ventured into the hurly-burly of Tennessee politics, winning the gubernatorial race in 1827.

After a brief and unsuccessful marriage in 1829 to 16-year-old Eliza Allen, Houston resigned as governor of Tennessee and left by steamer for Little Rock, Arkansas. Traveling by land and water, Houston reached a trading post at the falls of the Arkansas, where he took up Indian life again with some of his former Cherokee friends. Drinking certainly more than he should have, Houston set up as an Indian trader and took an Indian wife, Tiana Rogers; later humorist

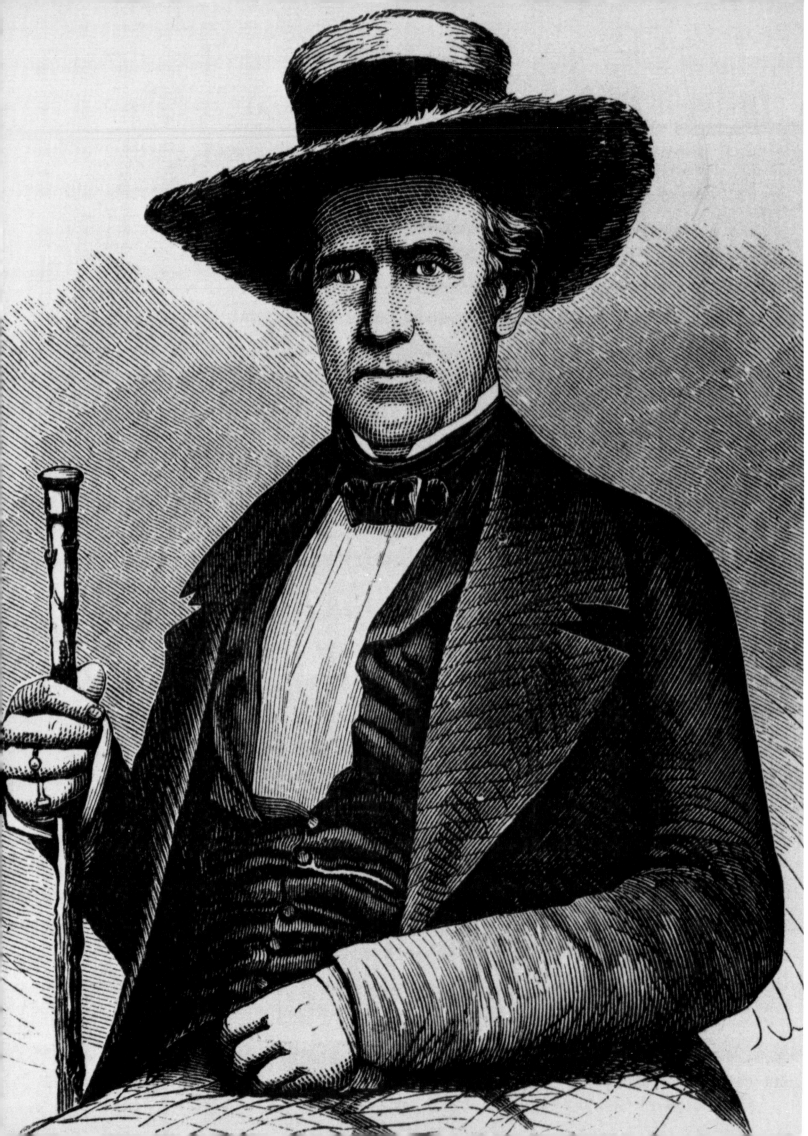

Will Rogers would be proud to claim descent from her.

Over the span of the next four years, 1829-1833, Houston was frequently in Washington, often the guest of his friend, President Jackson. Ostensibly "Ambassador from the Cherokee Nation to the United States," historians believe that he and Jackson discussed the ripening political controversy in Texas. In 1832, at the request of President Jackson, Houston crossed the Red River at Jonesborough and made his way to San Antonio. His commission was to report on Indian affairs in Texas and to urge the Comanches to cease their raids on American soil across the Sabine River. Some believe that he was in Texas to test the political waters and gauge the climate for revolution. He returned to Texas the next year to stay, and went on to represent Nacogdoches in the 1833 convention.

As chairman of a committee empowered to draft a state constitution, Houston made his presence felt almost immediately. The document provided for slavery and on paper established a government much like that of most Southern states. Resolutions similar to those passed the previous year were endorsed, and Stephen F. Austin was designated to present them at Mexico City. From there, Austin wrote home advising that steps be taken to form a separate state within the Mexican Republic. The letter was intercepted, and he was imprisoned without formal charge until mid-1835.

As Austin languished in prison, a political change was effected in Mexico that had a direct bearing upon Texas. In April 1834 dictator Antonio López de Santa Anna seized power, abolishing the republican principles of the government by declaring the Constitution of 1824 invalid, and demanding oaths of allegiance from the governors of the 19 states of Mexico. When Governor Francisco García of Zacatecas, a northern mining state, refused to swear fealty to Santa Anna, the tyrant himself led an army to coerce the disaffected state.

In the state of Texas-Coahuila, Governor Augustine Viesca announced his support for the old constitutional ideals of the Mexican

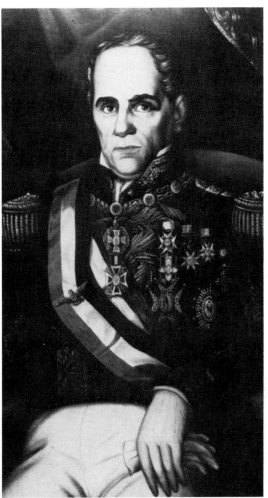

rebellion against Spain and rejected Santa Anna's grab for power. General Martin Perfecto de Cós, brother-in-law to Santa Anna, repaired to the state capital at Saltillo to crush the last pocket of opposition. Colonel Domingo de Ugartechea, Cós' deputy, was sent to San Antonio where he called for the arrest of William Travis and Lorenzo de Zavala, a Mexican opponent of Santa Anna who had taken refuge in Texas. This precipitated yet another protest convention, scheduled to meet in November 1835 at San Felipe. At just this juncture Austin returned to his colony, following his release from prison, and sanctioned the convention.

Before the elected delegates could convene, war broke out in earnest. The settlers at Gonzales had a cannon that had been given to them earlier as protection against Comanche raids. Ugartechea sent an underling to Gonzales to confiscate it. The colonists, aided by volunteers from neighboring settlements, were determined to resist. After

On March 16, 1836, David G.
Burnet (1788-1870) was
elected president of the ad
interim government of the
Republic of Texas. The night of
the day he was inaugurated, he
received the news of the fall of
the Alamo. From Cirker,
Dictionary of American
Portraits, Dover, 1967

a second demand by Mexican officials, the inevitable armed clash took place on October 2, 1835.

Two weeks later, on October 16, 1835, delegates to the third convention, known as the "Consultation," gathered at San Felipe. The delegates were still chary of complete independence and opted instead for separate statehood within the Mexican nation. Henry Smith was named governor and James Robinson, lieutenant governor, while Sam Houston was appointed commander-in-chief and ordered to raise and recruit a regular army. Pointedly, Houston was given no authority over the volunteer army that had formed after the clash at Gonzales and was at that moment marching against San Antonio. Finally, the land offices were closed in order to prevent speculation during the fighting, and Austin, William Wharton, and Branch T. Archer were ordered to the United States to speak for Texas while raising men and money.

The "Army of the People," as the volunteer force was appropriately called, then lay siege to Bexar. In the resultant battle General Cós was compelled to surrender and was required to retreat beyond the Rio Grande, a point of demarcation that future Texas governments would claim as their southwestern boundary. Texas was cleared of Mexican troops and on February 1, 1836, elections were held throughout colonial Texas to select delegates to one last convention.

Feelings ran high for a declaration of independence and the creation of an independent nation. While the delegates assembled at Washington-on-the-Brazos, the Alamo garrison was under siege by Santa Anna, and other Mexican forces were moving in to Attack. Also, the Texas commissioners, Austin, Archer, and Wharton, were writing from the United States that volunteering would cease and financial assistance would dry up unless Texas legitimatized its cause.

On March 2, 1836, independence was declared and the Republic of Texas was born on Sam Houston's birthday. The declaration of Texas independence, based on

Jefferson's more famous statement, was written by George Childress, a friend of Andrew Jackson from Tennessee. Patterned after the United States Constitution, a state constitution was written, to become operative after ratification by the people of Texas. Houston was again commander of the military forces, this time both volunteer and regular army. Land was offered to those who would fight for Texas, while transactions in land were suspended until the war's end. David G. Burnet was named president of the ad interim government and Lorenzo de Zavala, one of three Mexican signers of the independence declaration, was chosen as vice-president. The task of this body was to prosecute the war; it would relinquish office and popular elections would be held when Mexican troops had been driven beyond the Rio Grande.

When the Army of the People captured San Antonio in December 1835, Texas was the only state in Mexico not yet under Santa Anna's heel. Santa Anna had to crush the rebellion in Texas in order to secure his political base in Mexico City. Accordingly,

preparations were made to cross the Rio Grande with an army of 6,000 men. The campaign began on a high note when General José Urrea surrounded and then destroyed a Texas force commanded by Francis W. Johnson at San Patricio. The main body of the Mexican army, led by Santa Anna, marched from Laredo to Bexar, arriving at the Mission of San Antonio de Valero on February 23, 1836.

The mission (named for the "alamo" cotton flower that grew nearby) housed a garrison of 152 men, but should not have been used as a fortress. General Houston had, in fact, directed Travis and Bowie to evacuate the troops; neither would carry out the order. When James Walker Fannin refused to march his troops from Goliad to relieve the garrison, the men inside were doomed. Teenage volunteers from Gonzales swelled their number to 183 before the final Mexican attack. When the carnage was complete, not a defender was alive and some 500 attackers also perished.

On March 11, 1836, Fannin, still at Goliad, was ordered to abandon his position and retreat to the northeast. Here he would join forces with an army General Houston was assembling to make a final stand in the area of the Sabine boundary line. Fannin delayed following Houston's instructions in order to assist civilians fleeing before the Mexican army. He finally began his retreat on the morning of March 19, 1836, by crossing the San Antonio River and moving east toward Victoria

When he stopped to graze his oxen, he was surrounded and attacked by the cavalry of General José Urrea. A fierce battle continued until late afternoon and Fannin was severely wounded. He and his men spent a miserable night on the open prairie without water.

Urrea renewed his attack on the morning of March 20. When the Mexicans moved cannon into the battle and began bombardment of the Texans' exposed position, Fannin was forced to surrender.

Following his triumph at the Alamo, Santa Anna divided his forces. Some units began the march back to the Rio Grande,

the campaign seemingly won, while the remainder, under the dictator's command, started in pursuit of General Houston. Santa Anna reached San Felipe on April 7, but finding the Brazos impassable at that point, he headed downstream seeking a more favorable crossing. Mexican intelligence then reported that the personnel of the ad interim government had taken refuge at Harrisburg, which was serving as a temporary capital. For Santa Anna, the opportunity was irresistible; the campaign could be won at one swoop with the arrest of the civil leaders, who would be compelled to negotiate. The only Texas force of any consequence was beyond the Brazos and seemed to be retreating toward the United States.

In March of 1836 matters became desperate for the Texas cause. In an effort to rally the people to the defense of Texas, Sam Houston published his Army Orders, which were issued from Washington-on-the-Brazos on March 2, four days before the fall of the Alamo. Courtesy, Special Collections; Houston Public Library

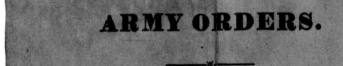

ARMY ORDERS.

CONVENTION HALL, WASHINGTON, MARCH 2, 1836.

War is raging on the frontiers. Bejar is besieged by two thousand of the enemy, under the command of general Siezma Reinforcements are on their march, to unite with the besieging army. By the last report, our force in Bejar was only one hundred and fifty men strong. The citizens of Texas must rally to the aid of our army, or it will perish. Let the citizens of the East march to the combat. The enemy must be driven from our soil, or desolation will accompany their march upon us. *Independence is declared,* it must be maintained. Immediate action, united with valor, alone can achieve the great work. The services of all are forthwith required in the field.

SAM. HOUSTON,
Commander-in-Chief of the Army.

P. S. It is rumored that the enemy are on their march to Gonzales, and that they have entered the colonies. The fate of Bejar is unknown. The country must and shall be defended. The patriots of Texas are *appealed to, in behalf of their bleeding country.* S. H.

Relaying word to his other units to link up with him, Santa Anna and about 750 men streaked toward Harrisburg.

They arrived too late. The government and some refugees had fled a few hours earlier on board the steamer *Cayuga,* seeking the safety of Galveston Island. He did encounter three printers who had fled San Felipe with the press of the first newspaper in Texas, the *Telegraph and Texas Register.* Disgusted, the Mexican commander ordered the printing press thrown into the bayou and the town of Harrisburg burned to the ground, amidst much looting and general destruction by Mexican soldiers. Thus ended the history of the pioneer community founded by John Harris; the city of Houston would rise upon its ashes.

General Houston learned of the disaster at Goliad on March 25. Fannin's defeat permitted General Urrea to join forces with General Ramirez y Sesma, who was advancing toward the Colorado River, and Houston sought to avoid a pitched battle with the combined Mexican forces. Retreating along the Brazos, Houston expected to fight a single decisive battle and thus waited for the most opportune time to attack. His motives were suspect and accusations of cowardice were hurled against him. His men, learning that Santa Anna had reached Harrisburg, demanded that Houston march to meet the enemy. The retreat was halted and on April 18, not far from the site of the present Houston Ship Channel, the "Raven" ordered his men to make camp.

When Santa Anna discovered the approach of the Texas force, he directed his army upstream. Houston broke camp, led his troops a few miles down Buffalo Bayou, crossed to its south side, and encamped in a wooded area near the juncture of Buffalo Bayou and the San Jacinto River. At four o'clock in the afternoon, on a bright, sunny

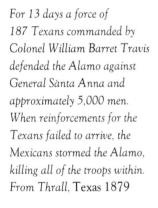

For 13 days a force of 187 Texans commanded by Colonel William Barret Travis defended the Alamo against General Sànta Anna and approximately 5,000 men. When reinforcements for the Texans failed to arrive, the Mexicans stormed the Alamo, killing all of the troops within. From Thrall, Texas *1879*

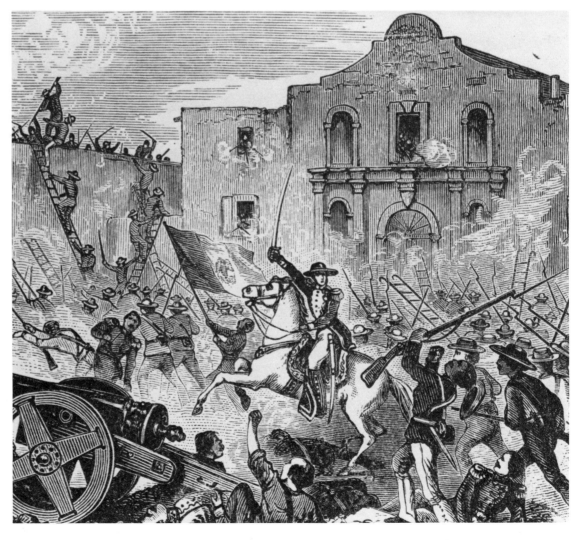

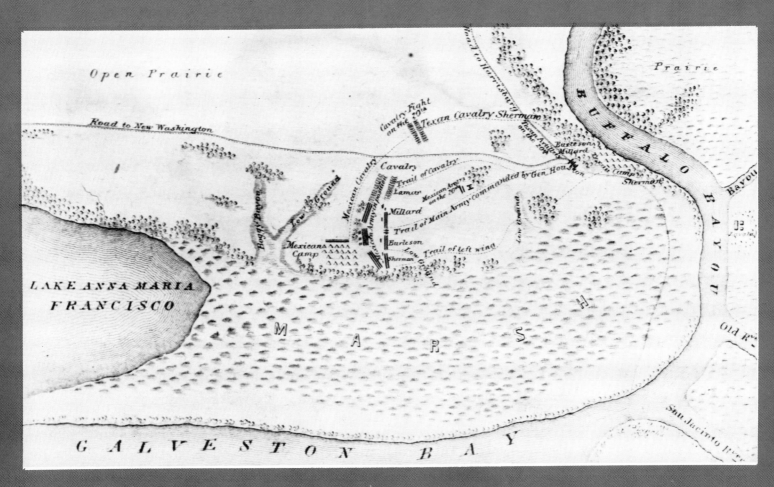

At four o'clock on the afternoon of April 19, 1836, Houston ordered his army forward. Catching the Mexican forces unaware, the Texas army smashed straight into the Mexican lines and ended the dreams of a Texas empire for Santa Anna within 20 minutes. Courtesy, Harris County Heritage Society

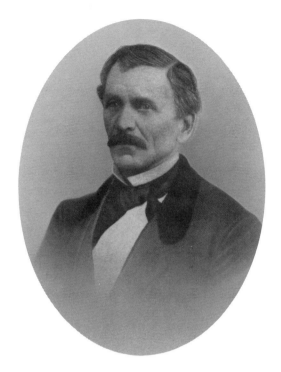

Augustus Chapman Allen (pictured here) and his brother, John Kirby Allen, saw new opportunities for wealth in Stephen F. Austin's colony. After spending four years searching for the right moment and playing a role in bringing independence to the Texans, the Allens founded Houston. Augustus Allen survived his brother, but in the 1840s problems stemming from the difficulty of settling his brother's estate and his growing differences with his wife forced him to leave Houston. He later served as a U.S. diplomat and in 1864 he died in Washington. Courtesy, Harris County Heritage Society

Charlotte Allen, the wife of A.C. Allen, remained a dominant force in Houston for many years in the mid-19th century. Though separated from her husband, she administered most of the Allen holdings until her death in 1895. Courtesy, Harris County Heritage Society

day, the command to attack was given. Enjoined to "Remember the Alamo," the Texans won the battle of San Jacinto in less than 20 minutes. The Mexican losses were some 600 dead and almost 750 captured. Among them was Santa Anna, the "Napoleon of the West," who fled the field of battle disguised as a common infantryman. In gratitude for his life, which Houston spared, Santa Anna signed the Treaty of Velasco and recognized the independence of Texas.

The Texans came through the battle with only six dead and a handful wounded. Among the latter was General Houston, who had been shot in the ankle. Houston, now the "Hero of San Jacinto," left for New Orleans on the advice of his doctors to seek medical treatment. On July 23, 1836, ad interim President Burnet issued a proclamation stating that elections would be held the first Monday in September for president, vice-president, and members of the Texas congress. The 1836 constitution drafted at the Independence Convention would be ratified and a straw ballot taken on the desirability of annexation. After a spirited campaign, Houston was elected president of Texas by a wide margin over candidates Henry Smith and Stephen F. Austin, and Mirabeau B. Lamar was designated vice-president, defeating Alexander Horton. The

constitution was overwhelmingly ratified and by the same margin the citizens of the Republic stated their preference for union with the United States. At West Columbia, another temporary capital site, Houston took the inaugural oath and pledged to seek annexation while at the same time maintaining the borders of Texas against any possible future threat from Mexico.

With independence from Mexico a reality and the Republic of Texas established, John Harris' widow anticipated that Harrisburg would be quickly rebuilt. It might have been, had not two enterprising pioneers from New York founded another town on Buffalo Bayou. Augustus Chapman Allen and his younger brother, John Kirby Allen, came to Texas from upstate New York in 1832. Reared by their parents to value real estate, the brothers became involved in land speculation in Texas. They settled in San Augustine and moved to Nacogdoches in 1833. Although neither brother served in the army during the 1835-1836 campaign, they did, at their own expense, outfit a ship that carried volunteers from the United States to Texas. Immediately after the San Jacinto campaign, they sought to buy land at Galveston and build a port city, but conceded failure when title difficulties could not be resolved.

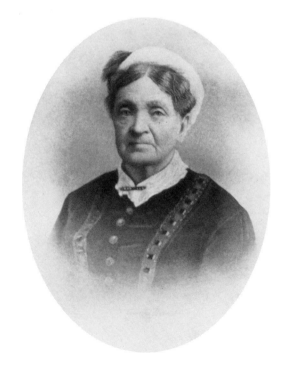

Because the Galveston location did not work out, the Allen brothers determined to look further upstream. The former site of Harrisburg, at what was then considered to be the head of navigation on Buffalo Bayou, was their next choice. There land and water routes converged, but that location was also tied up in litigation due to the claims of John Harris' widow and others to his estate. Speed was of the essence to the Allens, who feared that the Brazos River could be made navigable before the Buffalo Bayou route to the interior.

After further searching, a tract of land at the juncture of Buffalo and White Oak bayous was selected. Buffalo Bayou was still deep above Harrisburg, and extensive sounding revealed that White Oak rather than Brays Bayou marked the head of navigation. John Austin (no relation to Moses or Stephen F.) had acquired title to the land in question in 1824, and his heirs were willing to sell. Here there were no thorny title questions; the cost was $5,000 for the southern half of two leagues along the southwest bank of the Buffalo. To demonstrate their honesty and sincerity, the Allen brothers paid $1,000 down, with the balance due in 18 months. The purchasers confidently expected that the sale of town lots would defray the remaining debt.

Other speculators were also at work founding would-be towns along the banks of Buffalo Bayou and Galveston Bay, spurring the Allen brothers to work ever faster. Title was conveyed early in August 1836, and by the end of that month an official survey had been prepared by a firm of New Orleans engineers and town lots were offered for sale. Wisely, the promoters named their future city "Houston" in honor of the victor at San Jacinto. That Sam Houston might well be elected first president of the Republic of Texas also figured in their planning. On August 30, 1836, they began advertising the sale of town property in the Columbia *Telegraph and Texas Register.* Their vision for Houston was not modest:

The town of Houston is located at a point on the river which must ever command the

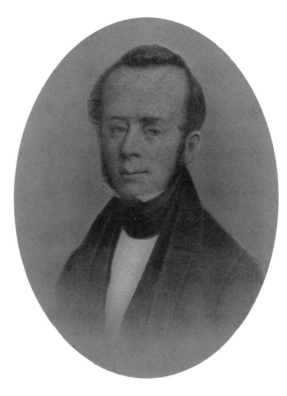

With his brother, John Kirby Allen came to Texas in 1832 to find his fortune. In the aftermath of the revolution, the Allens acquired the land for their new city on Buffalo Bayou. The site they selected was at the last point of measurable tidal change on the bayou. Allen lived only two years after founding the city. Courtesy, Harris County Heritage Society

trade of the largest and richest portion of Texas, and when rich lands of this country shall be settled, a trade will flow to it, making it, beyond all doubt, the great interior commercial emporium of Texas.

There is no place in Texas more healthy, having an abundance of excellent spring water and enjoying the sea breeze in all of its freshness. Nature seems to have designated this place for the future seat of government. It is handsomely and beautifully elevated, salubrious and well-watered and is now in the very center of population and will be so for a long time to come.

The Allens soon had an opportunity to fulfill their dream when the congress of the Republic decided the location of a permanent seat of government. Nacogdoches, San Jacinto, Matagorda, Fort Bend, Washington, and Columbia were all considered, but a consensus could not be reached. Then John K. Allen, an elected member of the house, presented the case for Houston. After four ballots Houston was finally chosen by a slender majority as the seat of government until the conclusion of the 1840 legislative session, conditional upon the promise of the Allen brothers to erect a $10,000 capitol at their own expense.

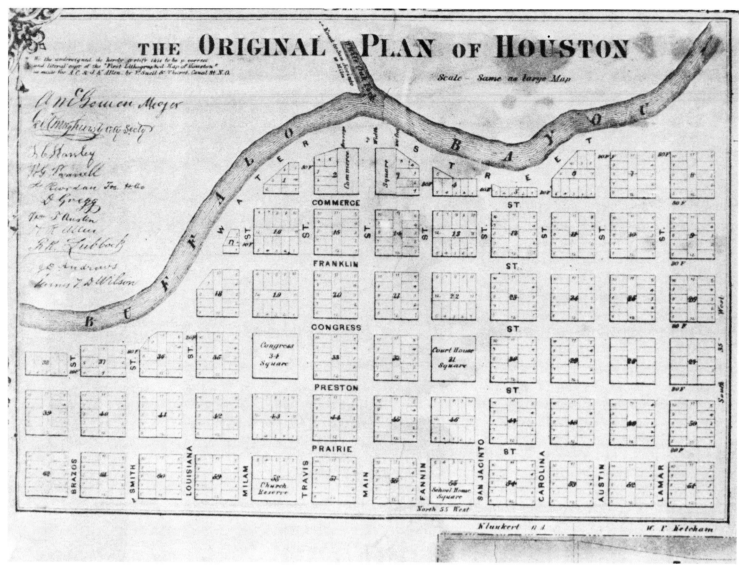

THE ORIGINAL PLAN OF HOUSTON

Scale — Same as large Map

The Allens now stepped up their advertising campaign, referring to the "City of Houston" and "The Present Seat of the Government of the Republic of Texas." Space was taken in leading Southern newspapers, and newcomers began to arrive in January 1837. Francis R. Lubbock, a future governor of the state, came to Texas intending to remain only until he could locate a brother who had volunteered in the Revolution. He visited Houston and later recorded in his memoirs:

My stay in Texas was short, but I had found my country. The strong, massive character of the people and apparent grandeur of the country impressed me greatly. So thoroughly was I persuaded of the bright prospect ahead for those who would settle promptly, that I at once made up my mind that if my young wife would give up New Orleans and follow me, Texas would be our home.

The Allen brothers had boasted that their city was situated at the head of navigation on Buffalo Bayou. Challenged to prove their

assertion by critics who insisted that the fledgling community was in fact 15 miles above the head, the promoters felt compelled to prove their claim. They chartered the steamboat Laura with Captain Thomas W. Grayson aboard to sail from Columbia to Houston and convinced a group of leading citizens to make the trip. The Laura was then the smallest steamer operating in Texas, indicating that the Allens themselves had some reservations. Although the distance to Harrisburg was traversed with ease, it took three days to get from that site to Houston; logs, moss, and other snags made progress difficult and painfully slow. While early historians of Houston disagree as to the exact day of arrival, the most likely date was January 22, 1837. The first sailing vessel to reach Houston, the Rolla, arrived on April 21, 1837, just in time for many of its passengers to attend the first San Jacinto anniversary ball. It encountered the same navigational hazards from Harrisburg to Houston as had the Laura. The channel above Harrisburg was narrow and obstructed; widening and improving Buffalo

Bayou was essential to the future prospects of Houston.

Despite these inconveniences, the city continued to grow. Perhaps with pardonable pride, Francis Moore, Jr., the new editor of the *Telegraph and Texas Register*, now published at Houston, noted that the city had become the "focus of immigration from all directions" and the "center of most of the spirit and enterprise of Texas." Within a few months of its inception, the city had more than 500 inhabitants. An anonymous visitor recorded his impressions in the following way:

Houses could not be built near as fast as required, so that quite a large number of linen tents were pitched in every direction over the prairie, which gave the city the appearance of a Methodist camp ground. Some of these tents, such as were used for groceries, were calculated to surprise one from their great size. A number of them measured more than a hundred feet each in circumference, with conical tops, thirty or forty feet in height, supported by means of poles in the center.

For the early period of Houston's history, trade rather than manufacturing was the most significant commercial activity. However, some Houstonians were involved in manufacturing; in 1841 the *Telegraph and Texas Register* pointed with pride to two new sawmills and W.K. Kellum & Company's brick foundry on the outskirts of the city. The next year the newspaper commented on the opening of a brass foundry and J. Wilson's Company's fabricating shop, which made stills, bells, stirrups, and spurs. During the era of the Republic, prior to statehood, a saddlery, lard-oil factory, corn mill, and pottery mill also opened for business.

Houston merchants exchanged goods such as furniture, clothing, farm tools, books, medical supplies, and groceries, for the produce of the countryside, principally cotton, lumber, livestock, and hides. Some merchants maintained permanent places of business and cultivated a regular clientele, but auction sales were common as well. Such firms as Hedenberg and Vedder and Davison and De Cordova sold real estate, dry goods, slaves, and other "commodities" at auction. The trading and auction season lasted approximately from September until April. Country produce came into Houston by wagon and later by railroad. Purchased by local merchants, the goods were then shipped down Buffalo Bayou to Galveston for transfer to oceangoing ships. Then, to complete the business cycle, Houston businessmen frequently journeyed to Mobile, New Orleans, and New York to purchase

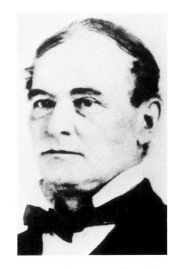

Houston's first mayor, James S. Holman, was an agent for the Houston Town Company and was involved in banking and business activities. After serving as mayor, he remained politically active but continued to develop his business career. Like many of Houston's mayors, he had strong ties to, and was part of, the business establishment. Courtesy, Texas Room; Houston Public Library

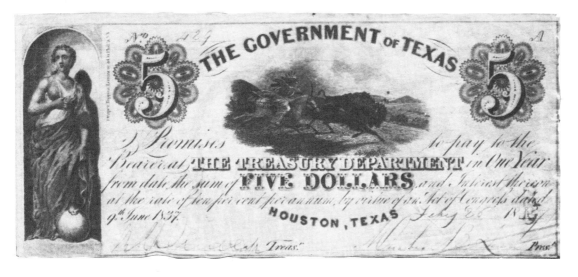

The government of Texas soon developed a series of engraved notes, which were issued from Houston. Designed with the image of a classical goddess and an Indian shooting buffalo, these five dollar notes were typical of the currency issued to foil counterfeiters. In all, $650,629 in notes ranging from one dollar to $50 were issued. Courtesy, San Jacinto Museum of History

new merchandise and arrange for shipment to Houston.

Amidst all this business activity, cotton remained the principal item of trade. Trains of oxen carried cotton from plantations along the Brazos and Colorado rivers to stores at the foot of Main Street, there to reload goods bound for the interior. Shipped down Buffalo Bayou to Galveston and then out to Northern ports, cotton provided an economic link between the Republic of Texas and the United States. The Allen brothers had dreamed of making their city one of the great cotton markets of the world and, indeed, its beginnings were auspicious.

In addition to envisioning Houston as a leading port, the Allen brothers also forecast the development of the city as a railroad center. The August 30, 1836, edition of the *Telegraph and Texas Register* predicted the following:

As the country shall improve railroads will become in use and will be extended from this point [Houston] to the Brazos and up the same also to the headwaters of the San Jacinto embracing that rich country and in a few years the whole trade of the upper Brazos will make its way into Galveston through the channel.

The Texas Railroad, Navigation, and Banking Company was the first railroad company chartered not only in Texas, but west of the Mississippi as well. It contemplated the construction of a railroad linking the Sabine River and the Rio Grande with Houston as the midway terminus. But opposition to the company arose almost immediately because of the company's banking privileges. With this political controversy, and with the shortage of capital caused by the economic Panic of 1837, the company never completed a mile of track. In May 1838 the Republic congress awarded a charter to the Brazos and Galveston Railroad Company, which sought to link Galveston with the trade of the interior. The promoters hoped to reach the settlements along the Brazos and Colorado rivers by following Buffalo Bayou to Harrisburg

and then overland to the Brazos region. This enterprise also failed, and nothing was accomplished on land or water, but it did alert some of the leading citizens of Houston to the dangers posed by Galveston's railroad ambitions. Then in January 1839 a charter of incorporation for the Houston and Brazos Railroad Company was granted. Augustus C. Allen was the principal organizer and stockholder of this projected road, which was to run from Houston to points along the Brazos River. Advertisements for laborers appeared and the spot where the road was to begin was marked by a slab with an appropriate inscription. However, a threatened Mexican invasion forced the project to be abandoned and no trace can be found of any actual grading.

Andrew Briscoe, a signer of the Texas Declaration of Independence and the first chief justice of Harris County, strongly believed in railroads, and with financial backing from investors in Harrisburg and Galveston, he received a charter for the Harrisburg Railroad and Trading Company in 1841. Designed to revive Harrisburg as a rival of Houston, a prospect that pleased his Galveston backers, Briscoe's charter designated the Brazos River as the western terminus of his projected road. However, he had no intention of stopping there. The doughty Briscoe actually planned a transcontinental railroad and employed an engineer to survey a route to the Pacific Coast. Two miles of roadbed were completed before the Harrisburg project collapsed, though 40 years later the Southern Pacific would follow its contemplated route to California.

In addition to rail connections, dirt roads and Buffalo Bayou linked Houston with the interior of the Republic. In truth, many of the roads leading to Houston were nothing but dirt pathways following an uncertain route; often a compass had to be employed to pick up the trail once again. The roads were dusty in the summer and became quagmires after a slight rain. During the period of the Republic one traveler, Samuel A. Roberts, recalled, "they were then impassable, not even Jack-assable." The Brazos prairie west of Houston was particularly

CONSULATE OF THE REPUBLIC

★

OF TEXAS.

I WILLIAM BRYAN, Consul for the Republic of Texas, for the port of New Orleans, State of Louisiana, and United States of America, do hereby certify that the annexed order or Draft drawn by Barnard M. Johnson on Messrs I H. Phillips & Co in favor of Thos Jenkins for One thousand dollars, dated Saint Augustine May 5. 1840, was presented this day to several persons by the Name of Phillips, and other Merchants of this City, and also a reference made to the Mercantile directory, and no knowledge could be obtained of the existence now, or anytime heretofore of any such firm or House as I H. Phillips & Co in the City of New Orleans

Given under my hand and seal of office, at the City of New Orleans, this Twentieth day of September eighteen hundred and ~~thirty~~ forty and the Independence of Texas the Fifth

Wm Bryan
by Edward Hall
Consular Agent

hazardous and prone to flooding in rainy weather, and the roads from Houston to the north were almost as bad. The lack of adequate roads most likely hampered immigration to Texas.

While horses and mules were used, ox teams hauled most of the goods coming into the city. Less expensive than draft horses, oxen could subside on prairie grass and could cover from 10 to 15 miles daily when the roads were not flooded. Upon reaching Houston the wagoners would deposit their goods and rendezvous at a wagon camp on the outskirts of the city to prepare for the return trip. Houston had two wagon camps, one of them on Main Street, where it is said that revelry and whiskey flowed late into the night. Although most of the teamsters were white, occassionally a Brazos cotton planter would send his wagon to Houston driven by a black slave. Because freighting was basically the work of planters and wagoners, attempts were also made to establish regular passenger service in and out of the city. The Texas Stage Line and the Houston-Austin line offered service to Richmond, Austin, and San Antonio. The prospective traveler was charged $15 and promised that he would reach Austin in three days; the pledge was rarely honored.

Buffalo Bayou would remain Houston's link to the outside world until the rail connections of the post-Civil War era. Writing in May 1837, Francis W. Moore, Jr., complained, "the principal objection to this place is the difficulty of access by water; the bayou above Harrisburg being so narrow, so serpentine and blocked up with snags and overhanging trees that immense improvements will be required to render the navigation convenient for large steamboats." Accordingly, in 1839, the Buffalo Bayou Company was organized by John D. Andrews, one of Stephen F. Austin's "Old Three Hundred" settlers, to dredge and clear the water route. Five miles of channel were cleared above Harrisburg, though snags and obstructions continued to be a persistent problem. Early in 1840 two ships, the *Emblem* and the *Brighton*, sank and partially blocked the channel. The *Brighton* was salvaged and renamed the *Sam Houston*, but

Established in 1825 on the banks of Buffalo Bayou, Harrisburg was a major competitor of Houston for trade in the late 1830s and 1840s. The city, incorporated under a trust to the Harrisburg Town Company in 1839, attempted to fund its development as a transportation center serving the Brazos. Although the first railhead in Texas, the city lost out to Houston after the Civil War. In 1926 it was annexed by Houston. Courtesy, Special Collections; Houston Public Library

even with its new name it sank again shortly thereafter.

The accomplishment of a deep-water channel able to accommodate oceangoing ships was still in the future, but a positive step was taken in 1840 when the Republic congress authorized the city to build and maintain wharves. In 1841 the Houston City Council created the Port of Houston, which consisted of all wharves and landing facilities along Buffalo and White Oak bayous. The city then proceeded to tax merchants using the channel to raise funds for bayou maintenance; free wharf space was also permitted to certain businessmen in return for their efforts to keep Buffalo Bayou navigable. Primitive roads, railroad projects, and works to widen and clear the water path to the Gulf of Mexico were all attempts on the part of Houston's leaders to solve their city's transportation difficulties.

Locating the seat of government at Houston had been greatly responsible for the city's initial surge. A number of small towns had been chartered by ambitious promoters along Buffalo Bayou and Galveston Bay, but Houston prospered while they failed. Colonel James Morgan, a Galveston booster with shipping interests in that city, sarcastically observed in a letter to a friend:

The new town of Houston cuts a considerable swell in the paper. I wish its projectors and proprietors success with all my heart . . . As for New Washington and Lynchburg, Scottsburg and all the other burgs, not forgetting Powhatan, all must go down now. Houstonburg must go ahead in the *newspaper at least.*

However, complaints about the Republic's capital were voiced almost from the start. Many legislators insisted that the Allen brothers had not provided the facilities they had promised. Irritation with the humid, muggy weather that often afflicted the Bayou City was widespread, and its location so close to the Gulf made the incidence of yellow fever a frightening specter. In exasperation a congressman wrote to his wife that, "Houston was the most miserable place

in the world," while a young attorney, John Hunter Herndon, castigated the city as, "the greatest sink of dissipation and vice that modern times have known." Yet this must not have been the prevailing sentiment, for Houston continued to grow and prosper.

The issue of the location of the permanent seat of government was ultimately decided by the 1838 presidential election campaign. Candidate Mirabeau B. Lamar favored moving the capital and campaigned on that issue. On December 1, 1838, President Lamar delivered his inaugural address at the capitol, the site of present-day Houston's Rice Hotel. He made no mention of his intention to work for removal, but the matter was never in doubt. Lamar's supporters quickly passed an act through the Republic legislature stipulating that the new capital would be called "Austin" and that it would be situated at "some point between the rivers Trinity and Colorado, and above the old San Antonio road." The legislative requirements effectively secured the bypassing of Houston and meant that the new capital would be located in Central or West Texas. Since Sam Houston's political base was essentially in the east and along the Gulf Coast, Lamar intended to cultivate the frontier.

After an intensive search, commissioners appointed by congress recommended the embryo village of Waterloo, a settlement on the east bank of the Colorado. Understandably, boosters of the city of Houston were displeased. One who had been a Lamar partisan during the campaign was the editor of the Houston *Telegraph and Texas Register,* Francis W. Moore, Jr. While noting that "the climate was remarkably healthy" in Austin, Moore also observed that it was "almost entirely uninhabited, and what is worse probably, more exposed than any other point on the frontier to the depredations of hostile Indians." Yet these sentiments were mild compared to the bitter comments of the editor of the Houston *Morning Star:*

The idea of *permanently* locating the seat of Government by commissioners appointed

by Congress, seems to be entirely absurd—the only satisfactory way is to leave it exclusively to the people. That there must be a called session of Congress at this place in the fall seems inevitable—for the law at present in force designating the time for the removal of the different departments to the new Capital, cannot by any possibility be obeyed.

The establishment of the permanent seat of government remained a political issue throughout the Republic period. In 1842, during his second term in office, President Houston convened congress into extraordinary session at the capitol in his namesake city. The announced purpose was to prepare for renewed war with Mexico, but many believe that "Old Sam" hoped to force the capital question once again. If so, he suffered one of his rare political setbacks when the solons met at Washington-on-the-Brazos for the next session.

The city of Houston had been compensated somewhat when it was designated as the county seat of Harris County in 1837. President Houston had named Andrew Briscoe, prominent in the Texas Revolution, as chief justice of the county. Perhaps fittingly, shortly thereafter Briscoe announced his impending marriage to Mary Jane Harris, daughter of John Richardson Harris, the founder of Harrisburg.

Among the matters falling under county jurisdiction was education. The 1836 Texas constitution guaranteed freedom of education and stressed its importance to a cultivated society, and congress passed the Education Bill of 1839, which granted to each county the proceeds from the sale of three leagues of land (13,284 acres) for the creation and upkeep of public schools. The institutions would be administered by county school boards, which were empowered to establish courses of study and set qualifications for teachers.

However, land was so abundant in Texas that it had little value for sale, and most counties did not even bother to survey the land available to them for sale. Therefore, the only schools that existed in Houston during the Republic were private. The best of these was the Houston City School, whose course of study included all disciplines taught in excellent academies. Tuition was three dollars per month, but children who could not pay the stipend were admitted free. Other smaller private schools that functioned on a somewhat regular basis in the city were the Classical School, Houston Academy, and the Houston Female Seminary. Private tutoring in the home, particularly in scientific subjects, was also not uncommon. Public education on the primary and secondary levels was still a goal for the future.

In addition to freedom of education, the Republic constitution also guaranteed freedom of religion and, in fact, prohibited clergymen from holding public office. In its infancy, Houston was home to many and diverse religious groups. The Reverend Littleton Fowler acted as chaplain of the senate in 1837-1838 and founded the first Methodist church in 1844. It eventually became Shearn Methodist Episcopal Church, South, named in honor of merchant and prominent member Charles Shearn. In 1838 the Reverend William Y. Allen started a Presbyterian congregation and also organized a Sunday School and Bible Society. The membership of the latter group included many who held political office in the city, county, and Republic governments. In the late 1830s Z.N. Morrell, an eloquent itinerant Baptist preacher, led celebrants in regular meetings while extolling the virtues of temperance. The Baptists finally built a church in Houston in 1847 on the corner of Travis Street and Texas Avenue. The Roman Catholics received the ministry of two missionary priests, Father John Timon and then Father J.M. Odin, who came to Houston from the Lazarus House in St. Louis. The first Jewish congregation was Beth Israel, founded on December 28, 1859. The cornerstone of Beth Israel synagogue was laid in June 1870 with the interdenominational cooperation that characterized Houston's early religious history. In a long procession to the new building, many religious denominations and civic groups were represented. A bless-

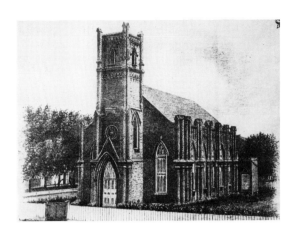

ing was recited by Henry S. Jacobs, chief rabbi of the New Orleans Port synagogue, and the Freemasons were in charge of the ceremonies

In lieu of regular church services and established congregations, clergymen preached to anyone who would listen in revival-style services. The privations of life in early Texas made many eager for the consolation of religion, but the excesses practiced by some ministers irritated others. With obvious distaste, Ashbel Smith, a sophisticated physician and later the Republic's ambassador to England and France, recorded these impressions in 1838 of a revival service conducted in Houston:

Methodists of this town Houston are in a state of horrible—of frightful excitement—which has lasted already eight or ten days and attracts crowds of spectators. No pen or tongue could give you an adequate description of those riotous scenes—a person must see & hear in order to be convinced of their mad extravagancies & I fancy most will distrust the evidence of their senses. They call it a revival.

Preachers railed against the evil of drink, with some effect. The Sons of Temperance, the first Houston temperance society on record, was organized on February 20, 1839, with the Reverend William Y. Allen and Sam Houston among its leading members. Speeches were delivered by many prominent citizens and even President Houston, no stranger to alcoholic excess, made an impassioned plea for temperance. Nevertheless, drunkenness was a prevalent vice in the early days of the city.

In 1837 the Republic congress passed a law suppressing various kinds of gambling, such as roulette and rouge et noir, but in Houston this seems to have been honored only in the breach. In this connection, Gustav Dresel, a German businessman whose journals reveal much about Houston's early history, noted, "games of hazard were forbidden, but nevertheless the green tables were occupied by the gamblers for the whole night. What is more, these blacklegs even formed a regular guild, against which any opposition was a risky matter." Since thoroughbred racing was also popular in the city, this, too, increased the incidence of gambling.

Early Houston was no stranger to frontier rowdiness or violence. Francis W. Moore, Jr., editor and sometime mayor of Houston, mounted a spirited crusade against one form of violence—dueling. Legal in most Southern states at the time, it is not difficult to see why the practice took root in Houston. Moore was particularly incensed at the murder of Henry Laurens, a young man of good family, back in the States by gambler Chauncey Goodrich. The duel was provoked when Goodrich falsely accused Laurens of stealing. Contested with rifles at 20 paces, Laurens died two days later from wounds sustained in the encounter. Goodrich's death not long afterwards in San Antonio under violent circumstances enabled Moore to moralize once again concerning the high rate of bloodshed and violence in Texas. Thanks in great part to the efforts of the crusading editor, in 1840 both the city and the Republic passed anti-dueling statutes, which operated against the seconds as well as the participants in an "affair of honor."

As befitted a frontier community, the meting out of justice in Houston was swift and uncompromising. Trials were conducted in an informal manner with little attention paid to formal rules of evidence and legal procedure. William A. Bollaert, an English barrister who later practiced law in Galveston, has left this description of a trial held in Houston in 1842:

Organizing a church in 1839, the Episcopalians were one of the earliest religious groups to establish a congregation in Houston. The members waited five years to begin work on the first Christ Church at Texas and Fannin in 1845. The Gothic structure was replaced in 1893 by the present cathedral. Courtesy, Harris County Heritage Society; Litterst-Dixon Collection

There was a very gentlemanly man as Judge Morriss. The District Attorney as prosecution for the Republic was opposed by half dozen lawyers—ready of speech and loads of references—from Magna Charter upwards—the Court was over a crockery store used on Sunday for a Methodist Chapel—the Judge was chewing his quid—thrown back in his chair—his legs thrown up on his desk—the District Attorney was chewing and smoking . . . I saw the weed in the mouth of some of the lookers on—order was kept in the Court—but ever and anon there was a squirt of Tobacco juice on the floor.

If trials were sometimes conducted in a casual manner, sentencing was harsh and precise. In addition to fines and jail time, the city criminal code condoned whipping and death by hanging. Theft was routinely punishable by 100 lashes applied to the bare back of the offender, though juries could assess a greater number of lashes. Branding on the palm of the hand was at one time a recognized punishment, but the practice was later outlawed. Hanging was the sentence reserved for convicted murderers and rapists, with the execution carried out in public. The practice was defended as being salutary for the citizenry, but the large crowds indicate that there was a circus atmosphere attached to it. In 1838, amid a

Mirabeau Buonaparte Lamar (1798-1859), who had commanded the Texas cavalry at San Jacinto and had served both as vice-president and president of Texas, also served as president of the Philosophical Society of Texas. From Thrall, Texas 1879

boisterous crowd, lawyer John Hunter Herndon viewed the hanging of convicted murderers David Jones and John C. Quick. Herndon recorded these impressions in his diary:

A delightful day, worthy of other deeds—140 men order'd out to guard the Criminals to the gallows—a concourse of from 2000 to 3000 persons on the ground and among the whole not a single sympathetic tear was dropped—Quick addressed the crowd in a stern composed & hardened manner entirely unmoved up to the swinging off the cart—Jones seemed frightened altho as hardened in crime as Quick—they swing off at 2 o'clock P.M. and were cut down in 35 minutes not having made the slightest struggle.

Not all attractions that drew crowds of Houstonians were violent. Theatrical productions, both serious and comic works, generally drew overflowing and appreciative audiences. Minstrel shows, acts featuring trained animals, and practitioners of the "science of phrenology" were also warmly received. Of a more serious nature was the formation of the Philosophical Society of Texas, chartered in 1837. Mirabeau B. Lamar served as president and Ashbel Smith as vice-president. Meeting in Houston, the first paper that the members applauded arose out of Smith's experiences as a physician in treating yellow fever cases. Admitting that Houston's climate was a factor in the dread disease, Smith stressed cooperation and the exchange of information between the Bayou City, New Orleans, and Mobile in combating the common foe.

From its faint beginnings immediately following the attainment of independence, Houston had become the principal urban center of the Texas Republic. While its citizens were chiefly concerned with the economic growth of their city, they had not neglected social and cultural attainments as well. Greater challenges lay ahead as Texans debated whether or not they wished to enter the Union as a state or pursue their independent status.

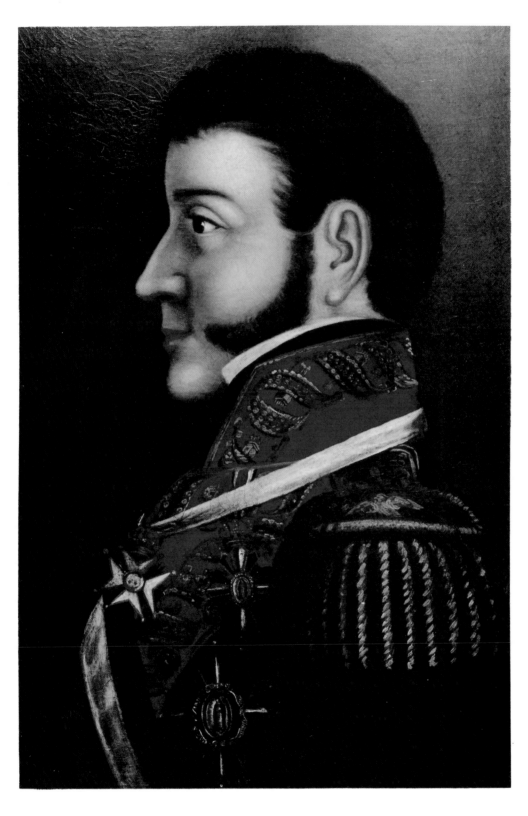

Agustín de Iturbide, the first emperor of Mexico, renegotiated the colonization laws that had been originally agreed upon by the Austins and the former Spanish government. Iturbide's legislation would serve as the basis for much of the colonization law, but he remained on the throne only a few months and was overthrown in 1824. The Republic of Mexico was established at the time of his fall. Courtesy, San Jacinto Museum of History, San Jacinto Monument

Lorenzo de Zavala was one of
the important Mexican leaders
of the Texas revolution. A
Federalist, he had been forced to
flee Mexico in 1830 and then
again in 1833. Although Santa
Anna's minister to France, he
resigned his office and moved to
Texas in 1834. His home,
across Buffalo Bayou, served as
a hospital for the wounded of
San Jacinto. He served as vice-
president of Texas from
March 17, 1836, until Octo-
ber 17, 1836. Shortly after his
resignation, he died, having
played an important role in
bringing his liberal ideals to
Texas. Courtesy, San Jacinto
Museum of History

This beaded cigar case was
brought by Stephen F. Austin to
Texas upon his release from a
Mexican prison in 1835. Austin
had been imprisoned by the
government of Mexico for
suspicion of inciting insurrection
when he traveled to Mexico at
the behest of the Convention of
1833 to protest the Law of
April 6, 1830. Courtesy, San
Jacinto Museum of History, San
Jacinto Monument

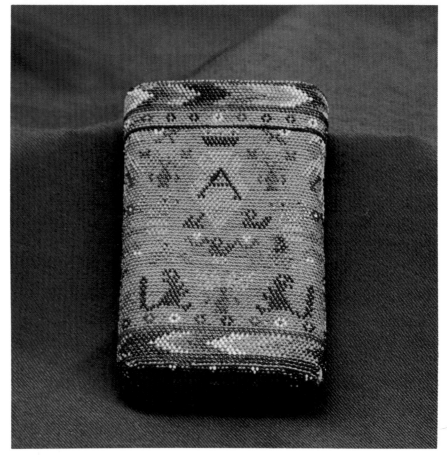

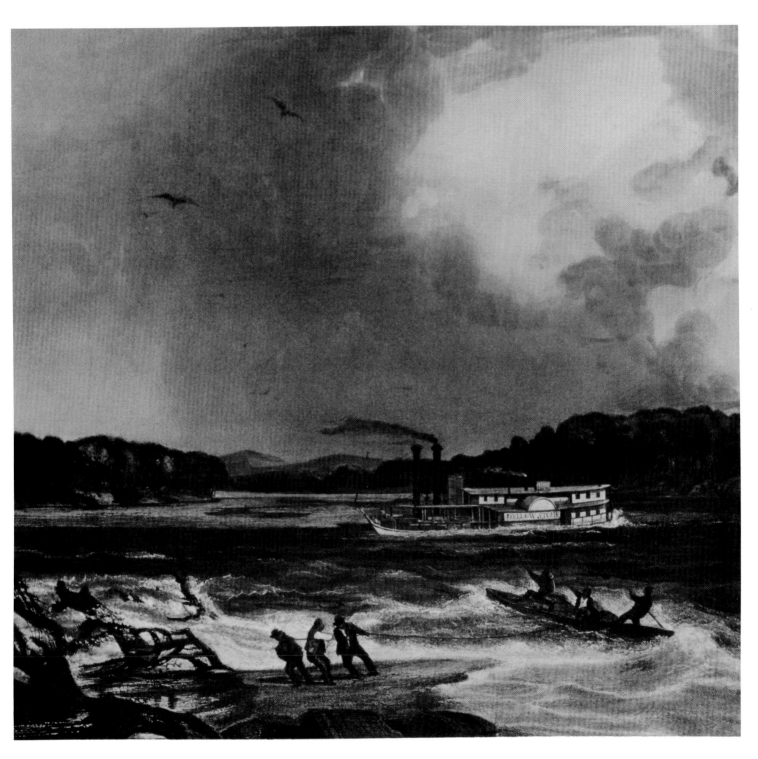

Built in 1830 for trade on the
upper Missouri River, the
steamer Yellowstone *was*
purchased in 1835 for use in
Texas waters by the Texas
bankers McKinney and
Williams. During her trip to
Texas, she carried 47 Mobile
Grays who volunteered for the
Texas army. On March 31, the
retreating Texas army crossed
the Brazos aboard her. Thirty-
nine days later she would carry
members of the Texas
government and their prisoner,
Santa Anna, to Velasco. After
the war she carried cargo and
passengers up and down Buffalo
Bayou between Houston and
Galveston. Courtesy, San
Jacinto Museum of History, San
Jacinto Monument

Right:
Commander of the left wing of the Texas army at San Jacinto, Sidney Sherman would play an important role in the development of Texas in the 1840s and 1850s. A leader in the community of Harrisburg and the representative for Harris County in the Seventh Congress of the Republic, Sherman also believed in the need for rail development in the region. In 1850 he became a leading promoter of the Buffalo Bayou, Brazos and Colorado Railway. Sherman later served as commandant of Confederate forces on Galveston Island until ill health forced his retirement. Courtesy, San Jacinto Museum of History, San Jacinto Monument

Far right:
Having come to Texas in 1821 and settled in San Antonio in 1822, Erastus "Deaf" Smith had been a neutral at the beginning of the Texas revolution, but was kept out of San Antonio by Mexican soldiers and then decided to join the forces of the revolution. At San Jacinto Smith was the leader of the scouts and destroyed Vince's bridge before participating in the battle. He later commanded a company of rangers. Courtesy, San Jacinto Museum of History

Left:
The wife of the man credited with the cry "Remember the Alamo," Catherine Cox Sherman, lived a life typical of an entrepreneur's wife on the Texas frontier. Her husband brought her to Texas from Ohio, finding a home in a one-room cabin near San Jacinto. Sidney Sherman later served in the Congress of the Republic, and after annexation tried many different enterprises, none of which quite worked. His wife supported him in all things, moving from San Jacinto to Harrisburg and finally to Galveston, where she died in 1865. Courtesy, San Jacinto Museum of History

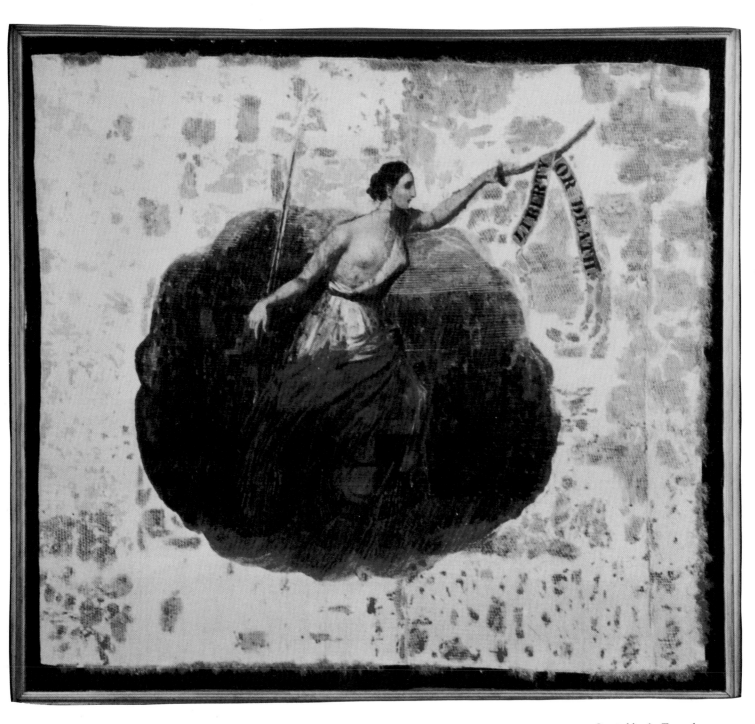

Carried by the Texas forces at San Jacinto, this flag was brought to Texas by a company from Newport, Kentucky. Made of white silk with an embroidered figure of Liberty, the flag served a nation that did not yet have its Lone Star flag. Courtesy, San Jacinto Museum of History

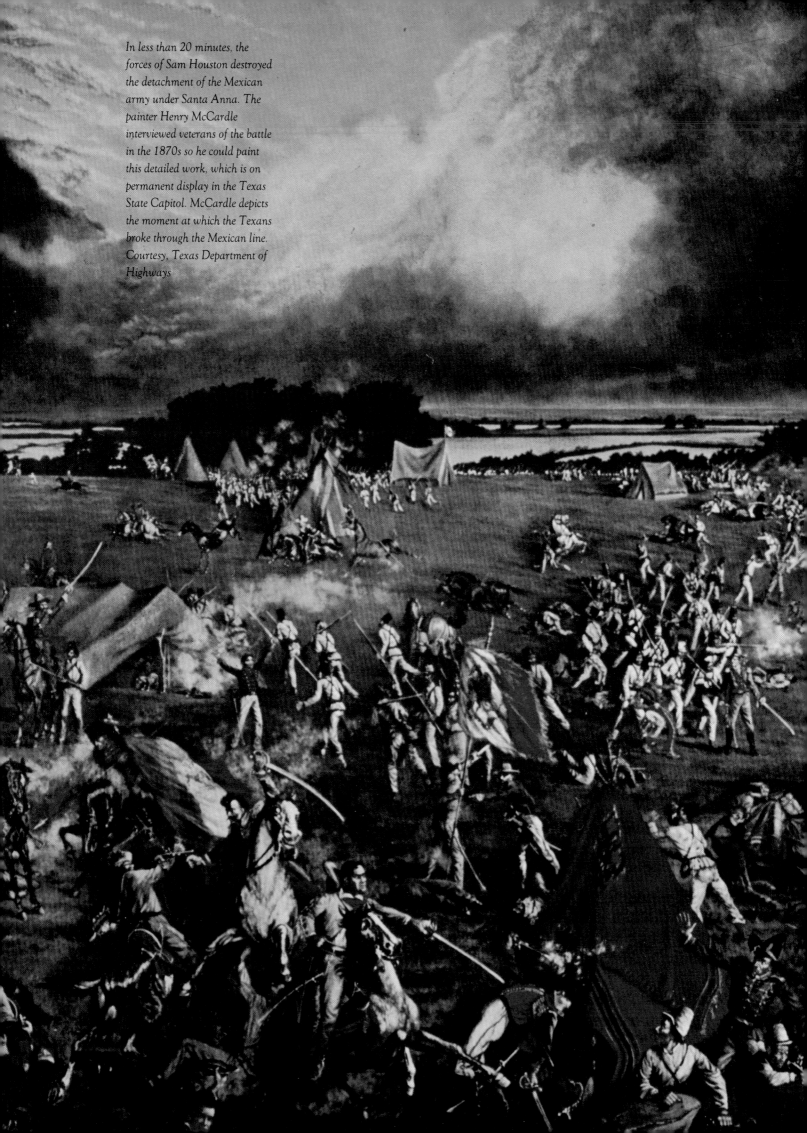

In less than 20 minutes, the forces of Sam Houston destroyed the detachment of the Mexican army under Santa Anna. The painter Henry McCardle interviewed veterans of the battle in the 1870s so he could paint this detailed work, which is on permanent display in the Texas State Capitol. McCardle depicts the moment at which the Texans broke through the Mexican line. Courtesy, Texas Department of Highways

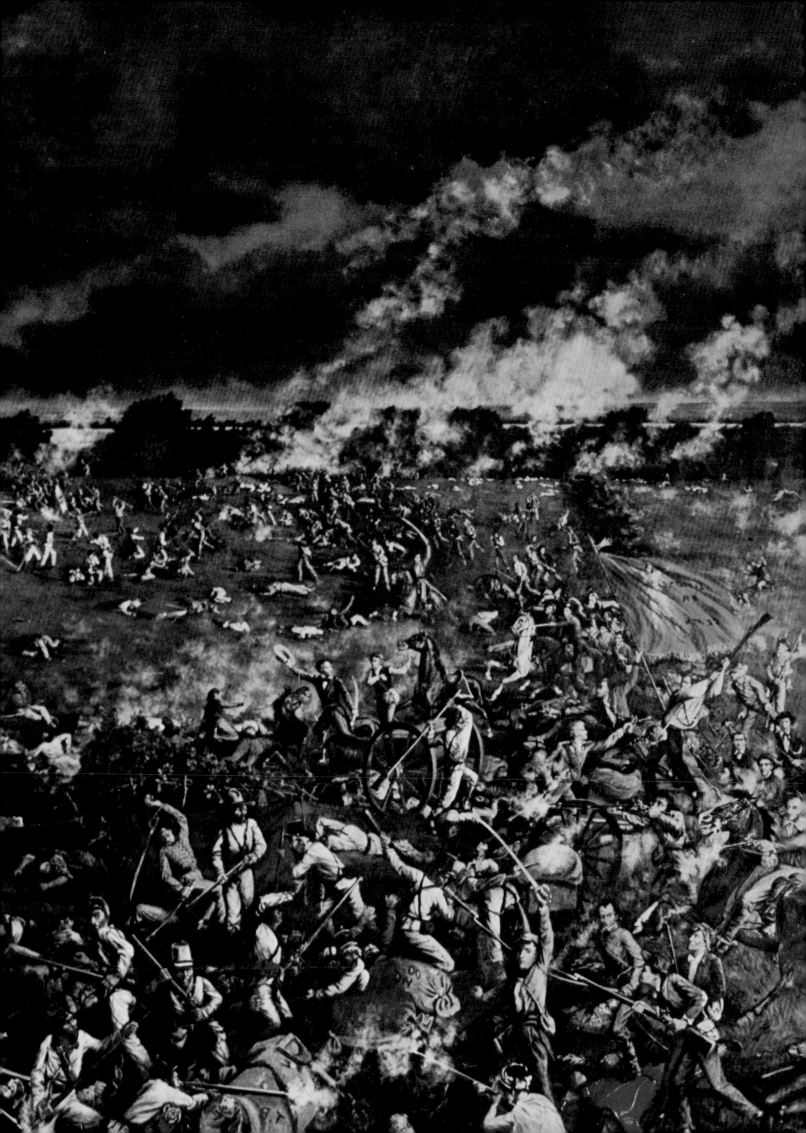

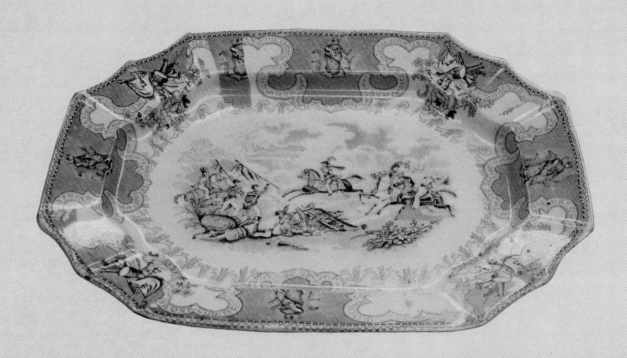

On May 8, 1846, U.S. forces
under the command of Zachary
Taylor met members of the
Mexican army under Mariano
Arista at Palo Alto, 12 miles
from Brownsville. The victory of
the U.S. forces was the first in
the two-year Mexican War that
confirmed the annexation of
Texas by the U.S. The war was
celebrated in a series of Texian
Campaign plates produced in
England. Photo by Story J.
Sloane III, Harris County
Heritage Society

STATEHOOD, GROWTH, AND CRISIS

Shortly after Texas achieved independence from Mexico, the issue of annexation to the United States came to the fore. Voters in the Republic's first presidential election cast a straw ballot for or against union with the United States, and a great majority of the electorate preferred annexation. In his 1836 inaugural address, President Houston promised that the issue would have first priority.

In fact, overtures to the United States had already been made by the ad interim administration of David G. Burnet. In response to a Texas request, Henry Morfit, a clerk in the State Department, visited the Republic in the late summer of 1836. Upon his return to Washington, he advised President Jackson against immediate recognition of Texas in light of the threat of Mexican invasion in response to annexation. This was sage counsel in a Presidential election year, as Northern opposition to the annexation of Texas had begun to manifest itself on anti-slavery grounds. Once Democrat Martin Van Buren was safely elected, Jackson announced the appointment of Alcee La Branche as charge d'affaires from the United States to the Republic of Texas. It was the last official act of his administration and Jackson celebrated it by sharing a glass of wine with William Wharton, appointed by President Houston to represent Texas at Washington. Throughout the period of independence, the American government maintained its diplomatic headquarters at Galveston, resisting all suggestions from leading Houston merchants that it move to that city.

In contrast to his predecessor Sam Houston, President Mirabeau B. Lamar opposed annexation, but following Sam Houston's reelection in 1841, the annexation issue became viable once again. On April 4, 1841, John Tyler succeeded William Henry Harrison as President, and shortly thereafter Abel Upshur, an ardent expansionist, became Secretary of State. As a Southerner, Upshur favored annexation, and he was also suspicious of British interests in the area. President Houston responded to the more congenial atmosphere in Washington by dispatching Isaac Van Zandt and James Pinckney Henderson as envoys to Washington, empowered to conclude annexation talks. On April 12, 1844, a treaty was signed by the Texas representatives and John C. Calhoun, who succeeded Upshur. However, all was held in abeyance as the summer approached and with it the party conventions to nominate candidates for the 1844 U.S. Presidential campaign.

Both the Whig and Democratic parties held their conventions in Baltimore. The Whigs named Henry Clay as their standard-bearer, and James K. Polk captured the Democratic nomination. Clay indicated that he favored the annexation of Texas but not at the cost of war with Mexico; Polk, catching the nation's mood of expansion, pledged to acquire Texas and Oregon. Anti-slavery feeling in the North helped spawn a third party. James G. Birney, the Liberty Party's nominee, vehemently opposed the admission of the slave state of Texas as fatal to sectional harmony. Texas and expansion were the issues that would determine the election.

In June 1844 the treaty for the annexation of Texas reached the Senate floor for a decisive vote. The Texas pact was overwhelmingly defeated—the first time a major treaty was rejected in United States history. Rather than attaining the constitutionally required two-thirds approval in the Senate, the treaty was rejected by almost precisely that count. Five months later, in November, Polk won a narrow victory at the polls and thus the electorate popularly endorsed the admission of Texas into the Union. However, the Congressional elections had resulted in only a slight change in the makeup of the Senate and thus the treaty's rejection could be anticipated upon a second vote.

At this juncture the Texan envoy, James Pinckney Henderson, suggested the "joint resolution" approach, requiring only a simple majority in the House and Senate, rather than a two-thirds vote of approval in the Senate. With the assistance of Senators Thomas Hart Benton and Robert Walker, a bill was quickly drafted. By its terms the State of Texas was guaranteed a republican

form of government and was permitted to retain title to its public lands. Slavery would continue as a legal institution and the state reserved the right to divide itself up into as many as five states, with slavery outlawed in any state north of the 36.30 line. After intensive debate and by a close margin in each chamber, the bill for the annexation of Texas carried.

Houstonians overwhelmingly supported union with the United States. The city's leading newspaper, the *Telegraph and Texas Register,* portrayed this sentiment in the following editorial comment:

The news of the passage of the annexation resolutions was hailed with a burst of enthusiasm by our citizens that has never been exceeded. The news of the victorious battle of San Jacinto scarcely excited such general and enthusiastic rejoicing. The sound of the drum and other musical instruments, the roar of the cannon, the loud shouts of the multitude resounding long after midnight, indicated the ardent longing of our citizens to return . . . under the glorious eagle of the American union.

The annexation legislation required that the people of the Texas Republic accept the proposal by January 1846, and that a state constitution acceptable to the federal Con-

gress be written by that time. After 10 years of struggle and privation the citizens of the Republic were willing enough to accept the benefits of American citizenship, but suddenly there was an alternative. Seeking to avoid war between the United States and Mexico over annexation and fearing that such a conflict would result in a decisive American triumph and additional territorial gains, Britain and France urged Mexico to recognize the independence of Texas. At virtually the same time that Andrew Jackson Donelson arrived to convey the American proposal of annexation to Texas, Charles Elliot returned from Mexico bearing an offer of independence from that nation. Under pressure from both camps, President Anson Jones agreed to submit the two plans to the vote of a specially elected convention. On July 4, 1845, at Austin, the delegates expressed their preference for union with the United States with only one dissenting vote. In Houston the decision met with celebrations in which the Stars and Stripes were raised and resolutions of approval were adopted. In rapid sequence a state constitution was written and ratified by the people, and Texas was admitted as the 28th state in the Union on December 29, 1845.

The annexation of Texas by the U.S. was viewed by Mexico as the taking of Mexican soil, which, the Mexican government had

warned earlier, would lead to war. The moment annexation was finalized, diplomatic relations with the U.S. were broken off. While annexation was the principal cause of the Mexican War, it was not the only one. Northern maritime interests avidly sought to acquire California and its choice Pacific Coast ports at San Francisco and San Diego, and all efforts to purchase California had failed. After an unsuccessful attempt to present a plan for the American purchase of land north of the Nueces River, including California, President Polk insisted that he had made every reasonable sacrifice in the cause of peace and ordered American troops to take up a position along the Rio Grande. A patrol unit of American soldiers commanded by General Zachary Taylor was engaged by Mexican troops along the border on April 24, 1846. In a statement that later became famous, President Polk demanded war to avenge, "American blood shed upon American soil," and on May 11, 1846, Congress rallied to the support of the Chief Executive and declared a state of war to be in existence between the United States and Mexico.

Between 125 and 150 Houstonians volunteered for military action in the war with Mexico, and wartime activities brought increased traffic through the Port of Houston. Tons of arms, cotton, and foodstuffs passed through the port, boosting the city's growth. After almost two years of fighting, Mexico finally yielded its claims to Texas and many other future American states in the treaty of Guadalupe Hidalgo, signed on February 2, 1848.

As Houston developed economically with the coming of annexation, the Mexican War, and statehood, the old Houston-Galveston rivalry flared up. At the time of Houston's origin, there was no town on Galveston Island. Although in the planning stage earlier than Houston, a major storm in 1837 delayed the founding of the city until the next year. Despite the boasts of the Allen brothers, few oceangoing vessels could make their way up Buffalo Bayou to Houston; therefore most ships of that size landed their cargoes at Galveston. However, Houston's designation as the first capital of the Republic was an honor not shared by Galveston. As Professor Marilyn Sibley points out in her book, *The Port of Houston*, the rivalry between the two young cities at

This 1859 drawing depicts a cargo of cotton being loaded at Main Street.

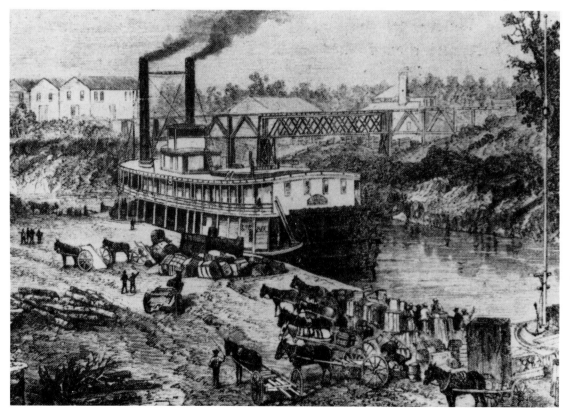

this point in their mutual history was a friendly one. Many Houstonians maintained business operations in both cities and many tended to view Galveston as principally a depot for goods ultimately destined for consumption in Houston.

At the inception of statehood, however, Galveston's population was almost twice that of Houston. The Bayou City's growth, which had been very rapid from the time of its founding, had begun to slow somewhat. The federal census of 1850 placed the city's population at 2,397, an increase of less than 400 over the count taken by the Republic 10 years earlier. Still, in 1850, Houston was the state's third-largest city, ranking behind Galveston and San Antonio. While somewhat disappointing to local boosters, the above tally did not take into account a floating population, temporarily resident in the city and dedicated to trade. In the latter category, the cotton trade appeared to be particularly booming. According to figures compiled in 1842 by the *Telegraph and Texas Register*, 4,260 bales of cotton were carted to the city from plantations along the Brazos and shipped out from Houston. By 1854 that figure had reached 11,359 bales, proving conclusively that Houston had established itself as a trading center where land and water routes converged.

The city took steps to improve its port facilities, and with the encouragement of the municipal council, wharves were built on the banks of Buffalo Bayou within the city limits. An ordinance was passed on June 10, 1841, creating the Port of Houston and placing all wharves and landings within the political jurisdiction of the city. Also, it was stipulated that the waterfront area between Main and Fannin streets would be held in reserve for large ships to dock while smaller craft would be given other locations. Then, in compliance with the ordinance, Charles T. Gerlach, a local merchant, was named to be wharfmaster. Encouragement was also given to efforts to clear the channel above Harrisburg and to prevent pollution along the route from Harrisburg to Houston.

In 1849, as the scramble to California to find gold reached its intensity, the city lay

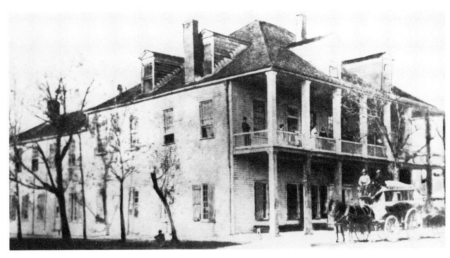

astride one of the most frequently traveled routes to the Pacific Coast. No less an authority than General Stephen Kearney, the Mexican War conqueror of Santa Fe, recommended the Houston to El Paso to San Diego route as the quickest and most practical way to the fabled gold fields. Writing in a St. Louis newspaper, Kearney insisted that an emigrant might make the trek from Houston to San Diego for not more than $20. A few Houstonians headed for California in search of gold, but prudent proprietors of general stores and businessmen like Thomas W. House and William Marsh Rice remained behind and enjoyed temporary prosperity from the sale of foodstuffs, rifles, powder, and kits of carpenter tools purchased by the "'49ers."

As the decade of the 1850s approached, Houston was but 14 years old. At this point in its history the city faced a major, perhaps inevitable, challenge from Galveston. Leading capitalists there sought to secure the trade of the interior of Texas, principally cotton from the Brazos and Trinity river bottoms. If those rivers were made navigable, given the lack of adequate roads from the interior to Houston, the Bayou City could be effectively bypassed as a trading depot. With this aim in mind, the Galveston and Brazos Navigation Company was chartered on February 8, 1850, to build a canal connecting the Brazos River with Galveston Bay. The canal was built, but the expenses of constant dredging exceeded the profits earned. This challenge was beaten back, but the rivalry between Houston and

As a part of their successful effort to make Houston the capital of the new Republic, the Allen brothers built a peach-colored, two-story structure to house the legislature, as well as other smaller government offices. Although not complete when the government arrived, the new structure served to house a small art gallery as well as the offices of government. After the government moved to Austin, the building reverted to the Allens and they used it as a hotel. Courtesy, Harris County Heritage Society

its neighboring cities then shifted to railroad construction.

Like Andrew Briscoe before him, San Jacinto veteran Sidney Sherman, a prominent citizen of Harrisburg, hoped to lure trade to Harrisburg rather than Houston through the construction of a railroad. He became the leading promoter for the Buffalo Bayou, Brazos and Colorado Railway Company, which was incorporated in 1850 with financial backing obtained in Boston. The road had been built to Richmond on the eastern bank of the Brazos by 1856, when construction was halted for lack of funds. Sherman and his partners were unable to command sufficient state assistance, and the outbreak of the Civil War doomed completion of Sherman's project. Nevertheless, he had finished some 80 miles of track from Harrisburg to the Colorado River, and the Buffalo Bayou, Brazos and Colorado could claim one other distinction; in 1853 one of its locomotives, the *General Sherman,* became the first to grace the Texas countryside.

Houston benefited from railroad construction when the Houston & Texas Central, chartered originally by the state legislature in 1848 as the Galveston & Red River, obtained a new charter in 1852 and

was granted permission to locate its terminus in the Bayou City. Houston businessman Paul Bremond was named president of the railroad in 1854. He was unsuccessful in securing Northern capital to finance the project, but state loans enabled the road to continue. By 1860 it had reached Millican in Brazos County, about 80 miles northwest of Houston. Interestingly enough, Washington-on-the-Brazos, jealous of its river traffic, refused to award the Houston & Texas Central right-of-way through the town.

In the decade before secession, two other projects were begun with Houston connections. On February 7, 1853, the Galveston, Houston, and Henderson Railroad Company was chartered with the endorsement of Houston and Galveston capitalists. Both cities gave their approval and financial groups in each city agreed to subscribe for $300,000 of the stock. Construction began just opposite Galveston on the mainland at Virginia Point and had reached the outskirts of Houston by 1859. At that point work ceased because of the outbreak of a yellow fever epidemic, but the road became the first in Texas to touch the seacoast. Triweekly train service was begun between Houston and Virginia Point. Passengers and freight were then transferred between

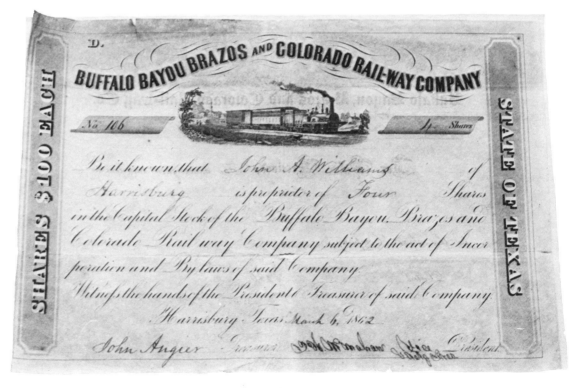

COMFORT, ECONOMY
AND SPEED!
Houston and Galveston!

THE HOUSTON NAVIGATION COMPANY'S
LINE OF STEAMERS
Consisting of the following first-class boats:

DIANA, Capt. Sterrett.
ISLAND CITY, Capt. Blakeman.
NEPTUNE.

All in the very best condit'on, leave Galveston for Houston, and Houston for Galveston, every day, making close connections, at Houston, with the Trains on the Texas Central and the Columbia Railroads, and at Galveston with the New Orleans Steamers.

On and after THURSDAY, MARCH 14, these steamers run by the following

SCHEDULE:

DIANA Leaves GALVESTON SUNDAYS and THURSDAYS, at 10 o'clock A. M., or on arrival of steamer from Berwick's Bay, reaching Houston at 8 P. M.; passengers taking dinner and supper on the boat. TUESDAYS at 4 P. M., arriving in Houston after midnight; passengers sleeping on board, and remaining at pleasure until the leaving of the morning trains for Hempstead, Navasota and Chappell Hill, for Richmond, Columbus and Columbia.

ISLAND CITY Leaves GALVESTON on MONDAYS, WEDNESDAYS, and FRIDAYS at 4 P. M., connecting, next morning, with all the trains from Houston for the interior of Texas.

DIANA Leaves Houston on MONDAYS, WEDNESDAYS, and FRIDAYS, and the
ISLAND CITY On TUESDAYS, THURSDAYS and SATURDAYS, at 6 P. M., on arrival of the trains on the various railroads from the interior, reaching Galveston by 4 A. M., next morning. Passengers for the New Orleans boats leaving same morning, taking breakfast, if they desire it, on board.

☞ The advantages afforded by these boats to the traveler, are the saving of expense, securing comfort, and no time lost in making the connections, either inward or outward.

☞ The Company refer to the testimony of all travelers as to the accommodations of the boats, and the attentiveness of the officers to the safety of the passengers.

FARE EACH WAY, $3
For Passage apply on Board.

Houston Telegraph Printing Establishment.

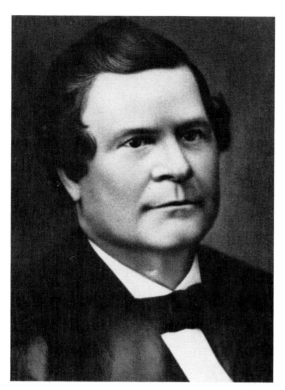

Virginia Point and Galveston across Galveston Bay by the ferryboat *Texas*. It required four hours to complete the trip between Houston and Galveston, but early in 1860 the completion of a railroad bridge provided a direct connection from the island to the mainland.

The most ambitious pre-Civil War railroad scheme was the Texas and New Orleans Railroad, chartered in 1856 with the purpose of binding Louisiana and Texas closer together in the event of war with the North. By January 1861 tracks had been laid from Houston to Orange and all 110 miles of the Texas portion of the road had been completed. Due to various delays and financial stringency, the Louisiana section of track was not finished until after the Civil War. The Texas and New Orleans as well as the Buffalo Bayou, Brazos and Colorado Railway Company eventually became part of the Southern Pacific's trunk line to California.

What was it like to travel on the early railroads with Houston connections? On the Buffalo Bayou, Brazos and Colorado, the first passenger coaches had originally been built in Boston to serve as streetcars. Each coach, sitting on only four wheels, could hold about 20 passengers, but they were later replaced by much larger coaches that

could accommodate as many as 50 travelers each. Both passenger and freight cars were pulled by the 13-ton locomotive engine, the *General Sherman*. A passenger on the line, the British writer A.S. Fremantle, recorded in his journal that the train gave a tremendous jolt when it started and, "every passenger is allowed to use his own discretion about breaking his arm, neck, or leg without interference by railway officials."

Houston had become the foremost railroad center in Texas by 1860. With the enthusiastic cooperation of the state in the form of loans and public lands, more than 450 miles of track had been laid in Texas by the time the state joined the Confederacy. Houstonians pointed with pride to the fact that of that figure more than 350 miles led to Houston. In 1860, 115,010 cotton bales came into the city, the great majority transported by rail. This count was just short of double what it had been only two years earlier in 1858 and almost four times what it had been in 1854. These statistics are eloquent proof of what the railroads meant for Houston in the period between the attainment of statehood and the outbreak of sectional warfare.

In addition to the growth of transportation, other business and commercial activity boosted the fortunes of Houston and its entrepreneurs at this time. An example of this can be found in the career of Thomas William House, whose son Colonel Edward M. House would become famous as Woodrow Wilson's close friend and advisor. An Englishman by birth and a baker by trade, Thomas came to Houston from New Orleans in 1838. In Houston he became an ice cream manufacturer, a grocery and dry-goods dealer, and a banker. As early as 1840 House began to function as a private bank, accepting deposits and lending money. To this activity he added cotton factoring, and with his grocery and dry-goods sales, he soon became the largest wholesaler in the state. Ox wagons could often be seen waiting half a day at the T.W. House Plantation Commissary and Wholesale Grocery at the corner of Main Street and Franklin Avenue for their turn to be loaded. During the Civil

War House became mayor of Houston. During the blockade of Galveston, he shipped cotton to England through the Mexican port of Matamoros and purchased desperately needed supplies for the Confederacy in return. In the postwar era House expanded his holdings by developing railroad, shipping, and banking interests, and when he died in 1880, he left an estate valued at more than one million dollars. As entrepreneurs like House experienced success in their commercial ventures, they also helped to make Houston an important mercantile community.

The Texas Telegraph Company, a commercial endeavor that advanced communications to Houston, was organized and founded in Louisiana. In 1853-1854 the company strung wire from Shreveport to a number of communities in East Texas and then to Houston. In 1854 the connection between Houston and Galveston was made by using a wire under Galveston Bay. Service and financial problems led to the ultimate failure of the company, which was finally consolidated into the Western Union system in 1869. Another financial enterprise that played a role in the city's economic development was the insurance business. The Houston Insurance Company, established in 1858, offered merchants fire and marine insurance. An out-of-state firm, Southern Mutual Life Insurance Company,

insured the lives of Harris County slaves as well as their masters. To facilitate these and other business ventures, a Board of Trade was created, mainly to regulate freight and storage rates.

Houston's commercial development was hampered by the lack of banking facilities. Because of lingering feelings concerning the causes of the Panic of 1837 in the United States and the fact that most Texans shared Jackson's prejudices against banks, the 1845 state constitution prohibited the establishment of public banks and the issuance of paper money entirely. This regulation remained in effect until the Civil War era and made possible the development of a limited number of private banks. In addition to T.W. House, cotton merchant B.A. Shepherd also engaged in banking activity in Houston. In fact, in 1854 Shepherd became the first Houstonian to engage exclusively in banking for a livelihood, and the B.A. Shepherd Exchange and Collection Office was the first real bank in the city.

While business development was on the rise, the faint stirrings of labor union interest in Houston were also taking place. In June 1837 the Houston Mechanics Association was organized, its purpose to "advance the interests of all workingmen." As its first priority, the Houston group sought to organize a similar movement in Galveston, but while a few joint meetings were held, the

Although Texas issued currency, banker Samuel May Williams of Galveston also issued currency during the period of the Republic and statehood. Operating the thriving Commercial and Agricultural Bank of Texas, Williams believed he could supply money to ease currency shortages. In 1848, however, the Texas legislature ended the right of local banks to issue such currency. The currency placed power in the hands of bankers, particularly those in Galveston. Houstonians opposed this activity, in part to protect their own trade position. Courtesy, San Jacinto Museum of History

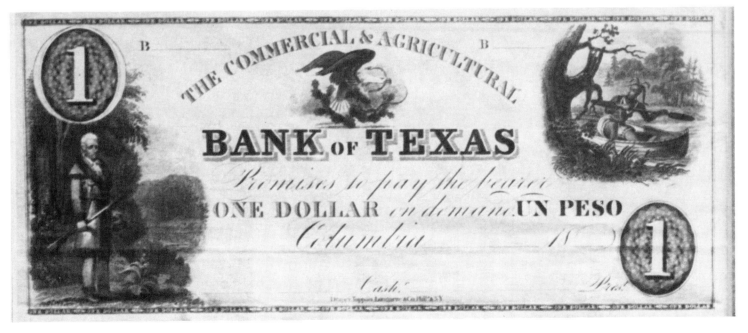

In the 19th century, waterborne trade along Buffalo Bayou and through Galveston Bay was dominated by Charles Morgan's steamship line. Sidewheelers ran from his headquarters on the Galveston Wharf to Houston and New Orleans. In the 1870s he developed a near monopoly on trade along Buffalo Bayou by taking control of the Buffalo Bayou Ship Channel Company and dredging the channel to a 12-foot depth. Courtesy, Rosenberg Library

Galveston laborers failed to organize. By the late 1840s and in the early years of the next decade, the Houston group was regularly represented in the annual Fourth of July parade. However, active unionism, complete with regular negotiations over salaries and working conditions as well as the threat of strikes, did not become a reality in the Bayou City until after 1870. Basically, there were two reasons for this lack of success: the slow pace of heavy industrial development in the city and the fact that no assistance was received from national union organizations until the post-Civil War era.

As the institutions of Houston's commercial life were being planted, the city's physical appearance took shape. Buffalo Bayou continued to flow at the foot of Main Street, and passengers arriving by boat from Galveston traveled by two-wheeled horse-drawn carts to the Capitol Hotel. On the site of what had been the capitol of the Republic, the hotel perched one story above most of the wooden storefronts flanking Main Street. Ferdinand Roemer, the German colonizer whose work *Texas* (1849) served as an inspiration for German migration to Texas, was a guest at the hotel and noted

with distaste, "a number of men, evidently farmers, clad mostly in coarse woolen blanket-coats of the brightest colors—mostly red, white and green—stood around the stove, engaged in lively conversation." Roemer also observed that while the hotel did not compare favorably with similar establishments in Europe, one phase of its operations was impressive:

The numerous saloons . . . drew my attention. Some of them (considering the size of the City) were really magnificent when compared to their surroundings. After passing through large folding doors, one slipped immediately from the streets into a spacious room in which stood long rows of crystal bottles on a beautifully decorated bar. These were filled with divers kinds of firewater— among which, however, cognac or brandy were chiefly in demand. Here also stood an experienced barkeeper, in white shirt sleeves alert to serve the patrons the various plain as well as mixed drinks (of which latter the American concocts many) . . . the saloons were always filled.

Not all approved of saloons, however, for

a municipal ordinance enacted in May 1855 closed saloons, billiard parlors, and bowling alleys on Sunday.

The cultural life of the city was improved by the organization in 1854 of the Houston Lyceum, located at 419 Main Street, which presented debates, lectures, occasional music concerts, and a free library for its members. Although for brief periods of time there were no recorded Lyceum activities, the group was strong enough to assist in the establishment of Houston's first free public library in the first years of the 20th century.

Since Houston's birth in 1836, the *Telegraph and Texas Register* had been the leading newspaper in the city. This was so because of the journalistic talents of its editor, Francis W. Moore, Jr. A brilliant man who had been an army surgeon during the War for Texas Independence, Moore also taught school and practiced law. He served as mayor of Houston in 1838, again in 1843, and from 1849-1852, and he was far from bashful in using his position as mayor to advance the fortunes of his newspaper. Neither the *National Intelligencer* nor the Houston *Morning Star* could rival Moore's creation in popularity or subscriptions.

In the pages of their favorite newspaper, Houstonians followed the politics of the day. Whereas politics in the Republic era had been essentially a question of personalities, national political parties now began to take root in Texas. Symbolically, the *Telegraph and Texas Register* affixed the word "Democratic" to its masthead, and commented, "the great principles that distinguish the Democratic party of the Union are the best calculated to advance the true interests of the people of Texas." Not only did the state become more involved in national political parties; it also became entangled in the crisis developing between the country's Northern and Southern states.

The annexation of Texas, coming as it did after nine years of sectional controversy, must be regarded as a major cause of the Civil War. Northerners saw the annexation of Texas as the extension and perpetuation of slavery, while Southern Congressmen openly threatened to abandon the Union if Texas were not admitted. Representing the Lone Star State in the United States Senate after annexation, Sam Houston had been a force for moderation on sectional issues and had voted to admit the free states of Oregon and California. Houston voted against the 1854 Kansas-Nebraska Act, which would have bypassed the Missouri Compromise, allowing slavery in Kansas and Nebraska territories. He was the only Southern Senator courageous enough to do so.

In Texas Senator Houston was pilloried and denounced as an apostate and traitor to the South. Twenty-two county conventions, among them Harris, demanded his resignation from the United States Senate. The state legislature adopted a resolution against virtually no opposition condemning his recent vote and notifying him that he would not be returned to Washington at the expiration of his term; indeed, had there been a provision for recall in the state constitution, his Senate term would have ended immediately. Finally, while he had enjoyed great popularity in the city of Houston over the years, here, too, he fell into disfavor because of his Union advocacy.

The state convention of the Democratic party assembled in Austin in January 1856. A resolution was quickly approved that cri-

Samuel May Williams, mason, banker, and entrepreneur, was typical of the men who had come to the Gulf Coast seeking a fortune. As a leader of the entrepreneurial faction in Galveston, Williams was one who stood in the way of those who sought to make Houston the dominant economic force in Texas. Like his opponents, however, Williams owned land across Texas, including property just over the Harris County line in Fort Bend County. Courtesy, Rosenberg Library

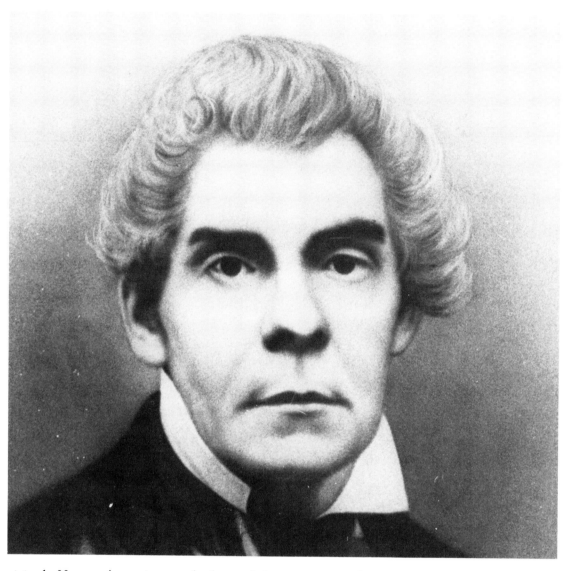

ticized Houston's action and demanded federal protection for slavery anywhere it might obtain. Rejected by his party, Houston decided to run as an independent in the 1857 race for governor. The "Old Hero" confessed his disappointment when the Harris County Democratic convention, meeting at the Houston Academy in February 1857, refused to nominate him but instead named Hardin R. Runnels, who went on to receive the state Democratic nomination at Waco.

A strong defender of states' rights, Runnels was prepared to consider the prospect of secession from the Union in order to protect those rights. His lieutenant governor, Francis R. Lubbock, had been active in Democratic party affairs and for several years had served as a district clerk of Harris County. Houston and his choice for lieutenant

governor, Jesse Grimes, campaigned as "old Democrats," a posture that placed them in opposition to the party's states' rights emphasis.

In the bitter campaign Houston put himself forward as the champion of the Union and a force for national harmony. However, his valiant efforts and past associations were not enough; for the first time in his Texas career, he suffered an election defeat. Runnels gained 32,552 votes and Houston 23,628, while Lubbock was also victorious by a substantial majority. Runnels was the popular choice in both Houston and Harris County.

The 1857 gubernatorial election destroyed existing political alignments in Texas. The two wings of the Democratic party stood for states' rights versus Union, or, expressing it another way, pro- and anti-

Houston. Sectionalism and the threat of secession were constant political themes and Houston newspapers joined in the debate over slavery. The institution was defended as a "positive good" and was justified on economic, religious, and social grounds. One Bayou City editor, Edward H. Cushing of the Houston *Telegraph and Texas Register,* insisted that slavery in Texas was a boon to the slave, considering his living conditions in Africa, and argued that the economic prosperity of the city was being retarded because of the lack of an adequate labor force. He concluded his editorial by urging the reopening of the African slave trade.

In reality, slavery was a significant factor in the economic life of Houston. By 1860 there were more than a thousand slaves working in both Houston and Galveston and the state's domestic slave trade was centered in the two communities. In the decade before the Civil War, a prime slave frequently sold for $1,500 in Houston. Also, Houston's economy was based mainly on the cotton trade and to a lesser degree on the sugar trade, and profitable cotton and sugar production depended on slave labor. Locally, slaves worked principally in domestic service, though occasionally a bondsman mastered a trade or worked on the wharves. Most urban masters retained two or three adult slaves and very few had more than six. The census figures of 1850 reveal that not a single master in Houston possessed 20; ten years later six owned more than that number.

At the fateful May 1859 state Democratic convention held at the Houston Academy the party nominated Runnels for reelection as governor and Francis Lubbock for lieutenant governor. Shortly after the convention adjourned, Sam Houston proclaimed that he would once again oppose Runnels for the state's highest office: "The constitution of the Union embraces the principles by which I will be governed, if elected." Edward Clark, a member of the state constitutional convention of 1845 and politically active since that time, announced as an independent candidate for lieutenant governor. Like Houston, Clark was running on a platform sympathetic to Unionism and opposed to secession.

In 1859 the "Hero of San Jacinto," now almost 66 years old and not in good health, decided upon one more race. As an independent, against the organized strength of the Democratic party, Houston made his position clear. As a slaveholder himself, he would not stand against the institution, but he would defend the Constitution and the Union come what may. After intensive campaigning Houston reversed the 1857 results and captured the governor's office in 1859 by a count of 36,357 to 27,500 for Runnels. The race between Clark and Lubbock was much closer; the former winning by about one thousand votes. In addition to the issues involved, the campaign demonstrated one constant in Lone Star politics; in times of crisis Texans turned to Sam Houston.

Governor Houston wished to interpret his election as a stand against disunion and secession, but such was not to be the case. The death of James Pinckney Henderson in Washington created a vacancy in the United States Senate and gave the state legislature an opportunity to appoint a moderate on the slavery question. However, the choice of Louis T. Wigfall, an ultra-secessionist and fierce foe of Governor Houston, indicated the political temper of the times.

When delegates met at the state Democratic convention in Galveston on April 2, 1860, they adopted an unrestrained secessionist platform. Houston lawyer Josiah F. Crosby was among eight delegates selected to attend the national Democratic convention at Charleston. Presided over by ex-Governor Hardin R. Runnels, the Texas delegation was committed to support only those candidates who would advance the Southern view on slavery and states' rights.

Two days before the Charleston convention met, a remarkable assemblage took place in the environs of Houston. Partisans of Sam Houston, a fair number of whom were veterans of the battle of San Jacinto, convened on the battlefield on April 21, 1860. Commemorating the 24th anniversary of the battle that marked Texas independence, they presented the name of Sam

Houston as "the people's candidate" for President of the United States. Thirteen delegates from Harris County urged "Old Sam" to accept the nomination and to contest for the nation's most prestigious office. In the official communication nofitying Houston of the action that had been taken, Harris Countians Andrew Daly and Jesse White stressed that the nation would turn to a candidate who was responsive to the interests of both North and South. Though he had few illusions about his election prospects, Houston did accept the nomination, observing once more: "The constitution and the Union embrace the principles by which I will be governed if elected . . . I have no new principles to announce."

At Charleston, amidst a growing atmosphere of crisis, Stephen Douglas remained committed to his "popular sovereignty" doctrine, which meant that slavery could be abolished if it was the desire of the local inhabitants. Douglas' position compromised too much to be accepted by many Southern delegations, including the united Texas delegation. Eight such groups bolted the Charleston meeting, repaired to Richmond, and nominated John C. Breckinridge of Kentucky as their candidate for President. Northern Democrats subsequently chose Douglas as their nominee, and the Republican party, anticipating victory because of the Democratic division, nominated former Congressman Abraham Lincoln of Illinois.

Threatened by the prospect of secession and war, some Texans joined other conservative Southerners in forming the Constitutional Union party, which adopted a platform advocating the abolition of slavery north of Missouri, essentially the restoration of the Missouri Compromise line. As one of the leading Unionists in the South, Sam Houston was a natural choice for the Presidential nomination. Houston did garner 57 votes on the first ballot, but John Bell of Tennessee received 68. In fact, Sam Houston had little chance of winning the Presidency in 1860, but he seems to have been heartened by the interest shown in his possible candidacy.

As national election day approached, General George Bickley, national commander of the Knights of the Golden Circle, arrived in Houston and organized a number of local units. A secret fraternal group, the purpose of the Knights was to perpetuate slavery and defend the way of life based on that institution. Founded in 1854, the organization was poorly financed and equally poorly led. In 1860 General Bickley planned a filibustering conquest of Mexico as an alternative to sectional strife. A filibustering expedition to Mexico could lead to war with that nation, and such a war could unite North and South against a common enemy. Two separate attempts, both financed and plotted in Houston, were made to invade Mexico. In each case when the expectant bands reached the Rio Grande, they scattered without crossing over into Mexico. Nevertheless, the Knights were a sign of the fanaticism of the times.

In the national election, which was conducted in Houston and Harris County without violence of any kind, Breckinridge received a handsome majority of the votes tallied. He also won the state with 47,561 votes to 15,402 for Bell; Douglas and Lincoln earned but a few votes between them. The almost one in four votes cast for Bell and thus against disunion have intrigued students of Texas history. Certainly slavery counted for little in West Texas, and federal military protection against Indian harassment was significant in that section. Sam Houston's popularity was also a factor, and pockets of Unionism existed wherever there were populous German settlements. Opposed to slavery and attracted to the political freedom of the United States, Texas Germans stood for the Union; that was particularly true of the German immigrant community in Houston.

Shortly after the results of the Presidential election came in on December 20, 1860, South Carolina formally seceded from the United States. In quick succession Alabama, Louisiana, Florida, Georgia, and Mississippi followed. Despite opposition by Governor Houston, a Texas secession convention was called.

The special convention began its deliberations on January 28 and unanimously chose Texas Supreme Court Justice Oran M. Roberts as its presiding officer. The convention delegates repealed the annexation resolution and drafted a secession ordinance. An interim Committee of Public Safety was organized, and February 23 was set as the date for popular statewide ratification of the convention's measures. The delegates themselves approved the secession resolution and the work of the convention generally, 166 to 8. All members of the Harris County delegation voted to secede, and anticipating approval in the upcoming popular election, the convention named seven delegates to attend the organizing sessions of the Confederacy. At Montgomery they witnessed the inauguration of Jefferson Davis as president of the new Southern nation. On February 23, 1861, the convention's action in favor of secession won the approval of the people, 46,129 to 14,697. Houston and Harris County went solidly for ratification of the convention's action. Just about all Houstonians of voting age wore the symbol of secession on their hats—a blue rosette with a silver star in the center. Prior to the vote, a mass meeting of Harris County citizens was held at the Market House in Houston and a resolution was drafted urging the resignation of all federal officers and recognition of the Confederacy.

Its actions ratified by the people, the secession convention reassembled in Austin on Saturday, March 2, and Texas was declared out of the Union as of that date. Memories were stirred, for exactly 25 years earlier Texas had proclaimed its independence as a Republic. On March 5 the convention approved and joined the provisional government of the Confederate States of America. The convention proceeded to modify the state constitution to make it conform to the Confederacy and called upon state officials to take a loyalty oath to that government. All consented to do so except Governor Houston and Secretary of State E.W. Cave. Houston refused to recognize the authority of the convention. At noon on March 16, the convention declared the office of governor vacant and swore in Lieutenant Governor Edward Clark as governor, a selection that was ratified at the legislature's next regular session.

In the interim, Houston received a letter from President Lincoln offering him 5,000 troops to keep Texas in the Union. This proposition Houston curtly rejected, noting that, "I love Texas too well to bring strife and bloodshed upon her." Still, another scheme was attractive to him. If the Republic of Texas were proclaimed once again, perhaps the conquest of Mexico would absorb the energies of the Confederacy rather than a fatal internal war. In Houston the old flag of the Republic was raised on a 100-foot liberty pole in Courthouse Square amidst the firing of cannons and a display of fireworks—a scene that was repeated in Galveston and other Texas cities. When it became apparent that the independent Republic could not be resurrected, Houston delivered one more bitter protest against the "usurpations" of the convention and resigned. Two years later at Huntsville, in the midst of the terrible war that he predicted would stem from disunion, Sam Houston passed away.

John C. Breckinridge (1821-1875) was supported by Southern Democrats, including the Texas delegation, in protest against the nomination of Stephen A. Douglas during the 1860 Presidential campaign. Engraved by John C. Buttre from a daguerreotype by Mathew Brady. From Cirker, Dictionary of American Portraits, *Dover, 1967*

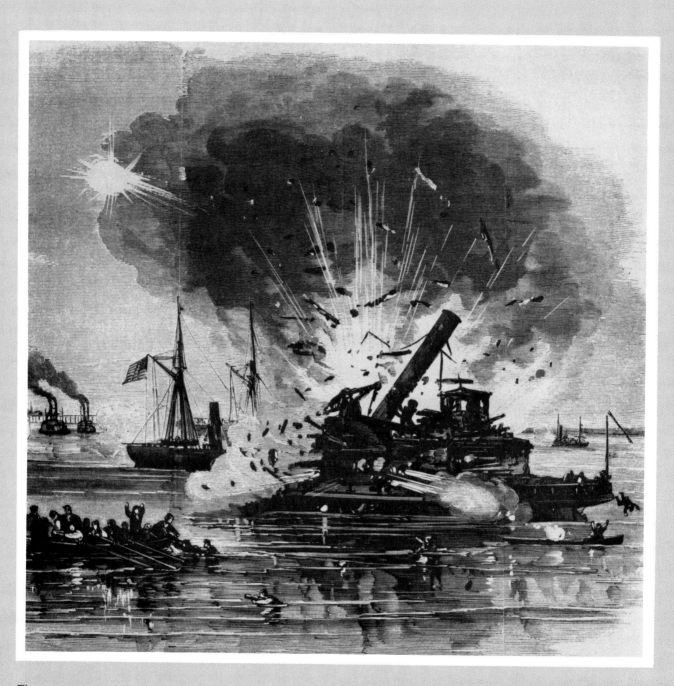

The turning point in the battle of Galveston was the capture of the Federal steamer Harriet Lane *and the destruction of the* Westfield *(pictured here). With the loss of the major naval vessels, the Federal forces called for a truce and eventually surrendered, giving control of Galveston back to the Confederate forces after a short period of occupation. From* Harper's Pictorial History of the Civil War, *1866*

CIVIL WAR AND AFTERMATH

In April 14, 1861, Fort Sumter in Charleston harbor was captured by the Confederacy. Two days later Houstonians read of that fateful encounter in the local newspapers. On the Courthouse Square a salute was fired to mark the Union surrender and a public meeting was called by Mayor William J. Hutchins. At that meeting a committee was named to recruit a battalion for the defense of Houston, a finance committee was authorized to raise $5,000 to finance military purchases, and a training camp for volunteers was set up beyond the city limits near Harrisburg. By the end of April, more than 500 Houstonians had enlisted in the Confederate Guards, the Bayou City Guards, and the Turner Rifles. An artillery company was also recruited locally and all involved pronounced themselves "ready for immediate campaign service." The Turner Rifles became the first unit recruited in Houston to engage the enemy. On duty in Galveston, they exchanged fire with Union troops on August 3 in response to shelling by the Federal gunboat *South Carolina.*

Any possibility of compromise between North and South was destroyed after the engagement at Sumter. President Lincoln then issued a call for 75,000 volunteers to suppress "isolated rebellions in isolated parts of these United States," and with that

action, Virginia seceded. That state's decision was greeted with cheers and rebel yells in Houston, where recruiting activities intensified. By the end of the summer the Sumter Guards and the Houston Artillery were stationed in the Bayou City as well as the Texas Grays, the Home Guards, and the Houston Cavalry. Peter W. Gray, Captain D. McGregor, and Captain A.D. Morse organized and led these groups respectively.

Captain F.O. Odlum's Davis Guards were also enlisted locally. Recruited mainly among the city's Irish population, the company saw action in the battle of Galveston on January 1, 1863, and also later in the critical defense of Sabine Pass on September 8, 1863. The soldiers of the Davis Guards spent the first summer of the war in training and caught the fancy of the local citizenry. The Houston Ladies Aid Association provided them with clothing and blankets, and even after the company was transferred to Galveston in the fall, Houstonians followed their fortunes with great interest and concern.

Before the war was over, Terry's Texas Rangers became the most famous Texas cavalry force to fight under the Confederate banner. Benjamin F. Terry and Thomas S. Lubbock, both of whom had seen action at Bull Run, returned to Houston and issued a

By 1860 Galveston had become the major port on the Texas Gulf Coast. Although Houston could be reached by shallow draft vessels, the center of commercial activity was on Galveston Island. The handsome houses, shops, and churches seen in this 1860 view testify to the prosperity of the island city. Courtesy, Rosenberg Library

call for volunteers to serve in Virginia. Enlistment was for the duration of the fighting and each man was required to furnish his own arms and equipment for his horse. Ten companies of 100 men each were needed and by far the great majority of the volunteers came from Houston and Harris County. When Colonel Terry accepted Captain J.G. Walker's company as part of his cavalry arm, nine companies from Harris County had joined the Confederate army. This prompted Edward Cushing, the feisty editor of the *Telegraph and Texas Register*, to comment:

We now think Harris County has done enough. The balance of her population is needed for home service . . . We think, under all the circumstances, it will be but right to ask the remainder of our volunteer forces to stay at home and give the rest of the State a chance.

The Rangers left Houston on September 11, 1861, and traveled by railroad and riverboat to New Orleans. There Terry was invited to meet General Albert Sidney Johnston at Bowling Green, Kentucky, where Johnston was recruiting an army for the defense of Tennessee and Kentucky. At Bowling Green the company was formally activated as the Eighth Texas Cavalry, but they continued to be known as Terry's Texas Rangers. On December 17, 1861, the Texans were engaged for the first time in battle at Woodsonville, Kentucky, and here Terry was killed while leading a charge. With Terry's death, Lubbock was advanced to command, but he was ill at the time and died in Memphis on January 9, 1862. The unit remained intact, however, and thereafter participated in many engagements, including Shiloh, Murfreesboro, Chickamauga, and Knoxville. At the conclusion of the war, they were placed under the command of General Joseph Wheeler and formally surrendered to General William Tecumseh Sherman at Greensboro, North Carolina, on April 28, 1865.

When Texas seceded from the Union, 400 miles of the state's coastline between

General John Bankhead Magruder (1810-1871) distinguished himself in the eyes of Texans when he recaptured Galveston for the Confederates. By the end of the Civil War, Galveston was the only major Confederate port not in Federal hands. From Cirker, Dictionary of American Portraits, *Dover, 1967*

the Sabine River and the Rio Grande were virtually defenseless. Realizing that this constituted a tempting invasion route, the Texas Secession Convention had voted sorely needed funds to fortify Sabine Pass, Galveston, Matagorda Island, Aransas Pass, and Port Isabell. As a commercial center and still the leading natural port in Texas, Galveston was of particular importance to the Confederacy. By midsummer of 1861 the Federal blockade had reached the Texas coast, and Major Joseph J. Cook, a graduate of Annapolis, assumed responsibility for Galveston's defense. A delegation of the island's leading citizens journeyed to Richmond and requested additional heavy ordnance for the protection of the community, but already the South had little to spare.

During the summer of 1862 there were minor skirmishes at Corpus Christi and Sabine Pass, but these were but feints in preparation for the concerted assault against Galveston. On October 4 Union Commander William B. Renshaw, with eight warships at his disposal, knocked out the only heavy gun defending the channel and demanded the surrender of the city. A truce was arranged, but it was not until Christmas Day that 300 Union soldiers landed at the harbor, occupied Kuhn's Wharf, and prepared to resist a Confederate counterattack.

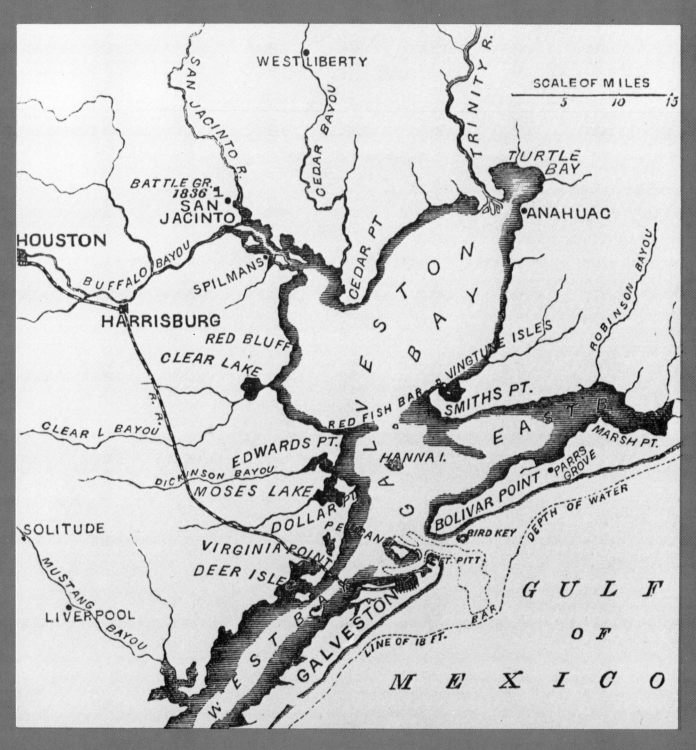

Before its capture by a Federal navy force led by Commodore Renshaw, Galveston had served as an important Confederate port. It was the main entrepôt for the commerce of a large portion of Texas. When the island was recaptured by the Confederates, it once again opened the way for the export of cotton and the import of munitions. From Harper's Pictorial History of The Civil War, 1866

Brigadier General Paul O. Hebert, a Mexican War veteran and former governor of Louisiana, had been named by President Jefferson Davis to the command of all Confederate troops in Texas. However, Hebert created a great deal of antipathy in the Lone Star State by his indifferent defense of Galveston and his arbitrary action in placing all of Texas under martial law. Consequently, when General John Bankhead ("Prince John") Magruder was named to replace Hebert, the appointment was viewed with enthusiasm by the citizens of Galveston and Houston. Magruder, a West Point graduate who had distinguished himself in the Virginia Peninsular Campaign, vowed to recapture Galveston. He also pledged that under no circumstances would he permit Houston to fall to Union forces. He believed the city to be in a class with New Orleans as a vital commercial and railroad center; it must be held at all costs.

Shortly after General Magruder replaced Hebert, he began to formulate his strategy for the recapture of Galveston. He determined to launch an attack both by land and sea, and river steamers figured prominently in the plans. At the foot of Main Street in Houston, the *Bayou City* and the *Neptune* were being transformed into gunboats. While stevedores lined the decks with cotton, sharpshooters crouched behind the bales. When the boats set sail from Houston, they looked like nothing more than Galveston-bound freighters. In their wake plodded two other Houston ships, the *Lucy Gwinn* and the *John F. Carr*, packed with veteran infantry troops prepared to storm the island.

Magruder decided to attack Galveston on New Year's Eve, anticipating that after an evening of celebration, the enemy's guard would be down. Details of the battle reached Houston on New Year's Day, and occasioned much joy. The *Bayou City* and the *Neptune* had engaged the Union gunboat, *Harriet Lane*; the *Neptune* went down but the *Bayou City* rammed and captured the United States cruiser. Both commanding officers of the *Harriet Lane* were killed in the fighting. The battle ended when the Federal

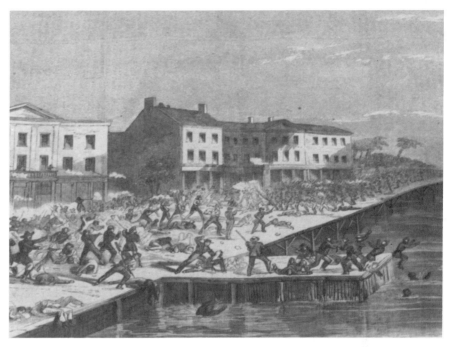

flagship *Westfield* ran aground and was blown up by its own crew. Four other Union ships escaped, but the ground forces, most of them recruited in Houston, captured the Union garrison. The North attempted to conquer the island city again in 1863, but the endeavor failed, and at the end of the war, Galveston was the only major Confederate port not in Union hands.

The significance of the campaign was not lost on the citizens of Houston. Had Galveston been taken, a gun would literally have been pointed at their heads. The reality of the encounter was brought home when about 350 Union prisoners were marched through the streets of the city before their internment in a local prison camp. On January 21 General Magruder and his officers were honored with ceremonies that included a ball at Perkins Hall and a victor's parade down Main Street. Given the joy of the moment, perhaps editor Edward Cushing of the Houston *Tri-Weekly Telegraph* could be forgiven a slight degree of exaggeration when he insisted, "this action will take place as the most brilliant, all things considered, of this war."

In September 1863 the Union once again attempted to gain a foothold in Texas. New Orleans had already been captured by the North and from there an army of 5,000 men was dispatched by sea to invade at Sabine

On October 4, 1862, Federal forces steamed into Galveston Bay and demanded the surrender of the city, thus denying the Buffalo Bayou trading network access to the sea. Waiting until December 25, 1862, to come ashore, the Federals landed on the island and occupied Kuhn's Wharf on the waterfront. Operating from Houston, General John B. Magruder marshalled his forces and struck back on December 31, 1862. The battle shifted along the wharf, although the Federals held on with support from their ships. Confederate vessels appeared, breaking the Union squadron and the defense of the wharf. Courtesy, San Jacinto Museum of History

Pass. The overall Federal strategy contemplated a successful landing and then an advance on Beaumont and Houston. If the campaign proceeded as planned, then Galveston would capitulate as a matter of course. The Union leader Major General William B. Franklin, set out with four gunboats and 17 transport craft carrying about 1,500 men for the initial attack.

The defense of the Texas side of Sabine Pass had been entrusted to the Davis Guards, who were holed up at Fort Griffin, an unfinished earthwork consisting of mud fortifications 100 yards wide and ringed by swamps. Although commanded by Captain Frederick H. Odlum, the defenders were inspired by the leadership of Lieutenant Richard Dowling. A genuine folk hero among his Irish compatriots, "Dick" Dowling had owned the Bank of Bacchus Saloon on Congress Avenue in downtown Houston. Anticipating an attack, Dowling encouraged his men to practice shooting at stakes in the narrow channels, which the attacking Federal armada would have to cross.

On September 8, 1863, the Federal vessels entered the harbor at Sabine Pass. The gunboats *Clifton* and *Granite City* steamed up the Texas side of the channel, defended by Fort Griffin, and the *Sachem* and *Arizona* proceeded along the Louisiana channel to attack the defenders from the rear. One of the Union transports prepared to land 500 infantry who would storm the fort when it had been reduced by the gunboats. The complete operation was thought to be easy work since Fort Griffin was defended by only 47 men, among them the intrepid Dick Dowling. Exercising great patience, Dowling waited until the Union ships came within close range and then opened fire. Dowling later claimed that in 35 minutes he fired his cannon 107 times, certainly a record for heavy artillery. In a few minutes the United States ships *Sachem* and *Clifton* were rendered helpless, and the others fled the harbor. The two disabled boats mounting 13 guns and their crews, consisting of 350 men, were captured by the victorious Dowling.

The battle of Sabine Pass spared Texas a successful Yankee invasion and a sustained campaign. Most certainly, Houston would have been captured and railroad communication between the city and the remainder of the Confederacy would have been cut. Desperate for a victory of any kind, President Jefferson Davis optimistically wrote, "Sabine Pass will stand, perhaps for all time to come, the greatest military victory in the world." In accordance with a personal order by Davis, one of the two war decorations officially granted by the Confederacy was especially struck for the Davis Guards. As for Dowling, a statue in his honor stands in Hermann Park today. Each year on St. Patrick's day, ceremonies are held com-

On September 5, 1863, a Federal force of 5,000 troops and 20 ships left New Orleans to invade Texas through Sabine Pass. The pass was defended by the 42 men of the Davis Guards, a company of Irish Houstonians commanded by lieutenants N.H. Smith and Richard "Dick" Dowling. As the Federal ships approached, the Confederates began a rapid-fire attack from their six cannon. This resulted in the damage and capture of the two lead ships and the retreat of the entire invasion force. Harper's Pictorial History of the Civil War, 1866

memorating his great triumph. Still a young man at the time of his death in 1867, Dowling was buried in St. Vincent's Cemetery.

A third effort to invade Texas also failed to endanger Houston and the more thickly populated portions of the state. Fearing that the South would receive aid from the French through Mexico, Union troops attempted to occupy the Texas coast near the Mexican border. On November 5, 1863, six thousand Federal troops led by General Nathaniel Banks captured Brownsville. Over the next 60 days, Banks strengthened his position by successfully investing Corpus Christi, Aransas Pass, Mustang Island, Indianola, and Lavaca. However, as the prospect of French inter-

vention lessened, most of the U.S. troops along the Texas coast were withdrawn, except a small contingent in Brownsville. The withdrawn troops constituted the bulk of a new Union army, which, led by General Banks, attempted to invade East Texas from Louisiana. But, on April 8, 1864, the hastily assembled Confederate troops commanded by General Richard Taylor routed the Yankees at Mansfield, Louisiana, less than 50 miles from the Texas boundary. Once again, a threat to the city of Houston and the interior of Texas had been subverted.

Compared to other cities of the Confederacy during the Civil War, Houston endured very little hardship and, in fact,

TO THE CITIZENS

OF

HARRIS COUNTY.

At the request of the Board of Aldermen, the undersigned have been appointed by the Mayor of the City of Houston, a Committee to solicit contributions of Warm Clothing &c., for the troops of the Confederate States, and particularly for the sons and brothers of Harris county, who have gone into the service of their country.

Those who are enjoying the comforts and safety of their homes, must not forget that they owe these things to the brave soldiers now in the field.

Harris County has responded nobly to the call for men; It remains to be seen whether all the patriots of the County have gone into the Army.

Our brave defenders will soon be exposed to the rigors of a cold climate, and to other hardships to which they are entirely unaccustomed. The Government is young, and has not been able to provide the soldiers with clothing. It remains for the people to supply the want by voluntary subscription.

What is most wanted is Woolen Socks, Blankets, new and old, Under Shirts and Drawers, Overcoats, Yarn, Flannel. Donations in money will also be received.

Depot at Wilson's Building, for Ladies' Committee ; At the respective places of business of the Gentlemen's Committee,

A list of all articles furnished will be kept, with the names of those by whom they are furnished. The articles will be handed to the Agent of the State, and when appraised it is expected the value of them will be returned in Treasury Notes of the Confederate States.

Confidently believing that Harris County will cheerfully clothe her own soldiers, we submit this appeal to our fellow citizens.

Mrs. T. B. J. Hadley.	C. S. Longcope.
" A. C. Allen.	T. M. Bagby.
" Jane Young.	F. A. Rice.

The following named persons are requested to act in concert with the Committee, and forward the donations to the Committee.

At Lynchburg,	Capt. J. C. Walker.
" Baker & Thompson's Mill,	Theo. W. McComb.
" Baytown,	Dr. J. L. Bryan.
" Harrisburg,	John B. Harris.
" Huffman's Settlement,	E. Dunk.
" West's Precinct,	R. D. Wescott.
" Cypress,	C. H. Baker.
" Spring Branch,	W. Tentdler.
" Mrs. Wheaton's Settlement,	Dr. A. J. Hay.
" Hockley,	— Abbot.
" Rose Hill,	C. F. Duer.

continued to grow and prosper. Although the bulk of the able-bodied male population was stationed on various fronts, thousands of slaves were sent to Texas from Arkansas, Louisiana, and other Southern states to prevent their liberation by advancing Union troops. They provided a work force for the successful crop harvests between 1861 and 1864, and also for stepped-up railroad construction.

When the Federal blockade of Galveston pinched off trade and commercial activity in the island city, business increased in Houston, accompanied by inflation. In the Bayou City flour sold for $50 a hundred-pound sack, milk for $1 a quart, and beef for 25 cents a pound. Whiskey, which had been 50 cents a gallon before the war, went up to $8 per gallon, and coffee, when it could be obtained, cost $3 a pound. Barbers raised their price for haircuts, and with starch at $1 per pound, laundresses increased their fees for washings. The increased prices angered Houston's newspaper editors, who lashed out at speculators and those who reaped exorbitant profits during "perilous times."

Houstonians also suffered minor food shortages during the war years. Coffee and tea were always in short supply, as were salt, flour, and soap. Beef, cornbread, and barley water became standard fare in steamboat dining rooms where before the war elegant dinners had been served. Non-food items, such as firewood, candles, and iron and brass products were also difficult to come by. Nevertheless, the people of Houston never experienced serious want during this time. However, as the problem of inflation increased, many creditors proved more reluctant to accept Confederate money in satisfaction of debts. Of course, this posture contributed to the decline of the value of the currency and in turn forced prices to escalate still higher.

While the Lone Star State was further removed from the locale of battles and less prone to invasion than other Southern states, proportionately more men were recruited for military service in Texas than any other Confederate state. As has been noted, Houston and Harris County con-

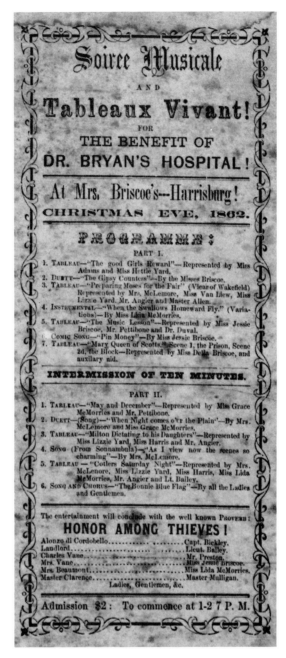

tributed more than their share of men. The Bayou City also contributed matériel and supplies for the war effort. Flour mills provided food for Confederate troops, while iron and brass foundries forged cannon and shot. A setback was sustained in June 1862, when fire destroyed the Alexander McGowen Foundry on Preston Avenue, which was attempting to fill two large Confederate government contracts. The Cushman Foundry and Machine Shop on the south bank of Buffalo Bayou filled the orders instead. In addition to the sinews of war, the foundries also manufactured cooking utensils and agricultural tools for use on

Facing page:
Although little action took place along the Texas Gulf Coast during the Civil War, the war was felt by the citizens through the shortages that developed and the needs of the troops. Early in the war volunteer committees of ladies were already at work soliciting aid for the soldiers. Courtesy, San Jacinto Museum of History

Left:
Houston has always been a city that uses social events to benefit worthwhile causes. In 1862 the ladies of Houston and Harrisburg organized a musical and tableaux vivant to benefit the hospital for Confederate troops established by Dr. Bryan. Courtesy, Special Collections; Houston Public Library

Facing page, top:
During the years of the Civil
War, local county governments
were authorized to issue
currency. This one dollar note
dated September 1, 1864, was
issued in 1862 and was to be
redeemed in 1864. Courtesy,
San Jacinto Museum of History

Facing page, bottom:
Issued by the government of
Harris County during the Civil
War, this 75 cent note reflects
the shortage of specie and
coinage that plagued the South
during the war. Courtesy, San
Jacinto Museum of History

While serving with the
Confederate army in Georgia in
1864, a Texan wrote home: "In
this army, one hole in the seat of
the breeches indicates a captain,
two holes a lieutenant, and the
seat of the pants all out indicates
that the individual is a private."
Fortunately for the soldiers,
Confederate women took the
time to produce homespun cloth
and make clothing to
supplement that provided by the
government. Etching No. 11 in
Adalbert J. Volck's
Confederate War Etchings.
Courtesy, Library of Congress

the home front. Spurred by the emergency nature of the times, small, primitive factories sprang up and produced wagons, ambulances, furniture, shoes, tents, and blankets. Also, the leather industry prospered from the increased demand for large shipments of harnesses and saddles. Finally, in 1869 the Houston City Mills, a textile factory on the south bank of the bayou near the eastern limits of the city, began production and employed 80 people.

In the year 1840 scarcely 1,000 bales of cotton entered Houston; by 1860 that figure had reached 115,854 bales. Then during the war years Houston continued to augment its stature as one of the principal cotton-trading centers of the Confederacy. This was due to a number of factors: the capture of New Orleans and temporary control of Galveston by the Union, and the trade that subsequently developed with Mexico. Furthermore, the northern Mexican states were on friendly terms with Confederate and Texas authorities and stood to profit from the wartime trade with Texas, so transporting cotton into Mexico and guns, ammunition, and other matériel out was a relatively easy matter.

With the Union blockade, Matamoros, previously a minor port, became a place of frenzied activity. Riverboats carried cotton

to the Gulf and at that point it was transferred to oceangoing vessels bound for international markets. A number of Houston merchants, among them William Marsh Rice, made fortunes by taking up residence in Matamoros and acting as cotton factors.

In January 1862 the state legislature approved a statute to consolidate and amend the various acts incorporating the City of Houston. Essentially nine square miles, with the Harris County Courthouse at the center, were set out as the city limits. The act also spelled out the qualifications for holding office in Houston. In order to qualify as an alderman, a candidate had to own real estate valued at least at $1,000; a candidate for mayor had to be worth twice that amount. The City Council was composed of eight aldermen, two from each of the four wards, and a polling place was situated in each ward. Geographically, the wards were defined as follows: First Ward, north of Congress Street and west of Main Street; Second Ward, north of Congress and east of Main; Third Ward, south of Congress and east of Main; Fourth Ward, south of Congress and west of Main. Then in 1867 the Fifth Ward was established north of Buffalo Bayou and White Oak Bayou.

While not sharply defined, the principal powers enjoyed by the City Council were

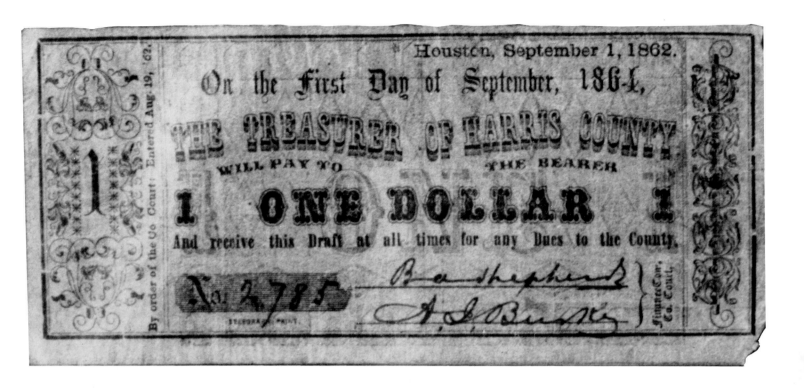

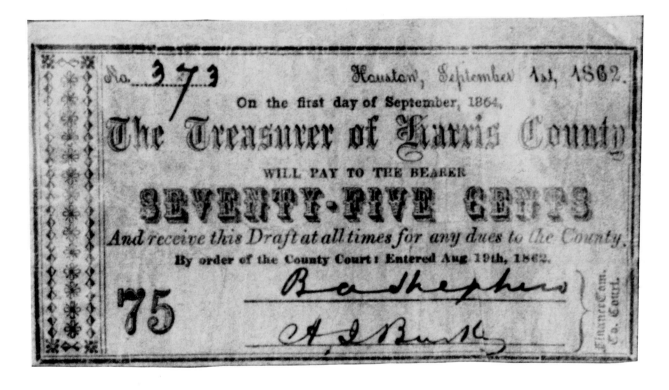

In the second half of the 19th century, Buffalo Bayou was filled with shallow-draft steamboats, such as the stern-wheeler Herman Paepcke, carrying cotton, hides, wool, other agricultural products, and passengers from Houston to the Gulf for transfer to oceangoing steamers off Galveston Island. Courtesy, Rosenberg Library

the right to grant or withhold licenses and the right to mandate taxes. When the periodic attempts by the Council to collect back taxes failed, tax collector and assessor G.S. Hardcastle promptly offered the uncleared property for sale. As with the houses, so with hogs. The City Council passed an ordinance providing that stray hogs be sold at auction after being impounded for three days. Also, in an effort to do something about unsanitary conditions in the city, the Council created Houston's first Board of Health on June 21, 1862.

From the time of its founding, the leadership abilities of Houston's mayors had varied. In the first race for mayor, held on August 14, 1837, James S. Holman, a business associate of the Allen brothers, beat Francis R. Lubbock and Thomas W. Ward. The turnout in this contest was very low, partially because to qualify to vote for a mayor or alderman a Houstonian had to be free, white, a citizen of Texas, a resident of Houston for at least six months, and the owner of at least $100 worth of city real estate for at least three months prior to the election. The city's first dynamic mayor was Francis W. Moore, Jr., an editor of the

Telegraph and Texas Register, who served on and off during the period of the Republic and early statehood. A crusader against lawlessness, Moore saw one of his objectives realized when dueling was abolished within the city limits. Thomas W. House, a successful businessman, became mayor of Houston in 1862 and served with honor during the Civil War.

The first regular wartime state election was held in Texas in August 1861. Confidence in and enthusiasm for the Confederacy was still running high and Francis R. Lubbock defeated the incumbent, Edward Clark, on a platform pledging loyalty to the South and the energetic prosecution of the war. A merchant and planter, Lubbock began his business career in Houston, where he claimed to have sold the first bag of flour in the city for $30 and the first sack of coffee for 25 cents a pound. He was Sam Houston's comptroller of the Republic and in 1841 was elected district clerk of Harris County. Lubbock had been a delegate to the Democratic National Convention at Charleston in 1860 as a proponent of secession. Once installed at Austin as governor, he sought close ties with the

Confederacy and announced himself an admirer of Jefferson Davis.

In November 1861 the state legislature appointed Louis T. Wigfall and W.S. Oldham to represent Texas in the Confederate Senate. Judge Peter W. Gray of Houston was elected a member of the House of Representatives in the First Congress of the Confederacy.

As the Texas gubernatorial campaign of 1863 drew near, Governor Lubbock announced that he had been offered a place on the staff of Jefferson Davis and thus would not be a candidate for reelection. He was succeeded by Pendleton Murrah, and locally Judge Grey was defeated for reelection to the Confederate House by A.M. Branch because of his support for conscription laws and the draft exemption for overseers.

The Confederacy was doomed: New Orleans had fallen to the Union on April 24, 1862; Vicksburg had been captured by Grant on July 4, 1863; and Lee's invasion of the North had been halted at Gettysburg in that same month of July. Financial and supply problems contributed to the internal collapse of the South as did increasing internal condemnation of the war. Union sentiment, present in Texas and other Southern states before the war, increased in intensity as the military campaigns wound down.

In January 1864 General E. Kirby Smith assumed control of the Trans-Mississippi department of the Confederacy, which included Texas, Arkansas, Louisiana, and Mississippi. Smith set up headquarters in Shreveport and then devised the strategy that frustated the Union invasion of East Texas in 1864. However, although Smith wished to continue the war after General Lee's surrender at Appomattox, his troops were not of the same mind. The desertion rate was high and many were fleeing to Mexico. In the middle of May some 400 soldiers at Galveston attempted to desert, but were held in check by their commanding officer, Colonel Ashbel Smith. However, a week later Smith acknowledged the desperate nature of the situation and ordered the evacuation of Galveston. Conditions

Francis R. Lubbock was elected governor of Texas in 1861. Previously, he had owned a mercantile business in Houston, had served as a clerk in the Texas congress, was comptroller of the treasury, district clerk of Harris County, and lieutenant governor. From Thrall, Texas 1879

throughout the state were chaotic, made worse by Governor Murrah's departure; he, along with many other public officials and military men, left Texas for Mexico, where he died within a month.

Although the city of Houston had not been invaded during the war, it was not spared at the war's end. On May 23, 1865, about 2,000 Confederate soldiers from Galveston looted the Confederate Ordnance Building and the Clothing Bureau of the Confederate army. Six-shooters and muskets as well as clothing and blankets were taken, but there was little personal violence committed. Mayor William Anders ordered all saloons closed, and a military guard of 1,000 men was hastily recruited to patrol the streets and ensure order. Civilians apparently did not loot or plunder military stores in Houston, though such conduct did take place at San Antonio and Huntsville.

General Kirby Smith departed Houston for Galveston accompanied by the wartime hero of the island city, General John Bankhead Magruder. On June 2, aboard the U.S. warship *Port Jackson* in Galveston Bay, Smith formally surrendered the territory of the Trans-Mississippi department to Brigadier General Edmund J. Davis. Shortly thereafter the Union standard flew over the Harris County Courthouse, replacing the old Confederate emblem. Federal occupation troops were not long in taking up a position in Houston. On June 20, 1865, five

When the war ended in defeat
for the Confederacy, General
Gordon Granger was sent to
Texas by the Federal
government to establish a
provisional government. From
Harper's Pictorial History of
the Civil War, *1866*

companies of the 114th Ohio Regiment and the entire 34th Iowa Regiment arrived by special train from Galveston and marched through the city. The orderly transfer of power was marred by the death of a black cook with the Union troops, stabbed by a local citizen whom he had threatened with a brick. In general, however, calm prevailed, and when the Amnesty Office of the provost marshal opened on June 25, Mayor William Anders was the first Houstonian to swear allegiance to the United States and be readmitted to citizenship. On July 4, 1865, American flags were displayed throughout the city and salutes fired in honor of Independence Day.

General Gordon Granger, a compassionate man and understanding of the defeated Confederacy, was sent to Texas to maintain order and to establish a provisional government anticipating the ultimate return of Texas to the Union. His first act upon landing at Galveston was to issue an order emancipating all Texas slaves and declaring illegal all laws enacted since secession. On June 19, 1865, General Granger carefully read a copy of the Emancipation Proclamation, which

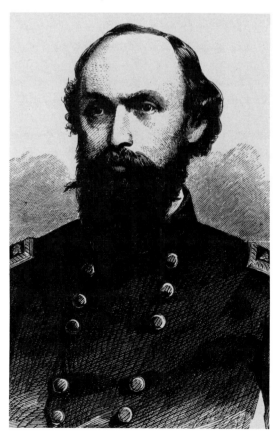

had taken effect on January 1, 1863, and was now operative in Texas. That day, called "Juneteenth," has since been celebrated by Texas blacks as Emancipation Day. Because thousands of slaves had been sent further south to Texas by frightened masters in Louisiana, Arkansas, and Missouri, there were more than 200,000 blacks in Texas when the 13th Amendment took effect. Appraised of their new status and cast adrift, many ex-slaves wandered into Houston from the plantation bottomlands of the Trinity and Brazos rivers. Their situation occasioned sympathy on the part of many Houstonians, as the editor of the *Tri-Weekly Telegraph* wrote:

We cannot help but pity the poor freedmen and women that have left comfortable and happy homes in the country and come to the city in search of what they call freedom. Nearly all the old buildings that were not occupied . . . serve as homes for these people. Many of these buildings are not fit for stables.

In January 1866 the crowds of blacks that gathered downtown were viewed with alarm by many white Houstonians. A 9 p.m. curfew for black people was enacted by occupation authorities along with a threat to compel the unemployed to work for the army without pay. However, some ex-slaves were able to find employment on a sharecropping basis for area planters.

It was not all discord between the races following the Confederate surrender. Old ties were renewed when many ex-slaves returned to their former plantations to work for wages or on a sharecropping arrangement. Blacks and whites mingled socially when at Houston's first "Juneteenth" celebration in 1866 a banquet was tendered by the ex-slaves and their families with their former masters as guests of honor. In the city of Houston there was no deliberate segregation of housing and the wards were fairly well balanced between white and black inhabitants. As an example, the Fifth Ward, which by 1920 was almost exclusively black, had a ratio of 561 white families to 578

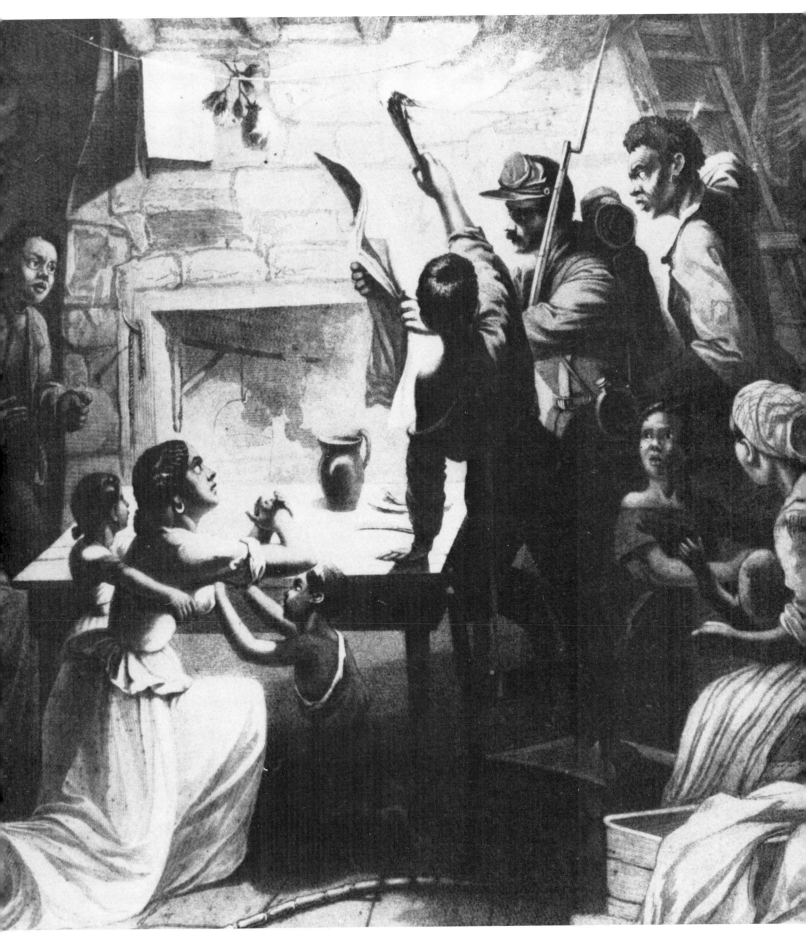

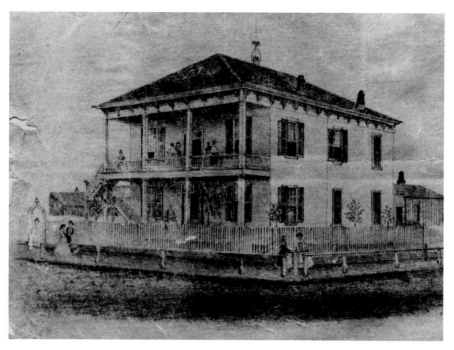

Houston's schools began as small private institutions, such as Miss Brown's Young Ladies Seminary (pictured here) and Mrs. Noble's Seminary for Girls. Classes in these girls' schools consisted mostly of the basic "three R's" and instruction in skills such as dancing, sewing, and sometimes French. In the 1870s the schools were absorbed into the public school system. Courtesy, Harris County Heritage Society

black families in 1870. Yet aldermen were elected on a ward basis, which made it difficult for blacks to secure representation on the City Council. Later, when residential segregation was a fact of Houston city life, aldermen were elected at large.

On March 3, 1865, President Lincoln signed into law the bill creating the Bureau of Refugees, Freedmen, and Abandoned Lands, more commonly known as the Freedmen's Bureau. General Edgar Gregory was placed in charge of the Texas District, with headquarters at Galveston, and arrived in Houston in December. Gregory began his assignment by making a 700-mile tour of the state during the course of which he spoke to some 25,000 freedmen and their employers. He called for understanding on the part of both blacks and whites and stressed that his first task would be to secure employment for former slaves roaming the countryside or milling about in the cities. He appointed 12 local agents to assist him in this work, one of whom was based in Houston. To improve the labor situation, he sought to promote the contract system of employment between blacks and their old masters. All agents of the Freedmen's Bureau were required to furnish copies of the Emancipation Proclamation to all employers and state officials and to make certain that it was read to all working freedmen. The agents were also required

to instruct the freedmen to make written contracts with employers and to register the contracts with officials of the bureau.

One of the statutory responsibilities of the Freedmen's Bureau was to "maintain schools for freedmen until a system of public schools could be established." With encouragement from bureau personnel, a Negro school began to hold classes at the African Methodist Church on Dowling Street in Houston. However, attendance was irregular and the content of instruction was disturbing to some whites, since it stressed the importance of the Union army in achieving black freedom. But the mere presence of a school for blacks acted as a spur to the movement for free public instruction in Houston. In February 1870 a public meeting was held and a committee drafted a bill for legislative consideration that would enable the city to begin free public education. Although this particular request was denied, a free county public school system, aided by state funds, did become a reality. By 1873 Harris County maintained 24 public schools in which 1,561 students were enrolled. A full term was rarely completed, however; in 1874 the county schools were in session for only four months and in 1876 for only two or three.

In 1876 the state legislature granted to Texas cities local control over the schools and the right to claim a pro-rata share of state educational funds. While the local election generated little interest and the turnout was very light, Houstonians did vote in favor of local control. Then, in 1877, the City Council passed legislation that mandated free public schools for all children 8 to 14 years old. It was stipulated that three trustees and a superintendent, appointed by the mayor and approved by the Council, would be responsible for the maintenance of the public school system in the city. Without a dissenting vote, and certainly reflecting the prevailing sentiment of the day, the schools were deliberately segregated.

The appointment of Andrew Jackson Hamilton as provisional governor of Texas on July 21, 1865, introduced the official period of Reconstruction in Texas. Since the

state had officially seceded from the Union when it joined the Confederacy, Texas had to repeal the act of secession, repudiate all debts incurred in the cause of the Confederacy, and draft a new constitution excluding slavery to legally regain its proper status within the national government. These steps were accomplished at a constitutional convention at Austin on February 7, 1866, and the new state constitution was ratified by the people of Texas. Houston's delegates at the convention were G.W. Whitmore, J.W. Flanagan, F.A. Vaughan, and C.W. Bryant. The convention's presiding officer, J.W. Throckmorton, was elected governor. A good start had been made; it appeared that Texas would rejoin the Union and moderation would prevail.

In the elections of 1866, Radical Republicans gained control of Congress and swiftly moved to impose their view that the ex-Confederate states were not repentant enough and that there was little genuine concern for blacks' rights in the South. Texas, which had elected former Confederate leaders to state and national offices and also passed a series of "Black Codes" restricting the status of freedmen, seemed to suggest the truth of their accusation. Governor Throckmorton was replaced by ex-governor Elisha M. Pease, and, as a result of federal prodding, still another constitution was adopted in 1869. The constitution of the United States was declared to be the supreme law of the land and the eventual ratification of the 15th Amendment enfranchised black males. Finally, in 1869, in a contest monitored by the military, Edmund J. Davis bested Andrew J. Hamilton in the election for governor.

In 1866 former Confederates who wished to participate in the government of the United States were required to sign an amnesty oath to establish their loyalty to the government in Washington. This oath, however, applied only to the period of Presidential Reconstruction. In 1867 the reconstruction of Congress limited the amnesty of 1866. Courtesy, Special Collections; Houston Public Library

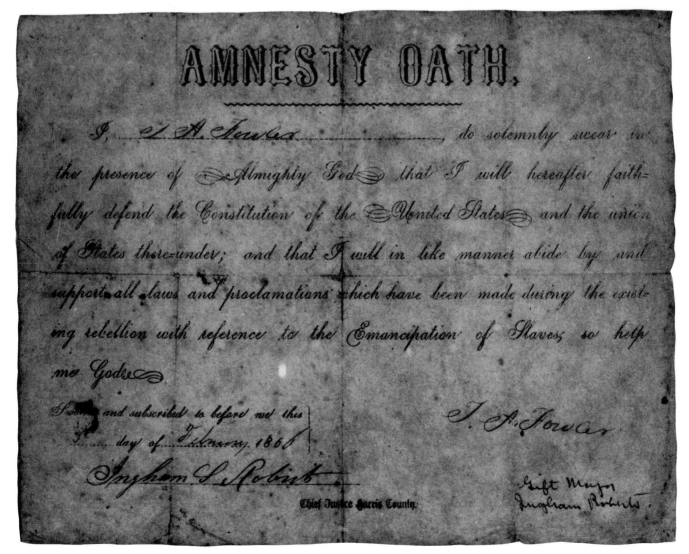

Right:

Dry goods merchants such as William Clark and Sam Sterne were still relying on family networks to expand their business in the late 1860s. Although Sterne was based in Houston, he used a relative in his operation at Millican. This was a traditional practice in the 19th century and reflected the continuing uncertainty regarding communications in trade and the need that many merchants felt to have kin taking care of their business interests. Courtesy, Harris County Heritage Society

Far Right:

Simpson, Branard and Company's 1866 advertisement emphasized productivity and labor-saving machinery for both the farm and the home, including the reaper, grain mills, a washer, and sewing machines. Through this advertisement the firm demonstrates its ability to serve a modernizing city, particularly one that had been cut off from such products during the war. Also, by emphasizing equipment used in the production of grain, the company suggests that the range of agricultural products for export was growing beyond textiles and hides. Courtesy, Harris County Heritage Society

Facing page, bottom left:
In the years after the Civil War,
the trade rivalry between
Galveston and Houston, which
had been suspended, was
renewed. Agents such as Arnold
and Brothers made every effort
to develop special services to
bring trade to them and to their
community. Courtesy, Harris
County Heritage Society

Facing page, bottom right:
In the years after the Civil War,
Houston continued to develop
as a center for trade. Firms
such as Peel and Dumble
took advantage of the
communication center to develop
a trade in cotton, hides, and
wool. All three were available
along the coast. In addition,
these firms distributed
machinery and farm equipment
to their customers. Courtesy,
Harris County Heritage Society

This page:
Although Houston had been
isolated from the East by the
Civil War, merchants reformed
their trade networks quickly in
late 1865 and in 1866. Peel and
Dumble, who were able to
reform connections for trade to
the East, were working to
reestablish the cotton trade by
importing the equipment
necessary for ginning the cotton
grown on the Gulf Coast.
Courtesy, Harris County
Heritage Society

The last phase of Reconstruction in Texas encompassed the administration of Edmund J. Davis from January 8, 1870, to January 17, 1874. Enjoying the complete backing of the military in Texas and President Grant in Washington, Davis reigned as a near dictator for four years. With the assistance of the "State Police," organized by Davis in July 1870, the governor sought to implement his radical beliefs. Democratic party meetings were frequently disrupted and martial law declared in order to ensure Republican victories at the polls. Often those who opposed Davis were falsely arrested and held on the flimsiest of charges. By the "Carpetbag Constitution" of 1869, Davis was empowered to appoint more than 8,000 state, county, and local officials, which left little power in the hands of the Texas electorate. In the gubernatorial race of 1873, Davis was opposed by Richard Coke. Coke won the 1873 campaign and, after a power struggle with Davis, became the governor of Texas.

Meanwhile, politics on a local level in Houston reflected statewide trends and developments. In 1867 Alexander McGowen was elected mayor in a contest that generated so little interest that not a single fight at the polls was noted. Perhaps with a trace of disappointment, the editor of the *Telegraph* commented: "What a quiet and peaceable city Houston has become. But few cities of the size and population of Houston can boast such a record the day after a city election." However, in 1869 the city could not meet its municipal payroll and military authorities ordered the removal of the mayor, recorder, and marshall. Joseph R. Morris was named mayor and, though a "carpetbagger" from Connecticut, turned in a credible performance; during his term the wages of city employees increased, as did the city's trade and general prosperity.

The local political situation changed rapidly in 1870. Radical Thomas H. Scanlan, who had served for two years as an alderman prior to that date, was appointed mayor of Houston by Governor Davis. Born in Ireland, Scanlan came to Houston in 1853 and quickly began business as a general merchant. After the war he declared for the Radical Republican cause and, enjoying the backing of the occupation forces, rose rapidly in municipal politics. He was honestly dedicated to improving the lot of freedmen and it was during his years in office (1870-1873) that blacks first served on the police force and black councilmen, Richard Allen and James Snowball, were elected in Houston for the first time.

Scanlan was a somewhat typical mayor of the times in that there were persistent charges of financial mismanagement and personal graft during his tenure of office. A report ordered by Governor Coke after Scanlan left office in 1873 placed Houston's indebtedness at $1,414,000 as against the approximately $200,000 to $300,000 it had been when Scanlan took office. Yet, the mayor's critics had to admit that he had improved roads and bridges, constructed a markethouse, and extended the sidewalks. In November 1872, in the first campaign in six years where local officials were freely elected, Scanlan triumphed along with the two black aldermen. Predictably, cases of fraud were heard along with the particular allegation that large numbers of nonresident blacks came into Houston from the countryside to register and vote. However,

From January 1870 to January 1874, Edmund J. Davis served as governor of Texas. Davis had come to Texas in 1848 from Florida and had served as deputy collector of customs on the Rio Grande, district attorney, and district judge. During the Civil War he rose to the rank of brigadier general in the Union army. Later he was elected to the first Reconstruction Convention and served as president of the second Reconstruction Convention. From Thrall, Texas 1879

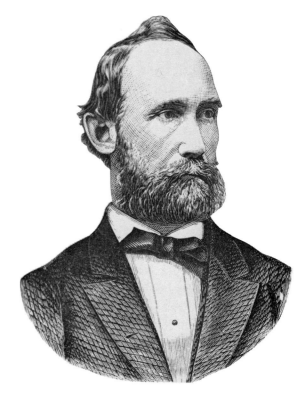

this contention was doubtful at best; Houstonians apparently believed that Scanlan's accomplishments and virtues outweighed his faults.

The 1872 municipal election was noteworthy in another way. The Ku Klux Klan, founded at Pulaski, Tennessee, in 1866, existed in many parts of Texas. The ultra-secret, terrorist organization committed to the maintenance of white supremacy and Southern sovereignty was most popular in East Texas. In Houston the Klan warned blacks not to vote in the 1872 race and implored white voters to refuse to elect any blacks to the City Council. The 1870 census count indicates that there were 793 male Negroes 21 years of age or older living in Houston and thus eligible to vote. It is impossible to say how many actually voted in the 1872 election, but the black turnout was heavy and two blacks were elected to the City Council. Always more popular in rural areas than in the city, the Klan in Houston was unable to muster much influence in municipal politics during the Reconstuction period.

Segregation of blacks and whites, begun in the public schools at this time, also extended to sports. On July 14, 1868, the *Daily Telegraph* informed its readers that a black baseball team had been organized in the city. Known as the Six Shooter Jims, the team offered to play a "match game with any other colored club in the state." During the Civil War there had been a complete lack of organized sports in Houston, but interest picked up in the period after the fighting ceased. On April 21, 1868, to commemorate San Jacinto Day, a baseball game between the Houston "Stonewalls" and the Galveston "Robert E. Lees" was played out at the battleground. With a number of veterans of the battle of San Jacinto in attendance, the reporter for the Houston *Daily Telegraph* caught the spirit of the occasion:

The contest now commenced in good earnest . . . but from the first innings it was apparent to the most disinterested that the Lees (although the vaunted champions of the state) had at last met more than their

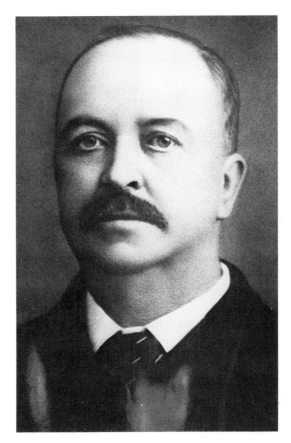

match. . . . At the conclusion of the eighth inning, the Lees, disheartened by the success of their antagonists, gave up the game and acknowledged themselves beaten fairly and squarely. The runs being counted, it was found that the score stood Stonewall's 34, the Lee's 5. Mr. McKernan, the umpire, then declared the Stonewalls the Champions of the State of Texas. Three cheers were then given for the Lee Club, three for the Stonewall, three for the umpire and scorers, and three for San Jacinto, when the bases were taken up, everything gathered together, and all started for Lynchburg, for the ball.

As it had in the past, horse racing also engaged the attention of Houstonians. The Houston Post Oak Jockey Club had been organized in 1839 and had promoted a few races before it disbanded in 1846, and racing flourished thereafter from time to time on an informal basis. Then in May 1868 work was completed on the Houston Racing and Trotting Park, adjacent to Main Street and two miles from the Courthouse. October 13, 1868, was proclaimed "Derby Day" and

Thomas J. Scanlan, Houston's Reconstruction mayor, may have been the most controversial mayor in the city's history. Although his administration was active in expanding the city's facilities, it was tainted with charges of corruption and building the public debt, which violated the traditional approach to public funding. In many ways Scanlan was typical of his era, but the traditional leaders of Houston were not ready to accept Scanlan's standards of administration and his term ended in 1874. Courtesy, Texas Room; Houston Public Library

almost 3,000 fans witnessed the event. Because of the Houston climate, racing continued into the winter months, attracting enthusiasts from all over the Gulf South. Also in the late 1860s, the Houston Turnverein, a society of German citizens, established the first bowling center in Houston. Amateur boxing also gained in popularity, but professional boxing and cockfighting were frowned upon by some and railed against by Houston's clergymen. Nevertheless, such events did take place.

Fairs provided another source of amusement for the city dweller. Again, Houston's German population was in the forefront, staging a celebration early in the summer called the "Volkfest." Out at the fairgrounds "King Gambrinus," the German Bacchus, presided over a series of floats and decorations. Speeches, gymnastics, music,

and dancing were the order of the day and annually attracted thousands of spectators. Also, the state fair of the Agricultural, Mechanical, and Blood Stock Association of Texas was often held in Houston. With financial backing from the local business community, farm machinery and products were displayed and prizes awarded. With its emphasis on rural values and farm animals, this meeting was certainly a precursor of the famous Houston Rodeo and Fat Stock Show of modern times.

After a dormant period occasioned by the war, culture and the arts began to flourish again in Houston. Theater groups and opera companies that had earlier come to the city from New Orleans and Mobile reappeared. To accommodate them, in 1873 a new theater, the Opera House, was completed at the southwest corner of Main and Franklin

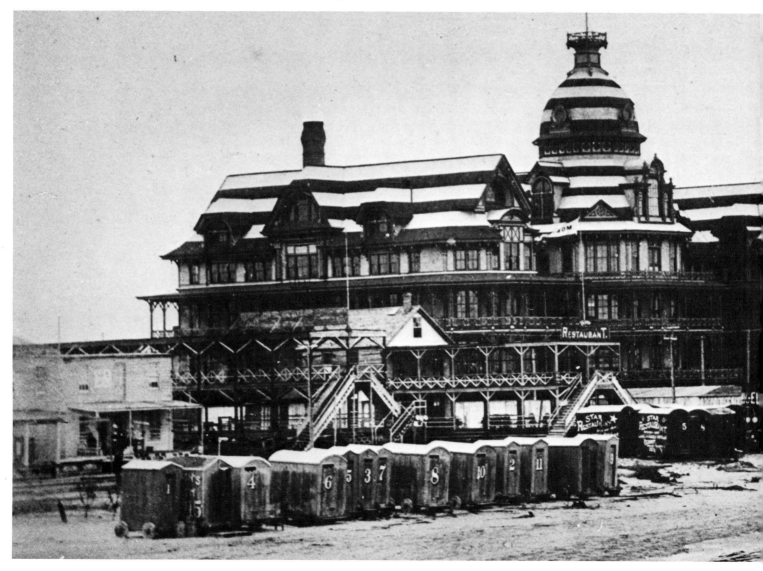

and opened to large crowds. A smaller variety theater on Fannin Street, Canterbury Hall was generally used for local amateur productions and minstrel shows. Various opera companies offered *Il Trovatore, La Traviata, Fra Diavolo, The Magic Flute*, and *Martha*. Finally, rave reviews greeted the performance of the famous Croatian soprano, Ilma di Murska, whose voice boasted a range of three octaves and who triumphed as the lead in *Norma* at the Opera House in 1878.

Literary societies continued to grow and develop, among them the Houston Literary Society (1875), the Horticultural and Pomological Society (1876), and the Houston Economics and Debating Club (1875). Also, as they had been doing since its inception, members of the Houston Lyceum continued to work for the establishment of a public library system. While the realization of that particular dream still remained in the future, Houstonians never wavered in their interest in and appreciation of cultural refinements.

As life in Houston began to normalize after the Civil War, its inhabitants were faced with yet another challenge. Because of its tropical, humid climate and its proximity to the Gulf, Houston had always been subject to the dread disease of yellow fever. Epidemics were recorded by city authorities in 1839, 1844, 1847-1848, 1854-1855, 1858, 1862, and 1867. The scourge in 1867 was among the worst in the city's history and was made even harder to bear by the negligence of local officials. When manifestations of the disease appeared in neighboring towns in January 1867, no quarantine was declared locally. By Septem-

Galveston gradually became ascendant as the entertainment and vacation spot for many Houstonians in the years after the Civil War. Bathers staying at such establishments as the Beach Hotel would change their clothes in the small portable cabins in front of the structure before going for a refreshing swim in the Gulf. Courtesy, Rosenberg Library

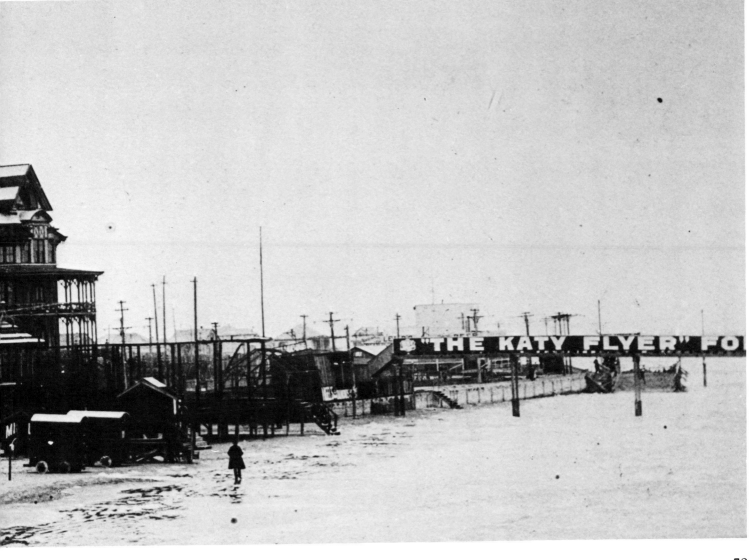

ber the plague had claimed hundreds of lives and numbered among its victims the only physician in Harrisburg and the still youthful Dick Dowling, hero of the battle of Sabine Pass. Perhaps hardest hit were unacclimated Northern soldiers on occupation duty. As a preventative measure, large vats of tar were burned in army camps, but the disease continued to ravage officers and men, blacks and whites alike. Extra grave diggers and additional carpenters were hired by sexton H.G. Pannell to bury the Union dead, but the work did not go fast enough. In his book *True Stories of Old Houston and Houstonians,* Dr. S.O. Young recorded an amusing incident. An angry Federal commander sent for the sexton, who was well known for his pro-Southern feelings:

He was taken before the commander who said to him: "Mr. Pannell they tell me you dislike to bury my soldiers!" "General!" said Pannell, "whoever told you that told you a damned lie. It's the pleasantest thing I've had to do in years and I can't get enough of it. I would like to bury every damned one of you."

Sexton Pennell was ordered imprisoned by the Union commander, but he did not remain in jail for long because his services were in too great a demand.

By November the crisis had abated. Frost and cold weather had killed the plague-bearing mosquitoes, and more rigid quarantine methods had also proven helpful. Interestingly enough, a number of Houston physicians, including Dr. Ashbel Smith, Dr. Louis A. Bryan, and Dr. Alva Connel, suspected that the mosquito was the chief culprit in yellow fever cases, but none had been able to adduce scientific proof. Although the city suffered a mild epidemic in 1873, it did not begin to approach the terrible ordeal endured in 1867.

The city had endured the travail of the Civil War and Reconstruction periods and emerged with its growth still constant. Unlike other major cities of the South, it had not been compelled to rebuild from the ashes of physical ruin. The questions of slavery and secession had been resolved on the battlefields of the vanquished Confederacy. Optimistic, perhaps to a fault, Houstonians looked to the future.

Although the 20th-century storms are better known, the Gulf Coast has been the target of many storms over the years. Evidence of the strength of the 1867 storm is to be found in this image of Galveston's waterfront. Damage inland caused by winds, heavy rains, and flooding from fast-rising streams was almost as severe. Courtesy, Rosenberg Library

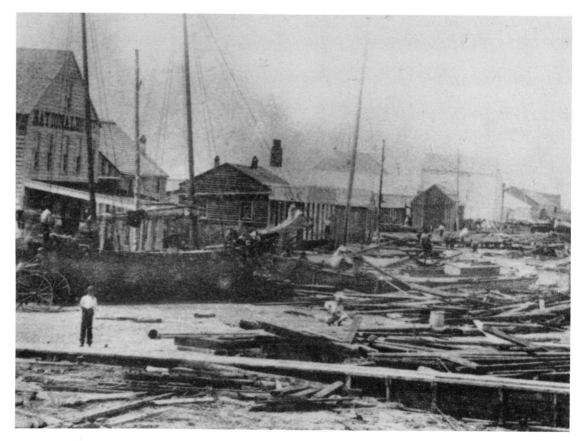

Houston and all of Texas were subjects of great discussion in Europe in the 1840s and 1850s. Land speculators, such as those responsible for this 1855 French illustration of Houston, sometimes created views that never existed. Courtesy, Bayou Bend Collection, Gift of Miss Ima Hogg; Houston Museum of Fine Arts

Texans have a special fondness for the traditional music played for the reels and other dances that were once part of annual celebrations and dances in Houston and elsewhere. Recreating the dinner and dance that Mrs. William Marsh Rice held every Christmas for 48 people, these musicians bring back 19th-century memories for 20th-century Houstonians. Photo by Story J. Sloane III, Harris County Heritage Society

During the days of the Republic and soon after, one of the most popular recreations was formal dancing. Photo by Story J. Sloane III, Harris County Heritage Society and the Texas Army

The Nichols-Rice-Cherry
House, built opposite the Harris
County Courthouse at the
corner of San Jacinto and
Congress by 1850, is a part of
the fabric of Houston. The
house served as an elegant home
for the merchant Ebenezer
Nichols and then was sold to
William Marsh Rice in 1856.
Later the house became rental
property, but was saved in 1897
by Mrs. Emma Richardson
Cherry who moved it to the far
prairie in the Montrose area.
The house has been associated
with enterprise, education, and
through Mrs. Cherry, with the
arts. Courtesy, Harris County
Heritage Society

In 1954 the oldest surviving residence in Houston was threatened with destruction by the city, which had used it as park headquarters, zoo building, and storehouse. Interested citizens began a formal preservation movement in Houston by uniting to save the structure. It had been the home of both Nathaniel Kelley Kellum, an early industrialist, and Zerviah Noble, an early teacher. Preservation of the house led to the creation of the Harris County Heritage Society, an active museum and preservation organization for Houston. Courtesy, Harris County Heritage Society

Built on the southeastern edge of Harris County on Clear Creek, the "Old Place" is the oldest standing structure in the county. Erected by John Williams, an early member of the Austin colony, the structure served as a line camp for many years before being expanded as a residence in the 1850s. In 1971 it was moved to Sam Houston Park and restored to its original condition as a tribute to the settlers who came to the county more than a decade before Houston was founded. Courtesy, Harris County Heritage Society

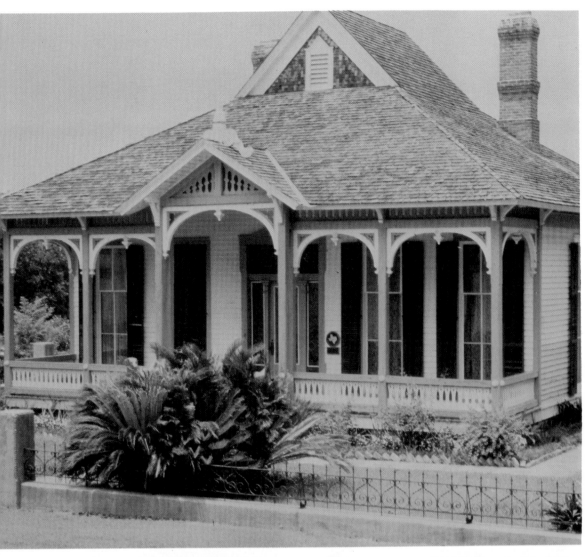

Left:
This residence built by Houston entrepreneur and lumberman Eugene Pillot in 1868 was perhaps the first major domestic building erected after the Civil War in Houston. Equipped with running water fed by a tank, with gas lighting, and with what may well have been the first attached kitchen in Houston, the home was both fashionable and modern, reflecting Pillot's position as a leader in the community. Courtesy, Harris County Heritage Society

Bottom left:
Throughout the 19th century, gentlemen of Houston would retire for an evening of brandy, cigars, and cards. The Pillot House smoking room is furnished for a game of cards that might have been played on an evening in the 1870s.

Bottom right:
Festivities in the home of Eugene Pillot were characterized by a French elegance captured in the home's restored interior. Photos by Story J. Sloane III, Harris County Heritage Society

The San Felipe Cottage, built in
1868 and remodeled in 1883,
represents the modest homes of
the Houston middle class in the
late 19th century. In its six
small rooms it housed small to
middle-sized families, including
those of two of Houston's fire
chiefs. Courtesy, Harris County
Heritage Society

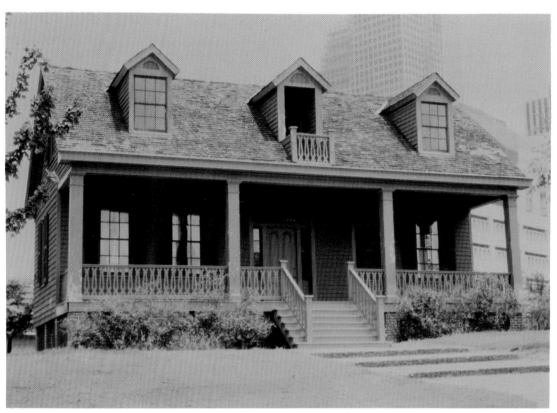

In Houston's German homes of
the 19th century tables at
Christmas time were laden with
cakes, cookies, and other sweets
made with recipes brought from
Germany. The Germans appear
to have brought many
Christmas customs to Houston.
Courtesy, Story J. Sloane III,
Harris County Heritage Society

Above:
Born near Rusk in 1851, James Stephen Hogg, a progressive Democrat, served as the first native-born governor of Texas between 1891 to 1895. Moving to Houston in 1904, Hogg had already played an important role in developing the Texas Company following the Spindletop discovery. Hurt in a

railroad accident, Hogg maintained a limited schedule of activity until his death in March 1906. Courtesy, Bayou Bend Collection, Gift of Miss Ima Hogg; Houston Museum of Fine Arts

Left:
Presented to Governor James Stephen Hogg, this diamond ring with the stone set into tar from the Spindletop oil field captures the pride of Texans in their newly found natural resource. Courtesy, San Jacinto Monument

By about 1880 Houston had
grown from a village to a city
and was on its way to becoming
a mercantile and transportation
center. From Thrall,
Texas 1879

THE BAYOU CITY IN THE GILDED AGE

1209, 1211, 1213, 1215 Congress Ave. Houston, Texas

I n his widely read novel, *The Gilded Age,* Mark Twain lamented some of the "boom or bust" features of American life in the last quarter of the 19th century. Houstonians who purchased Twain's book at one of the city's growing number of bookstores or borrowed it from the Houston Lyceum would have found much with which to agree. No longer a placid village astride a picturesque bayou, Houston was fast becoming a noisy, bustling, mercantile and transportation center. Unmarked by the type of Civil War devastation visited upon Richmond and Atlanta, Houston had continued to grow and prosper during the era of Reconstruction. The city was now poised for a period of expansion unlike anything it had known before.

Railroad construction played a significant part in facilitating this growth. One important railroad emanating from the Bayou City, the Houston & Texas Central, had been chartered in 1848 with the Allen brothers among the original stockholders. Some 55 miles of track had been completed before secession, and it was the first railroad to resume building after the Civil War. Connections were made with Bryan in 1867, Corsicana in 1871, and Dallas in 1872. When the line extended even farther northward to Denison in 1873, its linkage with the Missouri, Kansas & Texas at that site gave the Lone Star State a through con-

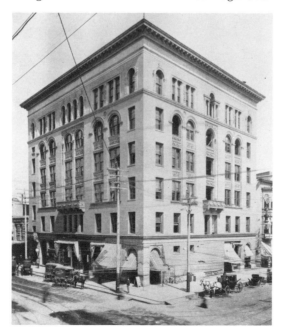

nection to St. Louis. The first Pullman service in Texas was established on this line between Houston and St. Louis in 1873. However, some costly mistakes were made in the purchase of other Texas railroad properties, and the Houston & Texas Central was forced into receivership. In 1893 it was incorporated into the Southern Pacific system.

In 1875 three prominent Houstonians, Paul Bremond, Colonel T.W. House, and Eugene Pillot, joined other enterprising capitalists in chartering the Houston East & West Texas Narrow Gauge Railroad. Bremond, an imaginative man, had come to Houston in 1842 and prospered as a merchant and investor. Before work began on his railroad venture, he visited the Centennial at Philadelphia in 1876 and viewed an exhibit of a narrow gauge railroad. A subsequent trip to Colorado to observe the actual operation of another such road, the Denver & Rio Grande, confirmed his belief in that type of construction. He then purchased the two engines in the Centennial exhibit, the *Giraud* and the *Centennial,* and shipped them to Texas. After resolving some financial problems, work began on the projected road in 1876, and within four years it connected with Livingston and Moscow.

Nicknamed "Hell Either Way Taken," Bremond's road, designed to reach the Piney Woods region of northeast Texas, was projected in two parts. One trunk would run

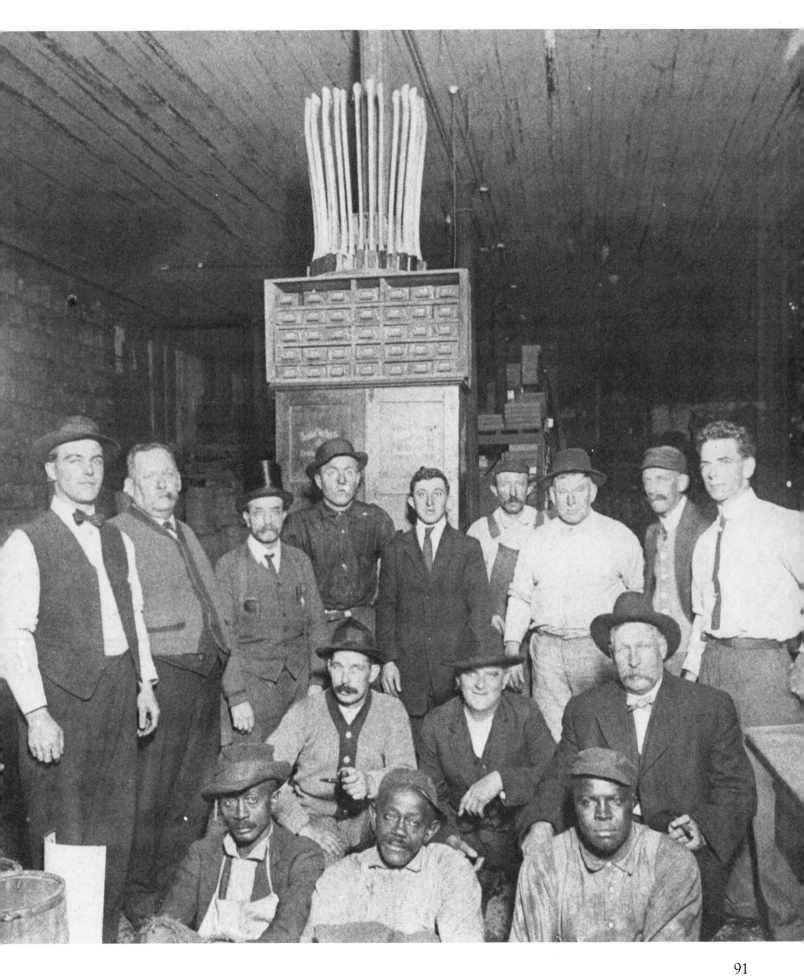

Facing page, left:
Although Houston was still a market for the traditional self-taught builder who had not studied building in a formal manner, it also began to attract trained designers, such as Eugene T. Heiner, who could build commercial structures for the growing city. Courtesy, Harris County Heritage Society

Facing page right, top:
As Houston began to prosper, the city itself became a market for fashionable goods. While A.C. Morin, a carpenter, represented the traditional way of building houses, other firms, such as the Bayou City Marble Works, were importing fine architectural elements and building a taste for sophisticated design. Courtesy, Harris County Heritage Society

Facing page right, bottom:
In the mid-19th century, George E. Dickey was the leading force in Houston architecture, trading on his experience throughout Texas and his experience with both domestic and commercial architecture. Though clearly an important regional architect who grew with Houston, Dickey aspired to national status. Courtesy, Harris County Heritage Society

This page:
In the late 19th century, medical practice was changing. Broadsides and advertising, however, were still in use and M. Kahen's advertisement reflects the character of practice and knowledge in the community during the years after the Civil War and Reconstruction. Courtesy, Special Collections, Houston Public Library

northeast from Houston through Marshall to Texarkana, with branches from Goodrich and Jasper to the Sabine. This route would link up with the timber-producing belt of East Texas, while the other trunk would run in a southwesterly direction to Laredo through Victoria and Goliad. However, this latter road was never constructed.

By 1883 the Houston East & West Texas had reached Nacogdoches, providing access to the Piney Woods timber forests, and by 1885 its ultimate destination, the Sabine River. In the last quarter of the 19th century, Houston became the hub of the state's lumber industry, and at the height of its operations, the three-foot gauge road transported 20 carloads of lumber to the city daily. Houston was ideally situated; the timberlands were to her east, and the vast market for lumber supplies lay to her west. Of course, as additional lines radiated out of the city, the market was proportionately increased. In 1899, 420 million feet of lumber passed through Houston railroad terminals destined for other parts of the state as well as national and international markets.

Bremond had invested his entire personal fortune, reputed to be $500,000, in the railroad that opened the timber forests, and his death in May 1885 forced the road into receivership. The property was acquired in 1894 by Blair & Company Bankers of New York City, who placed it under the direction of Norman S. Meldrum as president. Meldrum, who played a prominent role in Houston civic and cultural affairs, operated the road with efficiency until October 1899, when it, too, became part of the Southern Pacific.

Another career closely tied to the opening of the timber forests was that of John Henry Kirby. Born near Peachtree Village in East Texas, he attended Southwestern University for a brief time, but failed to graduate because of lack of funds. Returning to the Piney Woods, he took up residence at Woodville, read law, and was admitted to the state bar. Backed by Eastern capitalists, Kirby was instrumental in the formation of the Texas and Louisiana Land and Lumber Company and also the Texas Pine Land As-

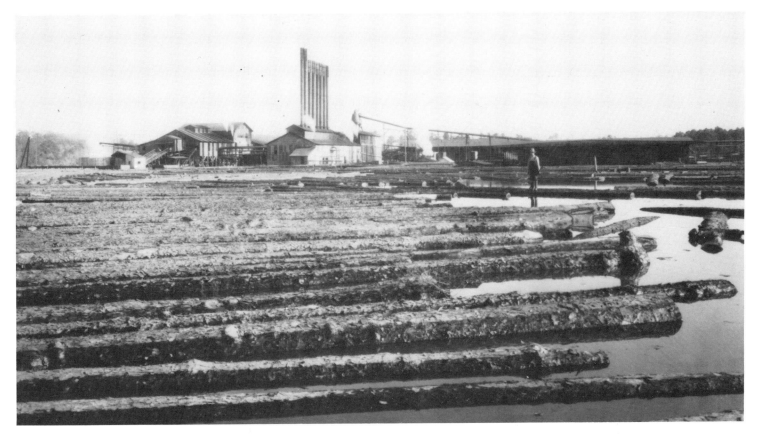

sociation. Kirby, by now the dominant force in two of the largest timber companies in Texas, moved to Houston in 1890 to join the law firm of Hobby and Lanier.

For better logging of his vast lumber holdings, Kirby, in 1893, began construction of the Gulf, Beaumont & Kansas City Railroad between the Neches and Sabine rivers. He continued to buy up timberlands and extend the railroad, and in 1896 he erected his first sawmill at Silsbee. In 1901 he founded the Houston-based Kirby Lumber Company and was reputed to be the "wealthiest man in town." The company's headquarters were located in a seven-story building erected by Kirby at the corner of Main Street and Rusk Avenue. Known chiefly as a lumberman, Kirby continued to practice law while branching out into banking and related interests. Still later, he became active in the oil industry, serving as president of the Southwestern Oil Company of Houston and then founding the Kirby Petroleum Company in 1920. During a lengthy and active business career, he found time to represent his district in the Texas state legislature and serve as a member of the War Industries Board during World War I. Kirby, whose initiative helped build the Bayou City's fortunes, died at his home in Houston on November 9, 1940.

By 1890 almost 8,500 miles of railroad track had been laid in Texas, substantially improving transportation to and from

Houston and contributing significantly to the city's expansion. Houston businessmen and transportation leaders had long cherished another prospect, that of bypassing Galveston and achieving direct access to the sea. On October 9, 1866, the Houston Direct Navigation Company was chartered to improve navigation conditions on Buffalo Bayou. Among the company's founders were Eugene Pillot, Timothy H. Scanlan, Joseph Jones Reynolds, and Peter Gabel. While the founders of the company were prohibited from exercising exclusive navigation rights on the bayou, they were authorized to have, "a sufficient number of steamers, barges, and propellers, to meet the demands of commerce."

The Houston Direct Navigation Company prospered from the time of its incor-

The long leaf pines of East Texas were logged and brought to many different mills for processing. Here we see the Weir Long Leaf Lumber Company's mill pond in 1900. Courtesy, Barker Texas History Center; University of Texas

The Weir Long Leaf Lumber Company was one of a number of Houston-based firms that owned vast stands of timber in the pine forests of East Texas. Taking advantage of the rail network, which focused on Houston, such firms made the lumber industry one of the bases of the Houston economy. Courtesy, Barker Texas History Center; University of Texas

Built to house Samuel E. Carter's Lumberman's National Bank, the S.E. Carter Building was the first tall building in Houston. Complete with a walnut-paneled boardroom, the structure marked the beginning of the growth of Houston's skyline. Carter, who had made his fortune in lumber, was one of those who brought the timber trade of East Texas to Houston. Courtesy, Texas Room; Houston Public Library

poration. Exorbitant Galveston wharfage costs and obstructions placed in that city's harbor during the Civil War worked to Houston's advantage. Oceangoing vessels bound for Galveston adopted the practice of unloading in mid-channel and transferring a portion of their cargoes to smaller barges that could navigate to Houston. This neatly avoided the payment of fees in Galveston. In addition to running barges carrying freight, the Direct Navigation Company also awarded contracts for the construction of four bayou passenger steamers to travel between Houston and Galveston. The trip aboard the *T.M. Bagby*, the *Diana*, the *Lizzie*, or the *Charles Fowler* was popular with both businessmen and honeymoon couples, who traveled in accommodations that rivaled any Mississippi River steamer of the era.

The same year that the Direct Navigation Company was chartered, the Buffalo Bayou Ship Channel Company was also chartered, with former Texas Secretary of State E.W. Cave as president. This company set about the task of deepening the channel but quickly expended its available funds. Ten thousand dollars was secured from the federal government, but by 1873 the company's financial resources were once again exhausted. Denied any further federal assistance, the principal stockholders, many of whom also held an interest in the Direct Navigation Company, turned to Charles Morgan of the Morgan Steamship line for assistance. Morgan, whose holdings at one time totaled more than 100 ships, had long chafed under the Galveston wharfage monopoly and was anxious to boost Houston as a rival port. Accordingly, in 1874 he entered into an agreement to purchase both companies and also to construct a nine-foot channel, not less than 120 feet wide, from Galveston Bay to the vicinity of Houston.

By mid-1875 eight dredges, six tugs, and a number of derricks and barges were at work clearing the channel day and night. Despite major storm damage and a hurricane in September, the channel was finished on April 21, 1876—San Jacinto Day. The western terminus of this channel lay seven miles

below Houston, and Morgan completed his larger scheme by building a railroad, the Texas Transportation Company, from that site into Houston's Fifth Ward. Morgan's steamers were thus linked with railroad connections to Houston and therefore with any connecting road in Texas.

This represented just the early beginnings of the Bayou City's future as a deep-water port. Two other developments aided this process: on July 14, 1870, the United States Congress designated Houston as an official "port of delivery" and authorized a federal survey of Houston's proposed channel; and in May 1874 a number of prominent cotton factors and local merchants organized the Houston Board of Trade. This organization was later joined in the task of municipal promotion by the Houston Commercial League, founded in 1890, and the Houston Business League, established in 1895. The present Houston Chamber of Commerce, organized in 1910, can trace its ancestry directly back only to the creation of the Houston Business League in 1895.

The Houston Board of Trade, established principally to encourage the cotton trade, soon changed its name to the Houston Board of Trade and Cotton Exchange. Almost from the time of its founding, cotton had been important to the economy of Houston. Plantations upriver on the muddy Brazos had sent their crop to Houston for shipment to Galveston, other parts of the United States, and Europe as well. Profits earned during the Civil War and after had bolstered the fortunes of such early Houston millionaires as Colonel T.W. House, William Marsh Rice, and others. To compress the cotton for easier shipment, a number of compress companies were founded. The Houston Cotton Compress (1860), Bayou City Compress (1875), and International Compress (1882) were among the most important of these concerns. Cottonseed-oil factories and cotton warehouses also dotted the Houston industrial scene. Since cotton was a major export from Houston at the time, the Cotton Exchange was vitally interested in reasonable transportation rates to foreign and domestic markets and thus enthusiastically supported the ship channel project.

In addition to the ship channel project and further railroad expansion, improvement of the city's roads and streets was also necessary to Houston's transportation network. Complaints about the dusty and muddy condition of Houston's streets finally resulted in some action. Conditions became so intolerable that in 1882 the Fifth Ward, a largely black area, petitioned the City Council for the right to secede and found the "City of North Houston." Faced with this threat, utility connections were extended to the area and some promises were made regarding the improvement of streets. In the heart of the city, Preston Avenue east of Main Street was topped with shell and Chenevert Street was ditched and graded. In the summer of 1882, two blocks of Main Street were paved with limestone squares over a gravel base, financed by owners of adjacent property. Other Houston merchants subsidized street improvement using planking, brick, and asphalt. In 1892 the Magnolia Cycling Club was able to conduct its first annual bicycle race over paved streets in the Houston Heights neighborhood. Perhaps the most significant statistic was that by the turn of the century the city

In the 19th century, lumber factories began to shape the lifestyles and homes of each community. Producing standardized sashes, doors, blinds, and trim, dealers such as H. House provided materials for the builders of the community and began to provide an elegance not previously available. Courtesy, Special Collections; Houston Public Library

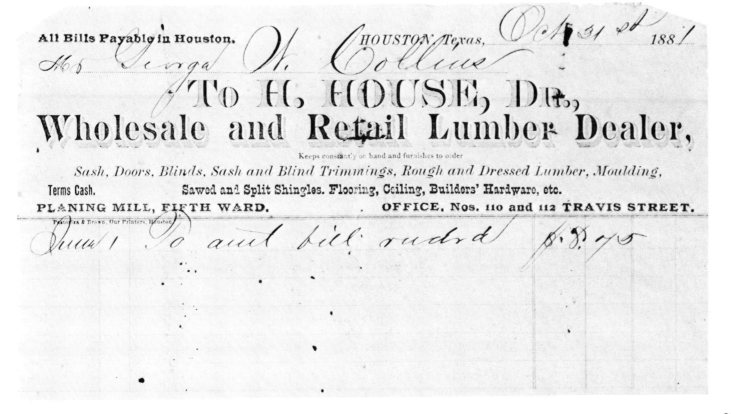

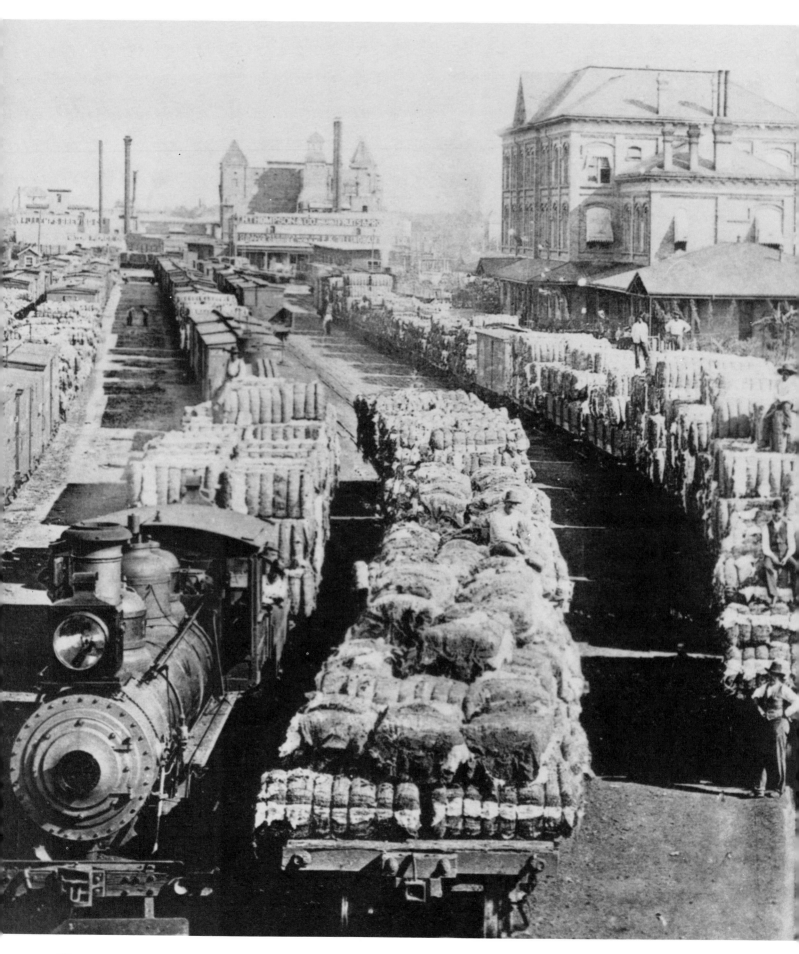

could boast of 26 miles of paved road.

Municipal improvements and business expansion were not accomplished without an increase in labor agitation and strikes. In 1878 the Houston City Council authorized the local street commissioner to pay his workers in scrip. The men were excused from their duties for a two-hour period during which time they had to find someone to purchase the paper. Thirty cents on the dollar was the highest offer for the vouchers, and the workers returned to inform the commissioner that they were unwilling to work at that rate. They removed their tools from the city's streets, as requested, and an alderman took their case to the Council, which decided against the strikers and ordered them back to work. Another situation in which public employees displayed new militancy occurred in 1880, when the city was unable to meet its December payroll and the Houston policemen threatened to strike. Efforts to hurriedly borrow the money proved unsuccessful, but the police officers stayed on the job and were eventually compensated.

Employees of private concerns also developed labor unions, such as the Texas Typographical Association, which maintained a chapter in Houston since 1838. In September 1880 printers employed by the Houston *Post* demanded a raise from 35 to

40 cents per thousand copies. Management struck back by pointing out that *Post* printers received a higher wage than those employed by any other newspaper in the city and threatened to discharge those who did not immediately return to work. In less than a week the strike was broken, and the printers resumed their employment at the old rate of 35 cents. However, the organizers of the strike, John Wilson and George Fortney, were denied their jobs back.

Facing page:
Cotton was brought to Houston by the trainload. On one afternoon in 1894, the Grand Central Depot area was filled with flatcars loaded with bales of cotton shipped in from the small farms and gins of the Coastal Bend and East Texas. Courtesy, Harris County Heritage Society; Litterst-Dixon Collection

Left:
To transform Houston into a port to rival Galveston, shipping magnate Charles Morgan (1795-1878) purchased the Direct Navigation Company and the Buffalo Bayou Ship Channel Company and constructed a ship channel from Galveston Bay to a point about seven miles below Houston. Courtesy, New-York Historical Society. From Cirker, Dictionary of American Portraits, *Dover, 1967*

Taste in the homes of Houston in the 19th century was usually established by prevailing national standards. Dealers in paint and wallpaper, such as James Bute, imported materials and allowed Houston homemakers to follow the standards established in such popular publications as Godey's Lady's Book. *Courtesy, Special Collections; Houston Public Library*

In 1885 a local chapter of the Knights of Labor was established, but two years earlier the organization's activities touched the Bayou City. In 1883, primarily because the Mallory Line at its New York pier discharged white union laborers and replaced them with black nonunion labor, the Knights of Labor called a general strike at Galveston. The Knights demanded that the company cease its discriminatory practices against union labor and reinstate the workers who had been discharged. Upon the Mallory Line's rejection of the union demand, some 2,000 Galveston longshoremen walked off their jobs. In less than a week, the strike spread to Houston, where local dockworkers refused to handle any shipments billed for Galveston. Although this strike ended unsuccessfully, it did aid in the establishment of the Negro Longshoremen's Association in 1884 with membership in Galveston and Houston.

Black involvement in politics in general increased after Reconstruction. Adoption of the Texas State Constitution of 1876 marked an official end to the decade of Reconstruction. The document called for

acceptance of the 13th and 14th amendments to the federal Constitution and outlawed discrimination on grounds of race where voting rights were at issue. Although many in Houston and Harris County were opposed to these and other features of the document, it was overwhelmingly ratified on a statewide basis. Amended countless times, this constitution, written more than one hundred years ago, serves the Lone Star State to this day as fundamental law.

Now that the Federal troops had been removed, Houstonians and residents of Harris County returned to their former political allegiance. Democratic candidates for the national Presidency were unfailingly supported as were nominees for the state's highest elective office at Austin. Perhaps the most popular political figure in Houston during this time was James Stephen Hogg. As state attorney general (1886-1890), he fought for effective legislation to regulate abusive railroad practices and also achieved more stringent control of out-of-state insurance companies doing business in Texas.

Campaigning as a reform candidate, he was elected for two terms as governor (1891-1895). His most significant contribution in that office was to champion the creation of the Texas Railroad Commission, which in time became the most effective state regulatory body in the nation. He also endeared himself to the Houston business community by his frequent trips to New York, Boston, and Philadelphia, seeking capital for local business development and stressing the opportunities that awaited the enterprising businessman in Texas. Hogg returned to private practice as an attorney and prospered through oil investments after the Spindletop boom. He continued to play a prominent role in national Democratic politics until his death in 1906, and important contributions later were made to the city of Houston by his son, Will Hogg, and his daughter, Ima Hogg.

The Democratic party also dominated politics on a municipal level. James T.D. Wilson was appointed mayor of the city in 1874 by Governor Richard Coke to replace

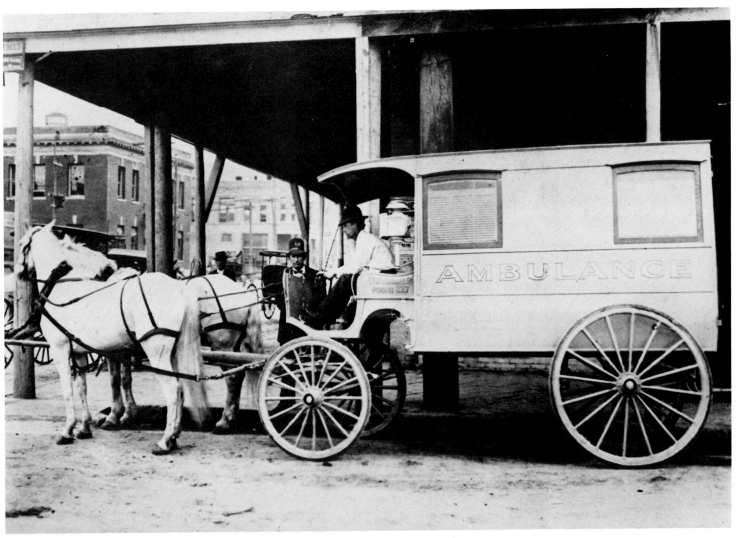

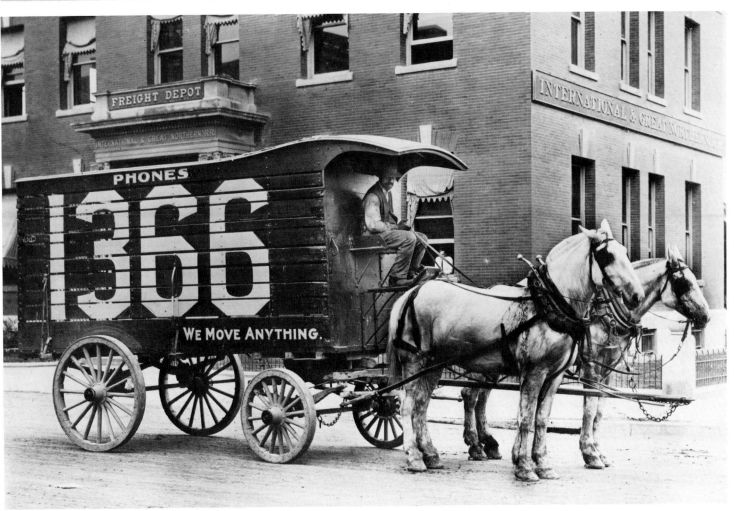

the local carpetbag administration of T.H. Scanlan, and a few months later he was elected in a popular contest. He also served as mayor for another term (1877-1878). Formerly engaged in real estate and banking, Wilson was a confident spokesmen for the city's business community. Another popular politician with a strong business background was William R. Baker, mayor in 1880-1886. A former director of the Houston & Texas Central Railroad, he was also for a time president of the City Bank of Houston. Other Houston chief executives of this era were Andrew J. Burke, Daniel C. Smith, and Samuel H. Brashear.

It was at this time, the last quarter of the 19th century, that blacks in Houston moved more into the political mainstream. Grateful to President Lincoln for their liberation and encouraged by the Freedmen's Bureau in that direction, most Texas blacks tended to identify with the Republican party. However, in their attempt to return to local ascendancy, Texas Democrats sought black support on fusion tickets. Generally, however, blacks resented such proposals in which they were granted only token representation on the ticket. As a case in point, the black vice-president of the Harris County Republican Convention commented on the county ticket selected in 1876: "You seem to think because a man says he is an independent Democrat he is better than a Republican. What good is it for us to . . . help independent Democrats instead of trying to help some of our own sort." However, the situation did not show much improvement in Harris County, for in 1880 only one black candidate was included on the ticket. Fusionism was also attempted on a local level when Houston Greenbackers selected a city ticket that included token representation. A black, Milton Baker, was nominated for street commissioner, but the entire ticket failed of election.

In an effort to discourage black participation in politics, Democrats proposed payment of a poll tax as a requirement for suffrage. This proposal, which had been voted down at the constitutional convention, came up several times during the late-

19th century but was always defeated. Although the purpose of the proposed tax was to eliminate black voters, many Democrats believed that it would fall just as heavily on poor whites. However, after a number of unsuccessful attempts, the state legislature, in 1903, passed a constitutional amendment sanctioning a poll tax for voting. The amendment was ratified by a two-to-one vote and it did reduce the number of voters in Texas elections. Houston and other cities then adopted a municipal poll tax for local elections, which acted to keep some blacks and Mexican-Americans away from the polls. One perhaps unexpected development was the formation of "poll tax associations" in which local politicians purchased poll taxes for minority voters to assure their casting a ballot for the party in power. One such "association" appeared in Houston at this time.

Not content with quasi-legal methods to keep blacks from the voting booth, so-called "white men's parties" sprung up in Waller, Harris, Matagorda, and Washington counties. Physical intimidation was used by these groups, sometimes ending in serious violence. Frustrated in their political ambitions

William R. Baker, Houston's mayor during the 1880-1885 period, had come to Texas as a young man in 1841 from New York. Baker had served as county clerk, but later became involved in the development of Houston's business community. He served as a member of a number of corporate boards, as owner of the Houston Post, and as president of the City Bank of Houston, helping to found one of the great banking institutions of the city. Courtesy, Texas Room; Houston Public Library

and suffering economic deprivation as well, blacks in Houston sought other means to advance their cause. In addition to joining such organizations as the Knights of Labor and the Farmers Improvement Society, they attended national protest conventions in Nashville, Tennessee, in 1876 and 1879. In order to publicize their achievements and encourage individual initiative on the part of blacks, fairs, most of them connected with agriculture, were frequently sponsored. Both the Colored Lone Star State Fair Association and the Afro-American Fair were often held in Houston. In 1890 Houstonians Richard Allen and Samuel J. Dixon attended the National Afro-American League meeting in Chicago, which was called to condemn the conditions under which blacks were compelled to live.

Richard Allen, who also attended the 1879 convention at Nashville, was among the most politically active members of the Houston black community. Elected to the state legislature in 1871, he also served as customs collector for the Port of Houston and as a city alderman. He became the first grand master of the Colored Masons in Texas and was a Presidential elector in 1904. As a leading exponent of black migration, he organized a statewide meeting where plans were drawn up calling for the organization of emigration clubs to facilitate the exodus from Texas. A mistaken impression circulated that lands could be had for almost nothing in Kansas and Oklahoma. Some interest was generated in an ultimately unsuccessful Mexican colonization scheme and in an imaginative proposal to establish a separate colony for Texas blacks in the northwestern corner of the state. A "back to Africa" movement also had its partisans, and in 1881 black Houstonians organized an ultimately unsuccessful society to encourage emigration to Liberia. Authorities differ on the exact number of blacks who left the state at this time, but the total was insignificant.

As blacks had to struggle to achieve political representation, they also had to fight for adequate educational facilities. The landmark Texas Constitution of 1876 abolished

James T.D. Wilson, a Houston banker, was the man selected to end the rule of the Scanlan administration. Appointed mayor in 1874 by the governor, he was elected for the 1875 term and then again from 1877 to 1878. Wilson rebuilt the market house, which had burned in an 1876 fire. Courtesy, Texas Room; Houston Public Library

the office of state superintendent of schools and provided for virtual autonomy on the part of local school boards. The statute also provided in generous fashion for the support of local schools. Any incorporated city or town, by a majority vote of the property taxpayers, could assume exclusive control of the public schools within its limits.

The City of Houston became among the first in the state to take control of its schools. However, this was not the first instance of free public education in Houston. A free county school system supported by state funds was already operative in Harris County. In 1873 Harris County operated some 24 schools with slightly more than 1,500 students in attendance. In 1874 Ashbel Smith, whose major contributions to education in Texas still lay in the future founding of the University of Texas, was named superintendent of county schools. A physician whose medical skills were much in demand, Smith found time to screen each applicant for a teaching position in the county and to become an active advocate of educational reform, including the improvement of black education.

Based on the results of the local election, the City Council in 1877 established free

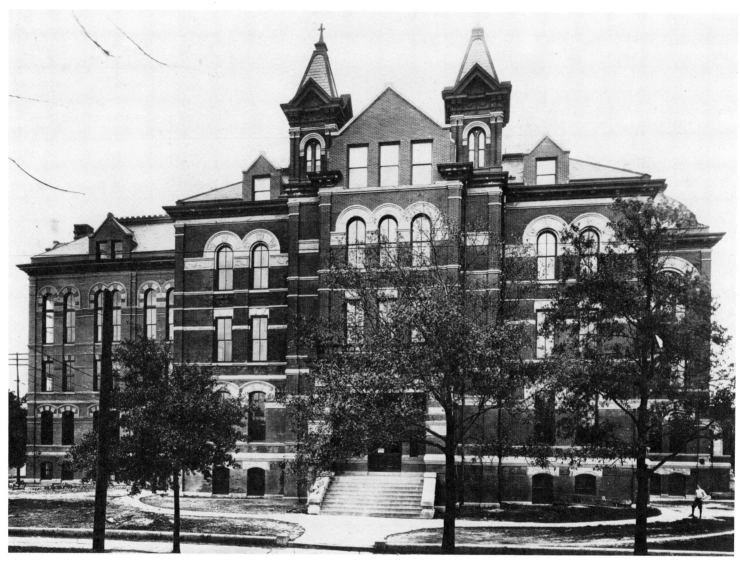

public schools for all children from the ages of eight to fourteen. Three trustees and a superintendent, appointed by the mayor and approved by the Council, would manage the system. From the very beginning the schools and teaching staffs were segregated by order of the City Council. Attendance was not compulsory and the school year lasted only six months. Finally, in order to be certified to teach in the Houston public schools, an instructor must pass examinations in "orthography, reading, writing, English grammar, composition, geography, and arithmetic." Still, because of the paucity of applicants, the records indicate that most applicants were deemed qualified. The average monthly wage for a teacher in the Houston public schools at this time was just under $50.

Segregation in the local public schools meant that from the beginning black schools would be poorly funded. The Slater and Peabody funds, created by Northern philanthropists, did provide some money for urban black institutions, but not enough to redress the imbalance. Spokesmen for the black community protested against a worsening situation and 13 black educational and political leaders, some from Houston, organized the Colored Teachers State Association in 1884. This organization called upon the state to provide college training for blacks and also sought help from the private sector. Colleges and universities for black students were established by the Methodist, Roman Catholic, and Baptist churches, but few of the educational attempts proved lasting. For example, the Baptist Missionary and Education Association of Texas founded Houston College in 1885 with 100 students,

but within a few years classes ceased to meet.

No single individual did more for the cause of education in Texas than Ashbel Smith. Although he maintained a home at Evergreen Plantation on Galveston Bay, his medical practice rooted him in Houston as well. In 1876 Smith published an article in the *Texas Christian Advocate* entitled "Education of the Negro," which urged the state legislature to increase its appropriation for black education. Shortly thereafter, Governor Richard Coke appointed Smith one of three commissioners charged with locating a site for the Agricultural and Mechanical College for Colored Youths, later Prairie View University. However, the chief labor of the last years of Smith's life was the founding of the University of Texas. As president of the first Board of Regents, Smith was instrumental in designing the initial curriculum at the university and assembling its first faculty. Although a statewide referendum resulted in the location of the university in Austin, Smith was successful in locating the medical department of the university at Galveston. Smith was the principal speaker on November 16, 1882, the day the cornerstone of the first building on the campus at Austin was laid. Prophetically, he told his audience, "Texas holds embedded in its earth rocks and minerals which now lie idle, because unknown, resources of incalculable industrial utility, of wealth and power. Smite the earth, smite the rocks with the rod of knowledge and fountains of unstinted wealth will gush forth." How could Smith know that his promise would be fulfilled beyond his wildest dreams in 1923, when oil was discovered on university-owned property?

In late-19th-century Houston, another great personality embarked on an eventually outstanding career. William Sydney Porter, born in Greensboro, North Carolina, came to Texas in 1882 and worked in Austin as a bank teller and as a draftsman in the General Land Office. In 1894 he resigned his position at the bank to devote all his time to editing a humorous weekly magazine, *Rolling Stone*. When this venture failed,

he moved to Houston in 1895 and began to write editorials and short stories for the *Post*. Ordered to stand trial for alleged embezzlement of funds at the First National Bank of Austin, he fled to Honduras, but later returned and was imprisoned. While in the federal penitentiary at Columbus, Ohio, Porter began to write short stories under the pseudonym "O. Henry." In 1902, upon his release from prison, he went to New York, where he died in 1910. His reputation as perhaps America's greatest short-story writer is undimmed to this day.

The Houston *Post*, which published Porter's work before he was "O. Henry," was founded in 1880 by Gail Borden Johnson, who in 1881 combined it with the old Houston *Telegraph and Texas Register*. Financial difficulties caused the paper to suspend publication briefly in 1884, and the next year a merger of the *Morning Chronicle* and *Evening Journal* resulted in the present Houston *Post*. Edited by R.M. Johnson, the newspaper employed a number of writers just commencing their careers who later became justly famous. Among this group was Marcellus E. Foster, later associated with the Houston *Chronicle*, and William Cowper Brann. Brann was briefly an editorial columnist for the *Post* before moving to Waco, where he founded the monthly *Iconoclast*,

Dr. Ashbel Smith (1805-1886) was made superintendent of the Harris County schools in 1874. Among his various accomplishments, Dr. Smith had been minister to France, president of the board of examiners at West Point, and a legislator from Harris County. From Cirker, Dictionary of American Portraits, Dover, 1967

which sought to combat "hypocricy, intolerance, and other evils." Brann, a bitter, sarcastic critic of the Baptist faith, was shot to death in Waco in 1898 as he prepared to depart on a lecture tour.

As well as being a time of initiative in the literary realm, the last quarter of the century was also a time of expansion for theater and opera in Houston. Shakespeare was represented by *Romeo and Juliet, Julius Caeser,* and *Othello,* but certainly the highlight was the appearance of Edwin Booth in *Hamlet* at Pillott's Opera House. Playing in Houston on February 23, 1883, the engagement had been sold out for months before Booth's arrival. On the day of the performance, disappointed ticket-seekers were offering as high as $20 for seats that had originally sold for $2. The drama critic for the Houston *Post* noticed that Booth's diction was "clear and incisive . . . moreover, he invested the role with an air of fascinating wildness and awe-inspiring mystery." Two women with somewhat lively reputations also adorned the Houston stage at this time. On April 19, 1888, Mrs. Lilly Langtry appeared in a one-night presentation of *A Wife's Peril* at Pillott's Opera House. The local reviews

were hardly complimentary both as regards her acting ability and her much-heralded beauty. On February 4, 1891, Sarah Bernhardt graced the stage before an audience of almost 2,000 in *La Tosca,* but once again Houstonians professed themselves disappointed. Many patrons left before the play was half over, and the ubiquitous *Post* critic observed that while her performance drew generous applause, there was nothing "wild and uncontrollable" about her actions.

In 1901 the famed Metropolitan Opera paid its first visit to Houston and performed *Lohengrin,* featuring Ernestine Schumann Heink as Ortrud. The company appeared in the Winnie Davis Auditorium, a hall located on the southern edge of town at the corner of Main and McGowen that opened in 1895 and was named for a daughter of the former Confederate President. Other famous personalities who entertained Houstonians at this time included the celebrated Oscar Wilde, who lectured on "aestheticism" at Gray's Opera House on Fannin Street on June 23, 1881. The Young Polish pianist and future president of his nation, Ignace Paderewski, was wildly cheered by his Houston audience on January 31, 1896. Paid the then remarkable sum of $2,500 for one night's concert at the auditorium on McGowen Street, the "wizard of the piano" did not disappoint his listeners.

One more person of note came to the city at this time, though not in the entertainment field. On March 29, 1880, some 5,000 residents of the Bayou City turned out to welcome ex-President Grant. The bitter memories of the Civil War must have been at least temporarily forgotten, because the former Union commander received a tumultuous reception when he arrived on the first train to enter the new Union Station. A large crowd followed Grant's party to the Hutchins House on Franklin Street, where the balcony almost collapsed under the weight of those who sought to shake hands with the distinguished guest. At a reception held later in the day, Grant, who seemed genuinely affected by the obvious good will of the crowd, said:

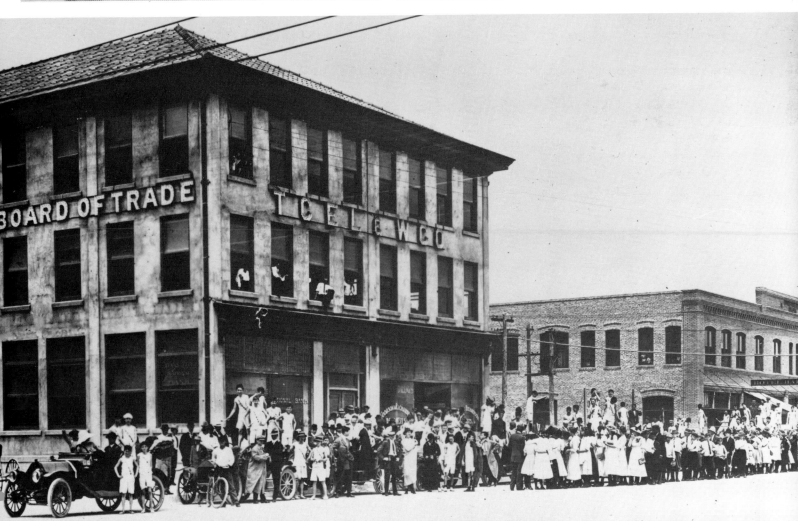

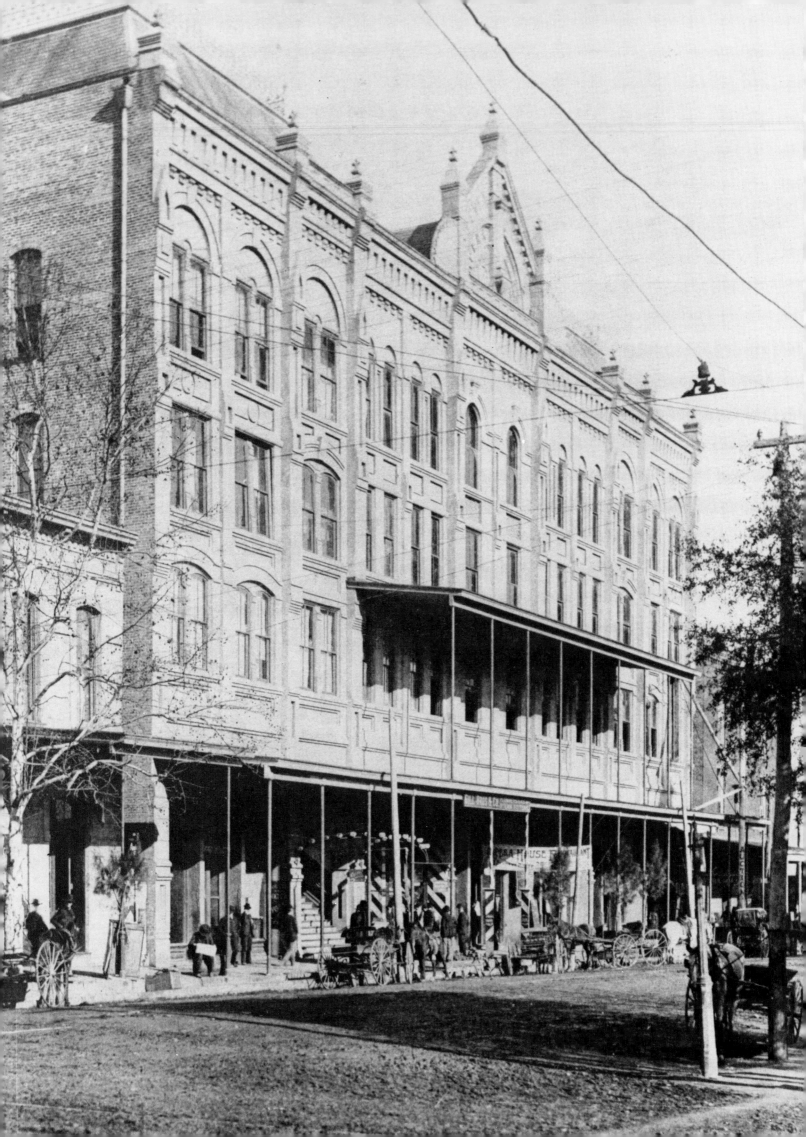

In regard to the receptions which have been tendered me elsewhere throughout the circle of the globe, I can assure you that none go nearer to my heart than those given me by my own countrymen. Especially is this gratifying in a section of the country that was so recently in conflict with us. I agree in the sentiment that we are a happy and united people, and it would take a stronger power than any one man now in existence to separate us. United as we are, we are the strongest nation on earth.

The "strongest nation on earth" would again become embroiled in war before the century's end. The controversy with Spain that culminated in the Spanish-American War at first occasioned little interest on the part of Houstonians. However, all of that changed when the USS *Maine* sank in Havana harbor on the evening of February 15, 1898. Two days later flags atop the post office and City Hall were flown at half-mast in honor of those who had lost their lives when the ship blew up. Within a week, a 30-ton cannon intended for the protection of Galveston was being closely guarded at the Congress Avenue depot of the Interna-

tional & Great Northern Railroad.

On San Jacinto Day, April 21, a pyrotechnical representation of the sinking of the *Maine* was staged, and four days later, when Congress declared war against Spain, the Bayou City was prepared to contribute to the war effort. Adjunct General W.H. Mabry of the Texas Volunteer Guard ordered all military companies in Houston to prepare for service and on May 4 the Light Guards and the Emmet Rifles departed for Austin. A recruiting station was opened at 209 Main Street and Camp Tom

Facing page:
Built on the site of the old Gray's Opera House, the Sweeney and Combs Opera House of 1890 was to be the "neatest and prettiest opera house in the South." The owners spent $30,000 on a structure that would give new life to the Houston stage in the 1890s. In 1904 the theater was destroyed by fire. Courtesy, Harris County Heritage Society; Litterst-Dixon Collection

Above left:
This vision of Houston 50 years in the future was published in the Houston Chronicle of October 14, 1902. It represented the view based on the best available understanding of technology. The artist saw a city with 20-story skyscrapers and a bayou that had been widened to allow visits from ocean liners. Transit would be either by rail or omnibus. In some respects the city did parallel the artist's vision, for the tall buildings were not built until some years after 1902, and liners did come up the bayou. Transit did not exist in 1952, however. Courtesy, Harris County Heritage Society; Litterst-Dixon Collection

Left:
In the late 19th century, prominent Houstonians often joined military units, particularly the Houston Light Guard. During its 1888 summer camp, the group assembled for its photograph. Missing people and leaders caught in certain distinct positions were added after the fact in this unique image of the group in dress uniform. Courtesy, Texas Room; Houston Public Library

Texas German Gazette,

(DAILY AND WEEKLY.)

69 Main Street. Houston, Texas.

HUGO LEHMAN, Propr.

CIRCULATES EXTENSIVELY IN THE CITIES OF HOUSTON, GALVESTON, AND IN THE GERMAN SETTLEMENTS OF THE WHOLE STATE.

IN COMPARISON TO CIRCULATIONS OUR ADVERTISING RATES ARE THE MOST REASONABLE OF ANY PAPER IN THE STATE.

SPECIMEN NUMBERS SENT ON APPLICATION.

For Advertising, Subscription and Club Rates, address

Texas German Gazette,

HOUSTON TEXAS

THE TELEGRAM
Has the Largest Circulation of any Paper published in Houston.
ADVERTISING AT LOW RATES.

Mr G. W. Collins

To TELEGRAM PUBLISHING COMPANY, Dr.

No. 111 CONGRESS STREET.

To Subscription to DAILY TELEGRAM, from 1st June 1880

to Sep 12 1880 $ 2.00

Received Payment,

Telegram P Co Agent.

SUBSCRIPTION:
DAILY, per Month 75
" per Year $8 00
WEEKLY, per Year 1 50

HOUSTON, TEXAS. Oct 10 1881.

Mr. G. W. Collins

To HOUSTON DAILY POST, Dr.

GAIL B. JOHNSON & CO., PROPRIETORS.

TERMS STRICTLY CASH.

To Adv. 6 ms in Daily Post 1.80

Paid Gail B Johnson & Co

Facing page:
The Centennial Beer Garden and the Moss Rose Saloon provided entertainment and alcoholic beverages to Houston residents and visitors in the 1880s. Most beer gardens were family oriented and reasonably priced. Courtesy, Harris County Heritage Society

During the mid-19th century, Houston attracted a substantial German community. Individuals and families who would contribute a great deal to the community, such as the Ruppersburgs and Meyers, found the German-language press to be an important part of their life. The merchant community also found this press a valuable aid in reaching markets across the state. Courtesy, Harris County Heritage Society

Houston newspapers, such as the Daily Telegram, were used by advertisers to circulate information about their products and businesses to the shopping area around Houston. As the major entrepôt for the region, the city had many merchants who advertised newly imported wares and thus gave business to the papers that would carry the news. Courtesy, Special Collections; Houston Public Library

On February 19, 1880, Gail Borden Johnson, grandson of the founder of the Telegraph and Texas Register created a paper that would be among the longest lived of Houston newspapers, the Houston Daily Post. Although Borden left the paper in 1884, it survived and merged with other papers. It has been owned by a number of notable Houstonians including two former governors of Texas, Ross Sterling and William P. Hobby. Courtesy, Special Collections; Houston Public Library

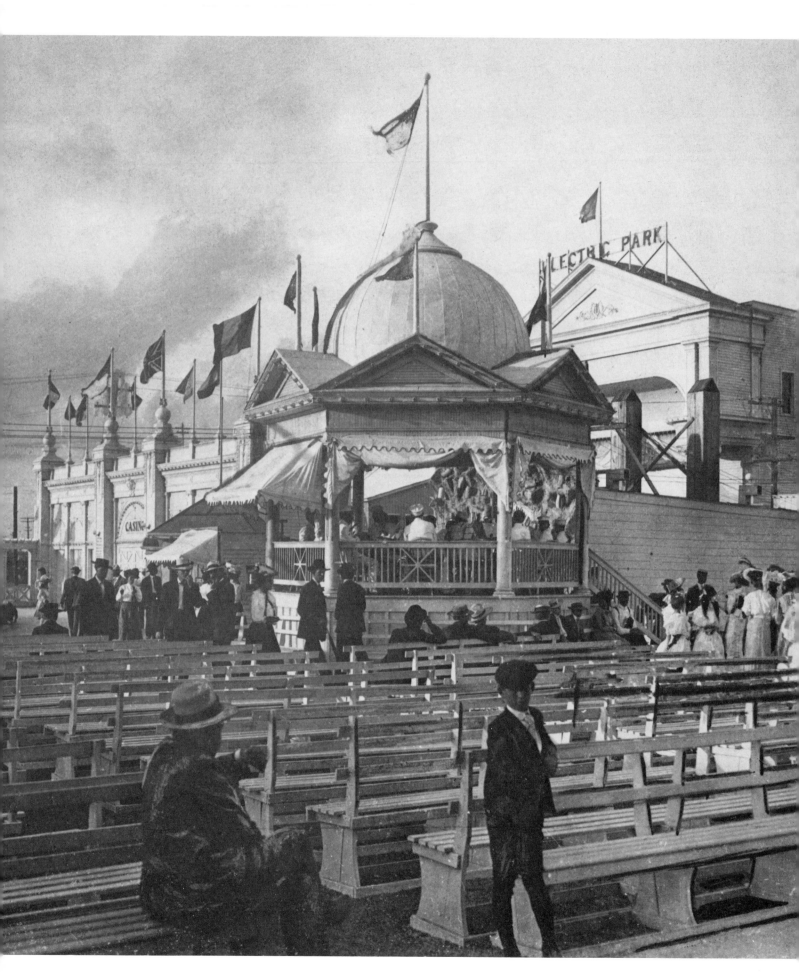

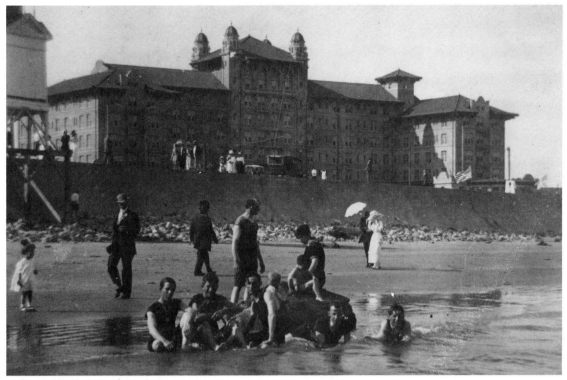

Facing page:
One of the great amusement centers of Galveston before the 1900 storm was Electric Park. Visitors to the beach were fascinated by the exhibits and activities associated with this park powered by the wonder of the age, electricity, which was introduced to Houston in 1884. Courtesy, Rosenberg Library

Left:
In the early 20th century, Houstonians found the attractions of the beaches and hotels, such as the Galvez on Galveston Island, to be a tempting escape from the Houston summer heat and humidity. Courtesy, Rosenberg Library

Ball was established at Forest Park, just east of Heights Boulevard. Perhaps the high point for the city was reached when on the night of May 30, Colonel Theodore Roosevelt and a trainload of his "Rough Riders" stopped over in Houston for six hours. Queried by a reporter for the *Post*, the future President confessed his impatience at the indefinite state of hostilities and his desire to "get some action." The "splendid little war" was concluded so rapidly that few Houstonians were actually able to serve.

From the time of its founding in 1836, the history of the city of Houston had been shaped by its rivalry with Galveston. In fact, the Allen brothers turned their attention to Houston only after first failing to secure title to a tract of land that later became the center of the settlement at Galveston. Although Galveston enjoyed natural advantages as a port and harbor, interest in a ship channel to give Houston direct access to the sea had begun even before the Civil War. During that conflict Galveston was captured and temporarily occupied by the Union, while Houston escaped unscathed. In the period after the war, Houston began to develop its potential as a port and to forge ahead as a railroad and trading center and, at

the turn of the century, Houston was beginning to emerge as a lumber and oil distribution center as well. The vision and foresight of Houston businessmen would have assured dominance for Houston in this intercity rivalry, but the terrible Galveston flood of 1900 hastened that process.

As early as September 4, 1900, the United States Weather Bureau at Galveston posted telegraphic bulletins to the effect that a "tropical cyclone" was moving westward in the Gulf of Mexico. Such warnings at that time of year were hardly novel and, unfor-

With music provided by a small chamber group on the balcony, the group dining in the outside dining area at the Brazos Hotel was capable of dealing with the extremes of the Houston summer. Courtesy, Harris County Heritage Society; Litterst-Dixon Collection

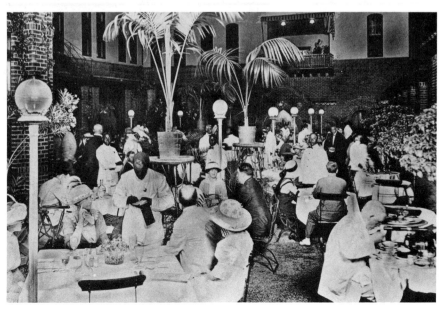

tunately, little attention was paid to them. By September 7, the surf had become too dangerous for bathing and the full fury of the storm hit on September 8. The entire city was under from one to five feet of water by 4 p.m. and by 5:30 all connections with the mainland had been destroyed. The climax of the storm was reached about 8 p.m. when the wind, blowing at an estimated 120 miles per hour, shifted from east to southeast and a tidal wave about six feet high swept across the city. After midnight the wind died down, although in the interim an estimated 6,000 persons had died and half of Galveston had been destroyed.

In the wake of Galveston's disaster, the tendency that had begun in the period after the Civil War whereby Houston emerged as the leading city in the Gulf Coast area was now complete.

As the 19th century drew to a close, Houston could boast electric lights, telephones, paved streets, and many other "wonders." It had 210 manufacturing plants, one stock-and-bonds house, and a population of almost 45,000. The 200-room Rice Hotel, a five-story structure, was still the tallest building in town and the largest hotel. The mayor and City Council pointed with pride to the fact that Houston was the

largest railroad center in the country south of St. Louis, the second-largest manufacturing center in Texas, and the second-largest city in bank clearings in the South, exceeded only by New Orleans. Now a major factor in the cotton, lumber, and rice industries in Texas, Houston was on the verge of realizing two principal reasons for its phenominal growth in the 20th century—the discovery of oil and the attainment of a deep-water port.

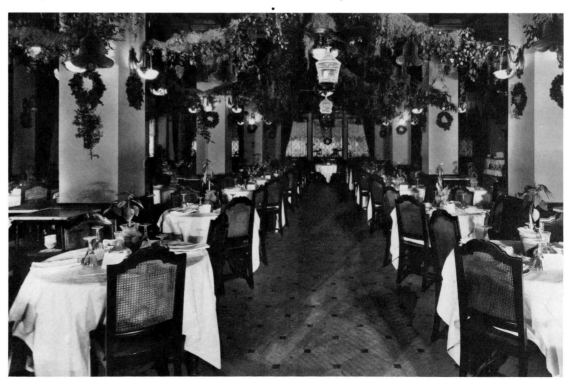

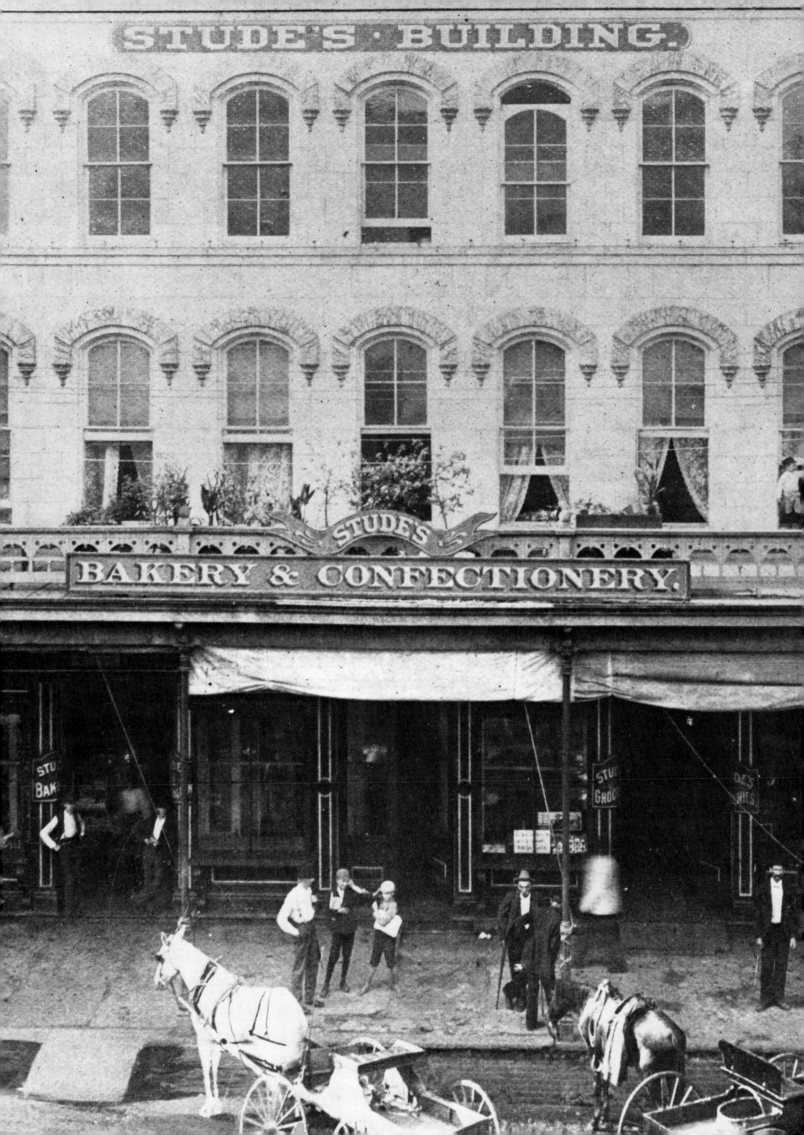

In the years before World War I, a number of notable breweries flourished in Houston. Locals such as these two delighted in the products of the Magnolia and Southern Select breweries, which helped to keep one cool on a hot summer day. Courtesy, Harris County Heritage Society; Litterst-Dixon Collection

Houston took many years to develop a professional police force. Beginning with constables in 1838, the force had an inconsistent tradition until the post-Civil War period, when it became professionalized. By the early 20th century, the officers of the force had begun to develop into a professional body that could protect the growing city. Courtesy, Harris County Heritage Society; Litterst-Dixon Collection

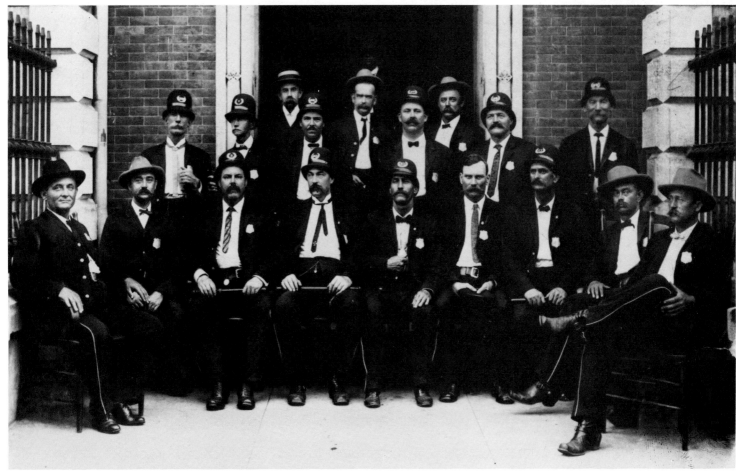

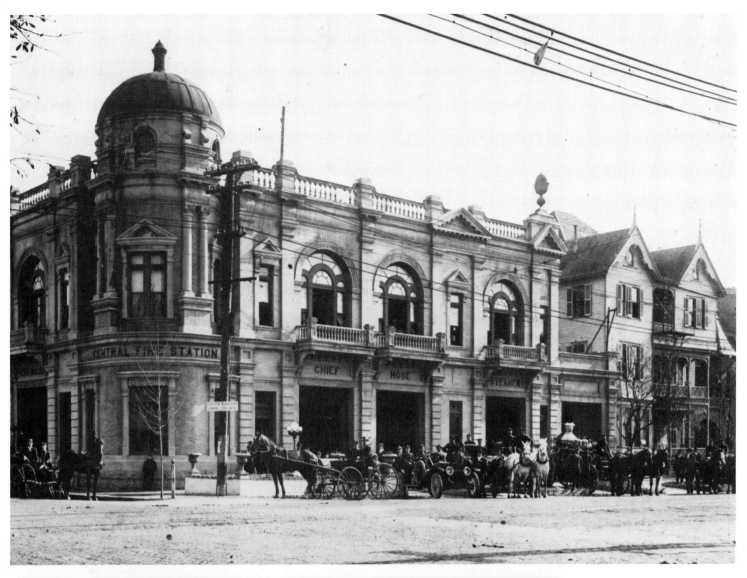

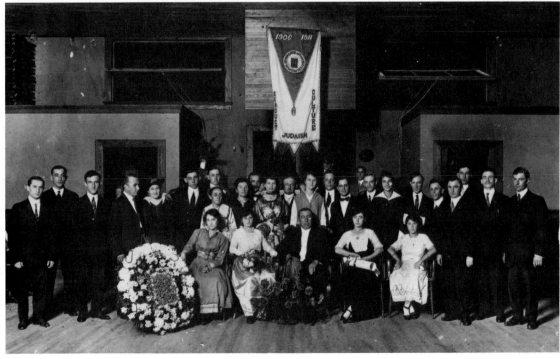

Above:
Houston was served by a
volunteer fire unit from 1836
until 1895, at which time civic
leaders instituted a professional
fire service. The Central Fire
Station housed both motorized
and horse-drawn equipment
during the era of World War I.
As the city changed, however,
the horse-drawn equipment was
phased out. Courtesy, Harris
County Heritage Society

Left:
For Houstonians in the years
before World War I, literary,
musical, and artistic societies
were an important part of life.
At a 1915 meeting, members of
the Jewish Literary Society fete a
visiting author. Courtesy, Harris
County Heritage Society;
Litterst-Dixon Collection

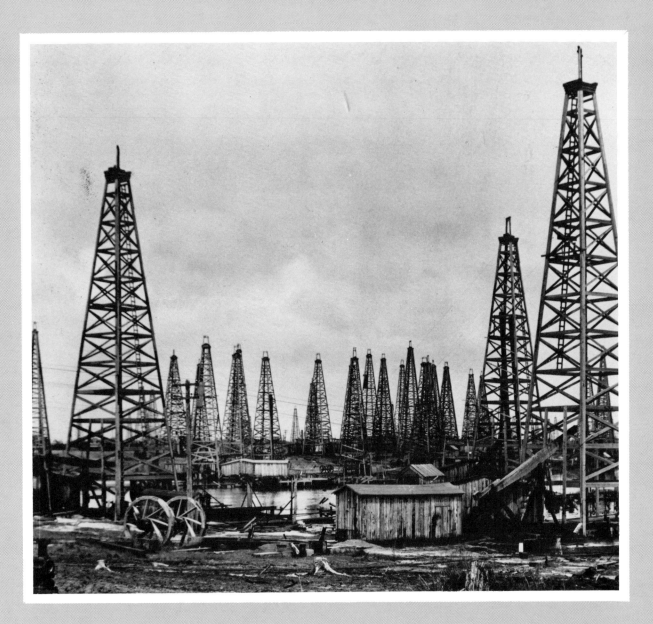

Although oil was first developed in the Spindletop fields, drilling moved closer to Houston as oil was discovered in Harris County at sites such as Humble and Pierce Junction. In the 1920s the derricks of the Pierce Junction Field could be seen from downtown Houston. Courtesy, Texas Room; Houston Public Library

ENERGY CAPITAL AND DEEP-WATER PORT

The earliest written account of the use of petroleum in North America dates from a stormy day in July 1543, when Spanish ships, returning the few survivors of the unlucky De Soto expedition back to Mexico, sought shelter along the Texas Gulf Coast. In the area of Sabine Pass the travelers sighted a dark, thick liquid floating on the water, and they used this substance to reinforce the bottoms of their ships. In fact, the Indians already knew of the existence of petroleum. The Karankawas visited oil springs along the Texas coast seeking their curative powers. The Indians immersed themselves in the springs to combat rheumatic pains and also applied the oil as a salve to cuts, burns, and sores. The narratives of the French and Spanish explorers in Texas touch on the location of various oil springs, and in the early colonial period of Texas history American settlers recorded oil "seeps" in Sabine, Shelby, Nacogdoches, Anderson, and Bexar counties.

Attempts had been made to drill an oil well in Texas before and during the Civil War, all of which resulted in failure. However, the Pennsylvania oil discoveries in the postwar era stimulated interest in further Texas exploration. Perhaps the mystique and allure of the search for oil has never been so graphically stated as in this letter to George W. O'Brian of Beaumont from a former Confederate comrade-in-arms, writing from Liberty, Texas. The letter is particularly in point since oil would ultimately be found in both the environs of Liberty and Beaumont:

. . . if we are prepared for the excitement, we will make our fortune. What is the use of toiling with aching brains and weary hands for bread, when gold so temptingly invites you to reach out and clutch it?

There were some minor wells drilled in Central Texas at Brownwood in 1878 and Greenvine, Washington County, in 1879. Rumored strikes in the neighborhood of San Antonio and Corpus Christi intensified the search for oil, which culminated in the first significant discoveries at Corsicana

in 1894. In his landmark work, *Oil! Titan of the Southwest,* Carl Coke Rister refers to the Corsicana field as the "curtain raiser" of the oil boom in the Southwest. Certainly drilling techniques and marketing strategies employed there for the first time were later utilized at the oil strike that ushered in the modern age of petroleum. In 1894 an artesian well company engaged in drilling for water at Corsicana hit an oil sand at 1,030 feet. Although located almost 200 miles north of Houston, what transpired at the Corsicana field was to be of vital concern to the Bayou City. In its first year of production, output from five wells constituting the Corsicana field totaled 1,450 barrels of oil; by 1900, 836,000 barrels were produced annually. However important the Corsicana discovery was, though, it served primarily as the forerunner of the Spindletop field at Beaumont.

Whereas at Corsicana oil was discovered accidentally while drilling a water well, Spindletop at Beaumont derived from the expertise of a trained mining engineer working with the theory that petroleum should accumulate around a salt dome. In 1892 Patillo Higgins, a young Beaumont businessman, had abandoned a projected well near that city at 300 feet because he was unable to drill through quicksand. Near despair and virtually at the end of his financial resources, in 1899 Higgins accepted Captain Anthony F. Lucas as a partner in the Gladys City Oil, Gas, and Manufacturing Company. For some years Lucas had worked with salt domes in Louisiana, and his experience persuaded him that oil would be found in the vicinity of the large salt dome known as "Spindletop." Also, Lucas was familiar with the problems of drilling in quicksand, an asset that proved invaluable at Spindletop. By now Higgins had sold all his drilling rights to Lucas, retaining only a small royalty percentage on the land.

Raising the necessary capital to finance the exploration proved an almost insurmountable task. The popular geological wisdom was that Lucas would fail. Virtually all available capital was depleted in an unsuccessful well abandoned at 575 feet,

but Lucas was determined to persevere. He took a small bottle of oil from the unsuccessful well and headed east seeking assistance. In Pittsburgh he convinced the wildcatting firm of Guffey & Galey, in fact a front for the Mellon interests, to take an interest and provide the working capital.

Drilling commenced on the Lucas lease in the fall of 1900, and as the year closed success still seemed far away. However, on the cold, clear, midmorning of January 10, 1901, the fantastic "Lucas gusher" at Spindletop blew in. Caldwell Reines described the famous event in *Year Book for Texas, 1901:*

At exactly 10:30 a.m., the well that made Beaumont famous burst upon the astonished view of those engaged in boring it, with such a volume of water, sand, rocks, gas and oil that sped upward with such tremendous force as to tear the crossbars of the derrick to pieces, and scattered the mixed properties from its bowels, together with timbers, pieces of well casing, etc., for hundreds of feet in all directions.

For nine days the phenomenon was the wonder and puzzle of the world. It flowed unceasingly and with ever increasing force and volume until when it was finally controlled it was shooting upward a tower of pure crude oil, of the first quality, quite two hundred feet, and spouting in wanton waste 70,000 barrels of oil per day.

In fact, for nine days Spindletop drenched the surrounding countryside with 70,000 to 100,000 barrels of oil daily; the largest flow from any previous well drilled in the United States had 6,000 barrels. Also, Spindletop was then the largest producing well in the world outside the Baku field in Russia. Certainly no single event in the first half of the 20th century gave such a prod to the modern industrial development of Texas and Houston as did Spindletop. Three major companies that were founded in Beaumont shortly after the Spindletop discovery—the Texas Company (later Texaco), Gulf, and Humble—later relocated their principal offices in Houston.

The original architect of the Texas Company, Joseph S. Cullinan, had been active in the Corsicana discovery. There he had organized J.S. Cullinan and Company, the first pipeline and refinery company in Texas, and in order to increase local consumption, introduced two new applications for oil: as a dust-settling device for streets and as a fuel for locomotives. He moved to Beaumont in 1902 and organized a $50,000 corporation named the Texas Fuel Company. Then, with financial backing from ex-Governor James Hogg, the notorious Wall Street speculator John W. "Bet-A-Million" Gates, and others, the Texas Company was chartered with assets of $3 million on May 1, 1902. The new corporation succeeded to the properties of the original Texas Fuel Company, among which were a number of leases secured near the original site of Spindletop. Almost immediately after its reorganization the Texas Company began to expand its operations. Subsidiary companies were utilized for production, and pipelines were laid to Port Arthur, Houston, and New Orleans. New leases were actively pursued, and in 1901 the Sour Lake discovery, 25 miles northwest of Beaumont, provided the corporation with its first bonanza.

Joseph Cullinan, who had learned the oil business in Pennsylvania, moved to Texas in 1897 to organize the first pipeline and refinery in Corsicana. Organizing the Texas Company in Beaumont in 1902, he brought his firm's headquarters to Houston in 1905 and in the process he established Houston as the executive headquarters of the American oil industry. Courtesy, Texas Room; Houston Public Library

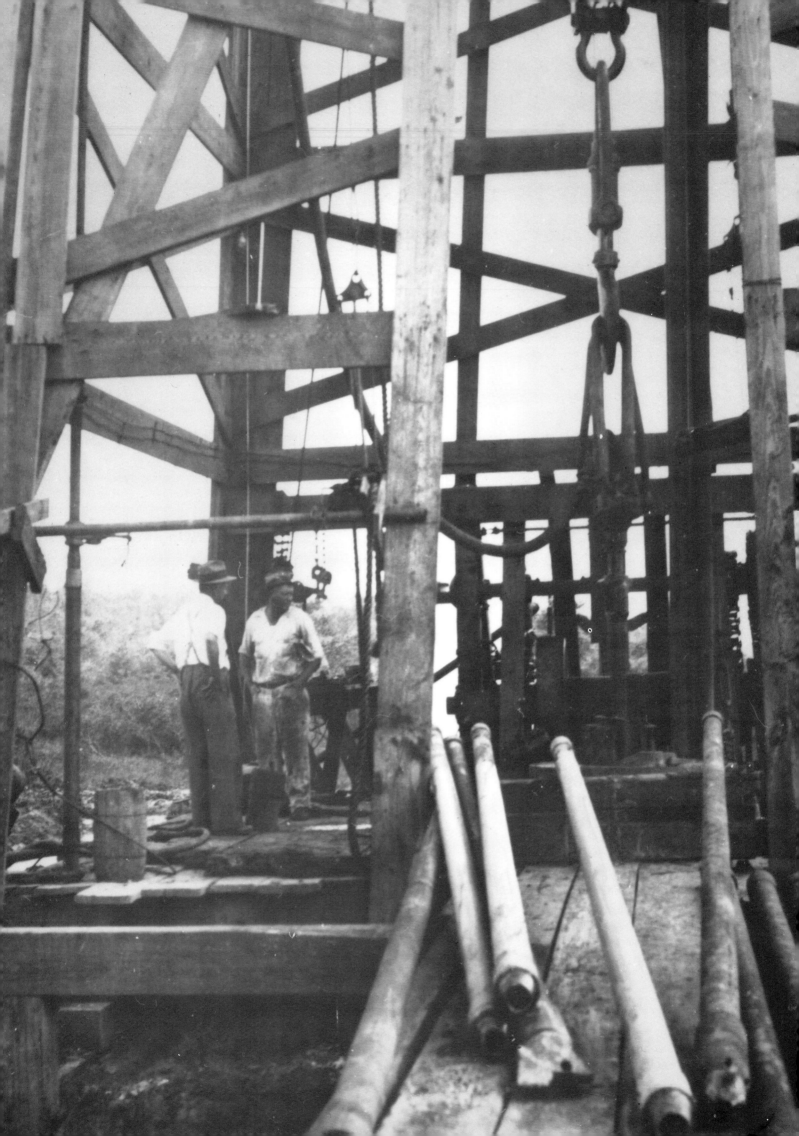

This was followed in 1905 by a major strike at the Humble field, just northeast of Houston in Harris County. Early in 1905 the first refinery was built at Port Arthur, and in 1908 the headquarters of the Texas Company were moved from Beaumont to Houston. The Sour Lake and Humble discoveries in the environs of Houston and the Bayou City's access to tidewater within the pipeline system of the Texas Company made such a move sensible. In February 1905 Cullinan wrote to a business associate, "Houston seems to me to be the coming center of the oil business for the Southwest." Relocating the main office of the company in Houston marked the beginning of the city's place as the executive headquarters of the oil industry in the Southwest. (The Texas Company moved its headquarters to New York in 1913 and its name was changed to Texaco in 1959.)

The modern-day Gulf Oil Corporation also stems from the discovery at Spindletop. An outgrowth of the J.M. Guffey Petroleum Company, which was organized in May 1901, the company has conducted operations in Houston since 1916. With financing provided by the Mellon interests in Pittsburgh, the Gulf Refining Company of Texas was created with interests acquired from Captain Lucas of the Spindletop field. In January 1907 the Gulf Oil Company was formed with A.W. Mellon as president and Guffey's interest was purchased for some $3 million. A 400-mile pipeline was then constructed from Port Arthur to the Glen Pool field in Oklahoma, discovered in 1906, and the refining of Oklahoma crude began the next year. By 1928 the company's assets had grown to an estimated $232 million, while crude production rose to 78 million barrels annually from operations throughout the U.S. and in several other countries.

Another corporation, the Humble Oil and Refining Company, was founded by William Stamps Farish and Robert Lee Blaffer, who met in an oilmen's boardinghouse in Beaumont in 1902. Farish, an attorney, and Blaffer, then working for the Southern Pacific Railroad, joined forces in 1904 to form a drilling partnership. The

Facing page:
Tri-Fin Oil Company's Moers No. 1 Well on Chocolate Bayou in Brazoria County is typical of the wells drilled in the Houston area after the Spindletop field came in. These wells produced oil that was shipped to Houston and the refineries and docks along the ship channel to the rest of the world. Courtesy, Rosenberg Library

Left:
Andrew William Mellon (1855-1937) served as president of the Gulf Oil Company upon its formation in 1907. Painting by Oswald Birley. Courtesy, National Gallery of Art. Gift of Ailsa Mellon Bruce. From Cirker, Dictionary of American Portraits, Dover, 1967

next year they moved to Houston in order to concentrate on the nearby Humble field, where oil had been discovered in January 1905. Suddenly the little village to the northeast of Houston with a population of less then 800 was experiencing the same "boom" conditions that had characterized Beaumont after Spindletop. Real estate that had been selling at $6,400 per acre at Humble leaped to $16,000 per acre within a week's time. In three months the output of the Humble field was two million barrels and by 1906 it had produced 15,594,000 barrels of oil. Robert L. Blaffer and William S. Farish were among the most successful of the oilmen active in Humble.

In 1911 Blaffer and Farish were joined by Ross S. Sterling, a future governor of Texas, and Walter Fondren as the original founders of the Humble Oil Company. During 1911 and 1912 the company operated almost exclusively in the Humble field, which by now had begun to decline in production. In 1912 the headquarters of the company were

moved to Houston and drilling operations were started in Oklahoma. By 1917 producing properties had been added at the Sour Lake and Goose Creek fields between Houston and Beaumont. On March 1, 1917, the company was reorganized and given a new charter as the Humble Oil and Refining Company with a capitalization of one million dollars. In the new organization Blaffer and Farish merged with Schulz Oil Company, Ardmore Oil Company, Globe Refining Company, and Parrafine Oil Company, founded by Harry Weiss. In 1918 Humble received $17 million from Standard Oil of New Jersey in exchange for a half-interest in a deal that brought Humble the capital for the construction of pipelines and refineries and brought Standard Oil a reliable source of crude oil.

At its inception the Humble Oil and Refining Company represented a combination of very successful but relatively small oil producers with an ambition to form a large, "integrated company" that would produce, transport, refine, purchase, and market oil. The new company was launched at a time when the demand for oil products was on the rise, which seemed to augur success in the future. However, just a few months after its incorporation, Humble was involved in a general strike of workers in the Gulf Coast oil industry.

In the summer of 1916, prodded by the Texas State Federation of Labor and the Houston Trades Council, a local union was formed at the Goose Creek oil field. Other locals were then organized in neighboring fields and discussions were held in Houston to coordinate an overall strategy. However, the producers, among them Humble, refused to recognize the oil workers or enter into negotiations of any kind. Therefore, on October 31, 1917, some 10,000 production workers struck the Gulf Coast Texas and Louisiana fields, seeking a minimum wage of four dollars a day. Federal mediation efforts were undertaken in Houston and Washington and the strike was settled to the detriment of the workers. There was no immediate improvement in wages and hours, but the continued demand for oil and increased

prices did indirectly benefit those working in the field.

One of the most interesting developments to flow from Spindletop was the creation, in 1901, of the Houston Oil Company. Capitalized at $30 million, the company was the largest in Texas at the time of its incorporation. The Houston Oil Company acquired more than 80,000 acres of pine and timber lands in an area just north of the Beaumont-Spindletop location from attorney John Henry Kirby. A long-term timber agreement was signed between Kirby's corporation and the oil firm whereby the Kirby Lumber Company would purchase and cut timber on lands possessed by the Houston Oil Company, thus providing the Houston Oil Company with a guaranteed income from timber sales and generating additional capital for petroleum exploration.

The financing required for this complicated venture was beyond Kirby's own resources and thus he sought the assistance of Eastern capitalists. In this connection he was put in touch with a New York City corporation lawyer, Patrick C. Calhoun, grandson of the famous Senator from South Carolina. However, potential investors were wary of oil explorations in unproved locales, and adequate financing could not be secured. Then in 1913 Joseph S. Cullinan

resigned from the Texas Company because of major policy differences and turned his attention to the prospects of the Houston Oil Company.

Finally, after almost three years of persuasion, an agreement was concluded in November 1916 between the Houston Oil Company and Cullinan's Republic Production Company. The deal gave Republic Production sole rights to petroleum exploration on Houston Oil Company lands. Further, Houston Oil accepted a half-interest in any oil drilled, while conveying to Republic Production a half-interest in the 800,000 acres owned by the oil company. The arrangement was good for both companies: for Houston Oil it meant diversification and for Republic Production, capital in the form of lands in East Texas on which to seek oil.

In July 1918 Republic Production successfully drilled a well at the Hull field in Liberty County. Other discoveries were recorded at the Spurger and Silsbee fields in the East Texas counties of Hardin and Tyler. The original timberlands of John Henry Kirby continued to produce oil until after World War II, vindicating the faith of

Joseph S. Cullinan.

The coming of the oil age to Houston spawned a number of related industries. By the mid-1920s the Houston Gulf Gas Company and the Houston Gas and Fuel Company supplied the needs of homeowners and business consumers. James Abercrombie, who began as an oil field hand and then functioned as a driller-contractor at the Spindletop and Humble fields, invented a device to prevent well blowouts caused by excessive pressure. Shortly thereafter Abercrombie's old roustabout buddy, H.S. Cameron, began to mass produce the invention. In this fashion, in 1922, Cameron Iron Works, today one of the largest suppliers of heavy duty oil field equipment in the world, began operations.

The career of Howard Robard Hughes, Sr., father of the eccentric millionaire, Howard Hughes, Jr., illustrates the significance of the many oil-related industries spawned in the wake of the great boom at the turn of the century. Hughes was born at Lancaster, Missouri, on September 9, 1869. He entered Harvard in 1893, but withdrew after two years to begin the study of law at

As the public utility companies developed, so did activities that they sponsored for their employees. Baseball teams were fielded by the Houston Gas and Fuel Company and the Houston Lighting and Power Company early in the 20th century to provide recreation for employees and status for the firms. Courtesy, Harris County Heritage Society; Litterst-Dixon Collection

As the center of the Texas oil industry, Houston was home to many firms such as the Mission Manufacturing Company, which supplied the pipe, gauges, valves, and machinery necessary to pump oil from the fields of East Texas and the Gulf Coast. Courtesy, Harris County Heritage Society; Litterst-Dixon Collection

the University of Iowa. When Spindletop was brought in at the turn of the century, he was practicing with his father at Keokuk, Iowa, and had the foresight to recognize the event as the beginning of a major new industry. He immediately came to Beaumont, entered the drilling and contracting business, and for seven years moved from one field to another experiencing the peaks and valleys of oil exploration at that time.

In 1907 Hughes was active in the Pierce Junction and Goose Creek fields, but failed to complete the wells because of the inordinately hard rock formations he encountered. For some time Hughes had been aware of the industry's need for a specially designed bit that could penetrate the surface of very hard rock. Hughes, with the encouragement of his drilling partner, Walter B. Sharp, determined to design a successful rock bit. He returned to Keokuk, and within two weeks he had designed a bit with cone-shaped revolving cutters laced with rigid steel teeth. Under a heavy weight of pipe, the bit would roll on the rock at the bottom of the well, grinding and pulverizing it, rather than merely scraping the surface of the rock. In its initial test at the Goose Creek field, the bit penetrated 14 initial test feet of hard rock, which no prior equipment had been able to accomplish. This was done in the then remarkable time of 11 hours—the Hughes bit penetrated medium and hard rock surfaces with 10 times the speed of any equipment previously employed.

In 1909 Hughes and Walter Sharp organized the Sharp-Hughes Tool Company to manufacture the bit on a large scale. Sharp died in 1912 and Hughes then assumed management of the company. Later improvements of the hard rock bit and the development of bits of different design appropriate to different formations have also been patented and manufactured by the company.

By the end of 1901, more than 50 Houston industrial plants had changed over from coal to oil usage, and the first local freight train utilizing oil rather than coal was run by the Houston & Texas Central Railroad. Although few Houston attorneys had specialized in oil and gas law prior to this time, they were able to draw articles of incorporation for fledgling young firms. In rapid fashion, the Peoples Oil & Gas Company, Florence Oil Company of Houston, Southwest Texas Oil & Mineral Company, and the Twentieth Century Oil Company of Texas, among others, were chartered with high expectations. On June 6, 1901, the Houston Oil and Stock Exchange was created, one of its purposes being to protect credulous investors from sharp promoters.

With the development of the Humble field, pipelines came to Houston. The Spindletop, Goose Creek, and Humble strikes were all within a short distance of Houston. The Bayou City enjoyed certain advantages that other potential refining and wholesale centers did not—great expanses of

uncommitted land, fresh water, and, once the ship channel was built, an inland waterway secure from devastating storms like those that had crippled Galveston and Texas City.

In her definitive study, *The Port of Houston: A History,* Marilyn McAdams Sibley notes that in 1914 when deep water was finally realized, Houston became the "perennial boom town of twentieth century Texas." Already a leading cotton-trading center, the combination of the beginning of the oil age and the completion of the ship channel coalesced to shape the destiny of the city.

Like so much in the history of the Bayou City, the ever-present rivalry with Galveston acted as the spur to completion of the ship channel. In 1890 the U.S. Congress appropriated $6.2 million for the construction of jetties at Galveston. By 1896 the jetties were completed, and Galveston became a true deep-water port with a channel 25 feet deep. This constituted a threat to the operation of barges on Buffalo Bayou. As long as oceangoing ships must anchor beyond the Galveston bar to discharge or take on cargo, barges could go to Houston as well as Galveston. However, if such vessels could load and unload at the Galveston wharves, the barges would quickly be put out of business. Also, once Galveston achieved deep water, Houston's primacy as a railroad center was also threatened. If a spur to Galveston were built, Houston could effectively be bypassed.

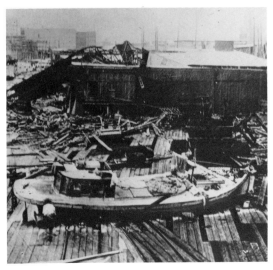

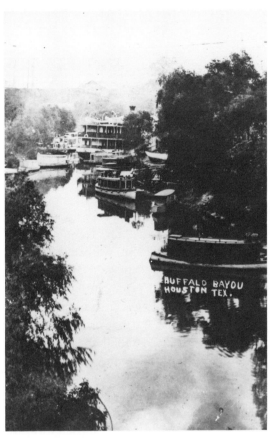

In the days before the ship channel was dredged, boats of all sizes lined the banks of Buffalo Bayou.

Just before he resigned from the United States House of Representatives in 1896, Joseph C. Hutcheson submitted a bill requesting a federal survey for a 25-foot channel to Houston. With little comment the bill carried in the House and was shepherded through the Senate by Roger Q. Mills of Texas. Then, as Congress was about to adjourn, Hutcheson set up a visit to Houston by members of the Rivers and Harbors Committee to inspect and appraise Buffalo Bayou. At this juncture, Thomas H. Ball, an attorney from Huntsville, was elected to the seat that Hutcheson had held and after meeting with a number of Houston's leading businessmen, including Thomas W. House, became an ardent spokesman for the proposed waterway.

The membership of the Rivers and Harbors Committee inspected Buffalo Bayou in February 1897. Fortunately for the city, heavy rains for almost two weeks before the inspection caused Buffalo Bayou to rise to its banks and then overflow, giving the appearance of a substantial waterway. In quick order the Rivers and Harbors Committee submitted a favorable recommenda-

In August of 1915 a storm ripped across the Gulf and into Galveston Island. Although the island was protected behind the sea wall, storm damage was still substantial, as the wreckage of the Mosquito Fleet along the Galveston wharves testifies. This storm, combined with the opening of the ship channel, played a major role in the decline of Galveston and the rise of Houston as a great port. Courtesy, Rosenberg Library

tion, with the agreement of a federal board of engineers. Colonel Henry Martyn Robert, chairman of the committee of engineers and better known as the author of *Robert's Rules of Order*, estimated that the initial construction cost of the waterway would be $4 million and that the annual maintenance would be approximately $100,000.

Selected as one of the minority Democratic members of the Rivers and Harbors Committee, Congressman Ball undertook the task of securing an appropriation for the proposed ship channel. The Republican administration of President William McKinley saw little political advantage to be gained by the appropriation and spokesmen for Galveston interests were also not encouraging. However, the terrible Galveston storm of September 1900 strengthened Ball's case and worked to the advantage of Houston by pointing up the desirability of an inland port protected from the sea. Thus in the same bill that allotted funds to restore Galveston to its pre-storm condition, an appropriation of one million dollars was granted to begin work on the waterway from Houston to the Gulf of Mexico. The plan was finalized on June 13, 1902, when President Theodore Roosevelt signed the bill making the appropriation.

Work on the channel began almost immediately but proceeded at a snail's pace. Continued funds proved hard to come by, and in March 1905 Congress modified the project by locating the turning basin of the channel at Long Reach, just above Harrisburg. The turning basin was almost five miles away from the foot of Main Street, where the Allen brothers had originally planned the head of navigation, but the Long Reach site was incorporated into the City of Houston in 1926. By 1907 the channel had been dredged to 18.5 feet, but the work languished once again as appropriations from the federal government were reduced.

The year 1910 proved critical to the ultimate completion of the project. In December of that year a delegation headed by Mayor Horace Baldwin Rice journeyed to Washington and requested an appearance before the Rivers and Harbors Committee. There they unveiled the Houston Plan by which the city consented to pay half the cost of a 25-foot channel from Bolivar Road to the Turning Basin. The proposal was accepted on the basis of a cost estimate of $2.5 million and the new terms were approved by Congress on June 25, 1910. The Bayou City's offer was unique, since before this time no substantial sharing contributions had ever been made by local interests. However, since that time no major project has been consented to by the federal government without assurances of local participation and guarantees that waterfronts would be publicly owned.

A bill was then introduced and passed in the state legislature enabling Harris County to create a navigation district encompassing the entire county and to put to a vote a bond issue of $1.25 million. Governor Thomas M. Campbell enthusiastically signed the bill and on January 10, 1910, the citizens of Harris County authorized the bond issue providing for the creation of the Harris County, Houston Ship Channel Navigation District. The bonds, which proved difficult to market, were eventually purchased by a number of Houston banks. Jesse H. Jones, by now a leading Houston

A nephew of William Marsh Rice, Horace Baldwin Rice was one of the mayors who led the way to Houston's development in the early 20th century. Serving from 1896 to 1898 and then from 1905 to 1913, Rice played a role in developing the city parks and encouraging city planning. During his term the city acquired the waterworks. Rice also helped to develop the ship channel. He had served as mayor under the alderman system and then became the first commission mayor of Houston. Courtesy, Texas Room; Houston Public Library

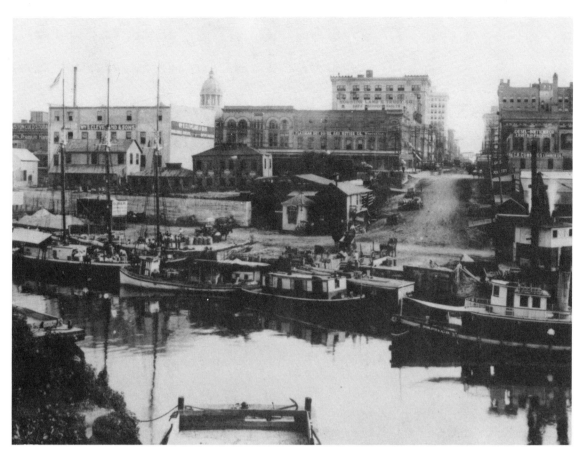

businessman, was influential in convincing the bankers to purchase the bonds and thus guarantee completion of the project. In 1913 the citizens of Harris County sanctioned another $3 million in bonds for port improvements and the City Council created a harbor board to administer the affairs of the port. In 1922 the city group was merged with a district board to establish a Port Commission with authority to acquire wharves and other properties for the improvement of the ship channel.

The 1910 and 1913 bond issues assured completion of the 51-mile ship channel. Twenty-four dredges were at work in the Turning Basin section by January 1913, and a year later the channel was dredged to a depth of 25 feet, with a bottom width of 100 feet. Houston now truly could boast of a link to the sea. In September 1914 the *William C. May*, a four-masted sailing ship, touched at the Clinton docks with a cargo of iron pipe. The next month the *Dorothy*, drawing almost 20 feet of water, delivered 3,000 tons of anthracite coal, also at Clinton.

The Houston Ship Channel was completed according to its prescribed width and depth on September 7, 1914. Although in use almost continuously from that time on, the formal dedication of the channel was on Tuesday morning, November 10. In addition to Mayor Benjamin Campbell and other city and county officials, Governor Oscar B. Colquitt, Governor-elect James E. Ferguson, and Lieutenant Governor-elect William P. Hobby were also present. Then President Woodrow Wilson, employing remote control, fired the cannon that heralded the opening of the new port. A few seconds later Sue Campbell, daughter of the mayor, threw a wreath of white rose petals into the waters of the Turning Basin, and the Port of Houston was christened. To complete the ceremonies, a band played the "Star-Spangled Banner" from a barge floating in

The mayor's daughter, Sue Campbell, participated in the dedication of the Houston Ship Channel on November 10, 1914.

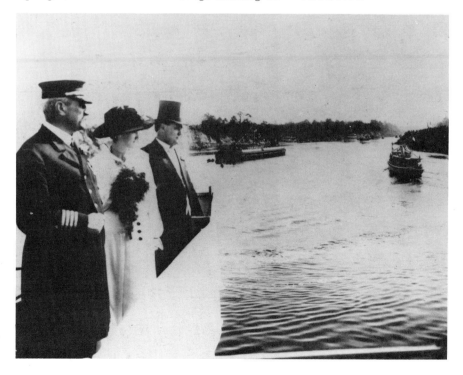

the center of the Turning Basin, and a 21-gun salute was fired by the United States revenue cutter *Windom*. In the evening the celebration was continued downtown with a "Ships of All Nations" parade; an exact replica of the battleship *Texas*, escorted by a company of sailors and marines, was the demonstration's highlight. The completion of the ship channel assured Houston's continued and increasing economic growth. Before the end of 1915, a number of ships were sailing regularly between Houston and North Atlantic ports and in the first year of the port's operation, almost 87,000 tons of freight passed through the city's docks.

There was certainly much cause for celebration in 1914. Two other major projects were finished in that year: the Gulf Intracoastal Waterway and the Panama Canal. The Gulf Intracoastal Waterway had been envisioned by Texans even earlier than the ship channel and was first approved by the federal government in 1873. It linked the Houston Ship Channel with a canal that ran some 200 miles below Galveston, thus further boosting Houston as a port city. The Panama Canal gave Gulf ports access to the Pacific and entree to the markets of the Far East.

However, at the start of World War I in Europe, Houston experienced a decline in trade, as did the rest of the nation. In late September 1914 the Houston *Post* noted that the crisis had caused more than a $58-million decrease in United States exports. At the outset of the fighting, Great Britain had placed cotton on the contraband list with negative results for Houston's economy. Since 1914 was the year that the city obtained deep-water status and the ship channel was completed, the new figures were all the more disappointing. Actually, the amount of overall trade through the Port of Houston declined by almost one-half, while cotton fell off by one-third. However, in response to political pressure exerted by Texan and other Southern Congressmen, and their own need for cotton, the British soon took the commodity off the contraband list. When the United States declared war against Germany on April 6, 1917, cotton was selling at $21.25 a bale, close to an all-time high. Prices of other staple products also rose dramatically.

While some discontent was expressed with the amount of business transacted by the Port of Houston early in the war, its future growth and development were

In the years before Prohibition, Houstonians found opportunities to enjoy the products of local breweries such as the Magnolia Brewery. These party-goers were photographed about 1900. Courtesy, Texas Room; Houston Public Library

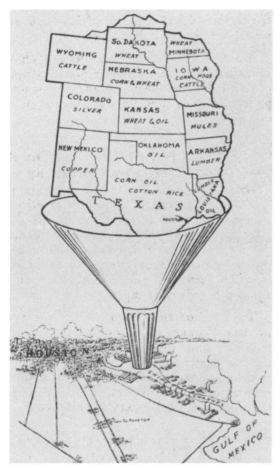

tected from storms. Abundant land and deep water made the area desirable, and refineries were assured of ample crude oil supplies from nearby fields. Because of these advantages, Humble Oil and Refining Company, Sinclair Oil Company, Empire Oil and Gas Company, and the Petroleum Refining Company either had plants in operation or purchased land along the channel route to construct refineries before the conclusion of the war in Europe.

The building of refineries and other industries along the channel led to a fundamental change in the character of business activity in Houston. From its inception in 1836, the city acted as a funnel, dealing with commodities ultimately bound for other locations. The improvement of roads and the construction of railroads that had marked the middle and late 19th century only acted to rivet this function as an intermediate trade center more closely on Houston. However, by 1918 some 22 industries had purchased sites for development below the Turning Basin and 16 above. Astute observers of Houston's economy now realized that the city would develop as an industrial as well as a distribution center. In an economic sense, the completion of the ship channel and the increased demand for petroleum fashioned the course of 20th-century Houston.

As Houston boomed in the 1920s, it became the focal point for produce throughout the middle United States. Groups such as the Young Men's Business League of Houston boosted this image with flyers and brochures encouraging everyone to share their vision of Houston. Courtesy, Special Collections; Houston Public Library

assured as a result of the conflict. The internal-combustion engine proved essential to the functions of a modern army and thus a greater demand for petroleum was created. The ship channel was a perfect location for oil refineries since it was inland and pro-

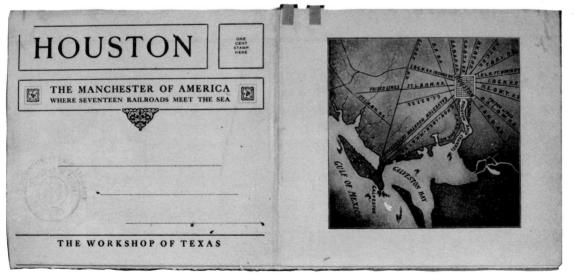

As Houston's port grew, so did the industries along the ship channel. Seventeen different railroads brought produce and raw materials to Houston and the leaders saw the community becoming a major industrial center on the Gulf. Courtesy, Special Collections; Houston Public Library

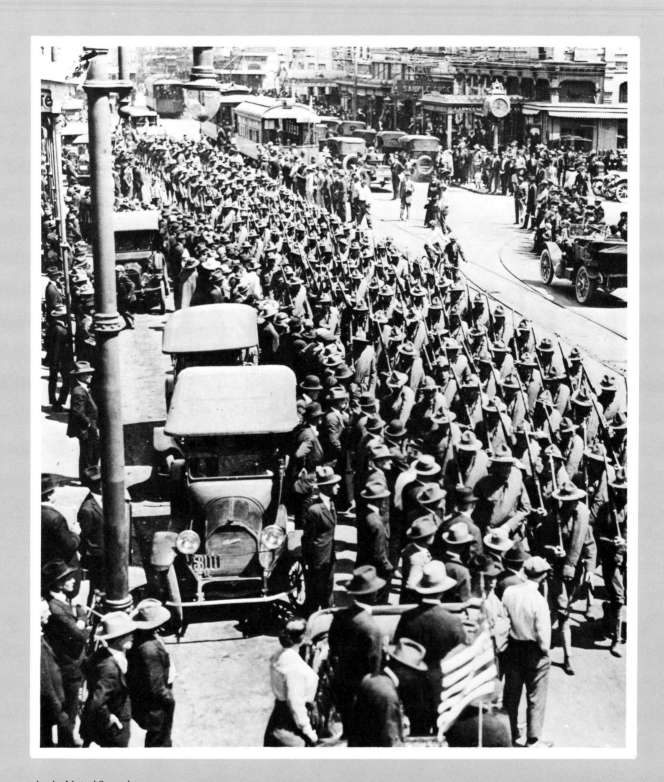

As the United States began to
prepare for World War I, it was
still defended by a small
professional army and national
guard units of the type seen here
marching down Main Street in
1915. Within two years, these
men would be fighting on the
Western front. Courtesy, Harris
County Heritage Society;
Litterst-Dixon Collection

BETWEEN THE WARS: THE BOOM CONTINUES

The assassination of the Austrian Arch-Duke Franz Ferdinand at Sarajevo on June 28, 1914, plunged the major nations of Europe into war. In less than three years the United States, the state of Texas, and the city of Houston would be deeply involved in the "war to make the world safe for democracy." Although many Houstonians adopted President Wilson's advice and remained "neutral in thought as well as deed," others were very conscious of developments in Europe. Four Texans—Albert Sidney Burleson, David F. Houston, E.M. Gregory, and Thomas M. Love—served in the President's wartime cabinet. Houstonian Edward M. House acted as Wilson's principal private advisor and would later be his chief negotiator at the Versailles Peace Conference. In the period prior to America's entry into the war, preparedness was a popular issue with most Houstonians, and eventually Camp Logan in Houston would become one of the largest military posts and training centers in the state.

The Congressional declaration of war on April 6, 1917, was popular in Houston and throughout the Southwest. The movement of troops through the city became a common occurrence and local recruiting activities were also stepped up. The old Federal Building on Fannin Street was repaired and improved for use as army, navy, and marine corps recruiting offices. The city took pride in the results of this service; by June 1917 more than 12,000 men were enrolled in local selective service registration. Also, the citizens of Houston had not been found wanting in financial contributions; Liberty Loan subscriptions added up to more than $2.5 million.

The Port of Houston was clogged with war materials being shipped to England and France. Conscious of their importance to the economy, workers were determined to share in the profits generated by the struggle in Europe. On October 31, 1917, Texas Gulf Coast oil workers, along with their coworkers in Louisiana, went out on strike demanding a wage of four dollars a day. The U.S. government quickly stationed 2,000 troops in the fields and at refineries and pumping stations to prevent sabotage. Just beyond Houston work was delayed on the construction of an airport at Ellington Field when laborers insisted on a more favorable federal government contract, and two companies of soldiers were required to restore order. There was no labor agitation on the docks during the war, but in 1920 a brief walkout against certain employers took place. In 1900 the Houston Labor Council claimed that there were 3,000 workers in the city who belonged to 41 different unions; the opportunities presented by the increased need for workers in 1917-1918 surely added to the number.

War-induced prosperity reigned in the city, and on the surface all seemed well. However, this was just the proverbial "calm before the storm."

Construction work had already begun on Camp Logan, a National Guard Training Camp situated about 3.5 miles from the center of town. The Third Battalion, 24th United States Infantry, consisting of 654 black soldiers and eight white officers, arrived in mid-July 1917 to take up guard duty at the camp. Mayor Dan M. Moody and members of the Houston Chamber of Commerce were apprehensive about these soldiers coming to Houston. They acquiesced after learning that only black troops could be spared for guard duty and that they would stay in Houston no more than seven weeks. Mayor Moody later recalled telling a friend, "the feeling that something was going to happen was in the air."

A Night of Violence: the Houston Riot of 1917, by Robert V. Haynes, is the definitive account of what followed. On Saturday evening, July 28, most of the black troops went into town for a night's diversion. A few incidents took place over the city ordinance requiring segregated seating on streetcars, but they were all peacefully resolved. However, on the following evening two platoons of the 24th, anxious to make bed check, piled on to a streetcar, only to be curtly ordered off by the conductor for violation of the segregation rule. A fight almost ensued, but cooler heads prevailed.

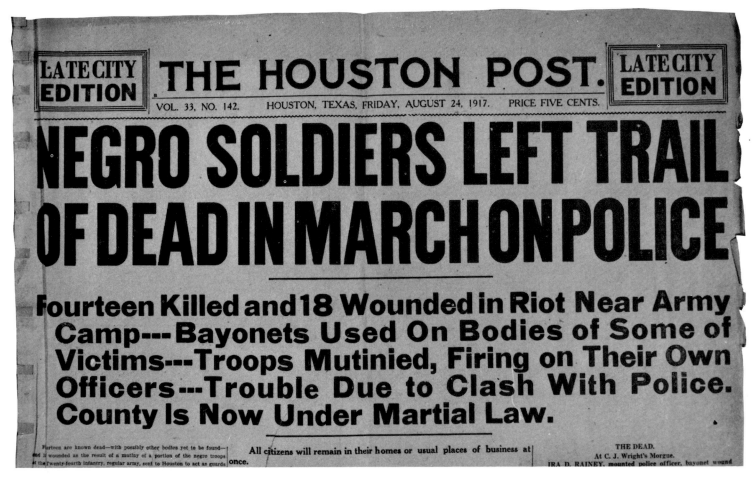

LATE CITY EDITION

THE HOUSTON POST.

LATE CITY EDITION

VOL. 33, NO. 142. HOUSTON, TEXAS, FRIDAY, AUGUST 24, 1917. PRICE FIVE CENTS.

NEGRO SOLDIERS LEFT TRAIL OF DEAD IN MARCH ON POLICE

Fourteen Killed and 18 Wounded in Riot Near Army Camp---Bayonets Used On Bodies of Some of Victims---Troops Mutinied, Firing on Their Own Officers---Trouble Due to Clash With Police. County Is Now Under Martial Law.

Fourteen are known dead—with possibly other bodies yet to be found—and 11 wounded as the result of a mutiny of a portion of the negro troops of the Twenty-fourth Infantry, regular army, sent to Houston to act as guards once.

All citizens will remain in their homes or usual places of business at once.

THE DEAD.

At C. J. Wright's Morgue.

IRA D. RAINEY, mounted police officer, bayonet wound

Following these events local police authorities met with some of the white officers and agreed on some steps: soldiers who persisted in challenging segregation would be disciplined by the military, and sidearms would be withheld from black military police. The latter step was a virtually unprecedented action, and it exacerbated the sense of alarm felt by many of the black soldiers.

Friction between Houston police officers and the soldiers precipitated the riot of August 23, 1917. It had been inordinately hot for the previous week, and on that day the temperature hit 102 degrees, increasing irritability on the part of everyone concerned. Following the arrest and beating of two black soldiers in downtown Houston, ostensibly for interfering in the detention of one of their comrades, all passes and leaves from Camp Logan were cancelled. A rumor then spread among the black soldiers that they were being confined to their quarters because a white mob was forming to march on the camp. A number of them then broke into four company supply tents and seized

arms and ammunition. Ordered to return the guns and repair to their quarters, some 100 to 125 men instead moved out of the camp. It was about nine o'clock at night when they started to march into the city. Firing at random as they proceeded on Washington Avenue, the soldiers gunned down four civilians, two of them children.

In the resulting battles with Houston police, five members of the force were killed and three black soldiers were seriously wounded. Two white soldiers were also killed while attempting to restore order. The acknowledged leader of the black troops, Vida Henry, acting first sergeant of Company I, urged the soldiers to attack the downtown police station. This they refused to do, and many returned to camp. Others sought safety in the homes of black Houstonians, where they were rounded up the next day. According to subsequent investigation, Henry refused to return to camp and took his own life; his body was discovered lying across the railroad tracks in Houston's Fourth Ward.

The cause of the Houston riot were many

On Friday, August 24, 1917, Houstonians were horrified to learn of the riot by troops at Camp Logan. Courtesy, Special Collections; Houston Public Library

and varied. City officials, anxious to secure federal contracts and not wishing to antagonize the War Department, had given little thought to protecting black troops in an alien, rigidly segregated setting. Undeniably, police brutality in enforcing segregation laws angered black soldiers. The trial records indicate that black soldiers frequently urged civilians to be more forceful in demanding their rights. It is also true that soldiers who were expected to give their lives in France to "make the world safe for democracy" would reasonably expect better treatment at home.

In the court-martial after the riot, 41 soldiers were sentenced to life imprisonment and 13 to death by hanging. The mass executions were carried out at Camp Travis, near San Antonio, in the early morning of December 11, 1917. The military authorities then conducted two more courts-martial in which 16 men were sentenced to death and 12 to life imprisonment. At this point President Wilson intervened and commuted the sentences of 10 men from death to imprisonment for life. With that action, a tragic chapter in Houston's history came to a close. As for Camp Logan, where the black troops had been stationed, it was used for hospitalization of wounded men in 1918. At the end of the war, the site was acquired by William C. Hogg and his

brother, Mike, who turned over more than 1,000 acres at cost to the City of Houston. Memorial Park, Houston's largest recreational area, is presently located on that site.

By the early spring of 1918, American troops were in action on the major battlefields of the Western Front. A number of Houstonians of the 12th Aerial Squadron, which had trained at Ellington, landed in England, and nine former members of the Houston Health Department were serving with the medical corps in France. The 33rd Division, which was made up of National Guardsmen from Illinois, was trained at Camp Logan before going to France, and in May 1918 Donald Gregg became the first Houstonian to die in action there. Before the war ended a tragic number of others were killed or seriously wounded in the carnage of Bellau Wood and Château Thierry. Thus, the news of the armistice was received with great joy and celebration in Houston. One day later, November 12, 1918, a writer on the staff of the Houston *Post* graphically described the local reaction:

At 4:15 the *Post* was on the street and then the city rubbed its eyes and awoke. First the cry of the newsboys, then the honking of automobile horns, then far out in the city came the rattle of the city's private arsenals of light pocket artillery. The locomotives then got into action and gradually all the factory whistles and sirens for miles around. No one able to get up remained in bed. Lights gleamed in every dwelling and people poured down into the business district. Until late in the day the revelry continued. Monday night it was renewed with greater vigor . . . at 6 o'clock the downtown streets were filled, at 7 they were crowded, at 8 they were jammed, at 9 they were choked and from then on it was one wriggling, squirming, squeezing mass of humanity, awakened rudely from sleep but joyously from a horrible nightmare which had lasted four years.

The racial tension that had plagued Houston during World War I did not completely dissipate at the war's end. The Ku

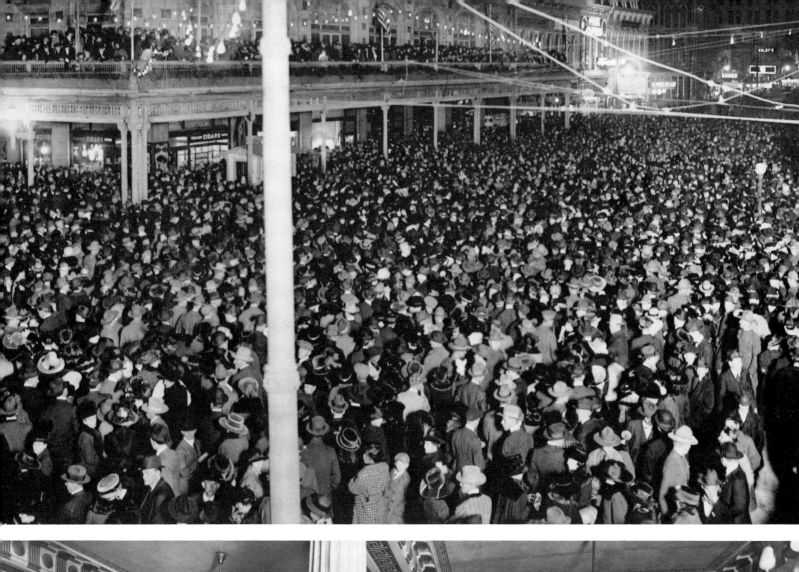

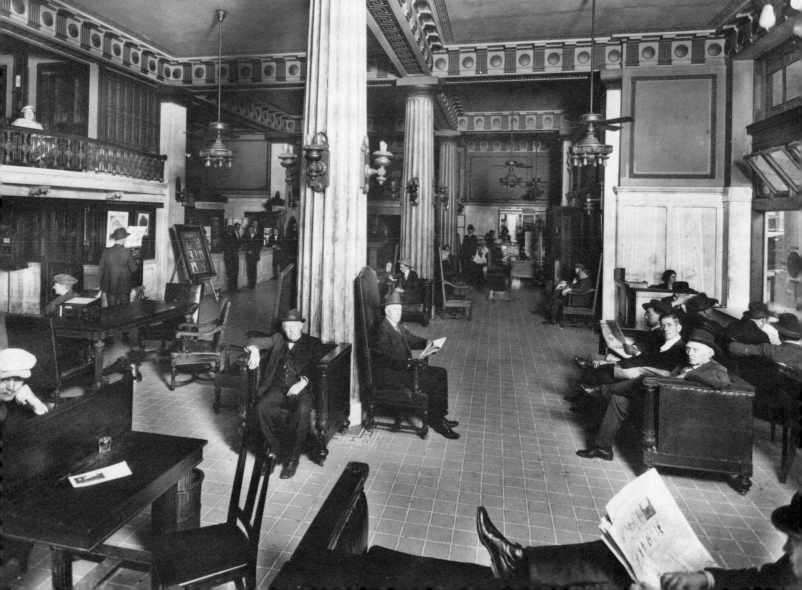

Although the San Jacinto Monument was yet to be built, the battlefield site was a popular spot for Houstonians. The waterfront area had been developed and many residents attended patriotic events at the site of San Jacinto. Many more visited the site for a picnic away from the city. Courtesy, Texas Room; Houston Public Library

Klux Klan, which had been active in the Reconstruction era but had since gone into eclipse, experienced a resurgence in Houston after the war. A local chapter was established again in 1920, and it directed its hatred against the city's foreign-born as well as against blacks. Oscar F. Holcombe, then a building contractor and real-estate investor, joined the group, but after a brief period he quit and sharply disavowed racial and religious bias.

In 1921 Holcombe was elected to succeed A.E. Amerman as mayor of Houston. The local Klan proposed not to campaign against Holcombe in his first bid for reelection if he would dismiss three Roman Catholics who held senior positions in his administration. When Holcombe refused, the Klan leadership tried to injure him with a false accusation of gambling, but that ploy also failed. From 1921 to 1957 the "Old Gray Fox," as Holcombe was called, served a total of 22 years as mayor.

The first full-time mayor in Houston's history was H. Baldwin Rice, who was elected in July 1905. The next year, after much citizen participation, a charter was adopted providing for a commission form of government. Referred to as "government by a board of directors," the system worked relatively well in Houston. The commis-

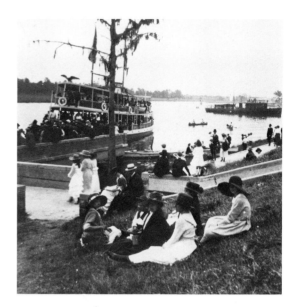

sioners and mayor successfully reduced the municipal debt and effected a gradual reduction in taxes. Houston's efficient form of government was praised throughout the nation as an example for the future. Rice, who served as mayor until 1913, found the new form of government particularly suited to his talents.

During Mayor Rice's tenure the subject of city planning was broached. In 1911 the Houston Chamber of Commerce called for a detailed master plan for the city's future development. A few years later the City Council funded a study of selected European communities in order to garner ideas.

Houstonians sought a variety of ways to escape the heat and humidity of Houston's summers. Sylvan Beach, with its pavilions, piers, parking lots, and other facilities was popular for many during the years after the turn of the century. Courtesy, Texas Room; Houston Public Library

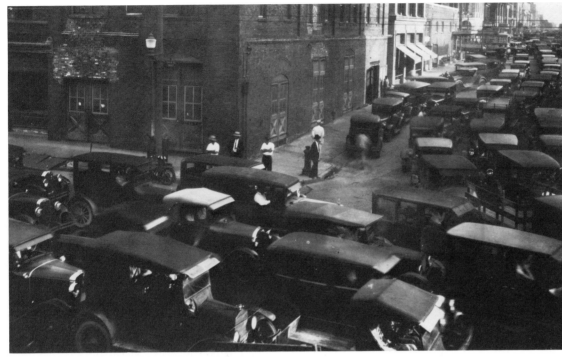

By the mid-1920s, traffic had already become a problem for the city that was about to become the largest city in Texas. Houstonians were finding that oil coming through the city from the nearby fields and refineries was changing every aspect of daily life. Courtesy, Harris County Heritage Society; Litterst-Dixon Collection

Most of the resulting recommendations attempted to assure greater citizen participation in local political affairs. Accordingly, in 1913 Houstonians approved amendments providing for initiative, referendum, and recall.

In 1922 Mayor Holcombe sought to create a municipal planning commission, but other than the preparation of some studies, nothing was really accomplished until 1929. In that year William C. Hogg was chairman of the City Planning Commission, which drafted a master plan for consideration by the City Council. As the developer of the exclusive and thoroughly planned River Oaks residential district, Hogg could speak with authority. However, coming as it did at the beginning of the Depression, the report was subordinated to more pressing problems.

Other efforts to improve the city came from the private sector. The event of long-

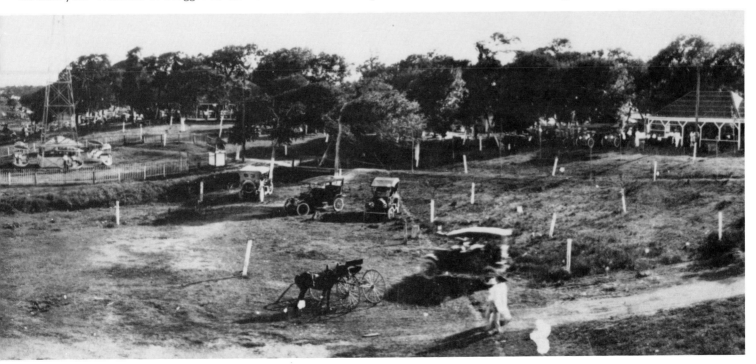

Texans have always found the art of barbecue to be a unique and wonderful experience. This is one food tradition that has been shared throughout the Houston community, both at small events and large celebrations. Courtesy, Texas Room; Houston Public Library

range significance for the city was the donation by George H. Hermann, on May 30, 1914, of 278 acres of beautifully wooded land that constituted the nucleus of present-day Hermann Park. As a member of Company A of the 26th Cavalry during the Civil War, Hermann fought with distinction in Texas and Louisiana. After the war he returned to Houston, operated a sawmill, and then went into real estate. The discovery of oil at Humble in 1903 made him a millionaire and left him free to devote his life to charity. In addition to providing Hermann Park, the bulk of his almost $3-million estate was used to create a trust for the purpose of building and maintaining Hermann Hospital, which was opened on July 1, 1925, on the edge of the park.

Another successful Houstonian who left part of his vast fortune to the city was William Marsh Rice. Rice came to Texas from Massachusetts in 1839 and prospered greatly during the Civil War as a cotton merchant. During the Reconstruction era he expanded his interests into railroad, banking, and real-estate operations. In 1891 Rice, who married twice but had no children, decided to return to the Northeast. However, prior to this he established a trust of $200,000 for the creation of a university

Will Hogg, son of Governor James Stephen Hogg, played an important role in the shaping of Houston during the 1920s. In addition to participating in a variety of charitable activities, he and his brothers began the development of the River Oaks subdivision in the 1920s, the area which has been home to many of Houston's modern leaders. Courtesy, Bayou Bend Collection, Gift of Miss Ima Hogg; Houston Museum of Fine Arts

"dedicated to the advancement of art, literature, and science"; enrollment was to be limited to the white residents of Houston.

By the time Rice left Houston, he had accumulated a fortune estimated at about $3 million. Some years later in New York City, he was murdered by his valet, Charles F. Jones, who placed a napkin drenched in chloroform over Rice's face. In the lurid trial that followed, Jones confessed and, in exchange for going free, implicated attorney Albert T. Patrick, who had conspired with the valet to forge Rice's will. Although Patrick was sentenced to death, he managed to secure a reduction of his sentence and ultimately a full pardon. Rice's will, which initially provided that tuition be absolutely free at the university, was involved in complicated litigation. But by 1912, all legal questions had been resolved, and Rice Institute began operations with an endowment of $10 million, then the seventh largest in the nation. In 1907 the Board of Trustees had unanimously chosen Princeton professor Dr. Edgar Odell Lovett as the first president of Rice, and Lovett embarked on a tour of illustrious European universities in order to incorporate their best features at Rice. The famous Boston architect Ralph Cram was engaged to design the distinctive campus, and an impressive faculty was

recruited, among whom were Julian Huxley as professor of biology and Stockton Axon, brother-in-law of President Woodrow Wilson, as professor of English.

Fifty-eight students entered Rice with the first class in 1912 and 35 graduated in 1916. From the very start the school, located on virtual prairieland out South Main and opposite Hermann Park, attracted students of the highest calibre. A distinguished and productive faculty, particularly in the physical sciences, added luster to the institution over the years. Because of its academic reputation, students from throughout the nation have been attracted to Rice, and all racial barriers to admission have been eliminated. A charter member of the Southwest Conference, the Rice "Owls" have had a storied football tradition. Particularly under Coach Jess Neeley, Rice generally fared well against such gridiron powers as Texas A & M and the University of Texas. Rice has also been successful in track and field, sending a number of its athletes to Olympic competition.

Another institution of higher learning established in the first part of the 20th century was the University of Houston. In 1923 the citizens of Houston voted to relinquish control of the city's public schools and create an independent system with its own taxing authority. An elected school board

was sanctioned, and in 1924 the schools were organized as an independent system. After a comprehensive search, the man hired as superintendent of public schools was Dr. E.E. Oberholtzer. From the inception of his term, Dr. Oberholtzer envisioned a municipal university for students who wished to remain in Houston while pursuing a college education. In 1927 funding was provided for Houston Junior College, which commenced its operations with some 400 students. At first the college classrooms were located at San Jacinto High School and classes were held in the afternoon and early evening. In 1934 Oberholtzer's dream was finally realized when the school board mandated the University of Houston as a full-fledged, four-year school; fittingly, Dr. Oberholtzer was appointed its first president.

Profiting from Dr. Oberholtzer's steady leadership, the University of Houston continued to grow. In contrast to Rice University's somewhat elitist admission policies, the University of Houston sought to enroll the working student living at home. Land was donated for a campus in the southeast portion of town and a building fund campaign was launched. It was at this juncture that Hugh Roy Cullen began his life-long association with the university. One of the legendary "wildcatters" of his day, Cullen made a

At the end of the 19th century, Houston began to develop a park system. At the bottom of Sam Houston Park, acquired in 1899, the city converted a small watercourse feeding into Buffalo Bayou into a pond, complete with fountain. The community needed more recreation and park facilities and, as early as 1910, Mayor Rice was advocating expansion of these facilities. Courtesy, Harris County Heritage Society; Litterst-Dixon Collection

fortune successfully drilling for oil in South Texas. While he was not a college graduate himself, he was passionately devoted to the cause of education. Until the time of his death he was the principal benefactor of the University of Houston and a strong supporter of its athletic teams as well. Often criticized for his conservative political views, he was at the same time a staunch defender of academic freedom.

As in the case of education, the arts in Houston were heightened by the contributions of civic-minded residents. More than any other single individual, Edna Saunders presided over artistic affairs in the city. As a booking agent, she brought many world-renowned artists to Houston, among them, in 1920, the great Enrico Caruso. The fabled Italian tenor performed before a full house and, at his urging, the outer doors of the City Auditorium were left ajar for the benefit of those who had been unable to purchase a ticket for the concert.

Until the Music Hall was built in the 1930s, the City Auditorium was the center of Houston's cultural life. During these years the Boston and Chicago opera companies appeared somewhat regularly in the city, as did the San Carlo Opera Company, which staged an annual tour of the United States. There were also attempts at locally produced operatic performances. In the late 1920s and early 1930s, Mary Carson, a local soprano, and Mrs. John Wesley Graham, an exuberant voice teacher, staged a number of performances, among them a very well-received *Madame Butterfly*. In January 1941 the Southern School of Fine Arts, a Houston group, produced *Carmen* as a benefit for the British-American Ambulance Corporation. Although the United States was not yet in the Second World War, concern was already felt in Houston for the nation's eventual allies.

The Houston Symphony Orchestra was founded in 1913 principally by the aforementioned Mrs. Graham, D.D. Naman, and Ima Hogg. Under its early conductors, Julian Paul Blitz, Uriel Nespoli, Paul Berge, and Frank St. Leger, progress was slow, but the orchestra began to make giant strides with the appointment in 1936 of Ernst Hoffman.

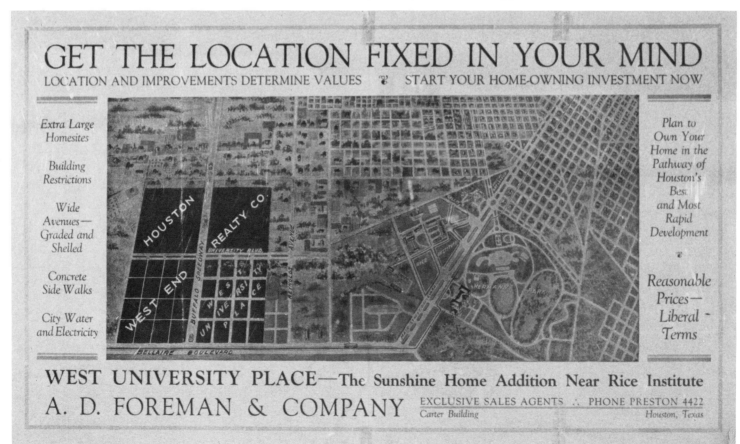

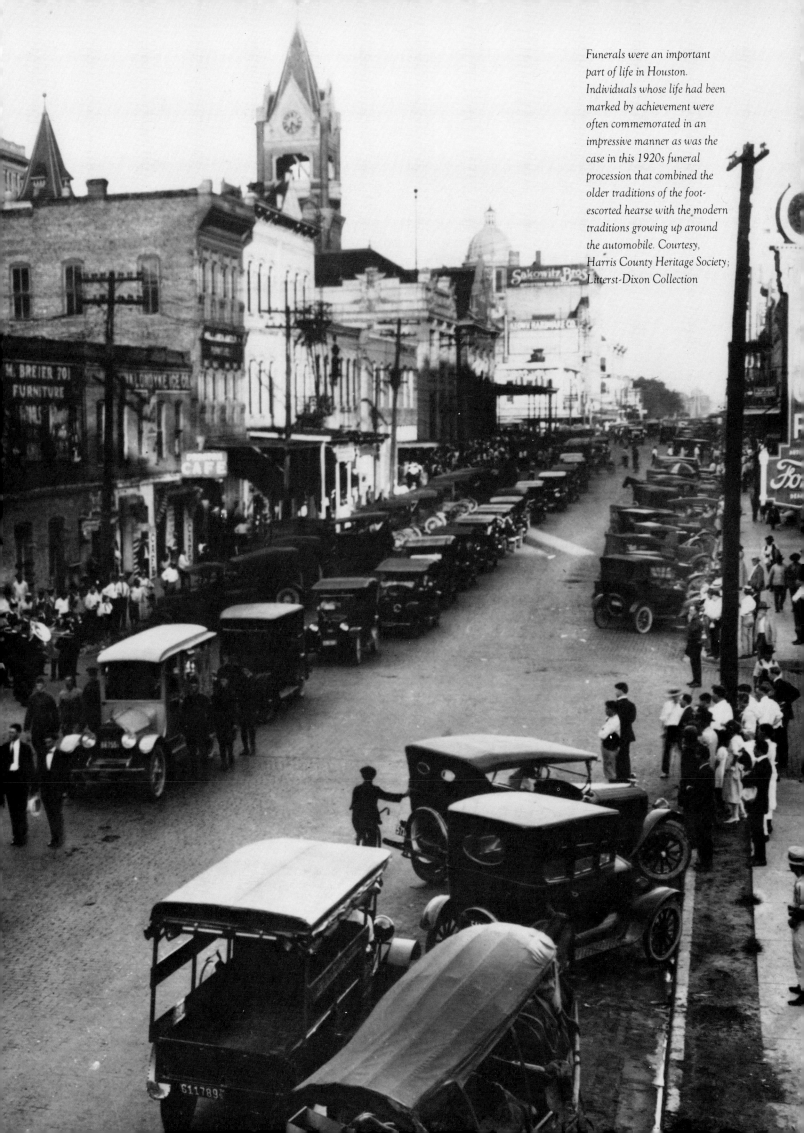

Funerals were an important part of life in Houston. Individuals whose life had been marked by achievement were often commemorated in an impressive manner as was the case in this 1920s funeral procession that combined the older traditions of the foot-escorted hearse with the modern traditions growing up around the automobile. Courtesy, Harris County Heritage Society; Litterst-Dixon Collection

Profiting from Hoffman's aggressive and inspired leadership, for the first time the Houston Symphony began to attract national interest. Another very popular innovation was the staging of free summer concerts in Hermann Park. On a beautiful summer's evening, an appreciative audience of more than 10,000 people became commonplace for these open-air concerts. Hoffman remained with the Houston Symphony until 1947 and had a decisive impact on the evolution of the organization.

In the field of visual arts, the Houston Museum of Fine Arts opened in 1924, becoming the first city museum in Texas. The trustees of the museum selected James Chillman, Jr., a professor of architecture at Rice Institute, as its original director. An energetic man, Chillman stressed the museum's availability to the public at large. He established the Junior Gallery with lectures, storytelling, and puppet shows, and the Art School where instruction was offered in both junior and adult divisions. Chillman was able to obtain some excellent

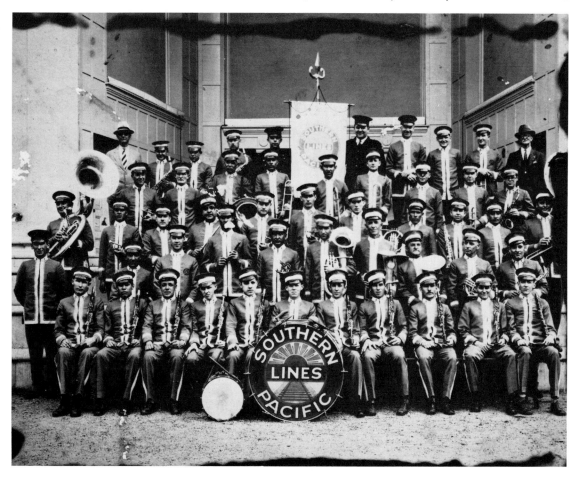

ARE YOUR PHOTOGRAPHS UP-TO-DATE?

collections for the museum, including the "Annette Finnegan Collection of Ancient Art from Egypt, Greece, and Rome," and the "Edith A. and Percy S. Straus Collection of Renaissance Paintings and Bronzes." Certainly Houston artists of this era, such as Helen C. Davis, Frederic Browne, and Grace Spaulding John, must have been heartened by the museum's presence. Like his counterpart Ernst Hoffman at the symphony, Chillman was a cultural builder for the future.

In a physical sense, the "master builder" of Houston from 1910 to 1930 was Jesse Jones. Already wealthy from lumber and

real-estate investments, Jones in 1913 obtained a lease on the Rice Hotel from the William Marsh Rice estate. Then he purchased the land, demolished the old five-story building, and began the construction of an 18-story, 500-room modern hotel, which would be the largest hotel in the South. Jones himself drew the plans for the hotel and took pride in the fact that the edifice was located on the site of the first capitol of the Republic of Texas. At the front entrance of the hotel, Jones placed a tablet that read, "Site of the Capitol of the Republic of Texas, 1837-1838. Commemorating days when, after her glorious struggle, Texas stood an independent nation." For more than 40 years, the expanded "Rice" was the center of Houston's social and civic life.

In subsequent years Jones erected and managed the Kirby, Commerce, Milam, Electric, and many other buildings along Main Street and in downtown Houston. Although these buildings were often named for the structure's principal tenant, Jones refused to name a building after himself. He maintained his own private offices in the Bankers Mortgage Building, another one of his creations. In 1926 Jones widened his sphere of involvement when he purchased a

controlling interest in the Houston *Chronicle* and became its owner and president. By the mid-1920s Jones had personally supervised the construction of some 30 commercial sites and retained ownership of all of them. He topped off this burst of activity in 1927 with the completion of the 37-story Gulf Building, the tallest in Houston to that date.

A man of conservative instincts, Jones confined his political activity to Texas state politics during the national heyday of William Jennings Bryan. However, with Woodrow Wilson's nomination for the Presidency in 1912, Jones became an enthusiastic worker for the national Democratic party, and in 1924 he became the finance director of the Democratic National Committee.

On January 12, 1928, the Democratic National Committee convened in Washington, D.C., to select a site for the party's national convention. As finance director, Jones was named to a subcommittee to consider the money proposals and available convention facilities of the competing cities. Jones was particularly interested in the financial proposals, because he hoped to use the winning city's bid to satisfy the party's remaining debt from the 1924 campaign. Therefore, a few weeks prior to the Washington meeting, Jones had solicited offers from interested sites. Cleveland ($100,000), Detroit ($125,000), and Chicago ($130,000) had responded to his invitation and were in the running for the convention location. Jones later said that he felt the convention would not consider a Texas city because of the climate, and thus he had not invited a

The Rice Hotel quickly became the center of many different kinds of social and recreational activities after it opened. During the World War I era, ladies would gather in the Crystal Ballroom of the Rice for a day of bridge. Courtesy, Harris County Heritage Society; Litterst-Dixon Collection

During the 1920s and 1930s, Houston developed its own set of palaces for motion pictures and vaudeville, theaters designed in the classical manner with wonderful interiors, elaborate lobbies, and marble-fronted cashiers' booths. Courtesy, Texas Room; Houston Public Library

145

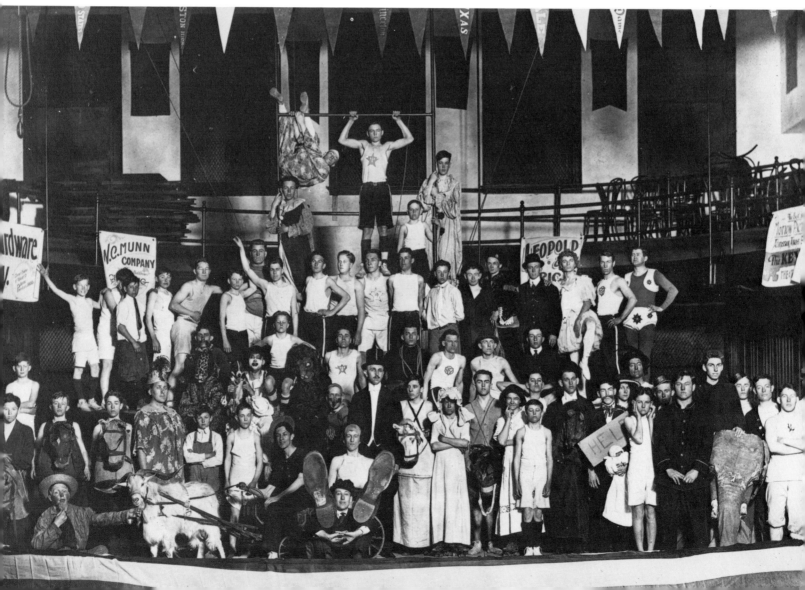

proposal from Houston.

Nevertheless, as he and the other two members of the subcommittee listened to the various proposals, Jones determined to enter a bid for Houston on his own. Reasoning that even if he failed, the city would at least receive some favorable publicity, Jones drafted a letter outlining his proposal and attached his personal check for $200,000, the highest bid to that point. No prior discussions had been held with Houston city officials; the action was entirely his own.

At this juncture in the subcommittee's deliberations, a $250,000 proposal was submitted on behalf of San Francisco, a city whose convention facilities were by far superior to Houston's. Jones admitted that Houston's convention hall would seat only 5,000, "but if you give us the convention we will build one to seat 25,000." That promise must have swayed a number of committee members, because on the first ballot Houston won 30 votes while San Francisco received only 25 (the remaining were scattered). In the final vote Houston was selected, with 54 votes to 48 for San Francisco.

The convention hall that Jones promised, the Sam Houston Coliseum at 810 Bagby Street, complete with 25,000 seats and all

modern facilities, was finished in mid-June, and two weeks later the delegates began to arrive. Yet however interesting the city of Houston proved, the delegates witnessed a relatively drab convention. Even for Houston the weather was hot and the proceedings needlessly dragged out for six days. Jones was nominated for the Vice-Presidency as a favorite son from Texas, but the Smith forces had marshalled their votes well in advance of the convention. Franklin D. Roosevelt nominated Smith, who won with relative ease.

Facing page, top:
Jesse Jones, the Houston entrepreneur who had brought the 1928 Democratic Convention to Houston, was involved in all aspects of this meeting. Under his supervision, the convention center grew rapidly to completion in a matter of months and Jones checked the development of the facility on a frequent and regular basis. Courtesy, Texas Room; Houston Public Library

Facing page, bottom:
This group of boys assembled for an amateur theatrical in the gym of the Houston YMCA. The production appears to have been a circus. Courtesy, Harris County Heritage Society

Above left:
In 1926 Houston's growth was celebrated by the installation of the 50,000th telephone in the city. Mayor Oscar Holcombe joined the telephone company and the residents of Houston in marking this event. Courtesy, Texas Room; Houston Public Library

Left:
In a community where the environment has always been a major factor in the deterioration of buildings, there has been a ready market for paints since Houston's founding. The James Bute Paint Company, which operated during the 1920s from the corner of Fannin and Texas, is the oldest supplier of paint to the Houston community. Courtesy, Harris County Heritage Society; Litterst-Dixon Collection

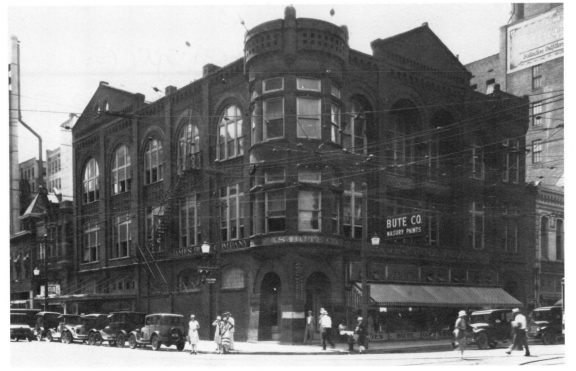

For Houston the convention was a great success. Delegates from all over the nation came to the Bayou City and saw firsthand the remarkable progress that had been made since the commencement of the "Oil Age." Also, since Smith intended to make his anti-Prohibition stand an important part of the campaign, the fact that he was nominated in the midst of the Southern "Bible Belt" was widely commented on. The importance of the South to the party was further dramatized with the selection of Senator Joseph Robinson of Arkansas as the New Yorker's running mate.

The federal census of 1930 revealed that Houston had eclipsed both Dallas and San Antonio to become the most populous city in Texas. While its population of 292,352 left it considerably shy of New Orleans as the South's largest city, the growth of Houston since 1910 had been unparalleled. Fueled by oil and to a lesser degree cotton and lumber, the future seemed bright indeed. Then with little prior warning, the hard times struck. In May 1929 Buffalo Bayou flooded its banks causing damage estimated in the millions of dollars. Five months later, at brokerage houses throughout the city, the ticker tape told the story of "Black Friday," October 28, 1929.

The effects of the Great Depression soon struck the economy of Houston. Building permits dropped drastically, and in May 1931 unions affiliated with the Houston Building Trades Council went on strike.

In 1932 Houstonians voted overwhelmingly for Franklin D. Roosevelt and favorite son John Nance Garner, and soon began to benefit from New Deal legislation. They were grateful for the relief legislation sponsored by Franklin D. Roosevelt during the Depression, but were aware of the fact that the City of Houston discriminated against blacks and Mexicans in dispensing relief funds. Funds from the Reconstruction Finance Corporation, headed by Jesse Jones, the National Recovery Administration, and the Works Progress Administration were used for county road repair, slum clearance, and public building construction. The ship channel was improved with federal funds, and in September 1934 the Public Works Administration granted a loan of $1,219,-000 for the construction of a new City Hall. The PWA also funded the building of a new city-county hospital, the Jeff Davis Hospital. In 1935-1936 the Works Progress Administration employed almost 12,000 Harris Countians and spent more than $2 million financing some 70 projects in

The growth of the rail networks and the port saw Houston develop in many different areas during the 1920s. Sig Frucht was one of the leaders in the creation of a produce trade that linked the farms and orchards of the Rio Grande Valley to Houston and, through Houston, to the United States. Courtesy, Texas Room; Houston Public Library

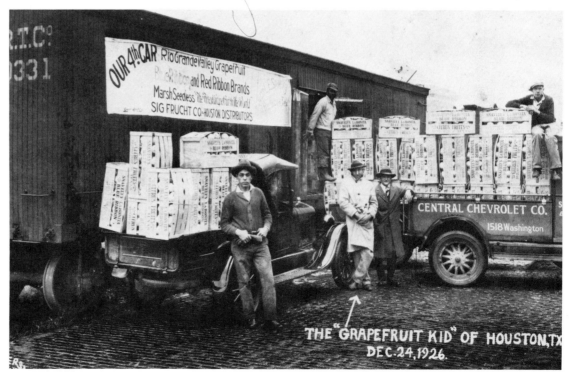

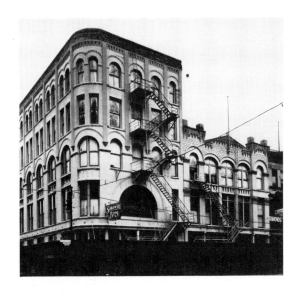

Harris County.

Urban historians have argued that Houston was less affected by the Great Depression than many other major cities in the United States. This seems to have been true principally because of the continued worldwide demand for oil and related petroleum products. Houston was certainly unique in that there were no bank failures and thus no panicky rushes for deposits. Two major banks verged on collapse, but they were saved through the intervention of Jesse Jones and other business leaders who pooled their resources to offset the possibility of failure. Although Houston lost

out to Dallas as the host city of the 1936 Texas Centennial, that year the federal government granted one million dollars for the construction of the San Jacinto Monument. Designed by Houston architect Alfred C. Finn on the battlefield where Texas won its independence, the monument remains a testimony to liberty and freedom.

The Great Depression did result in a change in city government. Mayor Oscar Holcombe called for revisions in the city charter to grant more authority to the executive and less to the City Council. Holcombe argued that the precarious economic conditions of the period called for a forceful mayor, with powers akin to those enjoyed on the national level by President Roosevelt. The Council resisted this attack upon its privileges and insisted that the question be submitted to arbitration. In 1935 five attorneys constituting a board of arbitration ruled that councilmen could head specific departments only if appointed by the mayor. The controversy waxed and waned until 1942, when Houston adopted the city-manager form of government with eight Council members and a part-time mayor.

Oscar Holcombe took the mayor's oath for the seventh time on January 2, 1939.

Built in 1893, the Kiam Building was the first example of Richardsonian Romanesque design in Houston. It was also the first building to use electric elevators and one of the first to include plate glass windows for display. By 1918 the Sakowitz Brothers had moved their department store into the structure. In 1929 the firm moved into a much larger building. The structure is still a landmark on Main Street. Courtesy, Harris County Heritage Society; Litterst-Dixon Collection

By the late 1920s, even small independent Houston grocers had changed their marketing practices. With the coming of national brands and standardized packaging and advertising, every store began to appear more and more like every other. The grocers used every device offered by the distributors to make their stores look modern. Courtesy, Harris County Heritage Society; Litterst-Dixon Collection

Houston and Galveston were the center of the oceangoing export trade in cotton during the 1920s and 1930s. Thanks to good land and excellent ports, the region came to dominate the cotton markets of the world. Courtesy, Rosenberg Library

Cotton, sold through brokers in the Houston Cotton Exchange, was an important part of the economic life of the city in the 1920s. With the ship channel allowing vessels to come up to the port, more cotton than ever came through the city. The first cotton from each season was always marked with a special ceremony, denoting the continuing importance of cotton to the Houston economy. Courtesy, Harris County Heritage Society; Litterst-Dixon Collection

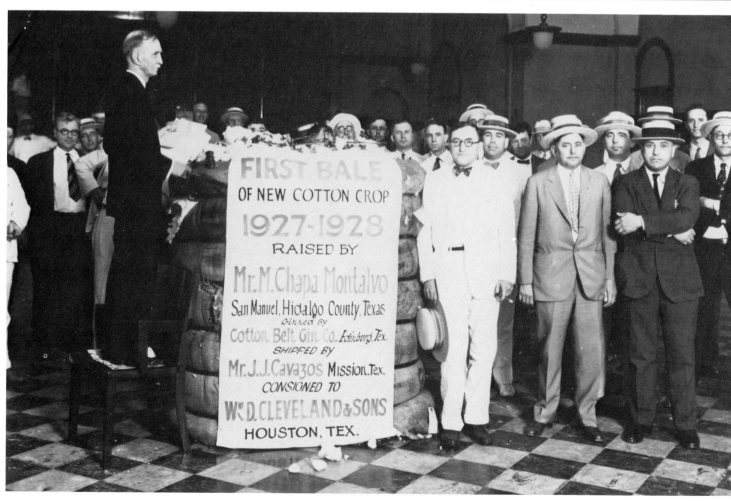

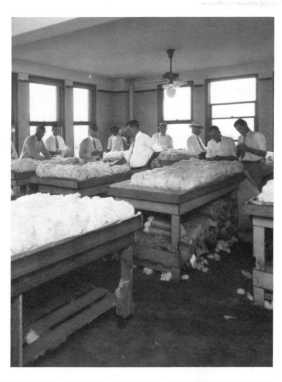

Far Left:
Cotton shipped into Houston was stored in large warehouses to await sale and shipment to the factories that would turn it into fabric. At various times of the year, these warehouses would be bulging with cotton bales. Courtesy, Harris County Heritage Society; Litterst-Dixon Collection

Left:
Before cotton could be marketed through the Cotton Exchange, it needed to be graded. Samples were taken and graded for quality and length of fiber by experts employed by the Cotton Exchange and by various merchants and factors. Courtesy, Harris County Heritage Society; Litterst-Dixon Collection

Mechanization came slowly to the farmlands around Houston, as it did throughout the country. Although railroads had penetrated the countryside and trucks were available to take cotton to the markets, most farmers still relied on mules and wagons to carry their cotton to the gins or the markets. Courtesy, Harris County Heritage Society; Litterst-Dixon Collection

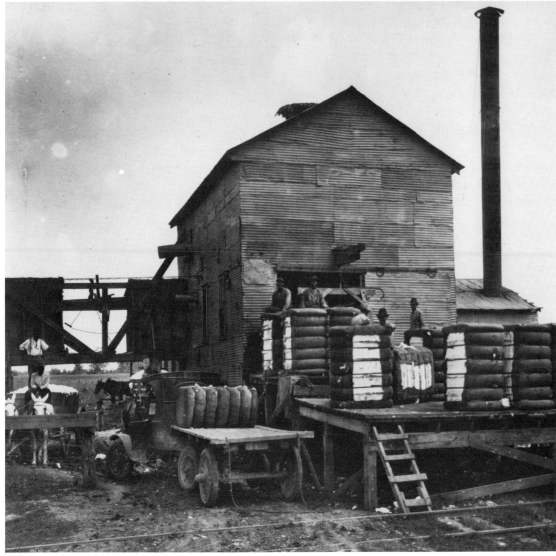

Later that year bank deposits reached an all-time high in Houston and the city appeared fully recovered from the Depression. In February 1939 Harris County taxpayers approved a $500,000 bond issue for a flood-control and drainage program, which upon completion was estimated to cost $23 million. Yet in the midst of these indications of progress, Houstonians cast an anxious eye toward European developments. When on September 1, 1939, Hitler's legions invaded Poland, most felt it was only a matter of time until the United States became involved. As the tempo of national defense increased, improvements were made at Ellington Field and Camp Wallace, both situated just outside the city limits. A number of industrial plants, including Humble Oil and Refining, Sheffield Steel, and Cameron Iron Works, were awarded contracts to furnish war materials, and in September 1940, marking the first peacetime draft in American history, 77,177 young men registered in Harris County.

The year 1941 dawned with its completion of Mayor Oscar Holcombe's seventh term; he was succeeded by C.A. (Neal) Pickett. Reflecting the increasingly ominous military situation, it was announced in Washington on April 1, 1941, that an ordnance depot would be built on a 4,700-acre tract opposite the San Jacinto battlefield.

Slips and docks along a lengthy frontage of the ship channel would be constructed so the depot could serve as a storage and distribution point for all Gulf Coast military bases. Also in 1941 the federal government awarded the Hughes Tool Company a contract to manufacture bomber parts for the army and navy, and Ellington Field's first contingent of airmen arrived for training that spring.

The summer passed uneventfully, and in November Houstonians learned that two Japanese envoys had arrived in San Francisco on a diplomatic mission to Washington. Commenting to reporters that they hoped to, "score a touchdown for peace," Saburo Kurusu and Kichisaburo Nomura flew to the nation's capital for protracted talks with Secretary of State Cordell Hull. The diplomats and Hull were still engaged in discussion when on December 7, 1941, Japan launched a devastating sneak attack on the United States naval base at Pearl Harbor. Responding to President Roosevelt's "day of infamy" address the next day, Congress declared war against Japan with but one dissenting vote. In addition to all of its other consequences, World War II would have a profound effect upon the history of the city of Houston.

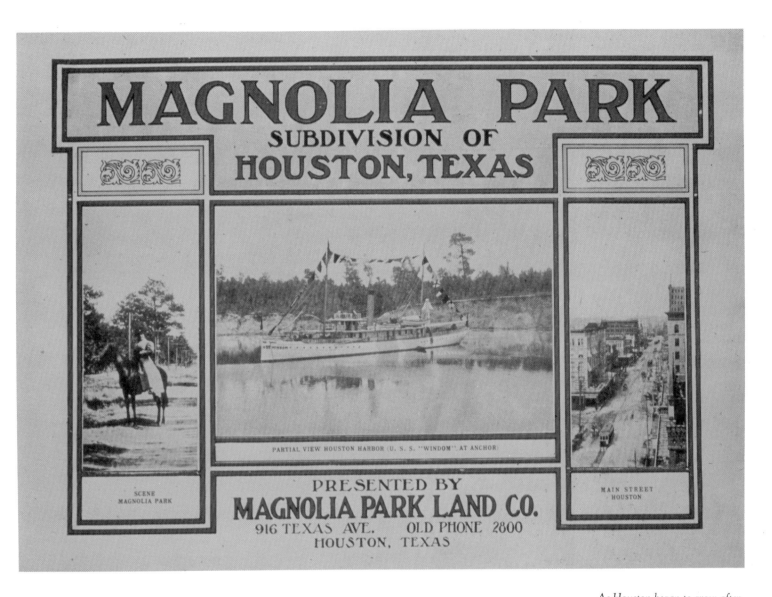

MAGNOLIA PARK
SUBDIVISION OF
HOUSTON, TEXAS

PARTIAL VIEW HOUSTON HARBOR (U. S. S. "WINDOM" AT ANCHOR)

SCENE
MAGNOLIA PARK

MAIN STREET
HOUSTON

PRESENTED BY
MAGNOLIA PARK LAND CO.
916 TEXAS AVE. OLD PHONE 2800
HOUSTON, TEXAS

As Houston began to grow after 1900, many areas were developed as residential subdivisions serving different markets around the city. Magnolia Park was located near the ship channel and attracted workers in the plants and on the docks of the port. It became popular with the Mexican community, but still served a large Anglo population as well. Courtesy, Houston Metropolitan Research Center; Houston Public Library

Once the rail network into Houston was completed, cotton was shipped to the city for delivery to oceangoing ships that were anchored off Galveston. The barges of cotton that departed from the Houston waterfront were great attractions for visitors and symbolized the city's role in the shipment of agricultural products in the late 19th and early 20th centuries. Courtesy, Barker Texas History Center; University of Texas

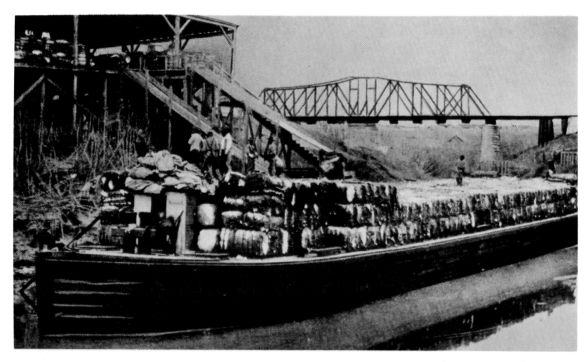

As the Mexican-Americans began to flock to Houston, they often found work in the port area as longshoremen, unloading the banana boats and other vessels that brought the produce of the world to Houston for distribution to Texas and the middle United States. Courtesy, Houston Metropolitan Research Center; Houston Public Library

Facing page:
At the heart of the intellectual life of the Mexican-American community were periodicals such as the Mexican-American literary magazine, Gaceta Mexicana, which was the outlet for a number of local writers in the 1920s and was developed by local entrepreneurs for the community. Courtesy, Houston Metropolitan Research Center; Houston Public Library

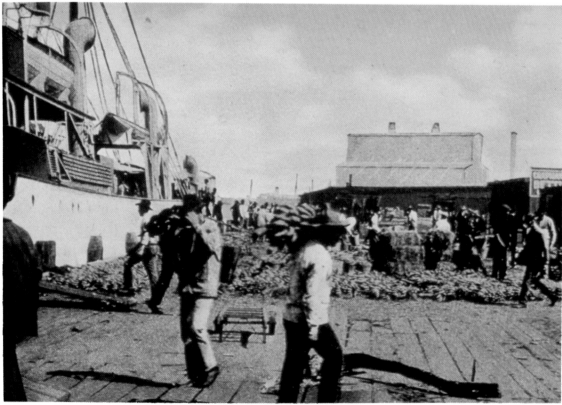

Gaceta Mexicana

REVISTA QUINCENAL

ORGANO·DE·LA·LIBRERIA·HISPANO·AMERICANA.

Vol. 1
Núm 7

JOSE SARABIA, Administrador

Mayo 15
de 1928

Una Esperanza para el Arte.

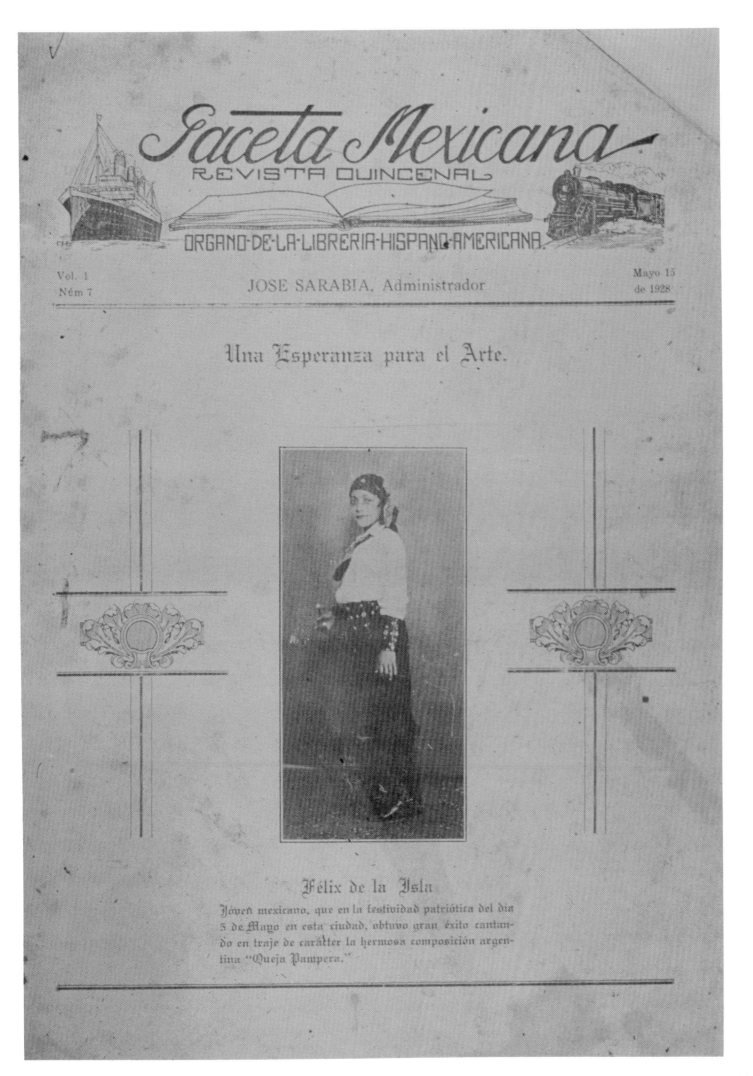

Félix de la Isla

Jóven mexicano, que en la festividad patriótica del día
5 de Mayo en esta ciudad, obtuvo gran éxito cantan-
do en traje de carácter la hermosa composición argen-
tina "Queja Pampera."

Facing page:
Captured in a portrait made of terra-cotta tiles and on display at San Jacinto Monument, Jesse Jones was the central figure in the development of Houston in the first half of the 20th century. He controlled most of the downtown properties and, with his architect Alfred Finn, built many of the office buildings of the era. He also played a major role in San Jacinto's development as an historic site. Courtesy, San Jacinto Monument

Daughter of the first native-born governor of Texas, Miss Ima Hogg devoted her life to the development of charitable and cultural institutions in Houston. In addition to assembling a distinguished collection of Early American decorative arts in her family's estate, Bayou Bend, Miss Hogg played an important role in the development of the symphony and also in the development of mental health activities. Courtesy, Bayou Bend Collection, Gift of Miss Ima Hogg; Houston Museum of Fine Arts

Designed by Houston's prominent residential architect, John Staub, in 1927, Bayou Bend was the center of development in the River Oaks area. It is now open to the public and symbolizes the charitable activities of many Houstonians. Courtesy, Bayou Bend Collection, Gift of Miss Ima Hogg; Houston Museum of Fine Arts

Facing page:
In Houston's Mexican-American community, Cinco de Mayo has been an event that has united the people. A celebration of Mexican revolutionary tradition and nationalism, the day has been marked with public programs such as a 1944 celebration at Jefferson Davis High School, a musical event in honor of the Mexican Revolution. *Courtesy Houston Metropolitan Research Center; Houston Public Library*

Completed in 1939, Houston's modern city hall is a statement of the WPA-style of architecture that was popular throughout the country. Thera Case's painting captures the park-like surroundings of the building, which was on property given to the city by George Hermann. *Photo by Story J. Sloane III, Harris County Heritage Society*

The visit of the heavy cruiser Houston to the city in 1930 marked the official celebration of 10 years of amazing growth stimulated by the ship channel. The cruiser was a symbol of the city, for she had been named after an intense campaign on the part of the citizens, including a mass mailing by schoolchildren. When she was sunk in 1942, the Houston became the symbol of World War II for the city. *Courtesy, Barker Texas History Center; University of Texas*

5 DE MAYO DE 1944

LA FEDERACION DE SOCIEDADES MEXICANAS
Y
LATINO-AMERICANAS

PRESENTA

Una

Velada Literario Musical

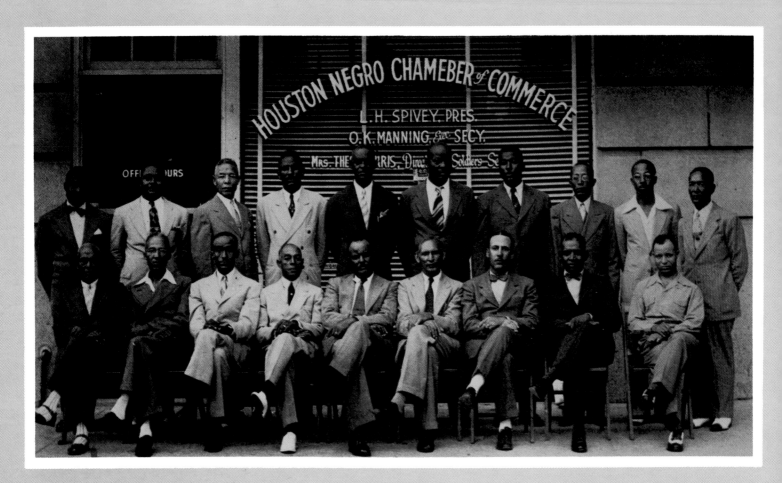

In the first half of the
20th century, the Houston
Negro Chamber of Commerce
was an important part of the
black establishment in the city. It
provided a network for the black
business community to establish
ties and networks. Courtesy,
Texas Room; Houston Public
Library

THE STRUGGLE FOR CIVIL RIGHTS

housands of Texas blacks, many of them from Houston, enlisted in the armed services after Pearl Harbor. High black enlistment had begun during the Great Depression, when the principal motivation had been economic. Segregation prevailed in the military all during the conflict, overseas as well as at home. Although Houston was spared the type of terrible riot that it had endured in 1917, white demonstrations resulted in the removal of the black 54th Coast Artillery from Camp Wallace on the outskirts of Galveston. In Houston itself, in order to minimize the possibilities of friction, an interracial committee of civilians and military officers was founded in 1943 to monitor the situation. Black pilots training at nearby Ellington Field found most recreational facilities in the city closed to them and were dependent upon the black community for amusement. A Reserve Officer Training Corps was located at nearby Prairie View, one of the few situated on a black college campus in the United States. The irony of risking one's life in the struggle against tyranny abroad while failing to enjoy the blessings of democracy at home was not lost upon Texas blacks. One of them, a poet, summed up his feelings in this fashion:

On a train in Texas German prisoners eat
With white American soldiers, seat by seat
While black American soldiers sit apart
The white men eating meat, the black men
 heart

The campaign for equal treatment for blacks and Mexican-Americans in Houston was intensified by the nation's entry into World War II. Blacks adopted the slogan, "Win a Double Victory," which referred to both the war for the enjoyment of civil rights at home and the war being fought abroad. In fact, the struggle for civil rights began before the war and, in the case of blacks, was closely tied to the rise of the National Association for the Advancement of Colored People (NAACP) in Texas. Suits were planned and initiated combatting racial discrimination in the areas of voting rights, employment, jury service, and education.

At the first Texas state conference of the NAACP, held in Dallas on June 18 and 19, 1937, delegates from Houston, among them Sidney Hasgett and Clifton F. Richardson, joined those from Dallas, Waco, San Antonio, and Marshall, and Richard D. Evans, a Waco attorney, was elected president. The next year the state convention met in Houston, but soon the local chapter was wracked with turmoil. An audit ordered by the national office revealed grave financial irregularities and also the fact that the chapter had become a virtual spokesman for the programs of the Houston Negro Chamber of Commerce. Walter White, national president of the NAACP, considered revoking the charter of the Houston branch, but when the Reverend Albert A. Lucas consented to serve as the new local president, a semblance of order was restored.

Part of the difficulty that beset the Houston office was based on a personality conflict. Clifton F. Richardson, a longtime worker for civil rights and one of the first local leaders of the NAACP, ran Houston's principal black newspaper, *The Informer*, first published on May 24, 1919. Two attor-

Mack H. Hannah, Jr., had backed Lulu B. White for the presidency of the Houston NAACP chapter. Hannah, who had operated a rubber plant in Beaumont during World War II, used his profits to start an insurance and building and loan business. He was the wealthiest black businessman in Texas in the 1960s. Courtesy, University of Texas, Institute of Texan Cultures, San Antonio

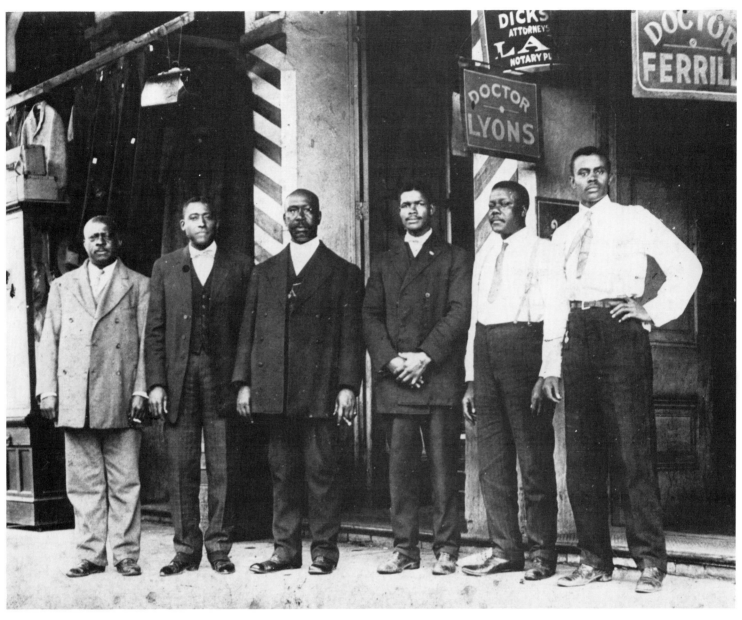

neys, Carter W. Wesley and James M. Nabrit, Jr., wrested control of the paper from Richardson in 1930 and then actively criticized his past leadership. Angry at what had transpired and lamenting the sale of his newspaper, Richardson then started a rival publication, *The Defender*. In 1939 Richardson lost the presidency of the Houston NAACP chapter to Lulu B. White, who enjoyed the backing of such prominent and wealthy Houston blacks as Mack H. Hannah, Jr., Hobart S. Taylor, Sr., and Carter W. Wesley. Within a year Richardson passed away. He had been the true founding spirit of the Houston NAACP, and at the time of his death, the local chapter could boast of almost 1,500 members.

For almost 20 years from the time of its founding in Texas the major ambition of the NAACP was to gain the right to vote in Democratic primary elections. Since the Republican party was almost nonexistent in Texas at the time, the Democratic primary contest was the only significant race. In March 1940 black leaders from all over the state met at Olivet Baptist Church in Houston and determined to raise funds to pursue a primary case through the courts.

The task that confronted Thurgood Marshall, then the leading attorney for the NAACP in civil-rights cases, was to override the Supreme Court's ruling in *Grovey* v. *Townsend* (1935). In that case the Houston

In the years before World War I, Houston's black community developed its own leaders. Affiliated with the church and working in small business, men such as those in this singing group played an important role in shaping life among the blacks in Houston. Courtesy, Texas Room; Houston Public Library

black law firm of Atkins, Nabrit, and Wesley had filed suit on behalf of R.R. Grovey, a Houston barber and political activist, against Harris County Clerk Albert Townsend for the denial of an absentee ballot in the 1934 Democratic primary. Both the state courts and the United States Supreme Court had found against Grovey. The judges found the Democratic party to be a "private organization," which could set its own rules for membership and participation in the primary: no rights of federal citizenship guaranteed to blacks under the 14th or 15th amendments had been breached.

Another Texas white primary case that eventually reached the Supreme Court began in January 1941 when NAACP lawyers filed suit in behalf of Sidney Hasgett, a black Houston laborer, against Harris County election judge Theodore Werner. Hasgett sought $5,000 in damages for being refused a vote in the Democratic runoff primary held on August 24, 1940, in Houston. The case was heard in United States District Court on May 3, 1941, and, relying on the ruling in *Grovey* v. *Townsend*, Justice Thomas M. Kennerly of Houston found against Hasgett.

Race was not a factor in the *United States* v. *Classic* (1941) case, which dealt with falsification of ballots in a Louisiana election for the U.S. House of Representatives. Speaking for the majority in a five-to-three opinion, Chief Justice Harlan P. Stone held that, "the authority of Congress . . . includes the authority to regulate primary elections . . . when they are a step in the exercise by the people of their choice of representatives in Congress." After reviewing this decision, Thurgood Marshall persuaded the Houston NAACP chapter to drop their planned appeal of *Hasgett* and find a case more in line with *Classic.*

Dr. Lonnie E. Smith, a black Houston dentist, had been denied a vote in the 1940 Democratic primary for elections to the United States Congress. Smith was a willing plaintiff and suit was filed against S.E. Allwright, the precinct election judge who refused the ballot. After both the District Court, Justice Kennerly again presiding, and the Fifth Circuit Court of Appeals found against Smith, Marshall and W.J. Durham, Dallas attorney and chairman of the Legal Committee of the NAACP in Texas, took the case to the United States Supreme Court.

James Nabrit, Jr., seen at right, was a partner in the Houston law firm that had filed suit on behalf of a Houston barber and political activist who had been denied an absentee ballot in the 1934 Democratic primary. The lawsuit proved to be unsuccessful. Pictured here with Nabrit are NAACP attorneys George E.C. Hayes (left) and Thurgood Marshall (center). From the Ebony *Collection*

The precedent setting constitutional case of *Smith* v. *Allwright* was argued before the United States Supreme Court on January 12, 1944. The attorneys for Smith, Thurgood Marshall and William Hastie, argued that the Texas "white primary" violated the 14th, 15th, and 17th amendments to the United States Constitution. On April 3, 1944, the United States Supreme Court handed down its ruling in *Smith* v. *Allwright.* By a vote of eight to one (Justice Owen Roberts dissenting), the jurists stated that the Democratic primary in Texas was by law a part of the machinery for choosing state and national officials. The primary was an integral part of the electoral process in Texas and therefore the white primary was in violation of the 15th amendment. It was a historic victory for black civil rights. Lulu B. White of the Houston NAACP chapter spoke of the decision as the "second emancipation of the Negro." As for Smith, his comment in *The Informer* summed up the situation aptly: "I guess I feel about like all the other Negroes in Texas and the South. I am happy to be able to vote and see Negroes free in the real sense of the word."

The practical benefits of the decision in *Smith* v. *Allwright* were not long in coming. After the April decision there was time enough for blacks who held poll tax receipts or exemptions to vote in the July primary race. In Houston the Harris County executive committee of the Democratic party instructed all precinct judges to permit blacks to vote without interference. On election day no racial trouble of any kind was reported and of an estimated 5,000 registered black voters in the city, 2,618, or about half, voted. Some 158,000 whites were registered in Harris County, and 55,645, or about a third, cast ballots. While the above figure was encouraging for those involved in the struggle to gain black suffrage, the fact remained that only three percent of the black population in Harris County was registered to vote.

White response to the legality of black voting was tentative. In 1945 Mayor Otis Massey created an "Advisory Committee of Affairs of Colored People" principally to

Marian Anderson, seen here performing in Washington, D.C., performed in Houston four times. Her last concert in the city was given at the City Auditorium to a capacity crowd. The audience was integrated. From the Ebony *Collection*

ease the apprehensions of the white community. Other such committees were also established, but Professor Chandler Davidson, in his seminal work *Negro Politics and the Rise of the Civil Rights Movement in Houston, Texas,* states that most local black leaders saw such gestures as essentially token and lacking in substance. However, some basic progress was made at the county level. Increasingly aware of their importance in local contests, Houston blacks organized the Harris County Council of Organizations (HCCO), an informal coalition of civic clubs designed to protect black rights. Among its leading members were Mack Hannah and the Reverend L.H. Simpson. In 1946 a number of black delegates were elected to attend the Harris County Democratic convention, 18 blacks were appointed by the county tax assessor's office, and five were elected precinct chairmen. For the first time since 1923, a black candidate from Harris County, Erma LeRoy, ran in 1948 for a seat in the state legislature. Campaigning as an independent, she was defeated, but it was a start.

The long campaign to gain the ballot on an equal basis tended to overshadow the advances made by Houston blacks in the fight against segregated facilities. Although on the statute books mixed seating was illegal until the early 1950s, as early as March 1931 the celebrated tenor Roland

Hayes performed in concert before an integrated audience in Houston at the City Auditorium. Hayes returned to the city four years later, again singing to an integrated audience. An artist who enjoyed even greater success in Houston was Marian Anderson. Anderson first sang in Houston for a benefit concert for the Bethlehem Settlement House for underprivileged black children. She appeared in the city again in 1939, 1940, and just prior to Pearl Harbor in November 1941. On the last occasion the City Auditorium was filled to capacity and the audience was integrated in accordance

with Marion Anderson's wishes. She performed works by Scarlatti, Handel, and Brahms, as well as an old spiritual, "Sometimes I Feel Like a Motherless Child."

The above, however, were exceptions to the general rule of the "color line." At a 1933 Houston Civic Opera presentation of *Aida,* in which a number of black Houstonians played roles as Ethiopian slaves, segregated seating prevailed. When a local performance of *Tosca* was produced in 1944, the white demand for tickets was so great that the "colored balcony" seats of the City Auditorium were sold to whites; the only opportunity that black opera enthusiasts had to view the production was at two dress rehearsals. During most of the 1930s, the only tickets available to the Houston Symphony concerts for black patrons were for "special reserved seats." In 1944, after many years of performing afternoon concerts for white schoolchildren, a Sunday afternoon concert was staged for black children for the first time. Although conductor Ernst Hoffman pronounced the event a great success, it still served to perpetuate the practice of segregation.

Unfortunately, the "color line" was not limited to musical performances. It was also observed during the first great showing of the work of black artists in the United States in September 1930 in Houston. The exhibit, presented by the Houston Museum of Fine Arts, consisted of 73 examples of painting and sculpture on the theme of black development. Blacks could only view the exhibit on one day each month that the museum set aside for "colored patrons" or by special appointment. This was all the more ironic since black children had contributed pennies to the expense of bringing the exhibit to Houston in the first place. Of course, the end result of such restrictive practices was the lack of any meaningful black patronage of the museum. By 1945 the museum trustees extended black visiting hours to include Friday afternoons in addition to the one day a month. Even at a showing of 100 drawings and paintings by black children in 1946 the limitations on attendance were still maintained.

Despite the exclusionary policies of the Houston Museum of Fine Arts, the work of black artists did receive some exposure elsewhere in the city. In 1933 the dedication of the Fifth Ward Branch Library in the black section of town was accompanied by an exhibit of the paintings of eight black artists. The next year the show was repeated in the Negro Carnegie Branch Library, and in 1937, the works of Frank F. Sheinall, a black artist from Galveston, were displayed there. In May 1949 the First Annual Festival of Fine Arts was held at Texas Southern University in Houston. The show featured the work of John T. Biggers, an art instructor at TSU and one of the most creative black artists ever to work in Houston. In 1950 one of his drawings, "The Cradle," won the $200 Purchase Prize awarded by the Museum of Fine Arts, and in 1954 an entire show at the museum was devoted to his paintings and sculpture.

Black cultural endeavors in Houston extended to the columns of *The Informer*. The weekly paper published the works of short-story writers and poets until the outbreak of World War II. Wartime limitations on newsprint curtailed this program, but during the postwar period the newspaper again tried to encourage such publication. In 1949 the paper sponsored a short-story contest, won by David Abner, an undergraduate student at Texas Southern University. Houston's black community was also active in the theater. In March 1931 the Houston Negro Little Theatre was organized as an amateur company. During the Great Depresssion adequate financing was difficult to acquire, but the company made its debut in 1935 with a one-act mystery drama, *No Sabe*. The performance was well-received by a predominantly black audience of almost 300. That year the group also performed Oscar Wilde's *Lady Windermere's Fan*, and in November 1941 the troupe put on Thorton Wilder's *Our Town*. However, the Houston Negro Little Theatre did not perform again until 1953, when it staged a highly acclaimed performance of Tennessee Williams' *The Glass Menagerie*.

In 1949 the work of Houston artist John T. Biggers was featured in the First Annual Festival of Fine Arts at Texas Southern University. Then in 1954 and 1968 the Houston Museum of Fine Arts held special exhibitions of his artwork. Courtesy, University of Texas, Institute of Texan Cultures, San Antonio

Access of blacks to libraries in the city was another issue of great significance during this period. In Houston the Colored Library Association, led by Ernest O. Smith, was founded in 1907 to provide library service and to raise money to purchase books. In 1911 the Carnegie Corporation authorized a grant of $15,000 to be used to build a separate library for blacks in Houston. The Negro Carnegie Branch Library, as it was officially called, was completed in 1913 and in 1924 was placed under the jurisdiction of the Library Board of the City of Houston. In 1934 three more libraries were funded within the black community as subdivisions of the main Negro Carnegie Branch Library.

Houston blacks, among them civil-rights lawyer James Nabrit, deplored the failure of the city to provide equal library facilities. In the columns of *The Informer*, Nabrit emphasized that of the approximately 300,000 volumes in the Houston public library system, less then 6,000 could be found in the four black libraries. Employees of the black libraries received lower salaries and operated in cramped quarters with inadequate lighting and restroom facilities. The situation improved somewhat when in 1933 James A. Hulbert became the first professionally trained librarian to accept a position in Houston. Hulbert envisioned the Negro Carnegie Branch Library as the center of black cultural and artistic life in the city. Although he did not meet this goal, Hulbert was responsible for a substantial increase in book usage and circulation at the black libraries. However, after his departure in 1936 and during the war years, the programs offered by the libraries fell off and interest seemed to decline.

In 1950, reflecting the postwar demand for a semblance of equal rights, efforts were made to gain access for blacks to the Main Branch of the Houston Public Library. The Houston NAACP chapter made this a priority and in an attempt to avoid a lawsuit, the Library Board doubled the budget of the Negro Carnegie Branch Library. However, this tactic failed to appease the black community. Upon the strong recommendation of Mayor Roy Hofheinz, the board, pressured by the threat of legal action

In the years immediately after the Civil War, formal educational institutions funded by public money were created to serve the black community. In the late 1870s the system was regularized and formal public schooling was established for both black and white. The Fourth Ward High School served black students in the late 19th century. Courtesy, Texas Room; Houston Public Library

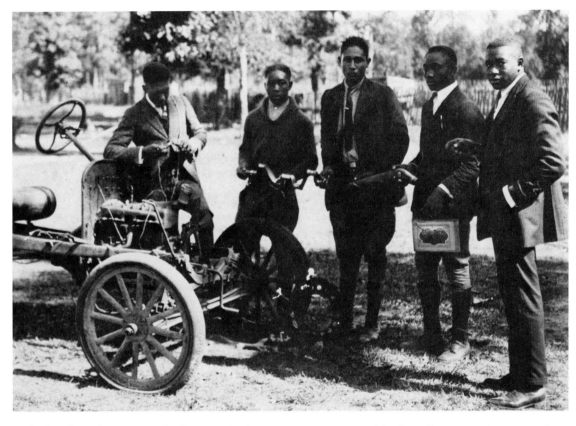

Developed in the early 20th century, the Conroe Normal and Industrial College was the first black higher educational institution established in the area. Classes such as this 1927 one studied vocational as well as academic subjects. Courtesy, Texas Room; Houston Public Library

and the fact that a suit had recently been won desegregating the municipal golf courses, opened all its branches to the use of "all persons." Although these advances were laudable, it was not until the 1960s that black librarians were hired or that there was black membership on the Houston Library Board.

Segregation in education continued in Houston. The amount of money appropriated by the school board per student was much higher at white schools than black. Physical plants and facilities were initially superior and maintained better at white schools as well, and the standards demanded of teachers when hired for the first time were more rigid and exacting at the white schools.

Until the mid-1920s there had been one state-supported university for blacks in Texas. As originally conceived in 1878, Prairie View A & M was envisioned as an agricultural school. In 1901 the state legislature provided funds to establish a program there in "classical and scientific" studies, but professional and pre-professional classes languished for lack of adequate funding. Some of the slack was taken up by the 20 or

so private black colleges in the state, but, without exception, adequate financial resources proved a constant problem.

In 1937 the Texas legislature increased the appropriation for the black school at Prairie View, enabling it to offer graduate study. However, although a few master's degrees were awarded and two faculty members with doctoral degrees were hired in the physical sciences, the program at Prairie View was in no way comparable to the University of Texas. In 1939 the general appropriation for Prairie View was slightly increased again, but it was still foolish to pretend that its facilities were equal to those of the University of Texas at Austin. A decision in the legislature to establish a separate law school at Prairie View was blunted by the approach of World War II.

Spurred by the sacrifices made by blacks in the war, the issue came to the fore again upon the conclusion of the fighting. At a meeting of all Texas branches of the NAACP in Houston, it was agreed that having abolished the white primary, the next attack would be against discriminatory policies in public education, starting with graduate and professional education. Anti-

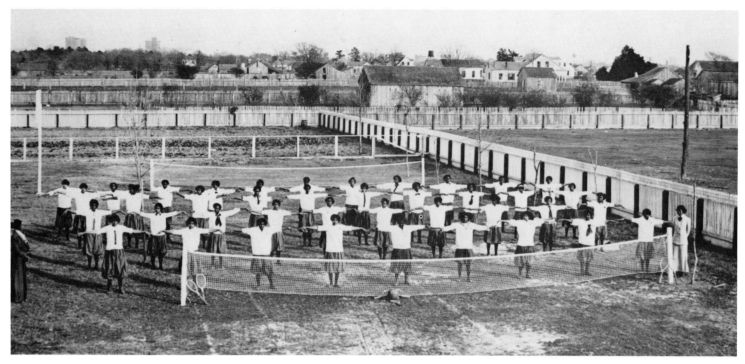

Houston's educational system always included opportunities for at least some physical education classes even in the 1870s. The students at Houston College, such as these women, took part in physical activities. Courtesy, Texas Room; Houston Public Library

cipating what was in the offing, the legislature upgraded Prairie View to a "State University" and authorized graduate training in law, medicine, pharmacy, engineering, and "any other course taught at the University of Texas." In theory, equal training at separate institutions now existed, but the facts were much different.

As Houston had been the focal point of the cases challenging the white primary, so would it be in education. In 1946 Heman M. Sweatt, an honor graduate of Wiley College and a World War II veteran, applied to the law school of the University of Texas at Austin. Sweatt, a native Houstonian employed as a mailman at the time, was denied admission solely on the grounds of his color. Once again Thurgood Marshall, on behalf of the NAACP, headed the legal team assisted by James Nabrit. A state judge ruled that since no black law school existed in Texas, Sweatt must be permitted to enroll at Austin unless equal facilities were guaranteed elsewhere within six months.

In the 1946 election every candidate for governor pledged to continue segregation at all state universities. Meanwhile the legislature sought to create a separate law school for blacks by hiring two black attorneys in Houston to offer courses in a rented building adjoining their offices. When no stu-

dents applied for admission and the subterfuge was roundly condemned by black leaders, a new tack was tried. Now space was rented in Austin in a basement near the state capitol. Classes would be taught by University of Texas faculty and black students would have access to both state and University libraries. Only three students, one of them from Houston, enrolled. A difference of opinion resulted among the leadership of the Houston black community; some were inclined to accept the situation in Austin as a step forward, while others agreed with the NAACP decision to take the Sweatt case to the Supreme Court if necessary.

The Sweatt matter indirectly led to the establishment of Texas Southern University, the principal state university for blacks located in Houston. Texas Southern University traces its origins back to 1926. In that year, a group of Houston black leaders, despairing of any other solution, arranged for Wiley College at Marshall to offer extension courses at the Jack Yates High School in Houston. In 1927 this program was assimilated into the curriculum of the Houston Colored Junior College, which was set up to provide further education for the graduates of Houston's three black high schools. The junior college was municipally controlled

and functioned until 1934 when an upper division was added. In 1935 the upper division became the Houston College for Negroes, a branch of the University of Houston, and the lower division remained Houston Colored Junior College. In quick order the degree programs of the Houston College for Negroes were approved by the Texas State Department of Education and the Southern Association of College and Secondary Schools.

After World War II the Houston College for Negroes launched a fund-raising campaign that proved eminently successful. Encouraged by a gift of $100,000 from Hugh Roy Cullen, the major benefactor of the University of Houston, $283,000 was ultimately raised through the contributions of white and black Houstonians. In 1947 the legislature earmarked a special appropriation to locate a black university in Houston. A 53-acre campus was located near the University of Houston and by the fall of 1947, Texas State University for Negroes (later called Texas Southern University) opened its doors to some 2,000 students. The temporary law school was then moved from Austin to Houston, but

Sweatt reiterated his determination not to attend a segregated institution.

Meanwhile the Sweatt case worked its way through the labyrinth of state and federal courts. Before the Texas Court of Civil Appeals and the Supreme Court of Texas, Attorney General Price Daniel successfully argued that the Texas State University for Negroes provided a "separate but equal" legal education. But applications for admission to medical school and for professional degrees in other fields were also before the Board of Regents of the University of Texas and it was apparent that some decision must soon be reached. In April 1950 Thurgood Marshall of the NAACP and Price Daniel, representing the state of Texas, appeared to argue before the United States Supreme Court. In June the Supreme Court handed down its opinion that the law school in Houston was not equal in any way to the established University of Texas Law School; the faculty, library holdings, moot court and law review facilities were decidedly inferior. Sweatt was thus confirmed in his constitutional right to enter the University of Texas. He was 40 years old when finally admitted and had not attended a college

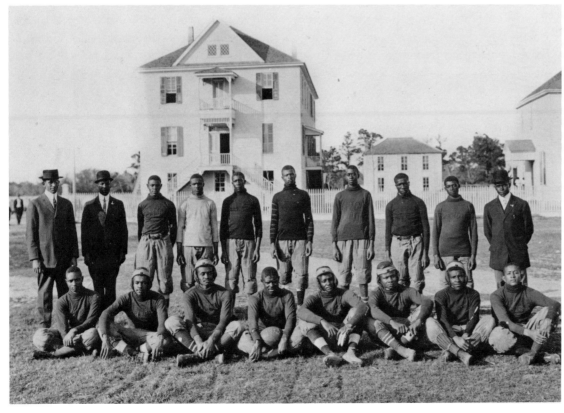

Located on the west side of the the city near Buffalo Bayou, Houston College served the needs of the black community for a number of years. The 1914 football team played games with a number of other black schools in the region. Courtesy, Texas Room; Houston Public Library

class since 1937. Thus it came as no surprise that he was dismissed within a year because of failing grades. In a sense, he had willingly martyred himself in the cause of black education. Finally, within five years after the historic court fight the Texas Southern University Law School in Houston was accredited by the American Bar Association and the American Association of Law Schools.

Segregated facilities remained in place in Houston's public schools all during the 1940s. Funding for schools in black neighborhoods continued to be inferior and discrepancies persisted in teacher compensation, physical plants, and the like. Yet the Sweatt case was a harbinger of the future and pointed the way to the decision in *Brown* v. *Board of Education* (1954) that "separate but equal" policies are unconstitutional.

The sting of segregation was felt not only by blacks, but also by Mexican-Americans, who numbered about 55,000 in Houston in 1945. They were, for example, refused service at restaurants, and burial in predominantly Anglo cemeteries. They were condemned to residential segregation, and they, too, determined to fight back. As it was for blacks, World War II was also a decisive era for many Mexican-Americans. Experiencing relative equality of treatment during their

military service, they anticipated the same treatment upon their return to civilian life. Between 6,500 and 7,500 Mexican-Americans had enlisted, and many had been decorated for bravery in action. In the immediate postwar period, a chapter of the American GI Forum, founded in 1948 by Dr. Hector Garcia, was quickly organized in Houston. A voter registration plan was implemented and a policy of opposing educational segregation was also proclaimed. In addition, a drive to aid needy families and provide scholarships for deserving students was also announced. However, while the GI Forum attracted the backing of many Houston Mexican-Americans, it was neither the first nor the most successful of the Latin protest groups.

Houston's Mexican-American community dates back to the period of the Republic and early statehood. In the first half of the 20th century, most Houstonians of Mexican-American ancestry lived in the Magnolia Park and Houston Ship Channel sections of town. In more recent years, a substantial community has developed on the north side and to a lesser degree in the southwest sections of the city. Our Lady of Guadalupe Church on Navigation Boulevard, in the heart of the older Mexican community, attracts the greatest number of parishioners to Roman Catholic church ser-

Neighborhood restaurants served as the centers for much of community life in Houston's different ethnic neighborhoods. The La Consentida Cafe at 1700 Washington was one of the social centers for the Mexican-American community in the 1930s. Courtesy, Houston Metropolitan Research Center; Houston Public Library

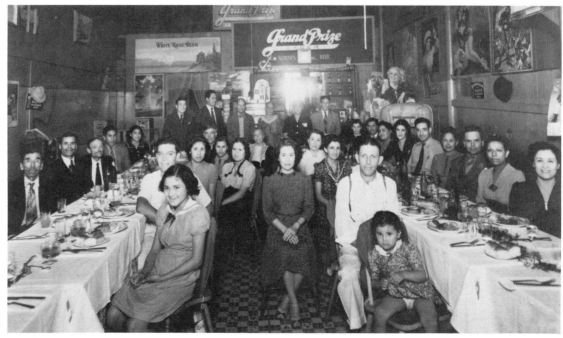

vices, while St. Hyacinth (San Jacinto) on Center Street and Annunciation Cathedral on Texas Avenue also have their adherents. Two Protestant churches, Iglesia Bautista West-End and Iglesia De Dios-Israelita, conduct services entirely in Spanish.

There are two Spanish-English community newspapers available to Mexican-Americans residing in Houston, *El Sol* and *Compass.* Of the publications, the latter is generally less content with the political status quo. Occupational groups, both professional and non-professional, abound, and

there is a local Mexican Chamber of Commerce subsidized by the business community. The most effective social service group is *Familias Unidas,* which employs as its motto, "Por el Progresso y Cultura de Nuestra Juventud" ("For the Progress and Culture of Our Youth"), and other clubs exist to commemorate Mexican holidays with a parade or fiesta. Finally, the League of Latin American Citizens (LULAC) and the Political Association of Spanish Speaking Organizations (PASO) together boast a membership of about 40 percent of the Houston Mexican-American community. PASO claims to be the strongest Mexican political organization in Harris County, but there is no doubt that the LULAC organization is the most effective on a state and national level.

LULAC was the very first organization of Mexican-Americans to wage a struggle for equal rights. The movement incorporated two splinter groups already functioning as protest organizations—the League of Latin-American Citizens and the Order of Sons of America. South Texas, where the concentration of Mexican-Americans was greatest, inspired this activity, and on April 17, 1929, at Corpus Christi, the League of United Latin-American Citizens was founded. A Houston chapter was formed in 1934. In the LULAC constitution, loyalty to the United States was put beyond ques-

Houston has become the site of a group of great medical institutions. Centered in the area around Hermann Park, close to both downtown and Rice University, these medical institutions have served the community, the nation, and the world, caring for rich and poor alike. Courtesy, Texas Room; Houston Public Library

As Houston's Mexican community continued to grow, Our Lady of Guadalupe provided more different services and religious activities for it. This religious procession took place in the 1940s. Courtesy, Houston Metropolitan Research Center; Houston Public Library

Right:
The Club Cultural Recreativeo Mexico Bello was organized within the Mexican community to serve the social needs of the leaders within that community. Active for many years, the club sponsored a number of social events and also served to bring the leaders of the Mexican community together for many different functions. Courtesy, Houston Metropolitan Research Center; Houston Public Library

Far right:
The Depression hit all parts of the Houston community. For some the prices of stores such as La Casa Verde were beyond reach. Courtesy, Houston Metropolitan Research Center; Houston Public Library

Right:
Although Houston had always had a small Mexican-American population, the turmoil in Mexico during the early 20th century caused many, such as this family, to migrate north to find stability and escape from the dangers of revolution. Courtesy, Houston Metropolitan Center; Houston Public Library

Right:
Orchestras tipicas, accompanied by Mexican dancers, provided popular entertainment for the Mexican-American community in Houston during the 1920s and 1930s. This orchestra tipica was being filmed by RCA for a short subject on Mexican music and dance to be distributed by Pathe. With their costumes and music, the entertainers were an important part of the Mexican tradition in Houston. Courtesy, Houston Metropolitan Research Center; Houston Public Library

-CLUB CULTURAL RECREATIVO MEXICO BELLO.-
-1932-

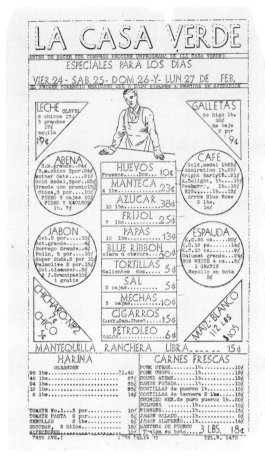

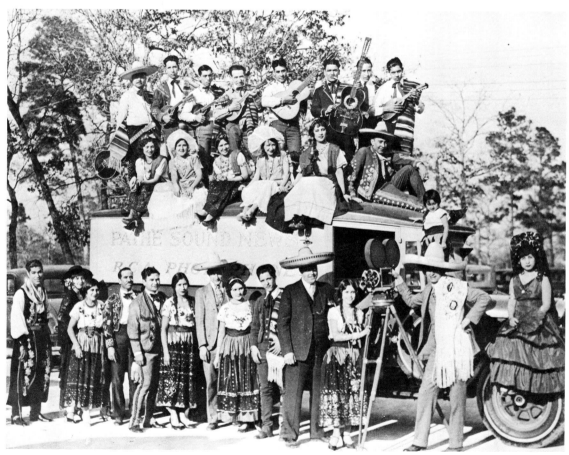

In the 1920s Houstonians were beginning to take advantage of the new medium of radio. The big clear channel stations brought the outside world to the city and then KTRH, KPRC, and KXYZ gradually came on the air, bringing local broadcasts to the city. Furniture stores, such as the Alamo Furniture Company (pictured here), sold radios to all ranks of the community. This store served the Mexican-American community, providing it with the latest in electronics as well as furniture. Courtesy, Houston Metropolitan Research Center; Houston Public Library

Below left:
Small grocery stores such as the Reyes Food Store in Magnolia Park served most neighborhoods in Houston well into the 1930s and 1940s. Owned by members of the community, these convenient stores were an important part in the group of social institutions that made up Houston in the years preceding World War II. Courtesy, Houston Metropolitan Research Center; Houston Public Library

Below:
Jose Sarabia's bookstore at 1800 Congress was the center of Mexican intellectual life in Houston during the 1920s. Courtesy, Houston Metropolitan Research Center; Houston Public Library

tion and the obligations of American citizenship were also duly noted. On the other hand members pledged to employ every legal strategem available to end discrimination against Mexican-Americans. Specifically, the delegates vowed to oppose any prohibitions against voting, integrated schools, or their right to serve on juries.

Another declared purpose of the League was to "promulgate the English language among Mexican-Americans." At the same time Latins must be made conscious of their history in Texas and the Southwest in order to stir pride in their heritage. To achieve these aims a monetary fund was established ensuring frequent access to the courts for the protection of civil rights. Cautious in their aims and anxious to work within existing political and economic alignments, the Houston LULAC chapter reflected the dominant middle class origins of the group.

Following the example of the NAACP, the LULACS turned to the courts to assure equal rights for Mexican-Americans. On June 15, 1948, the Texas Supreme Court issued an injunction against segregated education for Mexican-Americans beyond the first grade, in which classes could be segregated for the purpose of special instruction. However, conditions in Houston schools did not change overnight, and segregation continued.

Another class action lawsuit on behalf of Houston's Mexican-American community challenged de facto residential segregation. Until about 1950 most Mexican-Americans in Houston lived on the east side of the city in the area between Canal and Navigation streets. As the community became better educated and tended more toward a middle-class orientation, attempts were made to move into some of the city's more desirable residential areas. It was here that restrictive covenants, barring Mexicans from living in specific neighborhoods, were frequently encountered. While a Houston case was pending in the state courts, the Supreme Court of the United States outlawed restrictive covenants as in violation of the 14th amendment to the constitution. Still, the case had little practical effect on residential segregation of Mexicans; their inability to afford better housing continued to be the decisive factor.

Traditionally, in Texas, Mexican-Americans had been slow to exercise their political rights. Often the pawns of Anglo bosses, particularly in South Texas, Mexican-Americans tended to vote for Democratic candidates in both state and national elections. Never particularly militant, they watched with interest as blacks began to insist upon the right to enter into the mainstream of Houston's political life. Eventually, businessman Lauro Cruz, a conservative

KLVL, established in 1956, was the first radio station to offer Spanish programming for the Mexican-American community. Although its owner, Felix Morales, had planned to broadcast in English, he realized that the need for Spanish-language programming was sufficient to merit a Spanish station. Courtesy, Houston Metropolitan Research Center; Houston Public Library

member of LULAC, became the first Mexican-American from Houston elected to the Texas legislature.

No national political figure has had a greater appeal to Mexican-Americans in Houston or throughout Texas than the late John F. Kennedy. A "Viva Kennedy" club was organized by Albert Fuentes in Houston in 1960. While national Democratic candidates had done well with Mexican-Americans in Texas from the 1930s on, John F. Kennedy surpassed them all. Of the 17 counties in Texas (not including Harris) where more than 50 percent of the population had Spanish surnames, Kennedy failed to carry only one. Perhaps even more impressive was the fact that of the 24 counties (including Harris) in the state with a Spanish surname population of 30 to 49.9 percent, Kennedy triumphed in 19.

The "Viva Kennedy" clubs had been so successful in turning out the vote that leaders of the party decided to create a permanent organization. In February 1961 delegates from Houston attended a statewide meeting in Victoria, Texas, at which the Political Association of Spanish-Speaking Organizations (PASO) was established. While the aims of PASO were similar to other Mexican-American organizations, the group was distinct in its emphasis on political action to achieve equal rights. No racial or ethnic barriers to membership in PASO were stipulated, and the participation of all minority groups was welcomed. Since its establishment, the Houston chapter of PASO has been among the most vigorous in Texas.

In conclusion, Houston's minorities of color made substantial gains in civil rights during and immediately after World War II. Both groups began by emphasizing access to state and federal courts in pursuit of their rights. In this connection the city of Houston played a disproportionate role in the civil liberties arena since *Grovey* v. *Townsend*, *Smith* v. *Allwright*, and *Sweatt* v. *Painter* all involved Houstonians as plaintiffs. After winning legal victories on several fronts, both blacks and Mexican-Americans then turned to the franchise as a method of making their demands felt. Not since 1881 had a black sat in the state senate at Austin, but that was now realized with the election of Barbara Jordan in 1966 as senator from Harris County. In the same election, Curtis Graves was elected to the state house of representatives. In 1961 the first Mexican-American to serve in the United States Congress House of Representatives, Henry Gonzales of San Antonio, was elected. Leaders of both groups were cognizant of the fact that their people had begun to enter the mainstream of politics, but that much still remained to be achieved.

"Glamburger" Girls were the
glamour girls of Houston during
the war years. Employed by
restaurants such as Prince's, a
chain of drive-ins, the girls
entered contests on Galveston
Island and elsewhere, showing
off their skills as waitresses and
their daring costumes designed
by their employers. The 1943
winner is on the right. Courtesy,
Rosenberg Library

BUSINESS, POLITICS, AND THE ARTS: HOUSTON'S HEADY MIX

On the eve of World War II, Houston could claim 385,000 inhabitants, 340,000 more than in 1900. After this rapid growth, the city's tremendous urban expansion continued unabated. Attracted by a favorable business climate, the population reached 690,000 in 1954, and by 1960 the city and county together were home to virtually one million people.

Among those who participated in Houston's expansion was entrepreneur Glen H. McCarthy, whose flamboyant lifestyle and rags-to-riches career masked a shrewd record as a successful oilman and land speculator. In 1944 McCarthy purchased 15 acres of land at the intersection of South Main Street and Bellaire Boulevard for $175,000. Until that time all of the city's major hotels were located downtown and only a handful of apartment hotels were situated in outlying residential areas. When in 1946 McCarthy began development of the Shamrock Hotel more than five miles from downtown Houston, a new stage in the city's growth commenced. Preliminary plans for the McCarthy Center also included seven apartment hotels, an ice-skating rink, a swimming pool, and a department store; most of these never progressed further than the architect's drawing board.

On St. Patrick's Day, 1949, the Shamrock Hotel was opened to the public. What followed has become a part of the folklore of the city of Houston. Almost 50,000 people turned out to see about 100 Hollywood stars brought in to witness the Dorothy Lamour radio broadcast from the hotel. Gene Autry, Lana Turner, Pat O' Brien, and other household names of that era were present and were nearly crushed by the surging crowd. It took Mayor Oscar Holcombe some two hours to gain entrance to the hotel, and other local political figures gave up trying. When the crowd became particularly unruly, NBC cancelled the radio show. Edna Ferber's memorable novel, *Giant*, and the movie starring James Dean that followed have immortalized opening night at the Shamrock.

By 1950, however, the hotel's builder was reported to be in serious financial difficulties. Because of increased state regulation, oil production in Texas was down, and McCarthy had incurred large debts in order to construct the Shamrock. While the hotel's operations were self-sustaining, other McCarthy holdings were not, and the hotel was acquired in a foreclosure proceeding by the Equitable Life Assurance Society. They, in turn, sold the hotel to the Hilton chain, and in 1955 the structure was renamed the Shamrock Hilton. Symbolically, the portrait of Glen McCarthy that had hung in the lobby since opening day was now replaced with that of Conrad Hilton. Although McCarthy lost his prized property, his foresight in building far from the downtown area was remarkable. Shortly after the Shamrock was built, Prudential Insurance Company announced the location of a Southwestern office near the site of the Shamrock, and this was followed by the construction of the Fannin National Bank in the same locale.

Sadly, in 1985, the Hilton Corporation sold this revered landmark to the Texas Medical Center. Two years later is was demolished and turned into a parking lot.

As had giants like Glen McCarthy in the oil business, leaders in other enterprises contributed more than just industry to the city. For example, Monroe D. Anderson of Anderson, Clayton & Company brought to Houston the beginnings of what has become a worldwide reputation for excellent medical facilities.

The origins of Anderson, Clayton & Company, the world's largest cotton concern, were modest. Founded in Okla-

homa City in 1904, the company moved to Houston in 1916 to be at the center of the cotton business. The original partners were Frank E. Anderson, his brother Monroe D. Anderson, and William L. Clayton, all of whom had prior experience in the cotton trade in Tennessee and Mississippi. They expanded the company's markets and began to diversify. Thus when the cotton market suffered a decline in the 1960s, the company was able to fall back on its interests in insurance and manufacturing.

In 1940 Will Clayton left Anderson, Clayton & Company to serve the federal government in Washington, eventually influencing the formation of the Marshall Plan. But the greater importance of the company to Houston lay principally in the charitable contributions of Monroe D. Anderson.

In 1936 Monroe Anderson, who had never married, established the M.D. Anderson Foundation, which at Anderson's death in 1939 received the major share of his estate, amounting to some $20 million. The trustees made a grant to Rice Institute for a classroom building and to the University of Houston for a library, but their principal accomplishment was the creation of the Texas Medical Center. University of Texas President Homer T. Rainey, Mayor Oscar Holcombe, Harris County Judge Roy Hofheinz, and Foundation trustees began negotiations to pur-

chase land from the city next to Hermann Hospital for the erection of a cancer research hospital to be supervised by the University of Texas. The land was purchased in 1942, and the first building was completed the next year. Today the M.D. Anderson Hospital and Tumor Institute is among the leading such facilities in the world. With President Rainey's enthusiastic approval, the University of Texas Dental School then relocated to the Medical Center, followed in 1943 by the Baylor Medical School.

Over the years the Texas Medical Center has expanded to include the Methodist Hospital, St. Luke's Episcopal Hospital, Texas Children's Hospital, Ben Taub Charity Hospital (Harris County), the University of Houston College of Nursing, the University of Texas Health Science Center and the University of Texas Medical School at Houston. The center has become a mecca for patients throughout the world seeking the latest developments in diagnostic methods and medical treatment. Dr. Michael DeBakey and Dr. Denton Cooley have brought fame to the Texas Medical Center through their pioneering work in cardiac surgery and organ transplantation. Although it has never been widely publicized, the Anderson Foundation has also contributed liberally to the support of city and county charity hospitals.

In medicine and in other areas, the climate of growth in Houston encouraged improvements in the quality of life. As the

The ABC network radio show Saturday at the Shamrock attracted all the major stars during its heyday. When new movies such as African Queen were released, the stars, like Humphrey Bogart, appeared with Shamrock owner Glenn McCarthy and host Fred Nahas to gag, perform, and promote their pictures. Courtesy, Harris County Heritage Society

Houston's rise as an economic and population center was symbolized by the increasing number of visits from national celebrities and leaders. General Douglas MacArthur came to Houston in the early 1950s as a part of his effort to build a national constituency. Courtesy, Harris County Heritage Society

The Museum of Fine Arts houses a collection ranging from ancient Greek and Egyptian art to contemporary masterpieces. It is the city's major museum.

Bayou City grew into a thoroughly 20th-century metropolis, it gained many of the features that make urban life attractive and stimulating, including up-to-date facilities for and offerings in the arts. In the postwar period, Houston made great strides in the area of visual arts. The holdings and facilities of the Houston Museum of Fine Arts were expanded, and the Contemporary Arts Museum and the Rothko Chapel, both initiated after World War II, enhanced the city's position as a Southwestern art center.

A number of paintings by Frederick Remington, which depict life in the West and the story of the American cowboy, were donated to the Houston Museum of Fine Arts by Ima Hogg in 1942 and remain an important part of the museum's holdings. In 1953 the museum's facilities were increased with the addition of the Robert Lee Blaffer Memorial Wing, which now holds an impressionist collection; in 1958 Cullinan Hall, featuring a more modern type of architecture, was dedicated; and in recent years a sculpture garden has been added.

Located across from the Museum of Fine Arts is the Contemporary Arts Museum, founded in 1949. In 1955 Dr. Jermayne MacAgy of San Francisco was employed as its professional director. A devotee of modern art anxious to bring the best of such works to the attention of Houstonians,

MacAgy provided skillful leadership. However, in 1959 she resigned in order to accept a position at St. Thomas University in Houston and was replaced by Sebastian J. Adler. The Contemporary Arts Museum has enjoyed the patronage of John and Dominique de Menil, who have devoted much time and wealth to its success.

The de Menil family has made further contributions to the advancement of fine art in Houston. In 1964 they commissioned the Rothko Chapel, in which 14 of Mark Rothko's abstract expressionist paintings create a meditative atmosphere lit through a single skylight. The chapel was dedicated in 1971, one year after the artist's death. The de Menils also commissioned the Barnett Newman sculpture, the *Broken Obelisk*, which stands in a pond outside the chapel as

The Alley Theatre is home to the nation's oldest resident professional Equity group. Founded in 1947, the theater company has gone on to international renown.

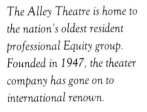

a memorial to Dr. Martin Luther King, Jr.

As in visual arts, Houston made great strides in the performing arts since World War II. In 1947 a small group of theater enthusiasts accepted the gift of a studio, partially situated in the alley at 3617 Main Street. The Alley Theatre was so successful that less than two years later it moved to new headquarters at 709 Berry Street. There for 19 years it staged more than 150 productions and built its reputation. From its inception the guiding genius of the troupe was Nina Vance, who acted as director, fund raiser, and liaison to the general theater-going public. Alley productions were often built around one recognized Broadway or Hollywood star, while featuring a local supporting cast. Such performers as Ray Walston, Jimmy Jeter, and Jeanette Clift all gained their first acting experience with the Alley, which is one of the oldest of the nation's resident professional Equity groups.

In 1959 the Ford Foundation made a grant to the Alley to further its work, and in 1962 it awarded $2.1 million in matching funds for the construction of a new theater across from the future site of Jones Hall. The Alley is now housed in a $3.5-million theater with two playhouses that seat 800 upstairs. The Arena Theatre downstairs has a capacity of 300 seats. Although Nina Vance has passed away, the Alley, under new leadership, continues to present a full and varied season each year. Also, semi-professional groups such as the Channing Players housed in Fellowship Hall, are flourishing. The Stages Theatre on Franklin Avenue and Chocolate Bayou Theatre on Lamar Avenue feature local casts and avantgarde productions and the Houston Shakespeare Society performs with a cast of non-professionals.

In addition to the talent these groups bring to the stage, the Houston Ballet, originally founded in 1955, has developed as a major force in the cultural life of the city under the leadership of Ben Stevenson. Generous funding for the Houston Ballet has been provided by local businessmen and corporations eager to further its success.

The Society for the Performing Arts also plays an important part in Houston's cultural offerings. A nonprofit agency, the SPA was the creation of John H. Jones, Jr., editor of the Houston *Chronicle* and a nephew of Jesse Jones. When the Jesse H. Jones Hall for the Performing Arts was completed in October 1966 with funding from the Houston Endowment, it was anticipated that the Houston Symphony and the Houston Grand Opera would be its principal tenants. However, since this would account for only two or three nights a week at best, the SPA was chartered and charged with bringing the "finest international touring attractions" to Houston. Since its inception in 1966, the Society has presented such diverse attractions as the Mexican Ballet Folklorico, the American Folk Ballet, *Hello Dolly*, *Fiddler on the Roof*, and the Obernkirchen Children's Choir, as well as world-renowned individual performers.

While the increasingly metropolitan Bayou City was acquiring modern facilities in the arts and sciences, its growth continued to be fueled by the oil and gas boom.

A successful company in the energy area was the Houston Pipe Line Company,

Baylor University College of Medicine, in the Texas Medical Center, became world famous with the cardiovascular surgery and organ transplantation work of Dr. Michael DeBakey and Dr. Denton Cooley.

William "Hopalong Cassidy" Boyd visited Houston for charitable events in the early 1950s, bringing his own special style to Houston children, who copied his dress. Courtesy, Harris County Heritage Society

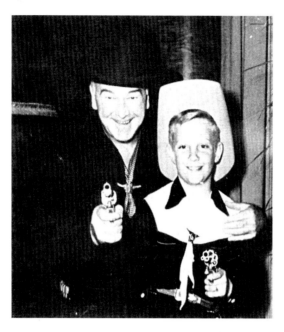

which became the major supplier of the Houston Natural Gas Company organized in the same year. Located originally in the Scanlan Building in downtown Houston, both Houston Pipe Line and Houston Natural Gas moved their offices to the newly completed Petroleum Building in 1927. A 22-story edifice, the Petroleum Building was the headquarters for a number of Houston-based oil companies and was on the way to becoming the landmark that it is today.

Until 1927 the Houston Gas and Fuel Company had been contracted by the City Council to provide the city with gas, but in that year Houston Natural offered the city a 10-year contract at a lower rate than Houston Gas and Fuel was offering, and from then on the Bayou City market belonged to Houston Natural Gas. In 1933 Frank C. Smith, a local banker, became president of Houston Natural Gas. He accurately foresaw the unmatched postwar growth of the city and by 1947 the company had installed more than 100,000 meters in Houston. By 1953 two hundred thousand meters had been installed and in that same year Houston Natural Gas Production Company was formed to obtain drilling properties and to participate in the search for oil and gas. The acquisition in 1957 of the McCarthy Oil and Gas Corporation, founded by Glen McCarthy,

facilitated this aspect of the company's business.

Chartered on March 16, 1925, the most successful Houston firm in the natural gas field was the Tennessee Gas Transmission Company, founded by H. Gardner Symonds. The company was organized in 1944 and just 12 years later had assets of more than a billion dollars. Renamed Tenneco, Inc., in 1946, the company became involved in the manufacture of automotive components and tractors as well as chemical and natural gas pipelines.

An energy company projected to bring downtown Houston many new facilities was the Texas Eastern Transmission Corporation. Texas Eastern began by purchasing the "Big Inch" and "Little Inch" pipelines, which were built during World War II and effectively linked Texas to Eastern markets. From the production and transportation of natural gas supplies, the company moved into the manufacture of petrochemicals. However, it was as the primary developer of the Houston Center that Texas Eastern has become best known. The project encompassed a 33-block central business district, which doubled the size of the city's downtown business area upon its completion in 1990. The Houston Center includes a convention center, hotels, people-mover vehicles, and enclosed parking for some 40,000 cars.

The oil business had always been the benchmark of Houston's growth since Spindletop, so the tidelands controversy of the 1950s era generated a great deal of emotion in Houston. The dispute had its origins back in 1933 when Secretary of Interior Harold Ickes stated that the federal government had no right to issue drilling permits in leases for submerged coastal lands and that such authority belonged to the states. However, by 1937 Ickes had experienced a change of heart after the discovery of the Wilmington-Long Beach oil field off California. The United States government now brought suit to prevent the exploitation of that field by a California company, and in

1946 the Supreme Court ruled that California's tidelands were the property of the federal government.

Texas challenged the California case in 1950, and the Supreme Court's ruling was eagerly anticipated by the Houston oil fraternity, but again the decision was in favor of the federal government. The dispute then moved to offshore lands. In the 1952 Presidential election, Adlai Stevenson, the Democratic nominee, endorsed federal ownership of the tidelands, while Dwight Eisenhower, his Republican opponent, announced his backing for state control. Houston oilmen led an ultimately unsuccessful attempt to place Eisenhower's name as the Democratic nominee on the ballot in Texas, though he was the Republican candidate everywhere else.

As he had pledged to do, Eisenhower soon signed legislation returning to Texas title to the submerged lands 10.5 miles out to sea. The bill actually restored state titles to their "historic limits," which meant three miles for all states except Texas and Florida. The latter were covered by Spanish law, which had granted title for "three leagues," about 10.5 miles.

Benign political viewpoints in Washington, D.C., and Austin combined with constantly increasing demand to make Houston the oil, gas, and petrochemical capital of the world. This status ensured the growth of banking, insurance, and investments tied to the search for oil and gas. Thoughtful economists, however, wondered whether this span of unrivaled growth since Spindletop in 1901 was destined to continue. By the early 1980s the world surplus of oil, OPEC's pricing policy, increasing conservation, and concern over the dangers of pollution had drastically changed the oil industry. The day of the colorful, independent oilman seemed to be a thing of the past.

While legislation and politics on the national level affected Houston business interests, local politics in the postwar period impacted public services, notably education. There were more than 80,000 students attending 126 public schools in Houston in 1949 when contention first arose over a school board resolution to accept federal aid for lunches. The proposal was attacked by the Committee for Sound American Education (CSAE), an ultra-conservative group, on the grounds that it would result in eventual federal control and supervision. However, compromise was reached when the board agreed to collect private funds for lunches. Opposition to the federal lunch program remained vocal until 1968, when the board finally agreed to accept funds from Washington.

The next controversy arose in October 1949 when the local board banned Professor Frank Magruder's *American Government,* a textbook that had been in use for many years, because of an alleged favorable reference to communism. Charges against the use of particular textbooks in history and government courses continued. Issues such as these were raised in the decidedly conservative political climate of Houston in the 1950s. In this period the *Houston*

Although Houston's career as a cattle town has been sporadic, the stock show that grew up in the city has attracted the interest of the cattle culture long before the modern revival of Saturday night cowboys. Western entertainers such as Roy Rogers made the stock show and the Shamrock stops on their tours in the early 1950s. Courtesy, Harris County Heritage Society

Chronicle and much of the city's business elite strongly supported the tactics of Senator Joe McCarthy.

One organization in Houston that flourished in this atmosphere of anti-liberalism was the "Minute Women of the U.S.A." This ultra-conservative political group was founded in Connecticut in 1949 by Suzanne S. Stevenson for the purpose of opposing "communism" in government and in the public schools. In 1951 a chapter of the Minute Women was organized in Houston and it rapidly became the most powerful of the local anti-communist groups. In its wake came organizations committed to many of the same beliefs, such as the Harris County Republican Women's Club, the American Legion, and the Doctors for Freedom. At meetings of the Houston School Board the Minute Women voiced their opposition to desegregation, federal assistance to education, and American membership in the United Nations. Board members complained that the routine business of educational matters was often left undone because of the ideological debates, and political divisions among classroom teachers and administrative personnel interfered with the daily business of educating children.

In the November 1952 school board election, candidates running under the banner of the "Committee for Sound American Education," which represented the interests of the Minute Women, won two of the four contested seats. With the election concluded, the Minute Women sought the removal of George Ebey.

Earlier in the year Ebey, an educator with a history of involvement with liberal causes and a reputation as an able administrator, was hired as deputy superintendent by William E. Moreland, superintendent of public schools in Houston. Moreland later said that he had selected Ebey on the basis of his high recommendations from Columbia University and his vast administrative experience. Moreland had not concerned himself with Ebey's political beliefs, which were admittedly liberal, but hardly radical.

At a board meeting a local attorney, John P. Rogge, accused Ebey of communist sympathies. The educator defended himself vigorously, and was completely exonerated of the charges by an FBI report; nevertheless, the board by a 4-3 vote refused to renew his contract. Chairman James Delmar insisted that Ebey had been dismissed because of a poor job rating, but both the Houston Teacher's Association and the National Education Association condemned Ebey's firing. The entire episode reflected the strong conservative emphasis in Houston politics at that time.

If communism was the issue during the Cold War, desegregation became the problem at a later date. In 1954 the United States Supreme Court handed down its decision in the landmark case of *Brown* v. *Board of Education of Topeka, Kansas,* in which it called the "separate but equal" doctrine discriminatory and gave the United States District Courts responsibility for the integration of educational facilities. In 1956 the Houston School Board ordered integration of the administrative wing of the public schools but postponed desegregation of the pupils until a construction program aimed at providing equal and adequate facilities everywhere for all students could be completed. Impatient with these dilatory tactics, the local NAACP chapter filed suit to compel desegregation.

By November 1956 the conservatives again controlled the school board, and Mrs. Dallas Dyer, a member of the Minute Women, was its chairman. The board issued a statement in May 1957 pledging no desegregation of the Houston schools until 1960, when the ongoing building program would be finished. In the interim, Federal District Judge Ben C. Connally had ordered desegregation with "all deliberate speed" but had carefully refrained from setting an exact date. Mrs. Dyer and school board attorney Joe Reynolds said there would be no appeal as the school trustees felt the order to be a wise decision. Judge Connally's decision was moderate, but the board took advantage of the absence of a starting date by postponing any attempt to begin desegregation. Judge Connally believed that a local plan of desegregation should be

instituted because court-ordered plans in the past had led to resentment and violence.

Then in 1958, for the first time in the history of the board, an Afro-American, Hattie Mae White, was elected to a seat, which she held until defeated for reelection in 1967. Pressed by Judge Connally to submit a workable plan of desegregation by June 1, 1960, the board submitted a proposal to integrate one elementary, one junior high, and one high school. Now, clearly out of patience, Connally stated that desegregation must commence in all first grades in September 1960 and continue at one grade a year after that. But, through the enforcement of rigid requirements, only 12 black children out of a student population of more than 175,000 were able to attend an integrated school in September 1960.

Subsequent attempts to remedy the problem of segregation included a federal court order to abandon grade-by-grade integration in favor of immediate desegregation of all grades; federal court-ordered pairing and rezoning of predominantly segregated schools; and the Magnet School Program. The Houston School Board has complied with all federal orders and regulations in regard to integration, and the city fortunately has been spared the violence and disorder which has scarred some other areas.

While in the area of education intense political and social struggles were being waged, the power struggle that had characterized relations between the mayor and the City Council during the Great Depression and New Deal era was resolved. In 1942 Houston adopted a city-manager form of government, with eight councilmen and a part-time mayor, who was paid the paltry sum of $2,000 per year. John North Edy, who had been city manager of Dallas, was brought to Houston as city manager. But in 1946 the "Old Gray Fox" won reelection on a platform advocating a strong mayor. Oscar Holcombe's salary was set at $20,000 and the mayor's job was defined as full-time. Also, in the 1946 election the city charter was amended to combine the responsibilities of the mayor and the former city manager. In practice this meant that the mayor functioned as the executive branch of government and also prepared the agenda for the legislative branch (City Council). Also, the mayor appointed all city department heads

In the years after World War II oil exploration moved offshore into the Texas Gulf waters. The early rigs were small affairs, serviced by converted LST's and similar craft. This well was at a depth of 11,017 feet when this photograph was shot in 1949. Courtesy, Rosenberg Library

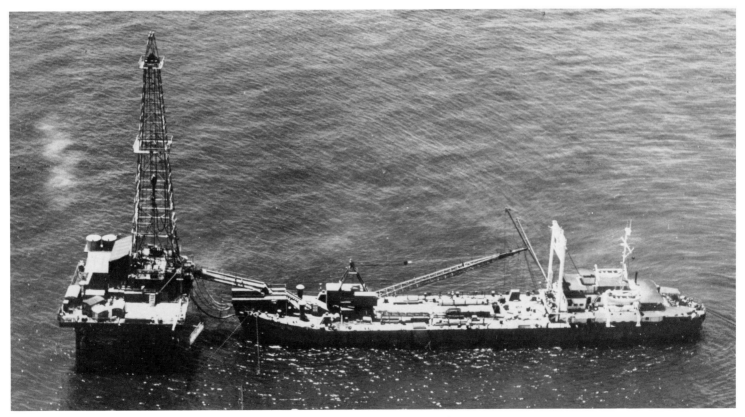

with the sole exception of the city controller, who was elected.

Buttressed by this authority, the office of mayor has attracted strong personalities in the Oscar Holcombe tradition. Perhaps the most dynamic was Roy Hofheinz, whose full and colorful life has become part of the Houston legend. He served as mayor in 1953-1955, between Holcombe's last two terms. Born on April 10, 1912, in Beaumont, young Roy moved to Houston in 1928 after the death of his father, Fritz, who had driven a laundry truck for a living. Roy worked his way through Rice Institute and the Houston Law School, graduating at the age of 19. Hofheinz was a successful attorney, but the political life attracted him. He was elected to the state legislature at the age of 22, and at 24 he was elected to the post of Harris County judge, the youngest man ever to hold such an office in the United States.

Referred to thereafter as the "Judge," Hofheinz remembered his term as county judge as the most rewarding of his life. He presided over the work of three courts and four county boards, including the county hospital board. He was responsible for the inclusion of the county hospital (Ben Taub) in the Texas Medical Center as well as the formation of the Harris County Probate Court. From his law practice, investments in land, and ownership of radio and television stations, he became a millionaire.

In 1953, at the age of 40, the "Boy Millionaire" was elected mayor of Houston. Although he became embroiled in a 1955 struggle over proposed charter changes that almost resulted in his impeachment, Hofheinz can be credited as a successful mayor. He was responsible for revamping the city purchasing department, which resulted in substantial savings to taxpayers. He also carried through a public-works and street-building program that greatly facilitated the city's growth and progress. Probably his most significant achievement as mayor was the construction of the Houston International Airport. Completed in 1954, the facility was renamed the William P. Hobby Airport in 1976. While it has since been superseded in the amount of both passenger and freight traffic it handles by Houston Intercontinental Airport, "Hobby" marked Houston's debut as a major Southern air terminal.

Despite his political involvements, Hofheinz will best be remembered as the builder of the Harris County Domed Stadium, better known as the Houston Astrodome. Completed and opened to the public in 1965, the "Dome" has since

In 1954 Houston's first modern airport was rededicated as Houston International Airport. Although the name would later belong to a newer facility and this field would become known as Hobby, the airport attracted major airlines to the city. Courtesy, Texas Room; Houston Public Library

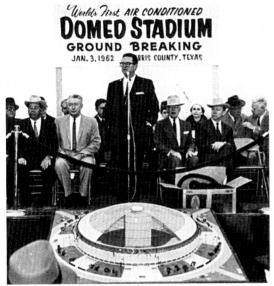

become the prototype for many stadiums built in the United States and abroad. Hofheinz maintained that he got the idea for the Astrodome while viewing the Roman Colosseum, which had a "velarium" or awning pulled by slaves and pulleys when weather conditions were inclement.

The Astrodome was a subject of controversy. In 1958 Harris County voters approved a $20 million bond issue for a combined football and baseball stadium. The Houston Sports Association then offered to lease the stadium when completed at a rental sufficient to redeem the bonds; the Sports Association would control and supervise the facility, and the county would build according to the plans of the HSA. However, the 1958 issue did not sell well and was cancelled, and a new and larger bond issue was proposed. The risk was obvious: if the Houston Sports Association failed—and there was a good chance it might—the county taxpayers would be saddled with the debt. Opponents of the Astrodome protested that it was unwise to assume a public debt on behalf of a private corporation. However, the project was endorsed by powerful factions within the city and promoted brilliantly by Hofheinz. The bond issue and yet another one were overwhelmingly approved.

The Astrodome was completed at a cost of almost $50 million and opened in April 1965, with an exhibition baseball game between the Astros and the New York Yankees. The Houston Sports Association, with Roy Hofheinz and R.E. "Bob" Smith as the principal partners, had been awarded a major-league franchise in 1960, and the Colt 45s began major-league play in 1962; by 1964 they had become the Houston Astros. On opening night for the Astrodome, Governor John Connally threw out the first ball, President Lyndon B. Johnson sat in the "skybox" with Hofheinz, and the Astros triumphed in 12 innings, 2-1. In 1968 the Houston Oilers, owned since the team was chartered in 1959 by K.S. Bud Adams, president of the Ada Oil Company, began to play their games in the Astrodome as well.

The postwar era was one of continued growth and development for the city of Houston. Business expansion and virtually full employment were made possible by the post World War II economic boom. In Bayou City fashion much of this new wealth went into significant and lasting charitable endeavors, such as the famed Texas Medical Center. Vigorous support was also given to the arts and the cultural life of the city attained new heights. Finally, although it required persistent legal action and was characterized by the tactics of delay, a beginning was made toward equal educational opportunities for all.

On January 3, 1962, leaders from Houston and the nation joined Houston political leader and entrepreneur Roy Hofheinz to dedicate the Harris County Domed Stadium, also called the "Eighth Wonder of the World." The first of the indoor stadiums, the structure was a record setting architectural achievement. Courtesy, Texas Room; Houston Public Library

Houston's Fat Stock Show, symbolized by western equipment and photographs of men performing in rodeos, became one of the major rodeo and stock display events in the country. From 1965-2002 it was held in the Astrodome. For many years before it was held in various open-air arenas around the city. It brought together great rodeo performers, fine stock, and a variety of animals raised for the event. Courtesy, Harris County Heritage Society

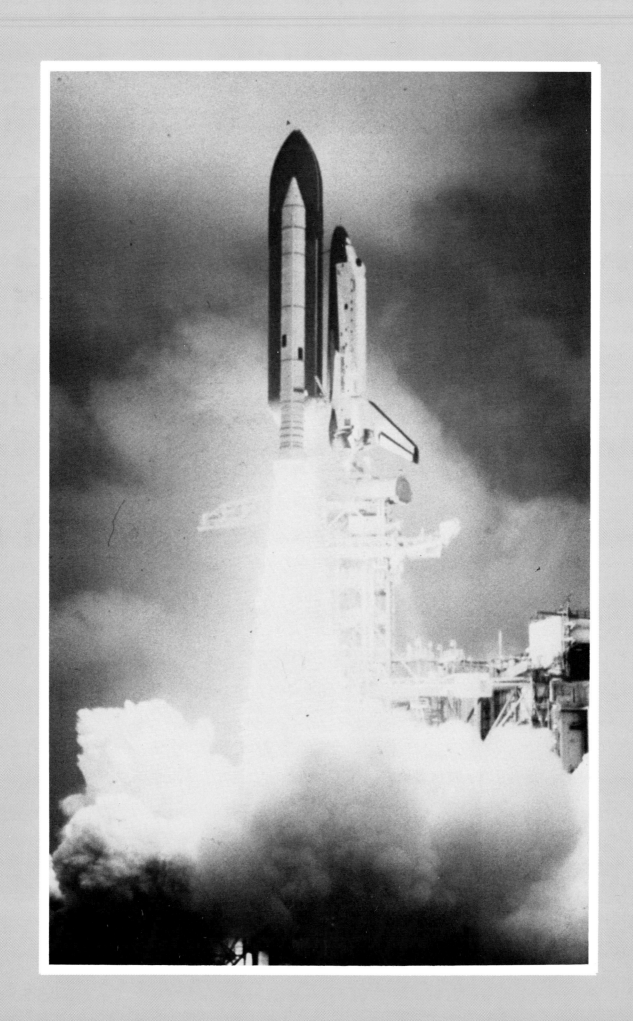

REACH FOR THE STARS: HOUSTON, CITY OF THE FUTURE

The Lyndon B. Johnson Space Center in Houston controls the flights of spaceships that lift off from Cape Canaveral. Here we see the Columbia *taking off on its third flight. Courtesy, National Aeronautics and Space Administration*

Houston in 1960 was a city on the verge of enormous change. The village founded amidst so much travail by the Allen brothers could now claim a metropolitan population of 1,251,700. A $3-billion oil and petrochemical industry, along with a ship channel whose business reached $68 million in that same year, defined the economic character of the city.

On September 19, 1961, the most significant event in Houston's postwar development took place when James E. Webb of the National Aeronautics and Space Administration announced that the city had been designated as the site of a new space center that would serve as the hub of the nation's space exploration program. Houston had prevailed over the candidacy of some 20 other cities. The facility would be constructed on a tract of land at Clear Lake, 22 miles southeast of downtown Houston.

The fine art of politics "Texas style" could be seen in Houston's designation as the space center. Congressman Albert Thomas, longtime spokesman for the city, was chairman of the House Appropriations subcommittee, which controlled the funds of the National Aeronautics and Space Administration, and Lyndon Johnson was chairman of the National Space Committee. However, there were yet other reasons to explain why Houston was selected rather than Boston, Los Angeles, New Orleans, Dallas, and Jacksonville, Florida, all of which made presentations. The ship channel and port facilities could readily transport space hardware to the other main NASA location at Cape Canaveral, Florida, and Houston's tremendous industrial complex, which was responsible for roughly 38.6 percent of the country's oil tool production, 32 percent of its petroleum resources, and close to 75 percent of petrochemical manufacturing, was capable of supporting an aerospace center. The city, which has a temperate climate, also has several major research centers at Rice, the University of Houston, and the Texas Medical Center.

By the spring of 1962 work had begun at Clear Lake on the construction of the

Lyndon Johnson served as chairman of the National Space Committee when Clear Lake, located about 22 miles southeast of downtown Houston, was chosen as the site for a space center. From Cirker, Dictionary of American Portraits, Dover, 1967

Spacecraft Center. Brown and Root, Incorporated, a leading Houston firm, was awarded the contract to build the main complex. Since the center would not be completed until 1964, NASA leased temporary facilities in Houston, which now acquired the appellation, "Space City, U.S.A." On July 4, 1962, the Chamber of Commerce staged a truly Texan welcome for the astronauts and their families as well as Robert R. Gilruth, director of the Manned Spacecraft Center, and Colonel John "Shorty" Powers, the "Voice of Mercury Control." Astronaut John Glenn, the first American to circle the earth, and Congressman Albert Thomas, without whom none of the festivities that day would have been possible, were also enthusiastically cheered. Thousands of Houstonians witnessed the Independence Day parade and were especially captivated by a Mercury spacecraft mounted on a long trailer.

On the evening of September 11, 1962, President John F. Kennedy arrived in Houston to personally inspect the facilities at the Manned Spacecraft Center. Obviously inspired by what he saw, he then proceeded to Rice Stadium for a planned address. There, before some 50,000 Houstonians, the young President sketched a bright future for the city and the nation. The city would reap benefits as scientists and en-

gineers would be attracted to its environs. More than $200 million would be invested in plant equipment, and salaries amounting to more than $60 million annually would be paid out, and presumably spent, in Houston. Less than a month after Kennedy's speech, Astronaut Walter M. Shirra, Jr., flew an Atlas rocket on a six-orbit ride into space.

From the beginning NASA officials were anxious to establish cordial relations with the people of Houston. Upon request, speakers were quickly provided for school and college audiences, and a NASA spacemobile featuring displays of rockets and other space hardware was made available as an exhibit to any school that requested it. Gilruth understood the worth of favorable publicity and friendly local relations when seeking additional congressional appropriations for the Spacecraft Center.

Work continued on the Mercury, Gemini, and Apollo projects. Nine new astronauts were chosen to work with the original seven Mercury pilots, who would serve as senior officers on all prospective voyages. By the summer of 1964, the permanent center at Clear Lake had been completed on land originally donated by Rice University. Of the structures in the permanent complex, the Integrated Mission Control Center was the most important. From that site all prior preparations and flight operations would be controlled. Although "lift-offs" would continue from Cape Kennedy (formerly Cape Canaveral) in Florida, the missions, once airborne, would be directed from Houston.

After the successful Mercury and Gemini projects, the Manned Spacecraft Center prepared for the Apollo moon landing. One technician said of the air of excitement, "We work in a place where 13,000 men can

On the southeast side of Houston the National Aeronautics and Space Administration has built a great complex of buildings, the Lyndon B. Johnson Space Center. From this complex the United States' space program is directed and control is maintained for the space missions. Courtesy, National Aeronautics and Space Administration

feel like Columbus." On July 16, 1969, commander Neil Armstrong, pilot Michael Collins, and Edwin E. Aldrin, Jr., embarked on their historic adventure. The attention of the world was riveted on Cape Kennedy and the Manned Spacecraft Center at Houston when the flight began.

The long-anticipated departure to the moon went flawlessly. *Apollo II*, the command ship, completed 2.5 orbits around the earth and then started off toward the moon, more than 200,000 miles in the distance. Once in the moon's orbit, Armstrong and Aldrin transferred into a small lunar module attached to the nose of Apollo II, which separated from the mother ship. Then, after orbiting the moon to a predetermined position, they landed on the moon at 4:17 p.m. Eastern Daylight Time on July 20, 1969. After receiving permission from Mission Control Center in Houston, they buckled on their cumbersome space suits, opened the hatch, and prepared to step out on the surface of the moon.

Until the expansion of the Medical Center in the 1980s and other diversification initiatives in the 1990s, NASA was the single most important economic stimulus in the greater Houston-Harris County area since Spindletop in 1901. The University of Houston Bureau of Business Research forecast that the Spacecraft Center would attract 200,000 new residents within 20 years, and a Texas National Bank survey hazarded a guess that the population of Greater Houston would reach 8 million in less than 50 years. In 1963 the Houston Chamber of Commerce published a study which concluded that the location of the Manned Spacecraft Center in Houston would commence an economic boom similar to the opening of the ship channel in 1916. Also, the city would escape an unhealthy dependence on the volatile oil-petrochemical industry while new capital was diverted to aerospace and electronic endeavors. In addition to studies and projections for the future, there were immediate results. More than one hundred aerospace firms with space-related contracts leased offices in Houston. Such well-known companies as McDonnell Aircraft, Grumman Aircraft, Lockheed, and Boeing all located in Houston as did General Electric and International Business Machines. Research grants, lavishly funded by the federal government, were awarded in 1962 to Rice University for aerospace research, and by 1967 some $30 million was being spent annually in the city by NASA employees.

During the postwar boom Houston had only four mayors. After Oscar Holcombe and Roy Hofheinz came Lewis Cutrer (1958–1964) and Louie Welch (1964–1974). Cutrer, a native of Mississippi, prospered in Houston as a lawyer and businessman. Believed to be the spokesman of the conservative Houston business community, he confounded his critics by ending racial discrimination in all public building facilities in 1962. On behalf of the city, he arranged for the purchase of land upon which the first jet field, Houston Intercontinental Airport, was

ultimately built. He also blocked attempts on the part of some neighboring communities to annex lands in the path of the airport's expansion. His successor in office, Louie Welch, a successful automotive-parts dealer and real-estate speculator, had the common touch and seemed to genuinely enjoy the rough and tumble of a Houston political campaign. Certainly his most important accomplishment in office was guaranteeing Houston's water supply for the future. In 1964 over the concerted opposition of Dallas and Fort Worth, Welch signed an agreement with the Trinity River Authority that was later approved by Houston voters. This and the $200-million Lake Livingston project in 1973 assured Houston's industrial and residential expansion at a time when other cities were desperately seeking new supplies of water.

Houston politics took on a familiar appearance in the mid-1970s when Fred Hofheinz, son of the former mayor, was elected to the city's highest office in 1974. Hofheinz, an intelligent man with an advanced degree in economics, professed decidedly liberal views and enjoyed the almost complete support of the black and Latin communities in Houston. In an attempt to inspire confidence in apprehensive business circles, Hofheinz was active

in promoting Houston's business climate before Chamber of Commerce groups throughout the country.

Because he was receptive to minority constituencies, Hofheinz was particularly sensitive to charges of police brutality. Although no civilian review board was created as urged by blacks and Mexican-Americans, there was a drive to recruit more police officers from among those groups. It was obvious that substantial additions to the police force were necessary because the crime rate had begun to escalate rapidly in the mid-1970s. With dubious distinction, Houston eased past both New York and Detroit as the "murder capital" of the United States. Short of supervisory manpower, the city was also woefully lacking in the facilities to adequately house prisoners.

During his term in office Mayor Fred Hofheinz continued to be opposed by some political factions in the city. He became the target of a smear campaign, and, having had his fill of local politics, declined to stand for reelection. On November 22, 1978, Jim McConn, a local builder and former city councilman, defeated Frank Briscoe, who had served earlier as Harris County district attorney, in the contest for mayor.

The new urban executive faced myriad

problems for which there were no easy solutions. According to the United States Census Bureau, Houston was the fastest-growing major city in the nation. Including surrounding metropolitan areas, its population was 2.5 million in 1979, making it the fifth-largest city in the country. The city itself expanded to more than 521 square miles, seven times its size after World War II. Such rapid growth placed a strain on municipal services and local government. In addition to the ever-upward homicide rate, Houston now ranked third in the nation in automobile fatalities. The streets were poorly maintained, and traffic jams assumed legendary proportions.

Responsibility for solving many of these problems lay with the City Council, which took on even greater importance. Black and Hispanic groups had long insisted that they enjoyed little if any voice in public policy-making. In response to pressure to make local government more representative, a new voting arrangement was instituted whereby 9 of the 14 Council members would be elected from designated geographical areas; previously all members had been elected at large. The new system made possible the election of four black or Mexican-American candidates, and Judson Robinson emerged on the Council as a leader of the black constituency and Ben Reyes as a spokesman for the Mexican-American group.

In 1981 a politically unprecedented event occurred, the election of the city's first female mayor, Kathy Whitmire. Whitmire, a CPA and the city's former

As the sense of identity of the Mexican-American community grew in the 1960s and 1970s, celebrations such as Cinco de Mayo assumed greater importance for the community. It drew individuals to centers such as Allen's Landing for celebrations of their Mexican heritage. Courtesy, Houston Metropolitan Research Center; Houston Public Library

controller, soundly defeated "good "ole' boy" Sheriff Jack Heard, breaking the old guard elite's stranglehold on city politics. Signs that Whitmire was "destined" to bring down the oligarchy appeared when former mayor and "good ole' boy" Jim McConn failed to make the runoff. Although a Democrat, Whitmire was a fiscal conservative, who campaigned on McConn's failure to live within the city's budget as well as criticizing his other financial practices, raising suspicions in many voters' minds that McConn was involved in some shady deals and other boondoggles. Brilliantly putting together a coalition of African Americans, gays, and traditional liberals, as well as garnering support from many of the city's business leaders who had grown weary of McConn's and others' financial shenanigans, Whitmire was easily elected. Although her opponent was Heard, she shrewdly tied him to the McConn administration, thus persuading voters that they were one-in-the same. Whitmire not only won in 1981 but ended up serving as mayor for ten years, tying former mayor Louie Welch's record of winning five two-year-terms in a row.

No sooner did she become mayor than Whitmire implemented several significant changes. She promised voters that solving Houston's horrible traffic would be a priority and thus it was during her administration that the idea of mass transit was seriously considered. For that purpose she brought from Atlanta, Alan Kiepper, who had been responsible for developing their transit system, MARTA, into one of the best in the nation. Whitmire appointed Kiepper to head the city's Metropolitan Transit Authority or Metro.

Demonstrating her commitment to minority participation in city government, she also lured away from Atlanta the chief of police, Lee Brown, who became the city's first black police chief.

The city and county have both been involved in the area of historic preservation. Founded in 1954, the Harris County Heritage Society is a "private, nonprofit membership organization dedicated to preserving a segment of Houston's past." One of the society's major accomplishments was the creation of Houston Park, an accredited outdoor museum. Within the park area can be found the Kellum-Noble

Ben Reyes was key in the political development of the Mexican-American community in Houston beginning in the late 1960s through the mid-1980s. Unfortunately, Reyes promising political career ended under a cloud of scandal. Courtesy, Houston Metropolitan Research Center; Houston Public Library

House, built in 1847 and probably the oldest brick house in Houston, and St. John Church, constructed in 1891 by German farmers for their Evangelical Lutheran congregation. First located in northwest Harris County, the church, still containing its original pulpit, was later moved to its present site. The "Long Row," a replica of Houston's first commercial building, constructed for the Allen Brothers in 1837, and the "Old Place," a cedar log cabin built on the west bank of Clear Creek and thought to be the oldest structure in Harris County, are also located in this unique outdoor museum. Thus, in the shadow of vibrant downtown Houston, are some gracious reminders of the city's more leisurely past.

While the Harris County Heritage Society has been the principal organization dedicated to the preservation of the area's past, other bodies have also been at work. In 1971 the Greater Houston Preservation Alliance was created to maintain or restore to their original form some of Houston's oldest and most interesting buildings. Aided by federal grants, the work of this

Elected in 1981 as Houston's first woman mayor, Kathy Whitmire was faced with a city whose population growth was slowing down due to the national recession. The temporary ebb in Houston's growth created new types of problems. Courtesy, Texas Room; Houston Public Library

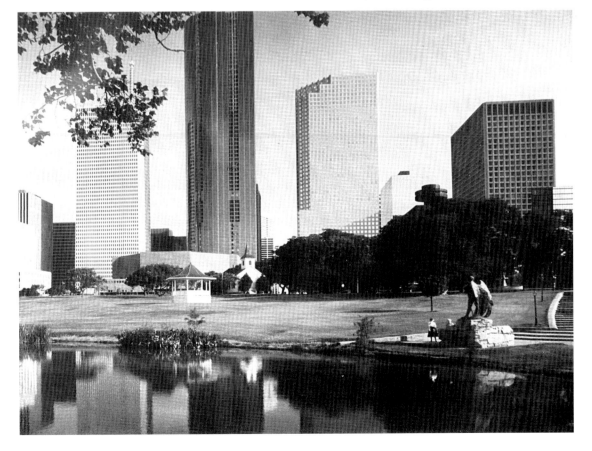

Houston's skyline changes every year as the city continues to grow and develop. Seen here in a 1982 view of the downtown area Courtesy, Story J. Sloane III

With the move of the San Diego Rockets to Houston in 1972, the city acquired athletic franchises in the three major sports. Courtesy, Houston Rockets

Jeff McKissack's "The Orange Show" is a unique museum assembled as a tribute to the orange by its originator over many years of individual work. In many respects; it is a perfect example of modern Houston Folk Art, combining mechanical and still exhibits in a unique celebration of the orange. Courtesy, Texas Room; Houston Public Library

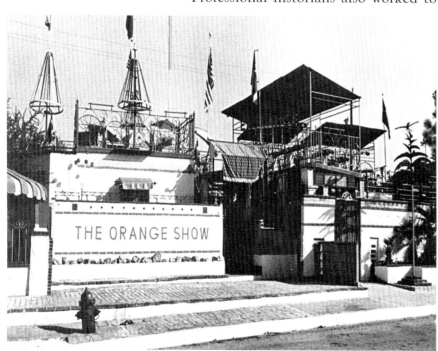

agency is proceeding apace. Still another group, the Houston Oldtown Association, was interested in converting Market Square into a New Orleans French Quarter type of development. Located near Buffalo Bayou at the base of the original city, the restaurants and shops that constitute the Market Square locale make an interesting place for tourists to visit.

Professional historians also worked to document and explain the Bayou City's record. In 1974 the National Endowment for the Humanities awarded a $116,000 grant to be shared by the University of Houston, Texas Southern University, Rice University, and the Houston Public Library. This project, known as the Houston Metropolitan Archives and Research Center (HMARC), has as its mission the "organization of a program that would locate and preserve historical records relating to the development of the Houston area." Originally housed at Rice University, in the summer of 1976 the project was transferred to the Houston Public Library and came under the supervision of Director David Henington. A new division within the library was then organized, known as the Houston Metropolitan Research Center (HMRC). Based in the Julia Ideson Building, the Research Center seeks to collect the data of Houston's past. In this connection, private papers, manuscripts, and oral interviews with Houstonians from all walks of life are being assembled. A particular effort is being made to emphasize the historical contributions of Houston's black and Hispanic communities.

More than 150 years ago, on April 21, 1836, the battle of San Jacinto was fought and Texas won its independence. The victorious commander, General Sam Houston, could have little inkling that his name would later grace one of the most dynamic cities of the 20th century. The 1980 census figures revealed that the state of Texas had 6.3 percent of the nation's population and accounted for 13 percent of its growth in the 1970s. During that decade, Texas expanded at a rate more than double the national average, second only to Florida among the 50 states. Within the boundaries of the Lone Star State, Houston outpaced Dallas and San Antonio, on its way to becoming the nation's fourth-largest city in the nation. Houston's role in the exploration of space was symbolic of its orientation toward the future—a future made possible by the willingness of its citizens to give of their time and resources.

*Nightfall always brings a light
show to please locals and visitors.
Courtesy, Allison Lopez*

The front of Fondren Library on the campus of Rice University. Known as the "Harvard of the Southwest," Rice is the city's premier institution of higher learning. Courtesy, K. Durham

The Gerald D. Hines College of Architecture on the University of Houston campus. Designed by Philip Johnson, world renowned architect. Courtesy, Patricia Lopez

Above: Cullen Walking Garden. Courtesy, Patricia Lopez

Left: The principal entrance to the city's Museum of Fine Arts. In the background is one of two specially commissioned monumental reliefs by Joseph Havel, titled Curtain. *Courtesy, K. Durham*

George R. Brown Convention Center opened in 1987. It is conveniently situated between Minute Maid Park and the Toyota Center and currently boasts 1,800,000 square feet and a $269 million dollar price tag. Courtesy, K. Lopez

Right: Menil Museum and an exhibit from the Menil Collection. Courtesy, Patricia Lopez

Far right: The Church of the Annunciation built in 1874 maintains its place of dignity in the bustling city. Courtesy, Patricia Lopez

NASA continues its space endeavors with world-wide participants. Courtesy, Patricia Lopez

Above: The University of Houston and Texas Southern University bands prepare for the half-time show at Super Bowl 2004. Courtesy, Allison Lopez

Left: Texans at Reliant Stadium—Life after the Dome. Courtesy, Allison Lopez

Above: The 50-foot ferris wheel, part of restaurant magnate Tilman Frettita's amusement park outside of his downtown Aquarium Restaurant. Inside, encompassing three dining floors is the largest indoor aquarium in the world. Courtesy, K. Durham

Right: Rockets pack them into downtown during 2005 NBA playoffs. Courtesy, Allison Lopez

Whether referring to the city or the food, this sign expresses the sentiments of Houstonians Courtesy, Patricia Lopez

Below: Houston Astros play to an enthusiastic crowd. Courtesy, Allison Lopez

The Metropolitan Transit Authority opened the new Lee P. Brown Administration Building in 2005. Although city buses have been the primary mode of public transportation, a new lightrail train now services a limited area with future expansion planned. Courtesy, Patricia Lopez

Recession and Resurgence in the Bayou City: Houston In the Early 21st Century

Only occasionally in the history of a civilization, nation, or city, do all the dynamic forces of existence combine to produce an extraordinary time or historical moment. By the 1980s Houston stood within the borders of a renaissance with many of the contours of potential greatness apparent. Houston was a city on the verge—an ever-expanding urban metropolis well on its way to becoming one of the most cosmopolitan, ethno-culturally diverse, and economically dynamic cities in the United States. By the end of World War II, Houston had emerged as Texas' largest urban area; by 1981, the fourth largest city in the country, with a population of 1.6 million, surpassing Philadelphia to claim fourth place.

In its 150 year-plus history, Houston has been called by many catchy names: the "Bayou City" and "Space City," "City of the Future" or "A Place of Dreams." Regardless of which manifestation is the most appealing, beginning in the late 1970s and down to the present, Houston has been the recipient of more emigrants per capita than any other major city in the United States. By the early 1980s Houston was attracting, on average, 1,000 new families a month to its environs. Houston was the only Texas city with more than a million residents in 1970; the city grew by 29 percent during the next decade, reaching a population of nearly 1.6 million as the oil boom approached its peak in the early 1980s.

The majority of the "new" Houstonians came from the economically depressed regions of the Northeast and Mid-East, referred to still today as the "rust belt." As steel mills and other capital goods production industries closed, largely as a result of "out-sourcing" for such products to foreign countries where labor costs were significantly lower, thousands of individuals lost their jobs. However, Texas, and particularly the city of Houston, presented a ray of hope from possible destitution. These "new Okies" filled their station wagons with their belongings and went in search of a new life. Instead of heading to California or the West Coast, as the majority of the old migrants had, they drove south, to Houston, Texas.

Indeed, in the early 1980s Houston newspapers sold by the thousands on the street corners of such economically depressed "rust belt" cities as Cleveland, Pittsburgh, Detroit, Gary, and even in Boston and New York. The people buying them quickly flipped to the want ads, finding there the "promised land" of job opportunities galore. Desperate for work and an income to sustain their families, many "rust belters" were willing to take any sort of job no matter how menial. They were confident that in time Houston's apparent recession-resilient, booming oil and

The Williams Waterwall adjacent to the Williams Tower. Courtesy, K. Durham

energy-dominated economy would soon provide them with an even better lifestyle than they had in the former cities. "This is not a city," the *U.S. News and World Report* wrote of Houston in 1980. "It's a phenomenon—an explosive, churning, roaring juggernaut that's shattering tradition as it expands outward and upward with an energy that stuns even its residents."

By 1982 when this migration peaked, the "Yankees" had surged into Houston at the unimaginable rate of 10,000 per week. Besides being called "rust belters," "new Okies," the generic "Yankee" assigned to anyone coming from anywhere else but the South, the new arrivals also became known as "black-platers," for their dark-colored, snow country license tags. Their flat Midwestern voices sounded numb to Southern ears and their attire looked somber, reflecting lives that had not seen much "fun in the sun" in awhile. Houston's weather was a welcome relief for some, after years spent coping with months of sleet, ice, freezing rain, and snow. However, for others, Houston's heat and humidity was not easily borne, especially if they came in automobiles not equipped with air conditioning.

The new Houstonians tried to fit in or adapt, wanting to become "instant" Texans as quickly as possible. Many of these individuals believed being "Texan" meant being a "cowboy," and armed with such a stereotype image, they flocked to the Western-wear stores. The new emigrants helped in a variety of ways to further the city's "boom times," not only buying clothes, but more importantly, homes, cars, appliances, and other necessities to outfit their new life as "Texans." Houston, unlike other Texas cities, never considered itself to be "cowboy town." In fact, quite the opposite, but the stereotype prevailed; so much so, that in 1981, Hollywood came to Houston (actually to the "outskirt" city of Pasadena) reinforcing Houston's image as an alleged "cowboy town," by making the movie *Urban Cowboy*, starring John Travolta. Needless to say, the majority of native Houstonians found the movie and its cast to be caricatures of reality. Although finding the movie mostly a farce, Houstonians loved all the attention, tending to think their city was not only special but invulnerable and invincible as well. Like everything else in Houston, the "Texan rage" provided hundreds of jobs and helped to keep Houston's boom-image alive and real, at least for a few more years.

More important than the buying of boots and hats, or the making of a Hollywood movie as manifestations of Houston's booming economy in the 1980s, was the high-rise architecture and overall construction extravaganza of that decade. In the wake of such a dramatic influx of emigrants, Houston's "suburbanization" began in earnest, as the previously undeveloped prairies to the southwest and northwest, and the piney woods section to the city's north, exploded in population growth and overall development. By the end of the 1980s, more new office buildings and space had been built in the suburbs than in the downtown area, to accommodate such burgeoning peripheral growth. In 1985 *Houston Magazine* listed over 75 suburban office parks. In addition, scores of nationally known "tract" homebuilders began flocking to Houston in the 1980s to help provide Houston's growing population with relatively inexpensive suburban homes.

Many of these builders were invited by such individuals as energy tycoon George P. Mitchell, and real estate baron/developer Gerald Hines, both of whom envisioned , building inexpensive housing for "baby boomers"—some of the first planned suburban communities in the United States. In many manifestations, Mitchell's "The Woodlands" in north Houston, and Hines' "First Colony" in Sugar Land, were simply more grandiose, modern, versions of "Levittowns," built in the Northeast after World War II by the visionary developer William Levitt. "These, developments and the multitude of other such "villages" continuing to proliferate outside of Houston, are much more than their earlier Levittown or older suburban productions, the majority of which were not "planned" hamlets. All tend to be self-sufficient residential communities with retail centers— some with massive, modern shopping

malls—schools, and recreational facilities, all connected by walkways, bicycle paths, and roads. The "Woodlands" is expected to number 120,000 residents by 2030. For thousands of Houstonians, the suburbs represent the opportunity to move and achieve home ownership. Houston's suburbs tend to be arranged in ascending orders of mobility. Thus, as one's job and income improve, one could buy a larger house with more land and space.

Because of sustained suburban growth, as of 2005, Houston is still considered a "bargain" for new and used home purchases with an average home sale of around $175,000 for a 2,000 square foot home. Naturally, home prices are considerably higher in some parts of the city such as the West University area, As increasing numbers of new arrivals as well as established Houstonians migrated to the suburbs in the 1980s and into the 1990s, the city's greater metropolitan population swelled to 5.2 million by 2004, making Harris County the third most populous county in the country. Naturally, along with the suburban housing and business boom was school construction, as the outlying school districts of Katy, the Woodlands, Sugar Land, Cy-Fair, and Pearland became dotted with new elementary, junior, and senior high schools. Over the last ten years an average of one new

high school and several new elementary schools open every two-three years in these communities. Unfortunately, for the city's largely "inner-city" Houston Independent School District (HISD), flight to the suburbs has negatively impacted the system. Many of its older schools have deteriorated both physically and educationally as loss of revenue and other issues have contributed to HISD's overall declension.

Although suburban growth has defined Houston's demographics in the last 20 years, it was during the 1980s that high-rise architecture reached its zenith in Downtown and "Uptown" Houston, producing by the end of the decade one of the most impressive if not spectacular skylines of any city west of the Mississippi. The city's wealth, low real estate costs, and open acceptance of architectural ideas, made such an accomplishment possible. Coming to the city at this time were some of the world's most renowned architects—I. M. Pei, Philip Johnson, Ludwig Mies van der Rohe, and Cesar Pelli. By the early 1980s, downtown Houston was on the threshold of a boom with 8.7 million square feet of office space planned or under construction to accommodate its burgeoning economy as well as to attract new businesses, especially multinational corporations. City boosters hoped that Houston's many pro-business

Green spaces dot the midtown cityscape softening the harsh atmosphere often associated with congested business districts. Courtesy, Patricia Lopez

initiatives would appeal to such enterprises and soon they would be moving their corporate headquarters to the Bayou City. Many did precisely that. Compaq Computers, for example, took advantage of these conditions, becoming the nation's fastest growing industrial firm in the 1980s. By the end of the 1990s Houston had become home to 550 foreign-owned firms. The city is also the base of operations for the international energy in-

dustry and for many of the nation's largest international engineering and construction firms such as Brown and Root and Haliburton. Over 5,000 energy-related firms are headquartered within the greater Houston area, including more than 200 companies with significant exploration and production operations. Such giants as Baker Hughes, Duke Energy, Cooper Industries, Apache, El Paso Oil, Schlumberger, and Exxon Mobil, and scores of others, call Houston home.

Up went the skyscrapers and business towers to accommodate the influx of so many companies. By the end of the 1980s, the Cullen Center, Allen Center, and towers for Shell Oil appeared. The Shell Plaza towers represented Houston's first major skyscrapers, both at 714 feet and 50 floors. Houston's tallest skyscraper, the 75-floor 1,002-foot-tall JP Morgan Chase Tower (formerly the Texas Commerce Tower) was completed in 1982. In 2002 it became the ninth tallest building in the United States and the 23rd tallest skyscraper in the world. Nineteen-hundred eighty-three saw the completion of the 71-floor, 970-foot-tall Wells Fargo Plaza.

Houston is a unique city in that it not only has a central or core downtown business district (and now arts and entertainment centers as well as venues for professional basketball and baseball), but other business, entertainment, shopping, and professional enclaves as well, where impressive,

A familiar and welcome sight in Houston as downtown construction continues to modernize the area. Such projects symbolize the city's continued growth but virtually disappeared during the recession years of 1986-1991. Courtesy, K. Durham

Old and new are combined in the design of the Harris County Civil Courthouse. The brick and sleek glass structure is topped with a Texas sized 70 foot gold colored dome. Courtesy, K. Lopez

to the construction of gigantic edifices. Greenway Plaza was the brainchild of master builder Kenneth Schnitzer, president of Century Corporation. The 127-acre-development represented Houston's first planned business-residential complex. Schnitzer remarked that by placing such a large area of land like Greenway Plaza under one owner: "We have imposed a discipline on ourselves in a city that has no such disciplines, no zoning; the private sector, with no help from public sources, has built a city with all the obligations and responsibilities of a larger municipality. Schnitzer's comments, deemed arrogant by some, touted the wondrous accomplishments of private enterprise in Houston during the boom times of the '80s which had a general political atmosphere favorable to such entrepreneurship.

Without question, the hallmark of such achievement was the construction of the landmark 899-foot-tall Williams Tower (known as the Transco Tower until 1999), built by one of the city's most creative and aggressive developers, Gerald Hines. At the time of its completion, it was believed to be the world's tallest skyscraper outside of a central business district. The Williams Tower in many ways was the climax of a unique era in Houston; a period when energy companies, loaded with assets built impressive, monumental structures to reflect their gargantuan economic power.

Until the mid-1990s the whole downtown area emptied by 6 p.m., for there was virtually no downtown living—no apartments, condominiums, townhomes, lofts, etc., nor much of a nightlife. Although the building boom of the 1980s was statistically impressive on paper, the end product, an awesome modern monolith to human ingenuity and vision, a spatial wonder, such construction nonetheless reflected Houstonian's inability or refusal to revere their past and preserve it by refurbishing old historic buildings. It was as if 1980s Houstonians considered anything not new, not worth the effort of preserving for either posterity's or simply aesthetic's sake. In order to build his new downtown monoliths, such as a new tower for Republic

modern architecture also appears in the form of skyscrapers. These other "downtowns" were the result of Houston's unique status among the nation's largest urban areas to have no zoning laws. Rather than having a single downtown as the city center of employment, Houston has five additional business districts throughout the inner city. During the 1980s a collection of mid-rise office buildings appeared along Interstate 610 in an area that became known as Greenway Plaza. That particular locale along with the Galleria area became one of the most impressive examples of Houston as a "cutting-edge" city relative

Inner-city town homes, shops and eateries are luring young professionals back into Midtown. Courtesy, Patricia Lopez

Banks, Houston's foremost developer at the time, Gerald Hines, demolished several venerable Houston classics, such as the 100-year-old Lamar Hotel and the long-since closed Loew's and Metropolitan, once the city's grandest movie palaces, built during the "roaring '20s" in the art deco motif that was the hallmark of that decade's architectural creativity. At the time Houstonians believed there was no better way to upgrade or modernize their city than destroying the old.

Nature is oppressive in the Bayou City and not especially attractive. Houston lacks such natural vistas as the Rocky Mountains of Denver or the bay of San Francisco. This may explain why until most recently, there was no effort to preserve open space or reserve land for parks, or even renovate historic buildings. The sights worth looking at were all constructed by humans. As such they fall apart, age, and people grow tired of run down buildings and want to replace them with something new, modern, clean, and, impressively big. As the architect George Luhn noted: "There is really no sense of history felt in the city. So everything is bright and shiny and new." It was as if Houstonians got carried away in the 1980s and through the early 1990s with being the most audacious mod-

ern city in the United States, requiring the new and the monolithic.

If there was little concern about nature, there was, beginning in the late 1990s, care about the beauty of the constructed environment. A popular columnist, Lynn Ashby, described the scruffy face of Houston offered to visitors traveling from Houston's "big airport," George Bush International to downtown along Interstate 45. The route was, and unfortunately still is, marred by intrusive billboards, trash, and poor maintenance. Returning home from a trip on which he had bragged about his home city, he said, "Now I am back in town to be made a liar. . . . My trees are telephone poles, my flowers are castaway tires, my limitless growth [the result of no zoning laws] is eye-gouging greed. Where did we go wrong?" Ashby's editorials were taken seriously as successive city governments have passed ordinance after ordinance to address such wanton urban sprawl.

Perhaps the most important ordinances passed were those forbidding sexually oriented businesses to locate in residential areas. During the boom years of the 1970s and early 1980s, such "enterprises" proliferated in Houston. However, with the downturn in the late 1980s, fewer and fewer new ones

Super Bowl 2004 was played to a sold-out crowd. Houston proudly displayed the city and its assets to the nation during its second hosting of the Super Bowl (the first was in 1974 when Rice University stadium was chosen over the Astrodome by the NFL to be the site of Super Bowl VIII). Courtesy, K. Lopez

Houston rush hour traffic enjoys a modernistic view of U.S. 59. Road repair is a major cause of congestion for over 4.9 million residents. Courtesy, K. Lopez

appeared and many old ones shut down. It was the perfect time to introduce legislation to prevent their future presence in family neighborhoods. Today such businesses are confined to designated areas. Yet, Houston officially remains a "zoning-free" city.

Now, especially "Midtown" Houston and downtown around Minute Maid Park, home of the Houston Astros Major League Baseball team, at the end of downtown, in Market Square and the old warehouse district, construction of apartments, lofts, and condominiums, has flourished, creating a whole new existence for many Houstonians who want to immerse themselves in true urban or big-city living. Such a lifestyle is particularly appealing for young professionals, who want to live "inside the Loop" (the

rectangular-shaped Interstate 610 which "encircles" the city) and thus close to their downtown jobs but cannot yet afford a traditional home in neighborhoods like West University. All manner of nightlife entertainment from clubs, restaurants, theater, opera, the symphony, and sporting events also have emerged downtown making it now a place to go after work, after hours, or for a "night at the Opera." Indeed, Houston has become known for the vibrancy of its visual and performing arts. Its theater district is ranked second in the country only behind New York City in the amount of theater seats in a concentrated downtown area. Houston is also one of only five cities in the United States with permanent professional resident companies in all of the major performing arts disciplines—the Houston Grand Opera, the Houston Symphony Orchestra, the Houston Ballet, and the Alley Theater. As a result, the city is widely recognized as the nation's third most important city for contemporary visual art.

Traffic is still a challenge in Houston and probably will continue to aggravate commuters for several more years. However, there are currently many freeway improvement projects taking place on all of the city's main arterials. Beginning in the 1980s and on through the 1990s and into the early 21st century, the city has launched comprehensive regional mobility plans, budgeting $1 billion a year for new roads, freeway expansions, transit ways, and toll roads. The best cure for Houston's congestion, a mass transit system, has recently been implemented, with the completion of the city's first light rail system, which runs seven miles from Reliant Stadium (home of the Houston Texans of the NFL as well as to the Houston Livestock Show and Rodeo) to the University of Houston, Downtown Campus. Interestingly, the rail system was part of the enticement "package" used by city boosters to secure Houston as the host city for the 2004 Super Bowl. It worked, as Houston hosted its second professional football extravaganza. Needless to say, Houston's restaurateurs, hoteliers, retailers, and virtually every other service-oriented business was overjoyed as thousands of

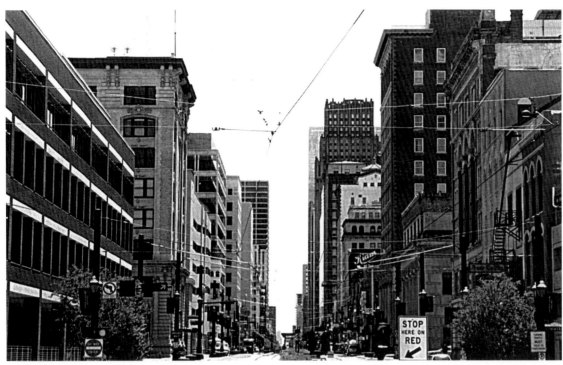

Approaching the heart of downtown Houston from aboard a Metro train. This photo depicts a significantly refurbished Main Street, along which older buildings dating from the 1920s and 1930s, have been preserved and renovated into spaces for businesses or for use as professional buildings. Courtesy, K. Durham

tourists and professional football fanatics poured into the city during the last week of January 2004, pumping millions of dollars into the city's economy. Plans are to extend the rail further out to the suburbs over the course of the next 20 years. Until then, however, people working downtown or uptown, or even in the Galleria area, can count on two plus hours a day in commuting time, depending on how far from city center they live and on what time of day they travel.

Houston's frontage roads, which locals call feeders, are an unusual feature of its freeway system. Alongside most arterials are two to four lanes in each direction parallel to the freeway permitting easy access to city streets. These frontage roads make freeway entry relatively easy but unfortunately have become eyesores, attracting mostly gas stations and unattractive "strip" center retail stores. However, for the past several years, municipal government has passed several ordinances regulating not only the type of businesses that can be established along the feeders, but funding as well for massive landscaping enhancement projects along all the city's main arterials. New billboards are also banned along feeders as city officials are finally attempting to remove the detritus and other manifestations of urban blight caused by the demand for convenience.

As a result of emigration, Houstonians, especially long-time residents, became more "location" and even class conscious, especially those living "inside the Loop" in the city's more established, traditional, tonier, and more expensive neighborhoods. The Loop has become more than just a freeway; it has come to define a lifestyle and state of mind. "Inner Loopers" tend to be white collar, well-educated professionals who earn on average today $300,000 a year. They send their children to the city's best private schools. They live in the city's most preferred, established neighborhoods such as Southampton near Rice University, West University, Bellaire, Old Braes, and if they can afford it, River Oaks, without question Houston's most affluent inner loop neighborhood. Also preferred by Houston's upper classes are Memorial and Tanglewood, which Houstonian and former president of the United States, George H.W. Bush presently calls home. "Inner Loopers" pride themselves on being individuals who contribute to the arts and other forms of entertainment. In short, Houston's highest socio-economic income brackets have made "inside the Loop" their private preserve. Homes values can easily cost five to ten times the price for the same home outside the Loop. By contrast, those Houstonians who live outside the

Loop, by and large do not earn six figures; live in fairly ethnically and racially homogenous planned communities, and leisure activities tend to be more family-oriented. In many ways, their lifestyles and expectations reflect the middle class American dream writ large. Homes are affordable; shopping malls abound; familiar chain eateries and services are plentiful; and perhaps most important, as of the last five years, some of the best public schools at all levels of education in the state. In many ways, it is not surprising that in the last 20 years it has been the areas "outside the Loop" that have experienced Houston's most prodigious demographic growth.

Another neighborhood of distinction is Montrose, which since the 1980s, has become home to Houston's large gay community, one of the largest, most active, visible, and progressive gay communities in the United States. It is a community that has great civic pride, emerging politically in the 1980s to become one of the city's most important interest groups. In many recent mayoral elections, gay votes proved to be the decisive margin of victory. Houston's gays have also helped in a variety of ways to transform the Montrose area into one of the up and coming inner city neighborhoods, both in gentrification and safety. Montrose has become the place to live for trendier Houstonians—a perpetual hot spot for all things hip and artistic.

There are two other Houston neighborhoods of historical and demographic importance. One is "The Heights," the city's first "suburb" and master-planned community established in 1887 just west of downtown. Named for its enviable geographic position (an estimated 23 feet higher than flood-prone Houston), the Heights was touted as a healthier utopian community for the new 20th century. At the zenith of its development, circa 1920s, magnificent Victorian-style homes lined both sides of the neighborhood's main artery. The Great Depression eclipsed the grandeur and potential promise of The Heights. Today, the boulevard is an eclectic mix of restored Victorian houses, jogging trails, quickie marts, and

aging apartment complexes. Although many historic homes have been lost, in the last ten years the area has undergone an intense revitalization of both its homes and businesses. The impetus for such renovation comes largely from Houstonians, mostly younger professionals, wanting to live closer to downtown and their work but cannot afford a home inside the Loop. They are increasingly choosing The Heights as the next best alternative rather than moving further out to the suburbs. Consequently, home values in the Heights are on the rise as the neighborhood, like Montrose, continues to gentrify.

The same cannot be said for Houston's six historic political wards, which either continue to decline because of endemic poverty compounded by municipal neglect, or are being completely demolished by developers to make way for new town homes, condominiums, apartments, and restaurants. In many instances older, poorer, African American residents, the ward's principal inhabitants for several decades, are being driven out by such "progress." White Houstonians had long since moved to the suburbs or inside the loop.

Such has been the fate of the historic Fourth Ward or Freedmen's Town, where many freed slaves from surrounding areas settled after the Civil War. The Fourth Ward became one of the most vital, progressive, and comparatively affluent communities in late 19th and early 20th-century Houston. During its heyday this was Houston's Harlem, with jazz clubs and restaurants lining Dallas Street. Unfortunately the area declined during the Depression and failed to recover in the post World War II years. In the 1990s developers began the gentrification process and rechristened the neighborhood "Midtown." Today there are more historical markers than historic restorations, and with downtown gentrification encroaching westward, this may be one of the most endangered neighborhoods in Houston.

As baby-boomers become empty nesters and Gen-Xers become home buyers, more and more of them want to trade in the commute for an "urban experience." Little do they realize or care, that they will be living

in a new gated town home community that likely caused the displacement of several poor families with no place else to go. Sadly, neither the city nor developers have been that interested in providing low cost housing for the city's less fortunate. Thus, the poorer neighborhoods like the wards have become the prime areas for the "urban renewal" projects of ambitious developers and their largely white, upper income customers. Only the Third Ward appears to have escaped this trend. Its predominantly African American residents have so far resisted the influx of developers while refurbishing their neighborhoods, schools, and businesses on their own initiative or with the help of those developers willing to provide affordable housing.

At the same time Houston experienced an influx of largely native-born white Americans from the Midwest and Northeast, the city simultaneously witnessed significant immigration from Asia and Southeast Asia. Beginning with "boat people" refugees from war-ravaged Indochina—Vietnam, Laos, and Cambodia—in the 1980s to the influx of Chinese, South Koreans, Japanese, Indians, and Pakistanis in the 1990s, by the end of the 20th century Houston was no longer a typical, "black and white" Southern city. It has emerged as one of the nation's most diverse urban areas, where over 90 world languages are spoken. Today Houston has the third largest Vietnamese population in the United States as witnessed not only by midtown street signs in both Vietnamese and English, but more importantly, by the 2004 election of the first Vietnamese state legislator, Hubert Vo from Alief, a west Houston suburb. The 1990s saw the election of the city's first Chinese Americans to city council, Martha Wong and Gordon Quan. Ms. Wong is currently serving in the Texas House of Representatives.

The largest immigrant group in the city and throughout the Southwest continues to be Latinos, who represent 40 percent of Houston's population, exceeding the city's African American population by 15 percent and only 9 percent less than its white population. That Houston's Latinos represent the fastest growing population sector is reflected on city council, where presently two Hispanics, Adrian Garcia and Carol Alvarado, occupy seats. Political forecasters predict that over the course of the next 10 years, if district reapportionment maintains accurate demographic pace, the city should have at least five to seven Hispanic members on city council out of the fourteen total seats. Demographers and sociologists predict that Houston's Hispanic population will exceed all others by the year 2015. The draw for Latin Americans continues to be job opportunities, which Houston continues to provide in plentiful amounts, ranging from restaurant employment to construction to landscape maintenance. In short, as long as Houston's economy remains robust, providing not only work but professional and educational opportunities as well, the city will continue to be recognized as one of the most cosmopolitan urban areas in the United States.

The economic boom that had attracted so many newcomers burst in Houston in the late 1980s. Causing the collapse was Houston's almost complete dependence on the oil and gas industry to sustain its economy. Thus, when the price of oil plummeted from a high of $38-$40 a barrel in 1982 to $10 a barrel by 1986, it was only a matter of time before the economic fallout would impact Houston's overall economy. From 1986–1991 Houston experienced one of the worst economic recessions in its

A large Vietnamese community in Midtown requested and received bilingual signage. Courtesy, Patricia Lopez

history, coming close in many sectors to the financial devastation of the Great Depression of the 1930s. Interestingly, until the "crash of '86," Houston and Texas in general, prospered in the late 1970s and early 1980s because of high energy costs while the rest of the nation fell deeper into recession. This Houston/Texas phenomenon occurred because Texas, like an OPEC country of today, *exported* oil and natural gas, not just to the rest of the nation but to countries abroad as well. In 1982 Texas exported a record 1,263,412,000 barrels of oil. Higher oil prices had brought fantastic prosperity to the state and especially to Houston while economic hard times stalked most of the nation.

Interestingly, the bursting of the oil bubble did not immediately destroy the Houston economic miracle because real estate continued to sustain the city's economy. Bankers, flush with profits from loans to oil companies but also heavily committed to a non-weakening industry, looked to place their money elsewhere and found land deals, construction, and development. Particularly interested in such speculation were the savings and loan operators, who, more than traditional bankers, plunged headlong into such ventures. Once called thrifts because they only accepted individual savings deposits at regulated interest rates and made loans to residential homeowners, S&Ls sought to take full advantage of the Reagan administration's deregulation frenzy—allowing them to pay higher interest rates and to make high-yield corporate and nonresidential real estate loans. Thus, despite the dramatic decline in the price of oil, Houston's economy boomed again briefly in the mid-1980s, stimulated by rampant speculation in real estate. Parcels of land were "flipped" two and three times in a matter of weeks or even days as developers, appraisers, and S&L directors worked together to approve and finance one sale after another, always at higher prices. Interestingly, at the close of 1985, some 200,000 more Houstonians had jobs than in 1980!

Unfortunately, the finance and real-estate-based economy of the mid-1980s did not have the same strength as the earlier boom. Thus, when oil prices fell to less than $10 a barrel in 1986, the good times in Houston and Texas in general ended. However, of all Texas' cities, Houston was the hardest hit by the recession because its economy was so tied to the oil industry. Thus when that industry collapsed, the effects rippled through the entire economy, destroying public confidence, bankrupting businesses, and throwing thousands of Houstonians out of work. Speculative real estate deals fell apart, taking dozens of S&Ls down with them. Defaulting developers and speculators left "thrifts" holding so much property worth virtually nothing compared to the money loaned that by the end of October 1987 the combined value of all the state's S&Ls was a minus $5.1 billion. Investigations soon disclosed the role of fraud and conspiracy as well as bad loans in causing losses. A few of the criminals went to jail but ultimately the federal government called on taxpayers to replace nearly $500 million lost by depositors.

One of city's more legendary swashbucklers brought down by the S&L scandals was real estate speculator J.R. McConnell, whose creditors forced him into Chapter 11. His obligations were said to be around $500 million and he was accused of swindling investors. McConnell was indicted on such charges in 1987, but the stress was too much for him as he committed suicide a year later in his Harris County jail cell. Even former Governor and Secretary of the Treasury John Connally became a victim of the Houston bust as he declared bankruptcy in 1988 as a result of loans he could not pay off. In order to raise the money to pay his creditors Connally and his wife sold virtually all their possessions at Houston's largest antique/art gallery, Hart Galleries, ultimately raising $2.5 million to pay their debts. Other statistics reveal the devastating effects of the recession in Houston. For example, the average number of business bankruptcy filings increased from 25 a month in 1985 to 93 a month in 1986; a number of these failures involved firms worth more than $200 million. During the first week of June 1986 a major office building and a major hotel were

among the 2,500 Houston area properties repossessed by banks and other lenders. For the entire year, a total of 25,602 properties were foreclosed upon. In the first nine months of 1987, 11 banks failed in Houston, the largest number since the Great Depression. The most dramatic of the bank failures was that of the First City Bank corporations. It received a $1 billion bailout from the FDIC, the second largest bank rescue in FDIC history. By the end of 1987 a total of 3,047 residential and commercial properties were posted for foreclosure at the Family Law Center in downtown Houston. Foreclosures included major hotels such as the Westchase Hilton and the French-owned Meridian, and major shopping centers such as the 100-store Town and Country Village. Most dramatic and sad was that 90 percent of the foreclosures—2,742—involved residential property. Most revealing was the fact that of that number, over 80 percent were homes in upper-income neighborhoods, whose owners lost high-paying jobs in the collapse.

A Houston version of the American dream turned into a nightmare as the city lost a good deal of its allure, especially since the nation did not suffer a recession. The city's population that had increased by close to 600,000 people by 1982, added only about 45,000 by 1989 and most of the immigrants were from foreign countries. By the early 1990s however, the Houston economy was on the rebound, largely the result of diversification, especially into communications, computers, manufacturing and medical technology, home and infrastructure construction, import/export, and education. Thus Houston's economy in the 1990s depended less on oil and would move in step with the rest of the nation to a greater extent than ever before. In a sense, the boom from the early 1970s to 1987 marked the final stage in the evolution of Houston's economy from "old" to modern.

Although the business failures of the late 1980s were legion and the demise of many the result of corporate mismanagement, greed, and other questionable practices, they all paled in comparison to the collapse of Enron in 2001. Enron was founded in 1985 when Houston Natural Gas merged with InterNorth of Omaha, Nebraska, forming one of the largest natural gas, energy trading, and electric utilities conglomerates in the United States. The new corporation made Houston its home and former HNG chairman Kenneth Lay became the new entity's CEO. Under Lay's leadership, Enron made millions legitimately as a transmitter and distributor of electricity and natural gas throughout the United States. In the early 1990s, Enron diversified, developing, constructing, and operating power plants, pipelines, and other infrastructure worldwide. However, it was not until the late 1990s, when Lay brought on board "whiz kids" from Wall Street such as Andrew Fastow, John Formey, Jeffrey Skilling, Timothy Belden, Jeffrey Richmond, and others, that the company entered yet another new realm to make even more money: the marketing and promoting of power and communications commodities and related tradable securities. As a result of supposedly pioneering a new trading venue, Enron was named "America's Most Innovative Company" by *Fortune Magazine* for five consecutive years, 1996-2000. It was also on *Fortune's* "100 Best Companies to Work for in America" list in 2000, becoming legendary for the opulence of its offices. By the end of the century, Enron employed around 21,000 of the city's "happiest," most "secure," Houstonians; at least that's what people said who worked there, especially those in upper management making six figures annually with all manner of stock options and other perks. Even those at the lower echelons of the corporate hierarchy exuded a peculiar "company pride," for on paper they all seemed to be benefiting from working for the seventh largest company in the United States, whose pension plans appeared to be the most generous of any major corporate enterprise.

Ultimately, however, much of Enron's success was unmasked to be a farce manufactured by a handful of its top executives for their own personal aggrandizement. By November–December 2001, it was revealed that these individuals as well as their counterparts at the giant accounting firm of Arthur

Andersen and at the telecommunications monolith, WorldCom, had engaged in all manner of stock jobbing, falsification of data, fraud, money laundering, accounting errors, and conspiracy. In reality, Enron's alleged profits were never there; they were the result of falsification and manipulation by the various companies' "corsairs." Company stock had been completely bloated. Thus, when reality hit, Enron shares fell from $85 to 30 cents by the spring of 2001. Thousands of once proud Enron employees not only lost their jobs but worse—their retirement packages and pension plans, many in the form of 401K's, which they believed had been skyrocketing in value. This, also, proved to be a sham, inflated by top executives to keep everyone quiet and happy. In the end, Enron's collapse became the largest corporate failure in United States history, becoming symbolic for institutionalized, well-planned corporate greed and fraud.

Fortunately, the economic fallout from Enron's collapse did not impact the city as adversely as many predicted. To be sure, some sectors, such as the high-end housing industry, suffered a momentary downturn, but Houstonians had learned from the crash of 1986 that dependence on just a few key industries to sustain the city economically is foolhardy. Thanks to Houston's ongoing diversification, when giants such as an Enron go under, the ramifications have minimal affect on the city's overall economic vitality.

An example of such diversification is the continuing efforts by city boosters to see Houston become a major "convention city." Although the oppressive summer and fall heat make such and endeavor seem rather foolish, Houstonians nonetheless believe their city has other amenities that mitigate the weather's affects. Motivating Houstonians to engage in such an effort was, and is, their desire to deny rival San Antonio the honor of being Texas' number one tourist/convention city. Beginning in the early 1980s, under the leadership of Mayor Henry Cisneros, San Antonians embarked on an aggressive building and promotional campaign to boost their city's economy by making the Alamo City Texas' premier tourist and convention-hosting site. Not to be outdone by its intrastate rival, Houstonians embarked on an equally assertive effort to make their city as attractive. In 1983 voters approved plans for a new convention hall to replace the antiquated Albert Thomas Hall in downtown. The inspiration for such construction came from George R. Brown, co-founder of Brown and Root, one of the largest construction companies in the world. Brown did not live to see his idea come to fruition, but when the new center opened in September 1987, it was called the George R. Brown Convention Center. Since its opening the "George R" has hosted numerous national conventions, ranging from that of the NAACP to the 2004 convocation of the

The Menil Museum. Courtesy, Patricia Lopez

The Lillie and Hugh Roy Cullen Walking Garden compliments nature's art along a winding path filled with realistic and interpretive sculptures. Courtesy, Patricia Lopez

National Rifle Association. Along with the simultaneous opening of the state-of-the-art Wortham Theater, home of the Houston Grand Opera, and the Menil Collection art museum in the Montrose area, Houston enhanced its cultural tourism and convention amenities.

The Menil Collection houses the art treasures of a variety of mediums collected over the span of 40 years by Schlumberger heiress Dominique de Menil and her husband John. The collection ranks among the greatest private art assemblages in the world. The museum consists of more than 15,000 paintings, sculptures, objects, prints, photographs, and books, dating from the Paleolithic era to the present day. Also noteworthy is the Lillie and Roy Cullen Sculpture Garden at the Museum of Fine Arts, created by internationally renowned sculptor Isamu Noguchi. It is the setting for major works by 19th and 20th century sculptors from around the world.

One of Houston's biggest convention coups was the announcement on January 8, 1991 by the Republican National Committee that the party would hold its 1992 national convention in the eighth Wonder of the World, the Astrodome. Sadly, the famous Astrodome—the first of such venues to use artificial "grass," still called "Astro turf" by old-timers—is destined for demolition in the near future the Dome was.

The roar of the crowd, whether it was for football, baseball, the rodeo, or concerts has not been heard inside its environs for several years; not since the last out of the Houston

Astros 1999 season. When the Astros and Oilers wanted new, separate stadiums, and Houstonians hesitated with their votes to approve new sites, the Oilers' owner, Bud Adams, precipitously announced in 1996 that he was moving the team to Nashville, Tennessee, where the Oilers became the Titans. Not wanting to lose another professional team, voters approved a new downtown ballpark for the Astros, who moved to Enron Field (now Minute Maid Park) in 2000. Houstonians, like all Texans, love football, and thus to no one's surprise, no sooner did the Oilers leave than city fathers began lobbying the NFL for a franchise. Led by multimillionaire energy executive Bob McNair, owner of Reliant Energy (formerly Houston Lighting and Power) Houston eventually prevailed over Los Angeles and was awarded a franchise in 1999 on the promise that it would build a new football facility. Thus

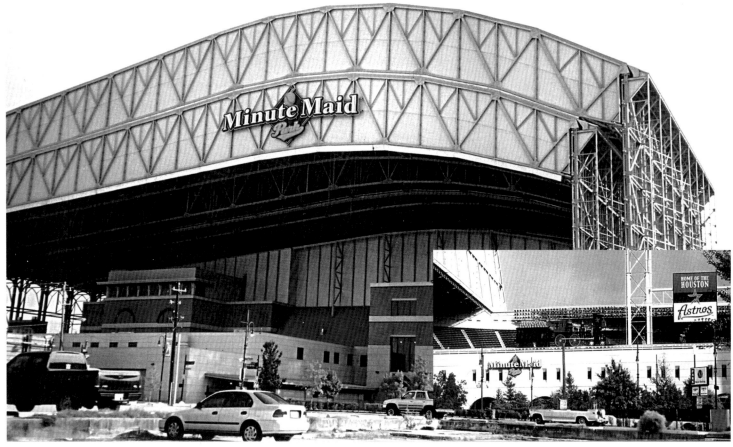

Minute Maid Park shares the eastern quadrant of downtown Houston with the Toyota Center making the area a haven for sports fans. This state-of-the-art field is home to the Houston Astros and is attracting much interest in new housing and business around the vicinity. Courtesy, K. Lopez

Inset: The homerun train at Minutemaid Park. Courtesy, Patricia Lopez

voters quickly approved funding for Reliant Stadium, the future home of the Houston Texans, who began play in their new venue in 2002 as a member of the AFC's Central Division of the NFL.

Perhaps the Astrodome's last, and most meaningful hurrah and most important moment in its history, came as a result of hurricane Katrina, which devastated the Gulf Coast cities of New Orleans and Biloxi, Mississippi in late August 2005. With New Orleans destroyed, many residents made their way to refuge in Houston.

Houstonians in particular and Texans in general, watching the devastation, rose to the occasion, offering to help their Louisiana neighbors anyway they could. Metro buses traveled to and from New Orleans round the clock for several days on Interstate 10, picking up the thousands of refugees who had literally waded out of the city. When they arrived, they were put up in the Astrodome, and by end of the first week of September 2005, the Dome had become the home for over 20,000 displaced Louisianans. Mayor

Bill White also authorized the opening of the George R. Brown Convention Center as well as the city's other large facilities to provide further shelter. Houstonians donated massive quantities of food, clothing, medicine, and other necessities to help get Louisianans back on their feet. Most important, thousands of Houstonians donated their time, doing whatever was needed to help out. Indeed, Houstonians' assistance to the victims of hurricane Katrina will more than likely come to represent the largest, most meaningful relief effort in the city's history to date.

On a more academic and political level, in 1990, Rice University, the city's premier higher education institution, hosted the "G-8" Economic Summit, bringing to Houston during the George H.W. Bush administration, the world's leading economic superpowers. For over a week, dignitaries and economic officials from Germany, France, Italy, Canada, the Soviet Union, Japan, Great Britain, and the United States met on the university's campus to discuss the world's current and future economic outlook.

During Kathy Whitmire's tenure as Mayor Texas became increasingly Republican, voting overwhelmingly for Ronald Reagan in 1980 and 1984, and naturally, for "Texan," George H.W. Bush in 1988. By the end of Whitmire's regime in 1991, Texas had become a thoroughly Republican "red" state. However, much to the delight of a beleaguered Texas Democratic party, its largest city remained an oasis of "blue" in a desert of Republican "red." Even all those candidates who tried to unseat Whitmire in the 1980s were Democrats, albeit conservative ones, nonetheless Democrats. Houston's loyalty to the Democratic party has been largely the result of three powerful interest groups: gays, African Americans, and the ever increasing Hispanic vote. Asian American Houstonians are not as tied to the party, but as their numbers grew in the 1980s and 1990s both parties have actively sought their support. As is true across the nation, traditional white male liberals are becoming increasingly extinct in Houston. Nonetheless, what is left of such a legacy has helped to keep Houston's mayors down to the present, Democratic.

By the end of Whitmire's fourth term in 1989, two black women won seats on city council. Sheila Jackson Lee was elected to a seat that had been occupied by a black male since 1979 and Beverley Clark defeated white male council member at-large, Jim Westmoreland. By 1991 many Houstonians had grown weary of the Whitmire administration and of the mayor herself. She appeared to have lost what little ebullience she originally had, and in the eyes of many voters she had become a rather cold, detached, insulated, lackluster "bean counter." It was time for a change. Moreover, largely because she had been mayor for ten years, the idea of term limits for all city officials became a serious topic of discussion. In the mayoral race of 1989 former early 1970s mayor Fred Hofheinz challenged Whitmire. Hofheinz had been a very popular city official during his tenure and many believed he could unseat Whitmire. The campaign's hottest issue was whether or not Metro should finally "go rail." Metro chairman Bob Lanier opposed rail plans and supported Hofheinz who also was not keen on seeing Houston develop a rail system. Lanier threatened to resign as Metro chairman if the issue was not dropped. Whitmire and her supporters convinced him to stay. With this apparent vote of confidence, Lanier then forced the resignation of Metro's pro-rail general manager, Alan Kiepper, whom Whitmire had appointed. To the surprise of many, Whitmire rather easily defeated Hofheinz. Soon after her reelection, she let Lanier know he would not be reappointed to the chairman's job. Lanier quit; Kiepper got a better job as head of the New York transit system and the Metro rail plan remained alive.

Although Whitmire prevailed in 1989, that proved to be her last hurrah. She ran again in 1991 but her defeat was all but certain; it was just whom would beat her. A vindictive Bob Lanier, one of Houston's wealthiest land barons, developers, and attorneys, entered the race as did the city's first black challenger, attorney Sylvester Turner. Not surprisingly, Whitmire finished a distant third to Lanier and Turner. A runoff was now set between these two. As progressive as Houston had become by 1991, the majority of white Houstonians were not ready to embrace a black mayor. Thus, Lanier beat Turner handily in the runoff. Term limits, however, had been passed by a referendum in that same election, limiting all city officials, including the mayor, to no more than three two-year terms.

Lanier proved to be one of Houston's more popular and effective mayors. In all fairness to his predecessor and successor, in many ways Lanier's success and popularity was the result of benefiting not only from Houston's economic turnaround in the 1990s but perhaps more important, from the general national prosperity of the Clinton years. No doubt the city's economic diversification contributed significantly to Lanier's success, (which he wisely continued to promote and enhance), but so did the national scene. Many benefits came Houston's way, ranging from investment by foreign and national institutions, to federal monies for higher education, to medical research and technology grants. Federal legislation such as NAFTA benefited both Texas and the city of Hous-

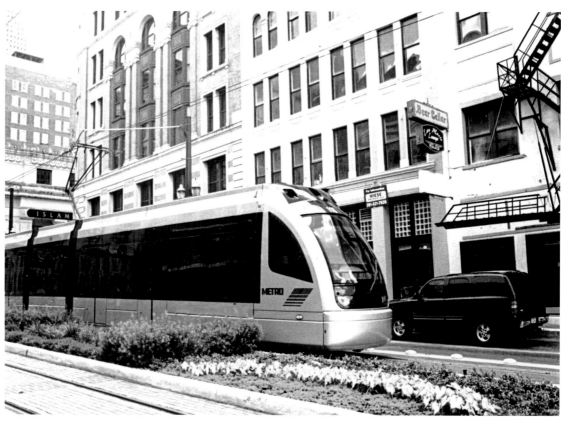

Mass transit at last comes to Houston. The "engine" of the city's first light rail train system that extends a distance of seven miles, carrying commuters from Reliant Stadium to the University of Houston, Downtown campus. Several stops along the way allow Houstonians to frequent the revitalized downtown area without having to worry about finding parking, which they can do at the various parking depots placed along the line. The rail has proved to be a great boon to downtown businesses, especially entertainment. Courtesy, K. Durham

ton via its Ship Channel, as entrepots for trade pouring in from south of the border. As a result of NAFTA and other trade initiatives promulgated by the city, by the end of the last century the Port of Houston became the largest in receipt of foreign tonnage in the United States, and the world's sixth busiest port in terms of overall tonnage.

In 1997, former chief of police Lee Brown, who had returned to Houston after serving a stint as New York City's chief of police, ran for mayor. Brown had been a popular and effective Houston police chief, and thus even white Houstonians could at last embrace a black candidate. Brown naturally could count on 100 percent of the African American vote, but more importantly he received pluralities as well among Hispanic and even Asian Houstonian voters. His opponent in 1997 was Rob Mossbacher Jr., son of former President Bush's Secretary of Commerce Bob Mossbacher Sr. Brown handily defeated Mossbacher in a runoff, and won again in 1999 and 2001. In 2003, voters elected Bill White, a successful businessman/lawyer as mayor. So far, White's initiatives have been well-received and consequently he appears headed for reelection in November 2005.

Without question, one of Houston's hallmarks remains the internationally renowned Texas Medical Center, which contains the largest concentration of research and healthcare institutions, including Baylor College of Medicine, the University of Texas Health Science Center at Houston, and the University of Texas M.D. Anderson Cancer Center. The Cancer Center is widely considered one of the world's most productive and highly regarded academic institutions devoted to cancer patient care, research, education, and prevention. More than 3.4 million patients visit the Texas Medical Center annually. The Methodist Hospital, located in the Center, with 1,527 beds is the largest private hospital in the country. Finally, the Medical Center remains one of the city's largest employers, as over 75,000 Houstonians work in various Medical Center-related capacities.

The ongoing influx of Hispanics has significantly transformed Houston's religious face, as Catholics now represent the second largest (behind the Southern Baptist Convention) denominational affiliation in the city. Over 25 percent of the total number of

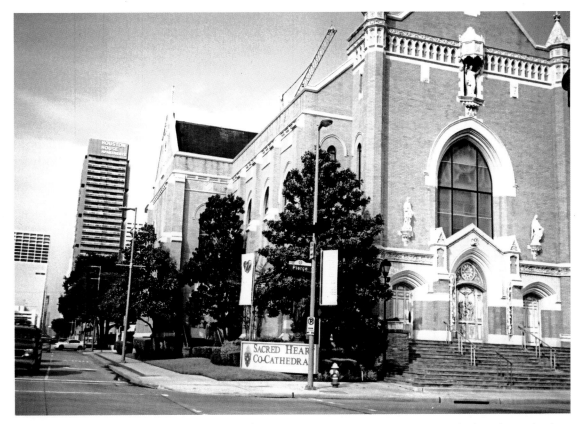

The Sacred Heart Co-Cathedral located in downtown is the largest Catholic diocese in the South or Southwest. Courtesy, Patricia Lopez

Houstonians professing a religious/church association declared Catholicism. In 2000, there were 12.3 million Southern Catholics, representing 12.3 percent of the total population. In the last 10 years the number and size of Catholic parishes have proliferated in the South's urban areas, with Houston leading the way. In 2004 the 10-county Houston-Galveston diocese reported membership of 1.5 million, making it the largest diocese in the South and Southwest and one of the ten largest in the United States. Residing in Houston proper are 1.2 million Catholics belonging to 63 parishes. Interestingly, Houston Catholics are less likely to have grown up in the city. Most have emigrated either from other states or foreign countries, most notably Mexico. Houston Catholics are also a very diverse population in their racial and ethnic composition, with parishes seeing not only increasing numbers of Hispanic emigrants in the Sunday pews but Asian and African American Houstonians as well. Finally, Catholic Houstonians have some interesting credentials that may help further the Church's presence in a city that was once a Baptist and Methodist stronghold. Despite the influx of relatively poor Hispanic

migrants, Houston's Catholics have higher income levels and education than their Protestant counterparts. Thirty-six percent of Houston's Catholics have annual family incomes of at least $50,000. Twenty-seven percent have at least four years of college education. Although Catholicism is clearly on the rise in the Bayou City, it still cannot compete with the non-denominational, essentially Protestant "mega churches," of which Houston claims to have the largest in the country in Lakewood Church. Its forty-year-old pastor, Joel Osteen, has become not only a local icon but one of the nation's most appealing, up and coming Christian evangelists. Many proclaim him to be the next Billy Graham.

Osteen's "holy house" is the former Compaq Center, previous home of two-time, back-to-back (1994, 1995) NBA champion Houston Rockets, who recently moved to their multi-million dollar downtown arena, the Toyota Center. Osteen agreed to lease the 18,000 seat Compaq Center from Compaq/HP computers two years ago with an upfront payment of $12.1 million and an option for an additional 30 years at $22.6 million. He then renovated the structure to

tune of $95 million, adding an additional 10,000 seats as well as gigantic television screens, new walkways, lush landscaping, and a variety of other essentials to transform a basketball arena into a "church." Every Sunday Osteen preaches to some 30,000 people while thousands of others throughout the city and millions across the nation watch his 10 a.m. service on television and sin is not on the menu. Osteen does not want "a churchy feel. We don't have crosses up there. We believe in all that, but I like to take the barriers down that have kept people from coming. A lot of people who come now are people that haven't been to church in 20 or 30 years. I want Lakewood to be a place of life and victory. I want people to be encouraged and uplifted."

Although Houston's economic future appears bright, the resurgence of the 1990s masked two trends that will challenge all Houstonians in the future. First, compared with the 1960s and 1970s, recent economic growth has benefited mostly middle and upper-middle class Houstonians, with the working poor losing ground. Second, the majority of new immigrants arriving in the city, are usually poorer, less well educated, and less likely to be fluent in English. These factors combined point to Houston developing a

Lakewood Church relocated to the newly renovated Compaq Center and is the largest mega-church in the U.S. The seating capacity is 28,000. Courtesy, K. Lopez

larger, more permanent underclass similar to those in the nation's older cities. Thus, one of the major tasks of city government in the 21st century is to reconcile the needs of poorer, mostly minority citizens possessing increased electoral power with the city's facilitation of sustained economic growth. The greatest challenge for Houstonians will be to ameliorate the growing economic disparities between more affluent citizens and their less well off neighbors.

In 2004 the *Chicago Tribune* published a scathing article about American cities. Houston ranked worst in many categories, including public transportation, parks, planning, weather, and energy conservation. Such indictments are not new to Houstonians; we have been hearing them for years and naturally have responded appropriately, not with stereotypical Texas bravado and invective, but rather, and much to the surprise of our "Yankee" critics, with urban sophistication and grace. In the opinion of this Houstonian, the best rejoinder remains the one given several years ago by Houston attorney Jonathan Day, in response to a similar condemnation at the time: "We are creating something unique. We are trying to be Houston and we are trying to make the best of it."

Interestingly, in September 2005, as Houstonians were about to embark on an unprecedented aid program for their Louisiana neighbors, another hurricane, Rita, originally established as a Category 5 storm was headed into the Gulf, with landfall expected in the Houston-Galveston area. Consequently, residents in low-lying areas south of Houston were ordered to evacuate by local and state officials. As the storm neared the coast, Houstonians proper feared the impact and began leaving the city as well, causing one of the largest urban evacuations in the history of the United States. Over 2.5 million Houston-Galveston area inhabitants fled the area along all major arterials, with Interstate 45 seeing the heaviest concentration of cars and people. Most along I-45 were headed for the Dallas-Forth Worth area. Northbound traffic along all the major freeways

leading out of the city were so congested, that destinations, such as Dallas, normally a four-hour trip, averaged 12-14 hours or more. Compounding the problems caused by such a massive exodus of humanity, was record breaking heat and a gasoline shortage. Consequently, people afraid of running out of gas before reaching an open gas station, turned off their air conditioners, rolled down their windows, allowing the heat index of 120 degree to enter their autos. As a result, several people and scores of household pets died of heat prostration and dehydration along the roads. Counterflow lanes were eventually opened along I-45 and I-10 but tragically too late for many Houstonians. In the end such a calamity proved to be all for naught; fortunately for Houstonians hurricane Rita shifted direction away from Houston, heading east toward the Texas-Louisiana border, sadly devastating that area rather than the Bayou City. No doubt city officials and Houstonians learned many lessons about evacuating such a large metropolitan area, and if or when, such is required in the future, the mistakes made during Rita will not be repeated.

Houstonians are proud of their city, are honest about its flaws, and continue to work assiduously to improve it. The city's continued renaissance will be unique, a combination of power, energy, and courage, to try new ideas originating from the city's most creative minds. Such thinking and perspicacity is here in abundance; it has been tapped already countless times, producing art galleries, theaters, museums, new professional sports stadiums, the magnificent downtown skyscrapers, the *avant-garde* sculpture and other artistic expressions found throughout the city; the list could go on. What the *Tribune* failed to recognize was how fast and how far beyond its oil-field roots Houston has grown to become one of the most culturally and commercially diverse cities in the United States.

The swashbucklers of the 1970s and 1980s are all gone. The big banks are owned by people from somewhere else and the influx of masses from all over the world has altered

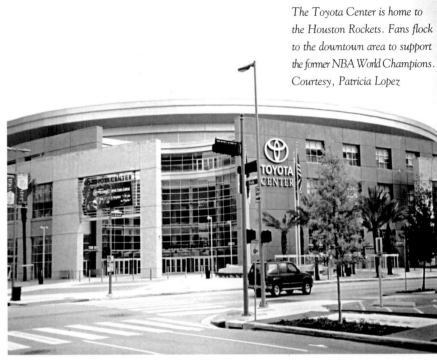

The Toyota Center is home to the Houston Rockets. Fans flock to the downtown area to support the former NBA World Champions. Courtesy, Patricia Lopez

Houston's atmosphere and attitude. The place the late columnist Hubert Mewhinney referred to as a "whiskey and trombone town" now has more joggers than whiskey drinkers (even though a 2004 study found Houston to be one of the "fattest" cities in America!) and more mariachis than trombones. Houstonians have grown accustomed to the criticisms of others and will continue to bet on their city, which has paid off before. Every great city is a test of faith.

Senior Executive Vice President and COO Michael D. McKinney, M.D., takes matters by the bullhorn, organizing the UT medical triage area for Hurricane Katrina evacuees at the George R. Brown Convention Center on September 3, 2005. Photo by Shannon Rasp

Replica of an early space capsule.
Courtesy, Patricia Lopez

CHAPTER X I
CHRONICLES OF LEADERSHIP

H istory—by its nature—is a look back, whereby past events are arranged—sometimes emphasized—in due order. Often these events hold a clue to the future. Such is the case in Houston's business world.

The community was established for land speculation by Augustus C. Allen and his brother, John K. Allen, after they paid $1,000 down and notes totaling $4,000 to Elizabeth E. Parrott (widow of John Austin and wife of T.F.L. Parrott) for the lower league granted to her by her late husband. The tract was situated on a waterway—now known around the world as the Houston Ship Channel—that would play a vital role in the development of Houston into one of the world's most vibrant business communities.

The Allen brothers, in an advertisement in the *Telegraph and Texas Register* on August 30, 1836, noted that their new town was located on the west bank of Buffalo Bayou at "a point which must ever command the trade of the largest and richest portion of Texas. As the country shall improve, railroads will become in use, and will be extended from this point to the Brazos [River], and up the same, also from this up to the head waters of the San Jacinto River, embracing that rich country, and in a few years the whole trade of the upper Brazos will make its way into Galveston Bay through this channel.

"The town of Houston must be the place where arms, ammunition, and provisions for the government will be stored, because, situated in the very heart of the country, it combines security and the means of easy distribution, and a natural armory will no doubt very soon be established at this point."

Today the Port of Houston is the third largest port in the United States. And the city has become the energy capital of the world; thanks to rich resources and the port, tremendous volumes of crude oil flow into and out of the area.

In the early 1970s another tag was placed on Houston: "International City." Due to the energy crisis, the big petrochemical complex on the ship channel, and low real estate prices, the city became a favorite of world investors—especially those from England, Canada, West Germany, Mexico, and several South American and Middle Eastern countries.

From the first years of Houston's founding, those involved in "trade," our present-day merchants, have held a major influence in the city's commercial devlopment. Until 1875 the general pattern of trade was much the same—merchants exchanged a variety of goods for the products of the countryside. However, by the early 1900s an improved transportation network allowed trade to be conducted at greater distances.

Houston's development has been unique. Perhaps because it is a relatively young city, and an affluent one, it is receptive to new ideas and new undertakings. For example, Houston is a showcase for the best modern architecture of the 1970s. In 1979 the city became the first in the United States to issue more than one billion dollars in building permits.

Much of this growth has been led by Houston's real estate industry, an industry deeply involved in helping to develop such landmarks as the Harris County Domed Stadium (the Astrodome), the Manned Spacecraft Center, the Houston Medical Center, and the Houston Ship Channel.

The organizations you will meet on the following pages have chosen to support this important civic event. They are representative of the businesses that have helped make Houston an international city, with the talent, skills, and determination that are the lifeblood of a thriving community.

CDTECH

Chemist Larry Smith had a hunch he was onto something big, but he had no idea the experiment he performed in his laundry room in 1977 would help revolutionize the petrochemical and refining industries. Now some 30 years later, Catalytic Distillation Technologies, or CDTECH, is a leader in process technology that seeks to produce chemicals more efficiently, reduce emissions and produce higher quality fuels.

The South Houston-based firm was inspired by the dreams of Smith and another chemist, Dennis Hearn, and a chemical engineer, Ed Jones. They were friends that believed catalytic distillation held great potential for improving the efficiency of refinery and petrochemical processes. They saw a large need for a practical way to use particulate catalysts in a distillation environment to enable reaction and distillation to occur simultaneously. A distillation column separates components with different boiling points so that the light component is produced at the top of the column and the heavy is withdrawn from the bottom. The challenge was to spacially suspend solid catalyst to allow the high volumes of liquid and vapor that exist in a distillation

Left to right: *Ken Johnson, Ed Jones, Dennis Hearn, Larry Smith and in the front Linda Riddick.*

One of CDTECH's licensed plants for production of low sulfur gasoline.

environment, to move between the catalyst particles where the reaction would take place. Others had tried it without success.

With the help of Jones and Hearn, Smith built a one inch diameter experimental column in the laundry room of his apartment in Pasadena, Texas. Smith put his new devices containing the particulate catalyst in the column, fed in a mixture of four carbon hydrocarbons (C4s) called Raffinate-1, and produced di-isobutylene. The di-isobutylene was removed as a bottom product and Raffinate-2 C4s distilled overhead.

This first experiment demonstrated the potential of using the concept of catalytic distillation to increase conversion in chemical reactions limited by equilibrium. Inside the distillation column, the product with the high boiling point was removed, thus achieving a much higher conversion of the reactants than had been accomplished previously by conventional technologies.

As a result of their research, the three scientists co-founded Chemical Research and Licensing Company (CR&L) in 1977 and began marketing their distillation applications to refineries. Ken Johnson, a patent attorney, became the fourth shareholder in the corporation the following year.

Jones and Hearn added to Smith's initial idea and their combined efforts resulted in numerous processes whereby, both the reaction and the distillation could take place in a single piece of equipment. These applications include etherification, di-olefin selective hydrogenation, olefin isomerization, benzene saturation, hydrodesulfurization of gasoline, kerosene, and gas oil, and alkylation for ethylbenzene and cumene production.

This technically superior system has numerous benefits. The combination of steps makes the chemical process more compact and efficient, thus reducing capital costs significantly. The integrated

heat removal simplifies the process even further, and overall operating expenses and utility requirements are reduced. The process also results in the extended life of the catalyst material.

"My partners all had day jobs and I was a consultant. That's an euphemism for being unemployed," says Smith, as he recalled what it was like to battle through the company's growing pains. "Fortunately, the consulting work did bring in enough to sustain my family during the lean years of CR&L."

A big break for the CR&L Company was the receipt of a grant from the U.S. Department of Energy (DOE) to build a three inch diameter pilot plant to further develop the concept. Charter Oil Company in Houston licensed the first catalytic distillation plant, with catalyst life guaranteed by the DOE.

Oddly, the likely tipping point for making this all important first commercial sale resulted from CR&L's secretary, Lynda Riddick being visited by Charter plant manager Sherman Justice's secretary, Ruby. During negotiations, Charter operations management kept expressing concerns about possible difficulties controlling a reaction and distillation together. They were told that if their operators had any problems working the CD tower, CR&L would be glad to send their secretary, Lynda to show them how it was done. Ruby's field trip verified that Lynda did indeed operate the pilot plant. The contract was agreed to shortly thereafter.

Currently Valero Energy owns the former Charter refinery. Valero now has 12 CDTECH licensed units in six of its refineries, enabling them to produce low sulfur gasoline.

Valuable lessons were learned from the lean years. Primary was the recognition that "we were collectively smarter than individually" says Smith. We also agreed to "test more and argue less." Further, they learned "good ideas often come from unlikely sources." For example the breakthrough for a vital catalyst manufacturing step came from a hairdresser, Ron Weston.

The owners realized they needed additional engineering and marketing expertise, and in 1988 they formed a

Where it all began—Larry Smith's laundry room in Pasadena, Texas in 1977.

partnership between Lummus Crest (now ABB Lummus Global) and the CR&L Company. The new enterprise was named CDTECH.

New fuel standards and more demanding emissions regulations enacted after 1990 helped catapult the partnership to a high level of success. CDTECH developed innovative ways of applying catalytic distillation in groundbreaking technologies that gave refiners cost effective ways to meet these standards while achieving their business goals.

Today in addition to the United States, CDTECH also has licensed its technologies to refineries and petrochemical plants operating in Canada, Europe, Mexico,

Russia, China, Singapore, Korea, Malaysia, Japan, Venezuela, Saudi Arabia, Taiwan, Kuwait, and South Africa. Its clients include major oil companies such as Exxon Mobil, Valero, Shell, Chevron, British Petroleum, PEMEX, ENI and Petrochina.

CDTECH has been credited with over 300 patents. The firm has developed a research center in Pasadena, Texas with 12 pilot and semi-commercial units, and has licensed over 170 operating plants. One of the great achievements of the company was the development of the CD*Hydro*® process, which involves selective hydrogenation of aromatics, olefins, dienes, and acetylenes, with the objective to enhance yield, reduce capital costs, and extend the catalyst's life. This technology was first demonstrated in 1994 at a Shell plant in Norco, Louisiana. The first refinery application was installed at the Valero McKee, Texas refinery in 1995 and ten years later the catalyst still performs like new. CDTECH has also been recognized for the CD*HDS*® hydro-desulfurization process that allows the lower cost production of cleaner burning gasoline with maximum octane retention.

CDTECH continues to be a pioneer in the technology revolution with new processes that change the ways petrochemical plants and refineries meet federal and state mandates. Such innovations provide low cost solutions for valuable products and meet environmental needs of these industries.

View of CDTECH's semi-commercial units at its R & D facilities in Texas.

GREATER HOUSTON PARTNERSHIP

Houston ranks as one of the top cities in the United States for a multitude of reasons—it is the fourth most populated metropolitan area, the center of the petroleum industry, one of the country's largest ports, and it is noted for its excellent quality of life, affordable housing, and wealth of cultural opportunities. Among its crowning achievements is the Greater Houston Partnership, a private, nonprofit organization which serves as the primary advocate of the city's thriving business community. Through an extensive networking system, the Partnership seeks to build and maintain economic prosperity in the region, with the overall objective to make Houston a great place to live, to work, and to play.

This unique organization was established in 1989 when the 149-year-old Houston Chamber of Commerce joined forces with the 62-year-old Houston World Trade Association and the Houston Economic Development Council. From its inception, the Partnership has aggressively positioned itself on the front lines of virtually every major issue impacting the region's business community. International competitiveness, the business climate, and work force issues are only the start. The Partnership is also directly involved in issues related to quality of life, the environment, education, infrastructure, and regional image. A true cooperative effort, the Partnership examines the issues, develops solutions, lobbies government officials, educates business owners and employees, and works with other organizations to make the most efficient use of the area's attributes and resources.

Port of Houston. Courtesy, Port of Houston Authority

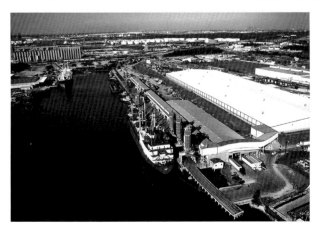

Texas Governor Rick Perry, left, with 2004 Partnership Chairman Robert Mosbacher, Jr.

Some 2,000 companies comprise the membership of the organization. As members, the companies receive assistance from the Partnership through conferences and seminars, referrals, expansion assistance, exposure to international trade, and consulting services. Over 87 percent of the Partnership's funding is derived from membership dues and contributions, events, publications, and interest. The remainder comes from government contracts and special projects.

The Board of Directors includes more than 135 CEOs or decision-makers. Companies of all sizes and from nearly every industry sector and geographic area within the region are represented. Twenty percent of the Board members are from Fortune 500 companies or subsidiaries, 31 percent from large area firms, 38 percent from small businesses, and 9 percent from local nonprofit institutions, such as universities and medical organizations. Twenty-three percent of the Board members are minority business leaders.

In addition, the Partnership has 10 advisory and 49 general committees, councils, task forces, and forums. Volunteers also play an integral role, with thousands from member companies lending their time, influence, and expertise to address the wide range of issues affecting the region. The Partnership serves eight counties: Brazoria, Chambers, Fort Bend, Galveston, Harris, Liberty, Montgomery, and Waller.

"The real power of the Partnership is what *all* member companies together can do to grow jobs in the entire eight-county region," said Partnership president and CEO, Jeff Moseley. "Our initiatives bring together representatives from Houston businesses of various sizes to impact change within our region, representing the can-do spirit of our community," Moseley said.

The Greater Houston Partnership is organized into seven operating divisions: Regional Planning, Regional Issues, Economic Development, World Trade, Government Relations, Member Services, and Resources.

The Regional Planning and Regional Issues divisions were created in 2002 as spin-offs of the Partnership's Chamber of Commerce. The planning division supports companies in the Houston area by working to improve the business climate through programs that address environment, transportation, and infrastructure.

Among its concerns are air and water quality, flood control, and urban mobility. The issues division focuses on education and the work force, healthcare, quality of life, and tax reform initiatives.

Named one of the top 10 economic development organizations in the nation by *Site Selection* magazine, the Partnership's Economic Development division boasts a long history of success in promoting the region and helping businesses to emerge, expand, or relocate to Houston. During the past five years, the division assisted with 96 companies, creating 21,168 direct jobs and 39,867 total jobs. The annual economic impact of these projects on the region was $5.2 billion.

"We are really blessed to have many allies in the region," said Pam Lovett, president of the division. "Our board members are active in helping us, and we have a really good collaboration with the City of Houston, Harris County, our educational institutions, and the commercial real estate community. All of those players together give us a very broad view of the market and the resources on which to draw to assist companies."

The economic development team provides business leaders with confidential assistance and general information related to economic and demographic profiles, work force and job training program data, tax incentives, real estate sites, transportation services, and public financing programs. With more than 40 institutions of higher learning, Houston has a steady stream of skilled workers. The division

Balloon festival. Courtesy, Greater Houston Convention and Visitors Bureau

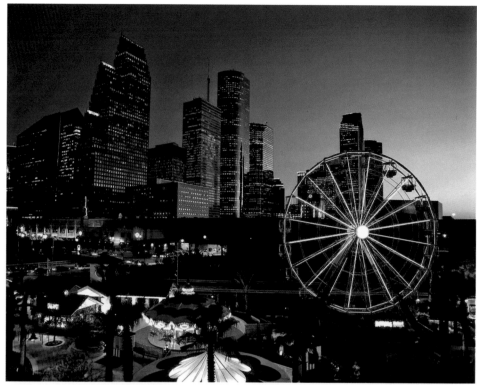

Downtown Hosuton.Courtesy, Mike Mallory

works with educational facilities to ensure that curricula meet the needs of the region's industries. Marketing Houston's image to the media and the business world is another key function of the division. The staff travels to several major U.S. cities each year to participate in trade shows that match the division's target industries and which present opportunities to network with companies interested in Houston.

Serving as a gateway to the global market, the World Trade division enhances Houston's role as an international business center by promoting companies, developing trade programs, and highlighting markets and issues of interest to the city's international companies. The staff helps Partnership firms sell more of their products and services abroad and bring international business opportunities to Houston. They promote the region as a transportation and distribution hub in cooperation with the Port of Houston Authority and the Houston Airport System. Seminars and special events, including visits by high-level delegates and heads of state, also open up opportunities for networking and business development.

A key component to the Partnership is the Government Relations division, which focuses on lobbying efforts at the local, state, and federal government levels to improve the region's business climate, economy, and overall quality of life. Through the diligence of the Government Relations Advisory Committee, as well as its subcommittees and task forces, major systemic advances have strengthened the region's presence in national and global commerce.

The Member Services division strives to increase the economic vitality of member companies through business development programs, networking events, and volunteer activities. The Resources division provides communications, research, and administrative resources and support for the other six divisions.

The Greater Houston Partnership stands as a testament to what can be achieved when private and public leaders, representing every facet of the community and business world, work together to make their region a model of revitalization and prosperity.

HOU-SCAPE, INC.

Gone are the days when a landscaping job meant simply planting a few begonias around a neatly manicured lawn. Now the industry has become high tech, and Hou-Scape, Inc. is one of the companies that is breaking new ground through sophisticated design and innovation.

Paula Hill and business partner Kirk Folkerts started the Houston-based company in 1989 after working for other landscaping firms for several years. "We figured we could do this ourselves, so we started our own business," says Hill. "The first year was tough, but we made it."

During that first year of operation, they provided maintenance services to only one client, Texas Medical Center, but the $100,000 they were paid was enough to get them through the initial challenges. Their one-truck fleet doubled the following year, and the company gradually began to establish its presence amidst a heavily competitive local industry. Today Hou-Scape has a fleet of 60 trucks, employs 200 people, and enjoys gross sales of more than $10 million annually.

Although Hou-Scape has worked on numerous large-scale design jobs, maintenance contracts still generate about half of the firm's revenues. Each week, Hou-Scape manages the health and upkeep of lawns for some 200 clients, along with an estimated 50 landscaping projects per year for both large and small commercial properties.

Paula Hill, president of Hou-Scape, Inc.

Greenway Plaza is one of the company's premier clients. Located five miles outside downtown Houston, the stylish campus covers 60 acres and includes office buildings, condominiums, and retail shops. In 2000 Hou-Scape and the Plaza were jointly honored with the "Turf Grass" award for the best turf landscape maintenance in projects of 10,000 square feet or larger. The Plaza placed first in its size category among all landscape maintenance projects throughout the state of Texas. Hou-Scape, Inc. also won the APEX Award for Landscape Construction. The company was the first specialty contractor in landscaping to

ever win the award from the Associated General Contractors (AGC).

And Hou-Scape is not without its competition. Landscapers from California converged on the city in the late 1970s, prompting some local entrepreneurs to break into the industry and reap their own successes. Because Houston takes great pride in its appearance, landscape services are in high demand, and modern-day clients are well educated about the variety of services offered by the industry.

"Clients have become really particular about what they want," says Hill. "They ask us what kind of chemicals are we using? What color flowers are we planting? They want us to come up with unique designs and arrangements for them that no one else has. It has become a real art just to plant flowers for clients."

Hill is a licensed Texas irrigator and also a licensed chemical applicator. Unlike the early days of the industry, environmental health concerns have led to the ban of several chemicals. Landscapers must have extensive knowledge of the chemicals on the market in order to determine which ones are most effective in a given situation.

"We tell people that the process of growing and maintaining grass is more sophisticated than they may think. Not every chemical can kill the same weed or the same insect," says Hill.

The firm specializes in computerized irrigation systems and has installed equipment at First Colony Mall, at the North Harris Montgomery County Community College, and at the Houston Downtown Aquarium. Although Houston receives its share of precipitation, periodic dry spells can significantly reduce surface water levels. Irrigation systems are fed by lakes or other bodies of water—important resources that need to be protected. Therefore, today's systems are engineered to use less water. Those installed by Hou-Scape waste no water yet perform with 100 percent coverage.

Recently, Hou-Scape did landscaping work for the Baylor Medical Center to help beautify concrete walls and berms that were built to serve as flood barriers. The company is now at work on a landscape project for the University of Texas Health Sciences Center. In addition,

Greenway Plaza winter color.

Hou-Scape serves clients in the cities of Dallas, Galveston, and Beaumont.

Perhaps the honor that has meant the most to Hill personally is her company's ranking in the Top 50 women-owned businesses in Houston for eight consecutive years, based on gross sales. The *Houston Business Journal* holds an annual dinner and awards program to recognize the achievements of these female entrepreneurs.

She can make jokes about the situation now, but for years Hill had to prove herself in a male-dominated industry. Over the past two decades, she has seen a noticeable change in acceptance as more women enter the contracting and landscaping fields.

"I've gone to meetings before with my estimator, who is a male, and superintendents have talked to him the entire time and never once spoken a word to me. They assume I must be the secretary and I am just there to take notes," Hill recalls. "It's pretty funny when they figure it all out. Sometimes we will go through a whole meeting and afterwards the superintendent will find out that the woman who was present is president of the company."

The Houston native had no previous experience in the landscaping industry when she accepted a job with Growth Systems in 1982. The recent divorcee and mother of two sons needed a fresh start

in life—and she needed a job. A friend directed her to Growth Systems. Hill, who holds a bachelor's degree in math from the University of Houston, started out as an estimator. It wasn't long before she moved up to the position of project administrator.

The company suffered some financial setbacks, however, and Hill accepted a job with Westside Services, where she worked in sales. Kirk Folkerts was also employed at Westside. Both later moved over to Westco, another landscaping firm, but finally decided they would like to be their own bosses. At present, Folkerts manages the landscape department and Hill oversees the maintenance portion of Hou-Scape, Inc.

"I'm proud that we have done so well for so many years," says Hill. "And our

Top: Landscape maintenance and summer color.

Above: Flower design.

employees enjoy working here. We are like a big family."

When Hill's two sons were teenagers, they spent their summers helping out at the company too. The memories are fond ones for Hill, but the experience was enough to convince young Chad and Michael to pursue other callings in life.

"The boys used to complain to me, 'Mom, all we ever do is pull weeds!'" recalls Hill with a laugh. "I sent them out with the work crews and told them they had to start somewhere and work their way up. But what they really wanted to do was ride the tractors."

Hill credits the success of the company in large part to the longterm relationships that have developed over the years with clients. She believes that the best days of Hou-Scape, Inc. lie ahead, as the firm continues to explore new opportunities for growth and strives to achieve higher levels of excellence and creativity.

Landscape maintenance and winter color.

THE HOUSTON ROCKETS

The National Basketball Association landed in the state of Texas on June 1, 1971, after the San Diego Rockets were purchased and moved to Houston by a group named Texas Sports Investments. With no permanent building to call home, the newly-relocated franchise was forced to split its "home" games between the Hofheinz Pavilion and a variety of venues located in other cities, such as San Antonio and Waco. Those humble beginnings formed the foundation for what would become one of the NBA's most successful franchises.

Five seasons—and many long bus rides later—the team had a court to call home with the 1975 opening of The Summit, which would serve as the team's home for the next 28 years. During its more than a quarter-of-a-century run, The Summit served as the scene for Houston's two greatest sporting moments—consecutive NBA Finals victories in 1994 and 1995. That was followed by four consecutive WNBA Championships by the Houston Comets from 1997–2000. In 2003, the Rockets and Comets moved into the friendly confines of the state-of-the-art

NBA Commissioner David Stern congratulates Houston Rockets owner Leslie Alexander as Houston is awarded the 2006 NBA All-Star Game. Toyota Center will host the star-studded event on Feb. 19, 2006.

Toyota Center, Houston's newest sports and entertainment facility, intent on creating even more championship moments in their new home.

Leslie Alexander spent 10 years in search of an opportunity to purchase an NBA franchise. On July 30, 1993, that patience was rewarded when he assumed ownership of the Houston Rockets. For Alexander, it was the fulfillment of a childhood dream and the opportunity to marry his love of sports with his business acumen.

"From early on, sports were a big part of my life and I am very fortunate to be able to continue my affiliation in this manner," Alexander said at the press conference to announce his purchase of the team. "I've always been a fan and I have achieved the fan's ultimate goal—owning a team. Everything is new to me, but I am a quick learner and I want our organization to be the best in the NBA."

Those final words proved to be prophetic as the Rockets would go on to win the first of two consecutive championships in Alexander's first year as owner. After Alexander's purchase of the team the Rockets celebrated the 1993–94 season with an NBA record-tying 15-0 start and a franchise-best 58-24 record. In the 1994 Conference Semifinals, two home losses to Phoenix prompted a Houston newspaper to post the headline "Choke City," but the Rockets responded to win the seven-game series and earn the moni-

Houston Rockets center Hakeem Olajuwon drives past David Robinson of the San Antonio Spurs in the 1995 Western Conference Finals. Olajuwon guided the Rockets to consecutive NBA Championships during Leslie Alexander's first two seasons of ownership.

ker "Clutch City." Houston then defeated Utah in the Conference Finals to advance to the 1994 NBA Finals against New York. The Rockets won the seven-game series against the Knicks to secure the first-ever championship for a sports team from Houston. Hakeem Olajuwon earned the NBA Finals MVP award, as he became the first player to ever win this honor along with both the regular season MVP award and the Defensive Player of the Year award in the same season.

With another NBA Championship in 1995, the Rockets became the fifth franchise in NBA history to boast back-to-back titles. The Rockets played the role of underdog in 1995, becoming the lowest seed ever to win a title and the first team to ever eliminate four 50-win teams. The Rockets swept Orlando in the 1995 NBA Finals, as Olajuwon repeated as the NBA Finals MVP. The following season, Olajuwon became the NBA's all-time blocked shots leader and Rudy Tomjanovich set the record for most career wins by a coach in franchise history.

Over the last 12 years, Alexander has devoted his efforts to making his teams champions both on the basketball court and in the community. In addition to his pair of NBA Championships, Alexander's

dedication to winning has also produced four WNBA titles with the Houston Comets.

An active participant in all phases of the team's operations, Alexander has continually proven his commitment to success. Since his arrival, he has engineered numerous bold moves designed to make the Rockets a perennial contender. In 1995, Alexander orchestrated a deal to bring Houston native Clyde Drexler to the Rockets. This trade served as a springboard to Houston's second-consecutive championship just four months later. He later rewarded the key contributors to Houston's championships by giving long-term contract extensions to Drexler, Olajuwon and Tomjanovich. Alexander made additional trades to keep the Rockets at a championship level with the acquisitions of NBA All-Stars Charles Barkley and Scottie Pippen. When the veteran Rockets teams needed an influx of youth, Alexander acquired Steve Francis and Yao Ming, who both produced standout rookie seasons for Houston. In recent years, Alexander has continued to make several bold person-

Houston Rockets owner Leslie Alexander listens to NBA All-Star Tracy McGrady give his opening remarks upon his arrival in Houston on June 30, 2004. Alexander's trade for McGrady marks the latest in a series of notable transactions during his ownership of the Houston Rockets.

nel decisions, deciding to complement Yao with Head Coach Jeff Van Gundy and two-time NBA scoring champion Tracy McGrady.

While Alexander's teams have been highly successful on the basketball court, unique to the Rockets organization is its off-the-court commitment to the community. Building a better quality of life for

Houstonians is a driving force for Alexander and the Rockets. A decade of active community involvement has resulted in more than $6 million in donations to local charities and allowed the Rockets to impact tens of thousands of Houstonians each year.

"It's so important to me that the Rockets find a way to thank the fans for their overwhelming support. One way we try to do that is by reaching out to young people through our community programs and fund-raising initiatives," Alexander said.

In 1995, Alexander established the Clutch City Foundation with the goal of providing help, hope and inspiration to those who might otherwise be forgotten. Through the Clutch City Foundation, the Rockets are involved in several community service and charity fundraising programs. The Clutch City Foundation funds and operates comprehensive programs benefiting thousands of children each year. In 1998, the Rockets were awarded the "Leadership Houston" Leadership in Action award for outstanding community service to education, one year after winning the same award for outstanding community service to youth. Alexander and the Rockets also received the 1997 Pro Team Community Award, given by the World Sports Humanitarian Hall of Fame to one professional team each year that exemplifies community service. Through his work with the

Bob Costas interviews Houston Rockets owner Leslie Alexander and Head Coach Rudy Tomjanovich following Houston's Game Seven victory over the New York Knicks in the 1994 NBA Finals. This marked the first-ever championship for a Houston professional sports team.

Clutch City Foundation, Alexander has ensured that the Rockets organization will continue to make a difference in the lives of Houstonians for years to come.

Yao Ming showcases his ability against the Dallas Mavericks in the 2005 NBA Playoffs. Rockets owner Leslie Alexander used the first selection of the 2002 NBA Draft to pick Yao, making the 7-foot-6 Chinese center the first-ever number-one selection to come from an international league.

JAMAIL & KOLIUS

There aren't enough superlatives in the English language to describe the unparalleled career of Houston-based lawyer Joe D. Jamail, Jr. *Time* and *Newsweek* named him the "King of Torts." *Texas Monthly* and the California Trial Lawyers Association lauded him as the "Trial Lawyer of the Century." He's even acknowledged in the *Guiness Book of World Records*. The cagey attorney won the largest lawsuit in history, *Pennzoil v. Texaco*, with an $11 billion verdict. Forbes ranked him number 348 on its 2003 list of the world's 400 richest people. With more than $1 billion to his name, you would think Jamail might want to kick back and take it easy. Not a chance. Although he's nearing 80, the self-described "sore-back" lawyer has no plans to slow down.

Long before Jamail made a name for himself as the richest lawyer in America, his family earned a reputation in Houston in the grocery business. His uncle, N.D. "Jim" Jamail, was born in a mountain village in Lebanon and came to Houston by himself at the age of 12 in 1904. By the age of 16, the teenager was in business for himself selling produce from a stall in the old City Farmer's Market.

In 1914 Joe Jamail's father, Joe D. Jamail Sr., left Lebanon and came to Houston where he enlisted in the U.S. Army. He served on active duty until 1918 when he returned to Houston and joined his brother Jim in the produce business. A third brother later joined the firm. The brothers branched out and joined the ABC Stores chain, which owned some 13 stores in Houston, Galveston and Beaumont.

By 1941 the brothers acquired nearly a square block in the 2100 block of South Shepherd. Their grocery store specialized in the highest-quality produce and meats as well as gourmet items. In 1944 *Time* named Jamail Brothers the best grocery store in Houston. Eventually, the family sold the firm to Kroger, marking the grocery giant's debut in the Texas market.

While growing up, lawyer-to-be Joe Jamail often helped out by carting packages to and from the family's grocery stores. It would have been a natural

Joe Jamail crushing Texaco in a lawsuit.

transition to join the family business, but young Joe wasn't one to follow a conventional path. A rebellious streak led the youngster to leave high school at age 16 and enroll at Texas A&M where his older brother had studied. But Jamail, an independent thinker, simply couldn't cope with the school's military-style rules. His stint there lasted only three days. After quitting, he hitchhiked his way to Austin where he enrolled in the University of Texas (UT).

Jamail signed up for five pre-med courses and managed to fail each and every one of them. It wasn't that Jamail wasn't bright; he had a very sharp mind.

He just felt lost and couldn't focus. After that dismal semester, he dropped out of UT. That's when he decided to join the Marines. The fact that he wasn't 18 didn't stop him. He forged his parents' signatures and convinced a druggist to notarize it.

After 27 months overseas, Jamail made it back home to Houston in 1946. He headed back to UT with a renewed sense of focus and earned his undergraduate degree. In typical Jamail style, he talked himself into law school without taking the entrance exam. In his book *Lawyer*, Jamail writes, "For someone who chose a profession steeped in procedure and protocol, I had little use for either." His tendency to think outside the box ultimately served him well.

Studying was never Jamail's strong point. In his freshman year of law school, the man who would become known as the "King of Torts" flunked his course on torts. The irony wasn't lost on magazine and newspaper reporters who would inevitably bring up the fact in interviews years later.

In keeping with his unconventional style, Jamail took the bar exam before he even graduated from law school. Jamail was having a few drinks in a bar with some other law students who were bemoaning the upcoming exam. Jamail told them to stop whining about it, and they bet him a hundred dollars he couldn't pass it. Jamail only had three days to hit the books before taking the exam. The enterprising young man convinced his professors to give him the class notes for the courses he hadn't taken yet. When his results came in, he felt sure he was going to have to cough up the hundred dollars. To his surprise, he passed with a score of 76, just one point above the cutoff.

Just as Jamail took the bar exam

On the left, former Texas football coach Darrell Royal, Willie Nelson and Joe Jamail on the right.

before graduating, he also tried his first case before he finished law school. One day, the lawyer-in-training was in a bar near campus when the bartender popped the top off a beer bottle and it chipped, putting a gash in her thumb. Seizing the

N.D. "Jim" Jamail, founder of Jamail Brothers Food market.

opportunity, Jamail convinced her to sue the beer company.

Six months before graduation, Jamail got his chance to try the case in an Austin courtroom. Jamail's law school friends filled the courtroom, eager to see their pal in action. When the judge asked the first-timer for a response to something called the "plea of privilege," Jamail balked. He had no idea what that meant. In *Lawyer*, Jamail recalls innocently asking, "Judge, I don't know what I'm supposed to say. What do you think I should say?"

Realizing Jamail's inexperience, the judge prodded the opposing counsel to settle so he wouldn't have to go through with a trial. The beer company's attorney offered $500. Jamail countered by asking for $1,000 and ended up getting $750 for the bartender. Jamail had just won his first case!

Never afraid to ask questions, the novice queried the judge about how much he should charge his client. When

the judge told him that one-third of the settlement was the customary fee, Jamail couldn't contain his excitement. He'd just earned $250 in half an hour! The young lawyer knew he'd found his calling in life.

When Jamail finally did graduate from law school in 1953, he stepped right into an enviable job with one of Houston's largest and most powerful firms, Fulbright, Crooker, Freeman and Bates (later known as Fulbright & Jaworski). On his first day at the new job, he was greeted with a litany of rules and a laundry list of don'ts: "Don't do this, don't do that." For a guy who had never been one to take direction well, this was looking like a big mistake. Twenty minutes into his new gig, he called it quits and walked out.

Later that same year, he landed a job with the Houston District Attorney's office where he worked for a year making only $600 a month. The money barely covered the living expenses for himself and his young wife Lee whom he had married in 1949. Even though the money was nothing to brag about, Jamail still thinks of that year as an exciting time in his life. Trying dozens of cases, he discovered the importance of jury selection and learned how to take command of the courtroom. Thanks to a few high-profile cases, the upstart lawyer's name started appearing in the press on a regular basis.

The learning process was invaluable, but Jamail recognized that if he ever wanted to support a family, he would have to go into private practice. In 1954 he joined the firm of Fred Parks along with his high school chum George Cire. After one year, Jamail and Cire left that firm to venture out on their own with a tiny office in Houston. Thanks to referrals from criminal lawyers, the hardworking pair had a steady stream of clients, mostly of the personal injury variety. That's where Jamail's reputation as a "sore back" lawyer originated.

Since launching his own firm some 50 years ago, Jamail has continued to take an unorthodox path. While most lawyers would pass on taking cases that seemed "unwinnable," Jamail relished the challenge of taking on cases nobody else

Joe Jamail.

dared take to trial. With that attitude, the hard-charging lawyer has tried and won some of the most high-profile cases in legal history.

One of his earliest "unwinnable" cases threw him into the spotlight. The year was 1959 and Jamail agreed to represent the widow of a man who had been drinking, hit a tree and died. According to other lawyers, *Glover v. the City of Houston* was an open-and-shut case—the driver was drunk and ran into the tree, case closed. But thanks to some smart investigative work, Jamail emerged victorious and the widow landed a bigger settlement than they had asked for. In addition, the city was forced to cut down the tree in question and the case went down in legal lore as "The Case of the Killer Tree."

Jamail's aversion to protocol and pro-

cedure would pay off in other cases—in particular, a case in the early 1960s involving an electrician who lost both his hands and a foot due to a faulty electrical box. The fact that Texas had no product liability laws at the time didn't stop Jamail. With his usual verve, Jamail convinced the jury that the product manufacturer was liable, and they awarded the man $500,000. Never before in American tort law had a single individual received that much money. A year and a half later, Texas passed a product liability law, something Jamail is very proud of.

America took notice of that victory. An article about the case in *Newsweek* dubbed him the "King of Torts," and Jamail began fielding calls from all across the nation. This led to several other notable cases, including three that resulted in faulty products being recalled nationwide. For Jamail, these victories surpass all others— even his biggest money-makers—because they served to protect the public interest.

The first occurred in the late 1970s. A deer hunting accident had left an Austin insurance attorney paralyzed. The heartbreaking part was that the man's 14-year-old son had been holding the Remington Mohawk 600 rifle when it discharged and hit the man in the back. Jamail was able to prove that a defect with the gun's safety was the cause of the accident, and Remington settled the case for $6.8 million. The day after the settlement, Remington recalled the Mohawk 600 in addition to three other models.

The second case Jamail tried that resulted in a national recall took place in 1984. That's the year a 16-year-old girl was thrown from the Honda All-Terrain Three Wheeler she was riding when the vehicle flipped over. The young girl's neck was broken, leaving her a quadriplegic, who would spend the rest of her life in a wheelchair. Jamail took the

Joe Jamail in final argument speech presents his style as an expert.

young girl's case and the jury found Honda liable with damages in the amount of more than $16 million. As a result of the findings, Honda was forced to remove every single one of its three-wheelers from around the country.

Jamail's third recall case centered around a prescription drug called Parlodel. The drug, given to new mothers who chose not to breast feed their babies, was supposed to help dry up the mother's milk. But the drug also caused strokes and Jamail proved that the pharmaceutical company knew about the risk all along. The lawyer settled the case for millions of dollars and soon after, the drug was removed from the market.

Jamail goes so far as to say that these are the cases that justify his very existence on this planet. However, most people associate the legal giant with a blockbuster case he tried in 1985 that shattered the record books: *Pennzoil v. Texaco*. Tagged as "the most important business case ever brought in the history of America," it shifted the moral compass for business ethics.

The basics of the case were simple. Pennzoil sued Texaco for convincing Getty Oil to break a verbal contract it had with Pennzoil. That verbal agreement would have allowed Pennzoil to acquire a percentage of Getty Oil that would have given Pennzoil one billion barrels of oil. Instead, the oil went to Texaco. According to Pennzoil's founder J. Hugh Leidtke, Texaco had virtually stolen a billion barrels of oil from them.

Despite the fact that Pennzoil had its own arsenal of lawyers, Leidtke called on Jamail to take the case. The pair had lived near each other in Houston for years and had often traveled together with their wives. At first, Jamail advised Leidtke to forget about suing Texaco. He thought it would be too costly and too time-consuming. But Leidtke insisted. Eventually, Jamail acquiesced despite the admonitions of the other lawyers in his office who were convinced it couldn't be won. Jamail knew he was in for a long, drawn-out, nasty fight, but he truly believed they had a chance to come away with a victory.

After five and a half months of a hard-fought battle in the courtroom, the jury returned with a verdict in favor of Pennzoil. The damages? A whopping $11 billion—the largest jury verdict in the history of law. The courtroom erupted into chaos. As Jamail exited the courthouse, he was met by a media frenzy—local, national and international TV and newspaper reporters crowded around the victor. In that moment, a legal star was born.

Jamail could have easily called it quits and retired on the fee he earned from that historic case. But the man was back in court the following week on another personal injury case. And he couldn't have been happier about it. The man simply loves trying cases. And he loves helping people who have been hurt or maimed due to no fault of their own simply because they were the victim of negligent manufacturers.

Jamail's newfound fame led to an avalanche of new clients and people clamoring to hire the big-name lawyer. To meet the demand, his office ballooned to 18 active lawyers and a host of paralegals. But he has since pared it down to four lawyers and several paralegals. Most of them have been with the firm for more than two decades, something that speaks volumes about Jamail.

Over the years, one lawyer on staff stood out in Jamail's eyes: Gus Kolius. Jamail claims he's never known a better lawyer. Before Kolius joined Jamail, the pair tried three cases against each other. The first went to Kolius; Jamail won the second; and the third ended in a settle-

Joe Jamail.

ment. Together they formed a formidable team, and the company eventually became known as Jamail & Kolius. "We were never partners," explains Jamail, "but he was a hard worker and I thought he deserved to have his name on the firm." Kolius used to work about six months out of the year and then sail around the world during the other six. Jamail recalls, "One time he called to say he wasn't coming back. 'I'm calling in rich,' he said." Jamail kept his name on the firm anyway.

Since his landmark 1985 case, the man who began his private practice as a "sore back" lawyer is now sought out by some of America's largest corporations. However, he has continued to take on a number of personal injury cases each year. These days, the lawyer takes on one case out of about every 500 requests he receives. Generally, he weeds out the

ones that have no merit, and he refers many to other lawyers who are specialists in a case's particular field. And while there's nothing that excites him more than taking a case to trial, most cases nowadays are settled before they ever reach the courthouse.

The man who started out in a small office with only two lawyers now houses his practice in the penthouse suite of one of Houston's most desirable buildings. "We have the prettiest offices in Houston, maybe anywhere," boasts the barrister. "It's a far cry from where I started."

A far cry, indeed, but Jamail will never forget his more humble beginnings. And he has made a commitment to give back to the community that has given him so much. During his 50-some years in private practice, Jamail and his wife Lee have donated in the neighborhood of $50 to $100 million to charities.

The couple have bestowed more than $21 million on his law school alma

mater, UT. To honor the world-famous alumnus, UT has erected not one but two statues of Jamail on campus—one in the university's law school pavilion and one in the football stadium, both of which bear his name. Other UT buildings bear Jamail's name, including the swim center and the legal research center, which contains the law library. The couple also provides the scholarship funds for some 2,000 UT students. Other charities have benefited from the Jamails' generosity, including Rice University, the Texas Heart Center and local homeless shelters.

Jamail's involvement with the community combined with his record-breaking legal victories make him one of Houston's brightest stars. As his age advances, people often ask him if he plans to retire anytime soon. To that, he replies, "Never!"

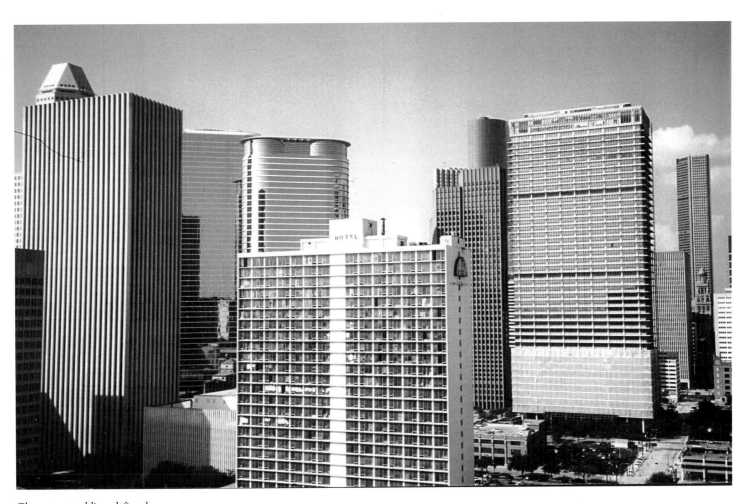

Clean structural lines define the building architecture on downtown's southwest side. Courtesy, Patricia Lopez

JIM COLEMAN COMPANY

In the 1960s the number of cars, trucks, vans and wood-paneled station wagons skyrocketed across the nation. America's newfound car culture dictated that we keep our shiny new vehicles sparkling clean. And that meant the need for car washes was on the rise. Jim Coleman, a gentleman from Houston, took a keen interest in this fact.

An electrician by trade as well as the owner of several coin-operated laundromats, Coleman had been looking for a new business venture. With suburbs sprouting up around the Houston area, more and more new homes were being equipped with washers and dryers. He was afraid this signaled an inevitable downturn in the laundromat industry and he wanted to find a more viable business. One day he saw an advertisement offering equipment for a coin-operated car wash and decided to build one. Coleman believed this fledgling new industry showed a lot of promise and he wanted to get in on the ground floor.

The car wash proved to be a success and Jim eventually went to work as a distributor in the Houston area for the Pennsylvania-based manufacturer from whom he had purchased his equipment. As new self-serve car washes popped up throughout Houston, Jim noticed that the

equipment could benefit from some modifications and made a few recommendations to the manufacturer. When they refused to implement any of the changes, he decided to branch out on his own.

In 1966 the Houstonian launched Coleman Company to manufacture self-serve car wash equipment. From day one, the business was a family affair. Coleman's wife Lorraine pitched in during the early days, working hard to help provide for the couple's seven children. Coleman's plan from the start was to create a family business and pass the ownership and management of the firm on to the second generation. It wasn't long before that next

Jim Coleman receives the Hall of Fame award from the International Car Wash Association.

generation of Colemans started learning the business by working part-time on weekends and in the summer when school was out.

Over the years about a dozen family members have worked at the company in some capacity and today seven are on the job full-time. Russell, the couple's oldest son, joined the firm in 1978 after graduating from the University of Houston with a degree in engineering. In 1997 after nearly two decades of on-the-job training, Russell stepped into the leadership position as president and his father turned over the day-to-day operations to him. However, to this day Coleman remains on the Board of Directors and is a part owner of the business.

Wayne, the second oldest son, came on board in 1975 and worked in numerous departments before assuming the role of vice president of production. The third oldest son, Randy, started his full-time career with the company in 1980 in sales and now heads up that department as the vice president of sales. Patrick, the youngest son, joined the family business in 1997 and currently is in charge of production in one of the firm's four plants. In 1997 Annette Coleman-Martin, the youngest daughter, joined the team and now acts as communications director and meeting planner.

Jim Coleman in 1968 building a touch-free car wash located on Sage Road in Houston.

The first home for Coleman Company in 1966 was located on Jensen Drive. In 1978 Jim Coleman Company moved to West 34th Street and in 1984 moved to its current home at 5842 West 34th Street on more than 12 acres with 163,500 square feet of offices and manufacturing facilities. With the Hanna acquisition, Jim Coleman Company also occupies nearly 50,000 square feet on Blankenship Drive to manufacture the Hanna line of tunnel equipment.

Since its debut in 1966 other second-generation family members have held posts within the company. Today the third generation is learning the ropes in much the same way the second generation did: working part-time on weekends and during breaks from school. Jamie Ware, a granddaughter of Jim and Lorraine Coleman, is the first third-generation family member to join the business on a full-time basis. She has worked in marketing and sales support since 2003.

With the family's assistance right from the start, Coleman's manufacturing concern grew quickly. The Colemans set up shop in a 3,800-square-foot space at 8310 Jensen Drive. The plant included just 300 square feet dedicated to administrative offices. As the number of orders for equipment rose, Coleman added about five full-time employees to help with installation and customer service while he took care of sales and strategic planning. Soon annual sales reached approximately $1,000,000.

In those days, the high-pressure wash and pumping equipment Coleman produced was simple in design but effective. Car wash customers could wash, wax and rinse their car for a typical price of 25 cents.

With that in mind, Coleman always made it a habit to talk with customers at his car washes to find out what other products and services they might like. He would also seek out advice from the independent car wash owners who bought his equipment to find out how he could make the equipment even more effective. In addition, the entrepreneur enlisted suggestions from his distributors who sold directly to the independent car wash owners. After listening to his customers, Coleman would fine-tune the equipment and add to his product line.

That tradition has since made Jim Coleman Co. a leader in car wash technology and innovation. In fact, the firm has earned numerous accolades in this department, including the 2004 Turtle Wax-Ben Hirsch Innovation Award and the 2003 Turtle Wax-Top Research & Development Award. Over the years, Jim Coleman Co. has introduced several product innovations that have helped transform self-serve car washes into complete car care centers that include vacuums, fragrance and hot foam shampoo.

One shining example of the family firm's innovative spirit is the Swipe-N-Clean credit card acceptance system. This

is the first and currently the only system on the market that allows customers to purchase a wash, time in a self-serve bay, vacuum, fragrance and vending items with one swipe of a credit card. When completed, the customer can return to the Swipe-N-Clean for a detailed receipt of all purchases.

Another technological advance from the company is the Entry Wizard, the first interactive entry controller for an automatic car wash. When a car wash customer arrives at the entrance of the wash bay, the driver is greeted by a pleasing voice message and a 13-inch touchscreen. The user-friendly Entry Wizard includes an easy-to-read menu and audio instructions. For car wash owners, the touch-programmable Entry Wizard also offers full, detailed reporting among other benefits.

In addition to these technological advances comes the Water Wizard In-Bay TouchFree automatic system. This automatic system offers scrubbing action high pressure washing over an entire vehicle. It is the only TouchFree unit to successfully adjust to the variety of heights of vehicles on the road today.

Coleman's belief in customer service and listening to what customers want is one of the things he has passed on to the second generation of Colemans who are leading the company today. But listening to what customers want is only one of the reasons why Jim Coleman Co. has become

a leader in innovation. Having family members at the firm who own and operate their own self-serve car washes also gives the company an inside edge. Their involvement is just one of a host of things that separates this family business from many of its competitors who don't have a first-hand knowledge of the industry.

Coleman's commitment to his customers who purchased equipment with the intent of building a car wash went beyond listening to their suggestions for new products and services. The company founder firmly believed that it was easier to keep an existing customer than to find a new one. To keep car wash owners coming back, he vowed to go the extra mile for them.

That has since translated into an extensive training program called the "College of Knowledge." This one-week, in-house training program covers the company's entire line of equipment and is designed for both regional distribu-

Randy and Russell Coleman making chemical deliveries to local car washes.

tors and independent operators who buy the equipment in order to own a car wash. In addition to providing information on how to use and service the equipment, the company also offers assistance with marketing and promotions. This also differentiates Jim Coleman Co. from many of its competitors who sell equipment without any follow-through or training. In short, the family business has realized that by helping make its customers more successful, it increases its own rate of success.

This attitude has helped the firm grow

Jim Coleman Company founders: Jim and his wife Lorraine Coleman.

from 17 employees and nearly $6 million in sales in 1994 to about 300 employees and $45 million in current yearly sales. What began in a 3,800-square-foot space has now expanded to approximately 163,500 square feet on Houston's 34th Street, including four separate manufacturing plants on 12 acres of land. The manufacturer, which focused exclusively

on the self-serve market for decades has since expanded to include products and services for every aspect of the industry, from self-serve to full-serve. And this company, which catered solely to the Houston market until 1980, has now branched out to include international sales to France, Germany and Australia among others.

Family members involved in the management of the business are quick to give credit to the city of Houston for much of their success. The Bayou City may have a reputation as the Energy Capital of the world, but it has provided the backdrop for thousands of entrepreneurial success stories in other industries as well. In fact, the city has been hailed as America's largest boomtown. In 1960 the Houston metro area's population numbered just 1,364,569. By the year 2000 that number had jumped to 4,177,646. Thanks to that growth in population, many businesses offering products and services to local residents have experienced tremendous success and Jim Coleman Co. is one of them.

The family members at Jim Coleman Co. also credit the city's relatively low cost of living for reducing operating expenses. Among major American cities, Houston ranks as the second lowest

High pressure Touchfree car wash built in 1968 on Jensen Drive in Houston.

Today's carwash with brick, stone, custom graphics, awnings, mansards and lush landscaping.

in cost of living. For business owners like the Colemans, that translates into lower payroll costs.

Being located in Houston has also facilitated Jim Coleman Co.'s expansion efforts. The nearby Port of Houston is one of the nation's busiest ports, rank-

A Hanna Tunnel Wash System. In 2005 Jim Coleman Company acquired Hanna car wash systems.

ing second in the world in foreign tonnage. Thanks to the Port's close proximity, the costs of shipping equipment to international locations are far less than it would be if the company was located elsewhere. With all these benefits, Jim Coleman Co. plans to remain in Houston for years to come.

The many Coleman family members who have been working hard since the car wash firm debuted nearly 40 years ago are thankful for the company's continued success and the many awards it has earned. As a token of their appreciation, Jim Coleman Co. gives back to the community on a regular basis. Among the company's many charitable efforts are the MS 150 bike ride which raises funds for Multiple Sclerosis; Faith in Practice, a community of Christians working to improve conditions in Guatemala; and, the Wash U.S.A. campaign for the Make-A-Wish Foundation.

Although Jim Coleman Co. has been built on the strength and

leadership of its family members, the company's leaders realize that their success must also be shared with the many non-family members who are employed at the company. The firm's president Russell Coleman insists that making employees feel like they are part of the family is an important part of the manufacturer's long-term success. And it's one of the many reasons why Jim Coleman Co. earned the 2004 Texas Family Business of the Year Award for Large Family Business, which was awarded by Baylor University's Institute for Family Business.

For founder Jim Coleman, that award meant more than all the other accolades

Wayne Coleman assembling pumps and car wash equipment in the waehouse.

the company has received. It even outshined the moment when Coleman received one of the highest awards the International Car Wash Association can bestow, the Car Wash Hall of Fame Honors him for demonstrating his outstanding ability and dedication to the car care industry. But for Coleman, who dreamed in 1966 of creating a lasting family business, that Texas Family Business Award proved that his dream had indeed come true.

MEMORIAL HERMANN HOSPITAL

The heritage of Memorial Hermann Hospital (MHH) spans nearly 100 years of Houston's history. Originally two separate entities, the Memorial and Hermann hospitals joined forces in the late 1990s. The founding fathers of Memorial and Hermann were both extraordinary visionaries who created a legacy of innovation, quality and caring that continues to thrive today.

The dream of Reverand Dennis Peveto was to build a hospital open to all, regardless of religion, race or ability to pay. In 1907 Reverend Peveto's dream became a reality. He purchased the 18-bed Baptist Sanitorium in downtown Houston. Peveto became the superintendent of the sanitarium and created what would ultimately become the Memorial Hospital System, a 200-bed facility.

Another local citizen shared Peveto's dream of building a hospital for Houston's citizens. Before his death in 1914 and having no heirs, George H. Hermann earmarked the bulk of his $2.6 million estate for the construction and maintenance of a hospital for the poor and sick of Houston. Hermann Hospital welcomed its first patients on July 1, 1925 and opened the Hermann School of Nursing that same year. With an eloquent exterior architecture featuring an open terrace and water fountain and an interior lobby

For nearly a century Memorial Hermann Hospital set new standards of care in Texas and the nation through revolutionary advances in medicine and surgery. Today, that legacy of accomplishment continues with research that results in less-invasive procedures, quicker recovery times, improved outcomes for patients, reduced medical costs and increased patient satisfaction.

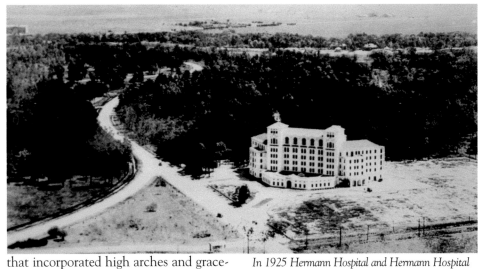

In 1925 Hermann Hospital and Hermann Hospital School of Nursing opens. Memorial Hermann was the first hospital to open in the world-renowned Texas Medical Center.

that incorporated high arches and graceful lines, patients felt more like they were visiting a palatial residence instead of a hospital.

Beyond its impressive architecture, patients from all walks of life found a caring and healing environment. Both founders were committed to the principle that everyone should have access to the best possible medical care and be able to face illness with dignity and courage. Hermann and Peveto also shared the belief that living, not dying, should be a hospital's focus.

Memorial Hermann Hospital is part of one of the largest not-for-profit health care systems in the United States, the Memorial Hermann Healthcare System. Located in the prestigious Texas Medical Center is a community-owned hospital dedicated to providing high quality health services for the people in Southeast Texas. Memorial Hermann strives to be the best in the U.S. by creating exceptional patient care experiences, providing outstanding medical services, supporting

biomedical research and clinical trials, and maintaining high standards in customer service and a reasonable price for the services offered to the community. These goals are met by assessing and creating innovative healthcare solutions that address the needs of Houston's diverse population, as well as through the hospital's ongoing commitment to the intellectual and spiritual growth and development of its employees.

The ongoing success of Memorial Hermann is owed to the leadership of two individuals. Juanita F. Romans was appointed as senior vice president, Memorial Hermann Healthcare System and chief executive office of Memorial Hermann Hospital in January 2003. She was the first woman appointed to the organizations President's Council. Ms. Romans joined Memorial Hermann Healthcare System in May 2001, as vice president and chief operating officer of Memorial Hermann Hospital. She was instrumental in providing leadership for the flood recovery efforts of the hospital after the devastation of Tropical Storm Allison in June 2001, only one month after her arrival. Ms. Romans has over 20 years of healthcare leadership experience in a managed care environment, with an extensive background in clinical, financial and administrative services.

Daniel J. Wolterman has served as president and CEO of Memorial Hermann Healthcare System since November

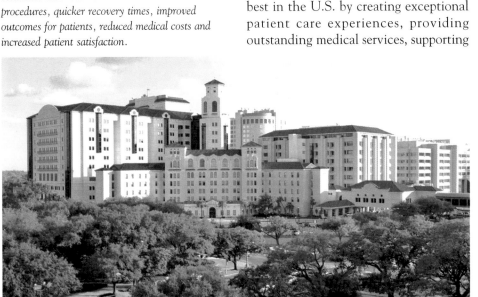

2002. Mr. Wolterman comes from an extensive background as a medical administrator and before serving as president of the system, he was the senior vice president of Hospital Operations and was responsible for the operations and activities of the System, including the acute care community hospitals. Mr. Wolterman has a total of 25 years of experience in various executive positions in the healthcare industry.

The Texas Medical Center operations include Memorial Hermann Hospital, the founding institution of the Texas Medical Center and Memorial Hermann Children's Hospital, the unique facility dedicated to the health of children, ranging from premature infants to 17 year-olds.

The $250 million redesign of their current campus is evidence of a commitment to the community and to a vision for the future. As they embark on a 10-year master plan, Memorial Hermann Hospital seeks to continue a tradition of innovation and excellence. With a new building scheduled to open in the Spring of 2007, the Memorial Hermann Heart & Vascular Institute in the Texas

Memorial Hermann's innovative technology offerings include the da Vinci® Surgical System the first operative surgical robotic system in the world approved by the United States Food and Drug Administration (FDA). Robotic-assisted surgery is the latest development in minimally invasive surgery (MIS). Robotic surgical systems give surgeons the flexibility of traditional open surgery while operating through tiny incisions.

Cardiac Catheterization Labs feature the latest technology for diagnosing and treating patients experience severe chest pain and other heart-related symptoms. Using minimally invasive techniques, physicians can pinpoint blockages and restore blood flow quickly to affected areas.

Medical Center exceeds the standard for cardiovascular services. The 165,000-square-foot Institute offer cutting-edge cardiology programs and technology that deliver a broad range of first-class healthcare solutions to Houston. The Institute offers comprehensive services for the full continuum of heart and vascular medicine—prevention, diagnosis, and treatment.

Physicians and patients alike benefit from the leading-edge programs and technology available at the $70 million Heart and Vascular insititute. It was the first

center in the world to perform robotic-assisted reconstructive aortic surgery, the first in the world to show that heart disease can be reversed, the first in Texas to give patients clot-dissolving drugs to stop heart attacks, the first in Texas to offer cardiac risk screening designed specifically for women, and the first in Houston to perform minimally invasive surgery to correct atrial fibrillation.

Robotic-assisted surgery is the latest development at Memorial Hermann in minimally invasive surgery (MIS). Robotic surgical systems give doctors the flexibility of traditional open surgery while accessing the site through tiny incisions. These innovative technologies are possible using the *da Vinci®* Surgical System, the first surgical robotic system in the world approved by the United States Food and Drug Administration (FDA). The *da Vinci* Surgical System integrates robotics, computer technology and surgical skill to simplify a number of existing surgeries, transforming traditionally invasive surgeries into minimally invasive procedures.

Two of Memorial Hermann's *da Vinci* systems are used clinically for a variety of surgical procedures, while the third is an essential component of the Memorial Hermann Institute for Cardiovascular Research and Robotics Technology. This training and research center opened in January 2003 and already has trained numerous surgical teams from around the country. It is one of the the largest training sites for robotic surgery in the nation and the only one in the southwest. The research center allows physicians affiliated with Memorial Hermann to be at the forefront of this groundbreaking technology.

One of the service lines in which the hospital specializes is weight loss (bariatric) surgery for morbidly obese patients. Utilizing the latest technology, including robotics-assisted surgery, physicians can simplify the procedure, making it less invasive and decreasing recovery time. Patients benefit from a dedicated floor with private rooms overseen by specially trained nurses and staff, who are attuned to the specific needs of weight loss patients.

The new Memorial Hermann Medical

Plaza will allow physicians to headquarter their practices on one of the world's premier medical campuses. Currently the largest construction project in Houston, the 30-story Memorial Hermann Medical Plaza will also be the largest medical office building in the Texas Medical Center. Additional state-of-the-art innovations and improvements are planned to address the service line growth including immediate and long-term parking needs and further improvement to patient rooms and care areas.

Memorial Hermann's Outpatient Imaging Service provides imaging tests and procedures integral to the diagnosis and treatment of many medical disorders and conditions. Using the advanced, 16-slice CT scanner, for example, the procedure time can be reduced by 50 percent, leading to a faster diagnosis and a much more comfortable experience. It also reduces exposure to radiation, enhancing safety.

Another major new tool used at Memorial Hermann is the eICU Monitoring System, which employs sophisticated telemedicine technology, early warning software and electronic monitoring to connect an off-site Memorial Hermann critical care team of specially trained, board-certified intensivists and critical care nurses directly to ICU patients. When a patient is admitted to the ICU, the bedside physician will enter data about the patient such as the admitting diagnosis, level of illness and care plan. Then the critical care team will begin

Designed for patients who prefer an atmosphere more commonly associated with fine hotels, Signature Suites and Services offer quality, attentive care in a private, healing setting.

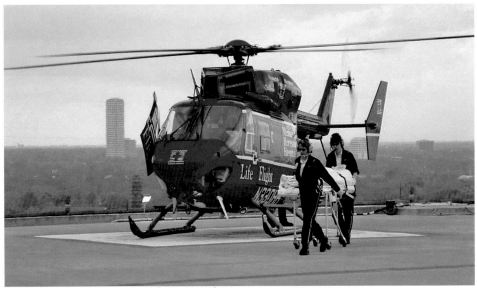

Memorial Hermann Life Flight, Houston's only hospital-based air ambulance. Serving a 150-mile radius, Memorial Hermann Life Flight transports more than 3,000 patients annually on 2,800 plus flights in rotor and fixed-wing aircraft.

tracking the patient's vital signs. The eICU is not intended to be a substitute for bedside staff, but an enhancement to the qualified personnel already caring for the patient. The equipment detects subtle changes in a patient's condition, allowing for early treatment of these symptoms before they become critical.

Orthopedics is a Center of Excellence at Memorial Hermann Hospital. The hospital's orthopedic specialists provide high-quality, patient-focused care, treatment, and rehabilitation for a full range of disorders for both children and adults. Their services include non-surgical and minimally invasive procedures such as microsurgery, trauma care, joint replacement, reattachment of fingers, hands, and wrists, treatment for spinal disorders, bone reconstruction, congenital disorders, and rehabilitation for muscle, joint, and bone injuries and abnormalities, and sports medicine. Because these programs are hospital-based, patients have fast access to around-the-clock emergency services and complete diagnostic resources such as laboratory, X-ray, CT scans, MRI and fitness testing.

Using innovative technologies and diagnostics, the hospital also offers a complete range of neurology and neurosurgery services to treat adults and children with epilepsy, brain injury, and stroke, as well as diseases that impair the nervous system. An example of this is the utilization of sophisticated techniques such as magnetoencephalography (MEG) to evaluate the surgical risks of patients with brain tumors and to identify strategies that will

best minimize those risks.

Through the cancer programs at Memorial Hermann Hospital and its affiliates, thousands of patients are able to receive expert diagnosis and treatment each year. Physicians and cancer specialists in a variety of disciplines are working to improve the survival rates and quality of life for people with cancer. Through the extensive knowledge and experience of Memorial Hermann's medical professionals and access to state-of-the-art technologies, the hospital is able to provide comprehensive, effective care close to patients' homes and families.

In the field of organ transplantation Memorial Hermann has led the way for more than two decades. The hospital saw its first kidney transplant in 1977. In 1980 the hospital was one of only three centers in the United States to test the anti-rejection drug Cyclosporine in humans. Since then, Cyclosporine has become the cornerstone of most immunosuppressive regimens.

To date, more than 4,000 transplants have been performed at Memorial Hermann Transplant Surgical ICU, and scientific discoveries continue to expand the hope and healing offered by this branch of medicine. Technology is now being developed for Islet Cell transplantation, which will help the pancreas of

diabetics to produce insulin. The professional staff of the Texas Liver Center includes hepatologists who specialize in diagnosing and treating all types of liver disease. Also on staff are transplant surgeons, who manage patient care throughout the transplant process—before, during and after surgery. Driven to be the best, these specialists are on the front line of disease management for hepatitis patients, immunosuppressant research and surgical advances including transplantation for cancer, split liver transplants, small bowel transplants, and living-related transplants.

Memorial Hermann also provides a Level I Trauma Center, the highest certification that can be awarded to an emergency care facility and one of only two such centers in Houston. Memorial Hermann's close affiliation with The University of Texas Medical School at Houston enables its emergency teams to draw on the expertise of specialists in many fields. These include emergency medicine, internal medicine, surgery, infectious diseases, nephrology, neurosurgery, transplantation, orthopedic surgery, neurology, cardiology, and pediatrics.

Memorial Hermann Life Flight, as it is known today, was founded in 1976. The program was one of the first emergency air ambulance services in the country. The award winning program was founded by Dr. James "Red" Duke, who also serves as its medical director. To date, Life Flight has flown more than 95,000 patient missions and was named the "2004 Air Medical Program of the Year" in Texas.

Memorial Hermann Children's Hospital is among the nation's finest hospitals, administering outstanding care for everything from life-threatening injuries to minor childhood mishaps. Each year, more than 37,000 children receive treatment at Memorial Hermann Child-ren's Hospital, where they provide exceptional pediatric services in a warm, compassionate environment. Affiliated with The University of Texas Medical School at Houston, Memorial Hermann Child-ren's

Hospital has 178 beds in the Hermann Pavilion within Memorial Her-mann Hospital. This location ensures patients access to advanced medical equipment and expert care offered by a full-service, university-affiliated hospital.

Pediatric care is their sole focus. Colorful décor, special play areas, and a reassuring staff attuned to the special needs of children help to make every child's stay a positive experience. They offer a complete range of general and specialty pediatric care. Memorial Hermann Children's Hospital has a 92 bed Neonatal Intensive Care Unit, a Pediatric Intensive Care Unit, a Special Care Unit and offers over 40 pediatric subspecialties in such areas as neuroscience, epilepsy, neurosurgery, burn treatment, organ transplant, liver and kidney disease, sleep disorders, ophthalmology, and more.

Memorial Hermann Hospital is devoted to providing a full line of high level services and medical care to both the American and international community. Through its International Services Center (ISC) the hospital welcomes patients from more than 70 countries. The ISC offerings include diagnosis, treatment, second opinions, and annual check-ups. Experienced physicians and staff are also fluent in a variety of languages.

Surgical Webcasts are also a major part of Memorial Hermann's commitment to be the best teaching hospital. These

Memorial Hermann Heart & Vascular Institute-Texas Medical Center (slated for completion in mid-2007).

Bright and inviting, the renovated Atrium and Conference Center are designed to meet the needs of patients, visitors and physicians.

webcasts provide a unique opportunity for physicians, residents, interns, and the public to watch and learn about life-saving techniques that few have mastered. These webcasts include gastric bypass surgery; endovascular aortic aneurysm repair; neurosurgical treatment of Chiari malformation; transforaminal lumbar interbody fusion (TLIF) procedure; and thoracoabdominal aneurysm repair.

Memorial Hermann Hospital is part of the much larger Memorial Hermann Healthcare System, which includes 3,188 licensed beds spread over three acute care hospitals, three long-term acute care hospitals and three specialty care facilities. The system also features 19 regional affiliates, and three managed acute care facilities. It also includes one retirement and nursing center and a home health agency.

Memorial Hermann Healthcare System employs more than 16,500 Houstonians, as well as more than 5300 medical staff members, 669 physicians, 142 fellows, and 26 residents. The system's physicians deliver more than 20,000 babies annually, and more than 300,000 patients visit their emergency rooms each year.

For more information about Memorial Hermann Hospital please visit the Web at www.memorialhermann.org.

SUHM SPRING WORKS, LTD.

For more than 120 years, Suhm Spring Works, Inc. has brought quality products and services to businesses across Texas. As the maker of springs that are used in the oil, aerospace, and chemical industries, its products have been used in cars, airplanes, manufacturing equipment, and hundreds of other machines and devices. Now a sixth generation, family-owned company, Suhm Spring Works has offices in Dallas, Houston, Mexico, and the Netherlands.

Originally a carpenter and cabinet maker in Germany, the company's founder, Carl Suhm, worked for several Houston area builders during the early 1880s. In 1885 he decided to open his own small woodworking shops that specialized in everything from cabinets to molding.

Over the years, Carl and his son Carl J. evolved the company from a small woodworking shop into a machine shop. After the Great Depression along with the rise of oil, the company made further advancements, noticing the need for specialty parts. Carl J. and his son, Carl Eugene, took what was then a profitable machine shop and focused it into the growing market for industrial springs stemming from the oil fields of West Texas.

In the '60s, Carl Eugene's son-in-law Donald Morgan came on board. He

Workers in the original Suhm plant, located in the heart of downtown Houston on Preston Street.

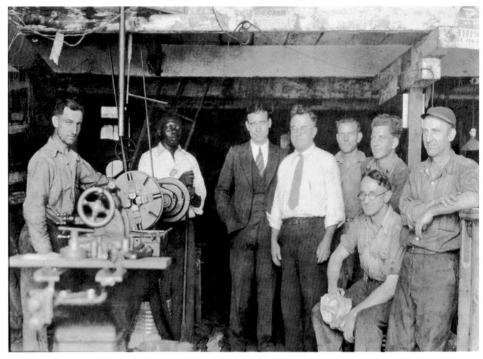

Carl Eugene on the left, and Carl J. on the right, with workers at the original factory in the mid-'40s.

helped grow the company from a 10 person operation to nearly 70 employees. Unfortunately, in 1965 Carl had an aneurism and was unable to work. It was then that Donald bought the company.

It wasn't long before Donald's son Russell started begging him to come to work. "I started working at Suhm in 1968 when I was 12 years old," says Russell Morgan. During high school he helped at the company during summer vacations. He started out working in the shop and moved around in the company whenever they needed someone to fill in. For the next 20 years, Russell worked in every

capacity within Suhm Spring Works. He never needed to be asked to do anything; he just saw where the need was and stepped in to help.

In 1992 Donald passed away and Russell became president of Suhm Spring Works. At the time, the company was doing $3 million a year. As of 2004, under Russell's leadership, the firm has grown into a $21 million business. Russell says one of his more significant contributions to the company has been to make it "less of a hard sell" business. He has taken many classes in negotiation tactics and has used those skills to improve the company. Donald's business philosophy had been to make the most money, whereas Russell's approach has been to offer competitive pricing and good customer service.

Russell is proud of the fact that the company has been able to retain all of its major clients over the years. He credits buying in volume as one of the keys to his success. "We offer a larger variety of products than the other companies do," Russell explains. "We realized that our customers had to go to four or five different spring shops to get the springs that they needed." Russell then adjusted his inventory so Suhm Spring Works could be a one-stop-shop for all his customers.

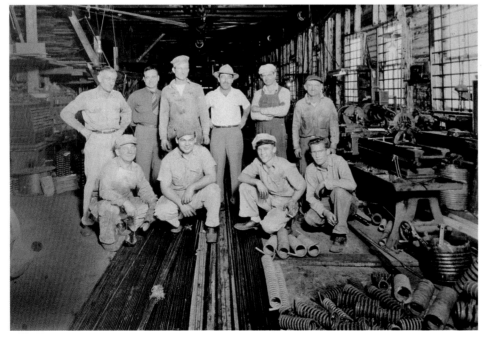

The company now boasts one of the largest in-house inventories of raw material in the industry.

A far cry from its humble beginnings, Suhm Spring Works now has 150 employees and four plants. The majority of that growth has taken place under Russell's leadership. In 1999 he opened the company's Dallas division and its European sales and marketing office in the Netherlands opened in 2000. In 2001 Suhm's auto coil division opened in Houston, and one year later, its plant in Mexico began taking orders. "We looked into the Mexico plant for two years before we opened it," says Russell. "We have a lot of customers who want us to produce our products at cost. This plant specializes in carbon steel springs and serves as our low cost center." The company's corporate headquarters and primary manufacturing facility on McKinney Street in Houston still serves as its largest plant. It has been open since the 1940s, and employs nearly two-thirds of its workforce.

Russell has taken many strides to develop solid business alliances with his customers. He realized early on the importance of partnerships and the power of customer confidence. Since Suhm Spring Works has developed such a

A hot-wound spring in process.

reputation for quality, its customers don't even inspect their parts before they're purchased. That sort of confidence is also evident in the company's inventory control and fulfillment programs, where Suhm manages their clients' needs electronically.

Suhm designs and sells only specialty springs to suit its clients' specific needs. Utilizing the highest quality materials and state-of-the-art design capabilities, its engineers can create springs to fit nearly any specification, ranging from commercial to nuclear. One example of this specialized work is the extension spring that Suhm created in 1969 to help hold a moon rock in place during a space mission.

Left to right: Vice President Mark Scarborough, President Russell Morgan, and Assisstant Vice President Richard Vargas at the company's McKinney Street location

In 1996 Russell's son, Gene, started working at the company during the summer—just as his father had. He learned how to make hot wound springs and familiarized himself with the other aspects of the business. In 2003 Gene came on board full-time. He now specializes in sales and marketing efforts, and maintains the company's website.

Now a sixth generation company, Russell has surrounded himself with people who are important to him. "These aren't just coworkers, these are people I care about," says Russell. He's known his assistant vice president since eighth grade and there are others on staff that he's been friends with since high school.

"We have very little turnover because we treat people with respect," Russell says. As evidence of that, there are many 20-year employees on the payroll. "I believe in working as a team," he says of his management philosophy. "I'm hands-off and don't micromanage the staff." Russell is a strong proponent of giving people an opportunity to work, and enabling them to grow with the company. "We have people here who want to excel, I try to give them that opportunity."

TEXAS SOUTHERN UNIVERSITY

When students begin matriculation at Texas Southern University, they enter through an open door that promises limitless opportunities. These students graduate knowing they have attained educational success, and they leave the University prepared for life, challenging careers and deserved success.

As alumni, they pass the torch on to future generations of scholars. But why do these torchbearers, past, present and future, choose Texas Southern University?

Many come for the outstanding faculty and others enroll for the high-demand academic programs. Several are attracted to an admissions policy that provides a unique opportunity to improve their lives—an opportunity that would not otherwise have been afforded them without TSU. Still, a significant number walk through those open doors because of the University's legacy of educating a legion of African American professionals.

Perhaps this legacy, most of all, is the reason that for over 57 years, TSU has opened doors to a diverse population of students and enabled them to reach great heights in their careers, communities and lives. For many of these young people, TSU is a fountain of hope and a catalyst toward a better tomorrow.

Texas Southern University, a special purpose institution for urban programming, has a history that dates back to 1927. The University's earliest antecedents were characterized by a progression of institutional constructs: extension classes, a junior college, four-year private institution, and ultimately, a state-supported institution. The University's status as an institution of higher learning came during the era of segregation when the State of Texas denied Heman Sweatt, an African American, entrance into the University of Texas Law School. Consequently, on March 3, 1947, the Texas State Senate of the 50th Legislature passed Senate Bill 140 providing for the establishment of the institution, including a law school, to be located in Houston. This bill was complemented by House Bill 788, which called for the purchase of a 53-acre site to house the campus.

Although it was designated as an institution of the "first class," when the

University opened its doors in September 1947, it had 2,300 students, two schools, one division and one college—the Law School, the Pharmacy School, the Vocational Division, and the College of Arts and Sciences. Responding to the changing times, in 1973, the 63rd Legislature designated TSU as a "special purpose" institution for urban programming. As a result, four more academic units were added—the College of Education, the School of Public Affairs, the School of Communications, and the Weekend College. This designation described what the University was doing from its inception—embracing diversity.

Today, TSU is a state-assisted institution offering bachelors, masters and doctoral degree programs in the follow-

Since 1947 Texas Southern University has provided a first class educational experience to deserving students, offering over 120 baccalaureate, masters, and doctoral degree programs in nine schools and colleges. The University currently has more than 11,000 students enrolled and is recognized as the second largest, single campus Historically Black College in the country. The direct economic impact of TSU to the Houston community was estimated at $299 million in 2004. Visit Texas Southern University online at www.tsu.edu.

Below: Excellence in achievement! They enter the university as students, and through comprehensive, quality instruction, they emerge as attorneys, pharmacists, educators, legislators—world leaders.

ing academic colleges and schools: the College of Liberal Arts and Behavioral Sciences; the College of Pharmacy and Health Sciences; the College of Science and Technology; the College of Education; the Barbara Jordan-Mickey Leland School of Public Affairs; the Thurgood Marshall School of Law; the Jesse H. Jones School of Business; the College of Continuing Education; and the Graduate School. Other programmatic emphasis are found in the Center for Excellence in Urban Education, the Center for Transportation Training and Research, the Center on the Family, and a variety of special programs and projects. Currently, TSU is staffed by 509 faculty members and 571 support personnel. More than 11,000 students, representing ethnically and culturally diverse backgrounds, are currently enrolled at the University.

As the reputation of TSU grew, so did awareness about its community influence and significance. Over the years, the University's educational facilities and programs expanded, and many of its graduates began to achieve local, regional, and national recognition for their influence in politics, education, business, technology, medicine, and the arts. The University grew from one permanent building and several temporary structures to the 45-building, 150-acre campus that exists today.

The late U.S. Congresswoman Barbara Jordan and Congressman George

To honor distinguished educators, TSU renamed three buildings during 2003.

Above: The Roderick R. Paige Education Building was designated after former U.S. Secretary of Education and former TSU dean and Houston Independent School District superintendent Dr. Rod Paige.

Above right: Once known as simply the University Auditorium, the recently assigned Granville Sawyer Auditorium now serves to commemorate the contributions of TSU's fourth president, Granville Sawyer, who was

instrumental in the development of academic programs that sought to identify and resolve urban problems.

Below: The University's sixth president, Leonard H.O. Spearman Sr., was recognized for his contributions to TSU—which include increasing federal funding, upgrading the physical plant, implementing a doctorate in pharmacy and a degree in accounting, and establishing the University's Center for Excellence in Urban Education—through the designation of the Leonard H.O. Spearman Technology Building.

"Mickey" Leland are two of TSU's most distinguished alumni.

Through their congressional achievements, both made significant contributions to the enhancement of the city of Houston, the state of Texas, the nation and the world. The Leland Papers and Barbara Jordan Archives are significant additions to the comprehensive collection of historical documents entrusted to TSU. The establishment of such annals provides unique research opportunities rarely found within the holdings of a traditional college system. The compilation expands the university's acquisition, access and preservation program and constitutes a major collection in the Southwest.

TSU is heralded as a pioneer, and distinguishes itself as one of the leading producers of African American scholars that obtain collegiate, professional, and graduate degrees in the state, as well as the nation. The University's enrollment has grown from 2,303 students to more than 11,000 undergraduate and graduate students from across the world. Although the University was initially established to educate African Americans, it has become one of the most ethnically diverse institutions in Texas.

What does it take to make a great university? If you said vision, strategic planning and execution, you would be

TSU is one of only two, four-year colleges in Texas to have an open enrollment policy.

right. For TSU, this winning combination has been its formula for success and has been greatly due to the visionary and dynamic leadership of President Priscilla D. Slade, Ph.D.

Strong leadership is critical to the success of any organization. It is the unique component that separates one institution from another. TSU is fortunate to have leaders who leverage the institution's rich history to guide it toward a more prosperous future.

In 1999 Slade was appointed the 10th president of Texas Southern University. She joined the University in 1991 as Chair of the Accounting Department and

Thirty-five percent of all African Americans in the Houston metro area with a college degree earned it from TSU.

was subsequently named Dean of the Jesse H. Jones School of Business in 1992.

Immediately after commencing her tenure, Slade established and articulated a vision for the University: "I envision Texas Southern University in the 21st century as an independent institution of higher learning of the first class."

The Five Vision Points, guiding principles for university growth, are as follows: fiscal integrity, service and accountability in administration, a hospitable living & learning environment for students, a commitment to community outreach and academic and faculty excellence.

As president and chief executive officer of TSU, she leads a teaching- and research-intensive institution of higher education and manages an annual budget of more than $115 million.

Her administration has been characterized by a turnaround strategy for the institution and a long-term improvement plan. Slade's pragmatic problem solving expertise gave rise to this strategy which included: (1) Repositioning the University and restoring stakeholder confidence, (2) Restructuring the University to facilitate growth and accountability, and (3) Re-engineering business processes to accomplish mission-centered goals and objectives.

TSU's quest for excellence has contin-

ued to reach new heights. By all accounts, the institution has been both re-energized and transformed by her Five-Point Vision to establish the University as a perennial educational resource for the city of Houston, the state of Texas, and the global community.

Her visionary approach to strategic planning and consultative management style provided core ingredients for the development and implementation of a long-term comprehensive plan for sustainable growth and improvement. Under this plan the University has achieved unprecedented successes: more than $80 million in facilities expansion and improvement, increase in graduate programs and faculty, increase in number of accredited academic programs, increase in research, increase in endowments, and increase in acquisition and use of technology to provide higher quality service to students as well as increased productivity of administrative staff.

She has led the strategic planning efforts that provide explicit directions on how to reach institutional goals and have mobilized resources to ensure the implementation of those plans. As a result, the University has achieved myriad accomplishments assuring its role as a viable institution of higher education.

The University provides an opportunity for all students, not just a select few,

TSU offers quality, comprehensive academic programs and services that meet and anticipate the unique needs of a diverse student population.

Priscilla D. Slade, PhD., president of Texas Southern University.

to take advantage of advanced professional educational programs. Throughout its history, TSU has demonstrated an unyielding commitment to increasing minority participation in post-baccalaureate education. Take, for example, the Thurgood Marshall School of Law, which has been instrumental in affording minority students from across the country a chance to practice law. As such, training students to become practitioners in the field of law is one of TSU's greatest legacies.

A look at the statistical breakout re-

veals just how significant TSU has been in shaping the state's legal community. Of the African American attorneys in Texas, 30.2 percent received their juris doctorate degree from TSU. A total of 11.5 percent of Hispanic attorneys also received their law degree from TSU. Perhaps the most impressive statistic is that 77.6 percent of all African Americans in public university law schools are enrolled at TSU.

TSU is committed to building the necessary bridges from high school to higher education. In turn, the University is consistently graduating future educators who are equally dedicated to leaving no child behind.

In fact, these graduates serve in school districts all over the country. Yet, their presence is most significant in Houston. Of all teachers in Texas' largest public school system, the Houston Independent School District, 12 percent have TSU degrees. A significant number of HISD teachers with graduate degrees received them from TSU; 21 percent of teachers with master's degrees and 14 percent of teachers with doctoral degrees all chose to further their education at TSU.

The University has had an even greater impact on the administrative level. A full 30 percent of HISD principals and assistant principals and 16 percent of higher-level administrators possess TSU degrees.

TSU's impact is not limited to education or the legal profession. In fact, the University's contribution to the field of pharmacy is nothing short of amazing. Of all African American students enrolled in pharmacy degree programs in Texas, 86 percent attend the College of Pharmacy and Health Sciences at TSU.

The College of Pharmacy and Health Sciences produces some of the University's most impressive research projects. In the Center for Cardiovascular Diseases, researchers study life-threatening diseases that affect the heart and blood vessels, and why they take a greater toll on African Americans than any other ethnic group.

In the University's HIV Prevention Center, researchers lead efforts to prevent the spread of HIV and AIDS in minority communities. In the 2002-2003 academic year, students calling themselves the

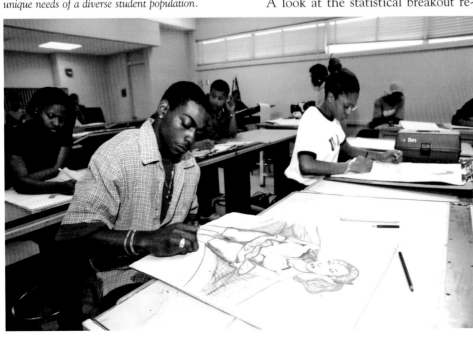

"Pharmaceutical Tigers" took to the sky to perform a NASA experiment to test a drug for astronauts to alleviate nausea and motion sickness during space travel. During the same year, the College joined the world-renowned Texas Medical Center.

The University has demonstrated performance in many critical areas. But its most impressive indicator is not a statistic—rather, it is a statement with supporting numbers.

TSU experienced a 6 percent enrollment increase in fall 2000; an 18 percent enrollment increase in fall 2001, the largest percentage increase among public institutions in Texas that semester; a 20 percent increase in fall 2002 enrollment; and an 11 percent increase in fall 2003. TSU is now recognized as the second-largest single campus Historically Black College and University (HBCU).

The University has searched the world to assemble its extraordinary faculty. These scholars distinguish themselves not only through outstanding achievements in research, but also by employing innovative and diverse teaching methods. There are few segments of society that have not been impacted by TSU through its students, graduates or research. The University partners with research organizations, governments and leading universities across the world.

TSU has a long history of initiating research that impacts urban life and

Every minute of every day, someone from TSU is making a difference.

Alumni pass the torch on to future generations of scholars.

fulfills its mission as a special purpose institution of urban programming. In recent years, TSU has initiated major projects, including:

• University Research, Engineering and Technology for Intelligent Bio Nano Materials and Structures for Aerospace Vehicles.
• NASA University Research Centers program.
• Center for Minority Training and Capacity Building for Disability Research.
• Research Centers in Minorities Institutions program.
• Department of Health and Human Services and American Heart Association grant for biotechnology and health-related studies focusing on high-frequency diseases in minorities
• Transportation research funding.
• Telecommunication Infrastructure Fund grant.

Armed with vision and value, TSU has embarked on its first major capital campaign to build its endowments and enhance its academic programs and facilities to fulfill its 21st century mission. Slade spearheaded the University's first capital campaign in 2002 called "Open Doors," a $50 million fund-raising initiative to benefit student financial aid and scholarships, existing facilities renovation and new building construction projects, campus beautification, and technological infrastructure upgrades.

Slade has increased efficiency, effectiveness, and performance in all areas of the University. The depth and breadth of achievements in virtually every area indicate sound planning and management practices implemented under her leader-

ship. She has forged viable partnerships that span business, government, and academic communities for the benefit of promoting the mission. Every opportunity to enhance visibility has been leveraged within the community at-large, as evidenced by her numerous invitations, awards, speaking engagements and requests for personal appearances. Slade has instituted a number of initiatives to highlight TSU as a first-class academic institution and to enhance its image, credibility, and support by fostering relationships with key external constituents.

She also provides the overall leadership and coordination of the University's Legislative Agenda and Legislative Appropriations Request. She leads the legislative team that articulates the University's priority appropriations needs and accomplishments of performance goals. Explaining and defending budgets through the appropriations process is a challenging responsibility; however, Slade's background in finance and accounting has contributed greatly to the success of the University's efforts.

Her ongoing efforts to build and maintain relationships with state and federal elected officials have assisted in developing a federal agenda to increase funding. At the mid-point of fiscal year 2004, the University had already received a record

TSU enriches the lives of thousands of people living beyond the walls of the campus.

level of more than $15 million in federal grants, contracts, and appropriations.

She has succeeded in providing an open, hospitable learning environment that fosters opportunity, creativity, critical thinking, and success for the students. Key indicators of student satisfaction demonstrate both the efficacy and effectiveness achieved in the implementation of new initiatives and in the continuous improvements to service delivery. Under her leadership, the University continued to make great strides in its quest to provide high quality, student-centered, services and programs.

Historically, students and faculty have voiced concerns about the conditions of buildings and grounds. To address the issues, several major initiatives were launched. Upgrading and maintaining the conditions of buildings and grounds, and increasing efficiency of facilities are a priority of her administration. TSU has made significant progress in the areas of facilities planning, construction, operations, and maintenance. Accomplishments included major renovation and new construction projects and the designation of three buildings: the Roderick R. Paige Education Building, Granville Sawyer Auditorium, and Leonard H.O. Spearman Technology Building.

Slade has capitalized on major opportunities for academic growth, which has facilitated the emergence of TSU as a more competitive and attractive University to better serve its expanding constituencies and address work force needs. Resolute to its academic mission, the University has made significant progress in the enhancement of existing programs and strengthening academic programs by conducting formal reviews and instructional assessments.

Finally, Slade set priorities for the advancement of research and began working towards achieving those goals. The University developed, adopted, and began implementing a new, comprehensive research plan designed to stimulate and promote scholarly inquiry.

A major focus of her administration has been upgrading and providing adequate funding for the management of information systems. The University has leveraged information technology to eliminate

the constraints of time, space and other barriers, to empower its students, faculty, and staff. Subsequently, the emergence of interactive technologies has enhanced instruction, learning, research, community service, and administrative efficiency.

Top: *The "Ocean," as the band is referred to on the TSU campus, has gained an enviable reputation for its thrilling performances, which include a stellar sound, precision drills and the execution of intricate dance routines. Founded by Benjamin J. Butler II, Ocean of Soul has become a TSU mainstay and a Houston legend. Over 200 members strong, the marching band is the largest student organization on campus and, arguably, the spirit of the University. Many former members of Ocean of Soul have achieved great success in the music industry, among them, Grammy award-winning jazz saxophonist Kirk Whalum. Moreover, a significant number of African American band directors in the city and region are products of TSU's acclaimed marching band. Under the direction of Richard Lee, Ocean of Soul performs at all TSU home football games and has performed on national television as well as before capacity crowds at games for several professional athletic teams. The band's most recent national performances were at the Stellar Awards in 2005, performing with Gospel Recording Artist Kirk Franklin, and during halftime at the Super Bowl in 2004.*

Above: left: *Texas Southern University's baseball team clinched its first-ever Southwest Athletic Conference title in May 2004, in a decisive 18-1 win over Mississippi Valley State Devils. Candy Robinson was named Coach of the Year.*

Bottom left: *On March 11, 2005 TSU track star Tremedia Brice gained the NCAA National Indoor Track and Field title in the 200 meters. Winning the race with a time of 22.9, she placed as the fastest half-lap sprinter in the nation. She was also the Southwest Athletic Conference champion in the 200 and 100 meter.*

Above and left: *Fifteen university representatives and guests performed the shoveling honors at the conclusion of the ground breaking ceremony at Texas Southern University. TSU broke ground on a $15 million, 82,000-square-foot building June 23, 2005 that will house the academic programs of the Barbara Jordan-Mickey Leland School of Public Affairs, the Barbara Jordan Public Policy Research Institute, the Mickey Leland Center on World Hunger and Peace, as well as several of the academic programs of the College of Liberal Arts and Behavioral Sciences. The building is scheduled to be completed in August 2006.*

Below: *In 1992 the award-winning, internationally acclaimed Texas Southern University Debate Team won the International Forensic Championship Award in London, England. This repeated in 1994 at the International meet held in Munich, Germany, and again in 2002 at the meet held in Rome, Italy. In 1999, the team took home the top awards in Classical Roman Oratory. In 2001, the team won* first place in Parliamentary Debate at the International Forensic Association held in Prague, Czech Republic. The Team was founded in 1949 by Dr. Thomas F. Freeman. Since its inception, the Debate Team has contributed to the personal growth and development of students through active participation in the program of the forensic arts.

Slade is deeply engaged in overseeing sub-committee progress in each giving division. Combining corporate and university resources has greatly enhanced success in this critical mission. President Slade has taken a lead role in building public, political, and corporate awareness for the "Open Doors" campaign and anticipates the many opportunities to share TSU's future goals and current successes with prospective donors and other interested parties.

Priorities for the funds raised include several academic programs, new centers, and the restoration of the University's library and museum. Additionally, as an integral component of the campaign, the "President's Endowed Fund for University Enhancement" was established allowing future presidents of the University, the discretion to respond quickly to unique growth opportunities.

Major potential corporate donors were invited to two retreats in Kennebunkport, Maine, hosted by former President George Bush, Sr. and Mrs. Bush. The activities resulted in additional prospects for million-dollar level gifts in the "Open Doors" campaign and individuals who will fill leadership roles in the campaign.

The University's efforts to date have yielded more than $19,000,000 million in gifts and pledges. This includes a pledge of $1 million by Kase Lawal, vice chair, Port of Houston Authority and chairman and CEO of CAMAC Holdings Inc. Lawal is the first TSU alumni to make a pledge of this magnitude in the University's history.

Changing the way the world works is not a solitary act, but an act of solidarity. TSU administrators, faculty and staff work in concert to open the doors to opportunity and academic excellence for all students—individuals who go on to make viable contributions to the community, nation and the world. In 1947, the University set out to make a difference. Fifty-eight years later, that determination has been realized through the lives and actions of men and women associated with TSU. Whether as students or alumni, teachers or researchers, the individuals who have benefited from TSU have found an extraordinary setting for extraordinary opportunities.

Left: *On an overcast morning, an array of architects, contractors, administrators and professors gathered under a tent on an unscarred remnant of TSU's Parking Lot L. With much fanfare, the University broke ground on its new science building, a four-story structure that will feature a glass atrium with downtown views and modern chemistry, biology, research and training labs. With a price tag of $30 million, the building is on schedule to be completed in June 2006.*

Below: *In October 2002 the University began operating its much-anticipated Recreation and Wellness Center. The dual level, $12.8 million facility features an exercise room with state-of-the-art fitness equipment including lifecycles, treadmills, free weights and resistant weight machines; a 25-meter pool with room to accommodate lap swim and instructional classes; a three-court gymnasium for volleyball and basketball; locker rooms with full and half lockers available for rental; an aerobic exercise studio; a food court and Subway sandwich shop; and a study area with wide screen TV and view overlooking the pool.*

Texas Southern University Historical Highlights

1947 Texas Southern University became the first publicly supported University in Houston. The University was originally founded as Texas State University for Negroes.

1948 Dr. R. O'Hara Lanier, U.S. Minister to Liberia, was appointed as the first president of Texas Southern University.

1950 Texas Southern University awarded its first Doctor of Jurisprudence degree from the Law School.

1955 Dr. Samuel M. Nabrit was appointed the second president of Texas Southern University.

Texas Southern University obtained accreditation from the Southern Association of Colleges and Secondary Schools, the Texas Education Agency, and the American Association of Colleges for Teacher Education.

The Law School was approved by the State Board of Law Examiners and by the American Bar Association. The School of Pharmacy was accredited by the American Council on Pharmaceutical Education.

1966 Dr. Joseph A. Pierce was appointed acting president. Dr. Pierce became Texas Southern University's third president.

1968 Dr. Granville M. Sawyer was appointed the fourth president of Texas Southern University.

1973 Due to its continually evolving urban focus, the Texas Legislature designated Texas Southern University as a "Special Purpose Institution for Urban Programming."

1978 The College of Education awarded Texas Southern University's first Doctor of Education Degree.

1979 Mr. Everett O. Bell was appointed acting president.

1980 Dr. Leonard H.O. Spearman was appointed the fifth president of Texas Southern University.

1986 Dr. Robert J. Terry became the University's sixth president.

The College of Pharmacy awarded Texas Southern University's first Doctor of Pharmacy Degree.

1987 Dr. William H. Harris was appointed Texas Southern University's seventh president.

1993 Dr. Joann Horton became Texas Southern University's first female president as she was appointed the University's eighth president.

1995 Mr. James M. Douglas, Esq., was appointed acting president. He was later appointed the University's ninth president.

1998 Texas Southern University awarded its first Ph.D. in Environmental Toxicology.

1999 Dr. Priscilla Slade was appointed acting president of Texas Southern University. She was later appointed the University's tenth president.

TMC ORTHOPEDIC, LP

TMC Orthopedic, located in Houston, is one of the largest and fastest growing orthopedic distributors in Texas. Founded in 1991 with only three employees, the company now boasts six locations and over 110 employees. TMC provides orthopedic products, equipment and services to approximately 95 percent of the Houston area hospitals and 70 percent of the area's orthopedic surgeons. Over the past 15 years, growth has been steady and expansion of goods and services has been widespread. The success of the company is primarily due to the innovative approach and entrepreneurial prowess of TMC's founder and CEO, Joe Sansone.

Non-conventional is the best way to describe Joe Sansone's journey to success in the orthopedic supply business. Perhaps that is because the man himself is somewhat of a wonderful dichotomy. He seems to be a great blend of Southern humility and striking confidence—both well-earned and useful character traits for running his growing company. He has a history of facing obstacles, even ones of his own making, with vigor and resolve to come out ahead. He has done so even from the beginning of his educational years.

Sansone always had an interest in science and in high school turned a hobby

TMC's founder and CEO, Joe Sansone.

of fish breeding into a science project that earned him a scholarship to Rhodes College. He lost the scholarship after his first year due to a low grade-point average. Later he returned to school and attended Memphis State University. He graduated with a bachelor's degree in microbiology—eight and a half years later. Even though his grades were less than impressive, he was hired by a chemical company as a sales rep to pulp and paper mills. He trained for his new position, relocated to Hattiesburg, Mississippi and was terminated two weeks later. Sansone was devastated.

After taking a few months off, Sansone decided to shift into a different line of sales. He sold Jeep tops for Suzuki. Sansone says he "sunk his teeth into the job," and actually began to produce results. Several months and a bit of confidence later, Sansone decided to venture into the medical field and was hired by Medicos, a medical device company specializing in orthopedics. He worked for the company from 1988 until he started his own firm in 1992. "Those four years taught me that to make it in this industry, service must be a priority. The experience [at Medicos] taught me the work ethic it takes to not just survive, but thrive in this industry," states Sansone.

The rollercoaster ride of false starts and redirections ceased. Sansone finally found a challenge worth keeping his attention. He worked hard in orthopedic sales and put in long hours. Often he would show up at hospitals at 7 a.m. and catch surgeons before surgical procedures. After putting in a full day of checking patients' equipment and completing in-office paper work, Sansone would show up again at 7 p.m. and see some of those same surgeons. "They got the message I wanted to deliver," says Sansone of his selling days at Medicos.

Medicos trained him well, but Sansone became aware that there were things he could do better. In 1992 he branched out on his own and began TMC Orthopedic Supplies. However, when Sansone opened his doors for business, he was greeted with a lawsuit by Medicos for violation of a non-compete agreement. His reputation and life savings were on the line; Sansone fought hard to stay in business. A year and a half later and after overwhelming legal expenses, the case was settled out of court and TMC was free to thrive. It has done so ever since.

TMC covers a spectrum of care and provides products and services to individual patients, while also catering to the ever-changing demands of hospitals and orthopedic surgeons. The company provides orthotics and prosthetics from an impressive list of manufacturers and has eight practitioners on-call 24/7. Practitioners even make house calls if necessary. The company makes a point to carry several types of each product to

TMC orthotist, Stan Sanderson, fits a patient with a back brace.

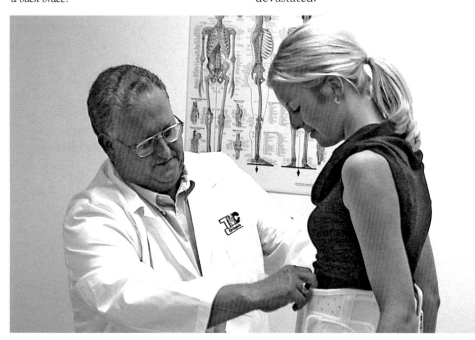

From humble beginnings, TMC now boasts six locations, totaling 40,000 square feet.

accommodate specific needs. For instance, TMC stocks fracture walkers from leading manufactures such as: Procare, Townsend Designs, DonJoy, Aircast, DeRoyal, Bledsoe, USMC and Cam Walker.

The company's Stock and Bill program has been an impressive endeavor saving time and money for both hospitals and medical offices. The program, which essentially hires TMC to stock shelves, pick up paperwork, deliver goods and even bill third party payers directly, has been a huge success. "This allows the hospitals and physicians to outsource what was a money losing part of their scope of services," explains Sansone. It also allows medical specialists the time to concentrate on the more pressing needs of their patients without having to worry about the business end of the process.

A new and remarkable service TMC offers is for the critical needs of the operating room. One of the manufacturers the company represents, Regeneration Technologies, Inc. (RTI), has developed an innovative process called BioCleanse that actually renders human tissue sterile. TMC keeps a supply of this delicate product and has a variety of samples to offer a surgeon facing a situation in need of this

type of tissue. The usual wait time can be up to 24 hours for this type of product. TMC is equipped to have a variety of samples delivered from its storehouses to the hospital's operating room within 20 minutes.

In addition to its outstanding goods and services are TMC's employees. The company hires the best and rewards them accordingly. Applicants must go through

Pediatric patient is fitted with a colorful, kid friendly ankle brace by TMC practitioner.

a rigorous interviewing process to be a part of the team. To fill one job position, 1,000 resumes might be examined. Thoroughness pays off. "We almost never have the typical employee-related problems," beams Sansone.

There is a certain fervor with which TMC employees approach their jobs. The work environment at TMC can be described as frenetic; an efficient frenzy. Employees attack their specific tasks with speed and expertise. "We have a fast-paced, high pressure environment. We live by the rules of 'work hard and play hard,'" quips Ryan Stelck, director of operations. Stelck is also an example of TMC's growth opportunity. He started in the warehouse and is now director of operations, the second person in command of the company.

Sansone's path to success may have been unconventional, but his 'small business venture' has paid off. "In the old days we were the company that no one had heard of; people wanted to help out this 'little guy.' Now, it's obvious we're the orthopedic company of choice in Houston," boasts Sansone. From humble beginnings to a $24 million a year business, Joe Sansone has earned the right to be proud.

UNIVERSAL WEATHER AND AVIATION, INC.

Universal Weather and Aviation, Inc., headquartered in Houston, Texas, is a family-owned "local" business with global success. Thanks to the far-reaching vision of its founder, Thomas G. Evans, the corporation pioneered international flight support services for corporate aviation. Founded in 1959, Universal® initially offered weather forecasting to private aircraft, a market that Evans realized was not being served.

The company's four-plus decades of success can be attributed to the ability of its founder and owners—still the Evans family—to adapt to the rapidly growing and ever-changing needs of its worldwide customers. Marjorie E. Evans, chairwoman of the company, credits much of the exponential expansion of both services and locations of the corporation to the simple idea of its founder, Thomas Gregory Evans.

Thomas Evans, a former Air Force officer and meteorologist at Braniff Airlines, saw the growing demand for personalized weather information for corporate aviators. He opened a weather office at Love Field in Dallas in 1959. Within a matter of months and with only a handful of employees, he began handling the needs for 35 corporate aviation accounts. By the next year Evans moved the home office to Hobby Airport in Houston and in 1967

Tom Evans, the founder of Universal Weather and Aviation Inc., pioneered the concept of providing trip support services to the private aviation industry. His entrepreneurial spirit created the company's Vision of anticipating and exceeding customers' needs.

President Ralph Vasami.

opened the company's first field office in Los Angeles. In addition, he began providing weather forecasts for the coastal Gulf region, including the Port of Houston. Gulf oil rigs began to depend on Universal's accurate weather forecasts. The company subsequently became a leading supplier of weather forecasts not only for aircraft, but for sea vessels as well.

In 1969 Evans made a personal merger and married Marjorie Evans. Together, they recognized the corporate aviation community was growing and the Evanses, along with their expanding company, were determined to meet, in fact, exceed, its increasing needs. Under their guidance, the company opened another office in White Plains, New York an established hub for domestic corporate aviators. Over the next three and a half decades, Universal would continue to grow its services to set the bar for the competition by providing weather forecasting and more. The company did so by not only exceeding customers' immediate needs, such as weather services, but also by anticipating their future needs.

While continuing to provide the critical service of accurate weather forecasts, the company, led by the Evanses, began to identify other areas of corporate aviation where Universal could offer quality services. As the needs of their clients grew, so did the company's expertise. In 1981, however, the company lost its beloved founder Tom Evans. His untimely

death was met with obvious shock, and even doubt as so many customers thought of "Universal" *as* Tom Evans. Marjorie noted, "By that time we had a core of officers, many of which were with us in the very beginning, who pulled together and made sure we not only survived, but thrived during that extremely difficult time. In fact, *all* of them stayed with us for the next 20 plus years and just recently retired."

Today the company offers a complete array of services to facilitate "a successful trip" from start to finish by being a vital extension of the customer's flight team. From the moment a corporate trip date is set until after the flight has landed, the clients' needs continue to be anticipated and met, arranging for such services as crew and passenger accommodations, discount fuel arrangements, catering services as well as providing ground handling services through a network of offices located in more than 50 countries.

UVair®, a service of Universal®, supports successful trips by providing worldwide fueling arrangements for corporate aircraft through a network of suppliers, handling agents, and FBOs. Accepted at more then 1,750 locations worldwide, the UVair Fueling Card offers negotiated savings, and streamlined custom billing.

"We provide detailed flight plans around the globe, along with over-flight permits, landing permits, customs arrangements, convenient and discounted hotel accommodations." says Marjorie Evans. In doing so, Universal has landed itself in the most enviable, and challenging of positions—that of the industry leader. With a highly trained staff of meteorologists, flight planners, hotel reservation specialists, and other technical

support staff, totaling more than 1,000 employees around the globe, the company has never forgotten that superior service is the key to exceeding customers' needs.

With a worldwide client base, Universal not only uses its expertise to service the aviation industry. Through its surface weather subsidiary, ImpactWeather, Inc., it also continues to serve the marine industry and has expanded its customer portfolio to include government agencies, construction corporations, media and sporting event coordinators, and a growing number of Fortune 500 companies.

Even though Universal operates and provides services worldwide, its employees maintain a personal touch. Universal team members learn more than the specifics of a client's business and flight needs; they also learn the client's personal preferences. When a client takes subsequent trips, those preferences are taken into account. This expedites the planning process and ensures a smooth and reliable trip. It also adds that special, personalized approach that makes the customer feel special, because they are!

Universal's list of services goes on and

CEO Greg Evans.

At Universal Weather and Aviation Inc., highly specialized Trip Support Services Teams work to ensure every trip their clients make, regardless of the destination, is a success. Flight planning, weather briefs, fuel and ground services are just a few of the many services they coordinate, arrange or provide for their clients. Their teams offer personalized service, anticipate clients' needs and know each client's definition of a successful trip.

on, and the list continues to grow as the needs of the industry grow. Despite the global expansion of services and impressive client list, Universal still maintains the culture of a family-run business. The company realizes that its employees are the keys to its success. Employees provide the superior customer service and expertise that Universal customers have come to rely on. Universal believes in investing in its people, and giving them the ability to grow as the company has grown. Even the president of the company started out working summers for Universal when he was in high school. Tom Evans promised Ralph Vasami a job after college

when he finished his degree in meteorology. Evans kept his promise.

And now, 20-plus years later, Vasami is helping lead the company he essentially helped create so many years ago. And he's still doing that with the leadership and support of the Evanses. Tom Evans' son, Gregory Evans, is CEO of the company. He firmly believes in the "personalized" focus on the customer, and he "walks the talk" by frequently traveling to various clients, making sure their needs are being met. Marjorie Evans, Universal's chairwoman, holds down the fort in the Houston office, ensuring that the company culture of honesty, integrity, and customer service is ingrained in all the Universal family.

Chairman of the Board, Marjorie Evans, is a member of the team that, over the past four decades, has been the driving force behind the global presence and wide array of services for which Universal Weather and Aviation, Inc. has become famous.

"We never take our success for granted. We remember what got us here—hard work and living up to our word of providing a quality service that our customers can trust," she says.

The company, which began because one meteorologist had a vision, is now a global force in corporate aviation. "Meteorologists have weather vanes for blood veins," says Marjorie Evans of her late husband's beloved profession. "He saw a need and was compelled to meet it."

His Universal family, both the immediate family of Evanses and all Universal employees, are still doing just that, if not more. No doubt, Thomas Gregory Evans would be proud.

UNIVERSITY OF TEXAS HEALTH SCIENCE CENTER AT HOUSTON

The University of Texas Health Science Center at Houston (UTHSC-H) was created by the U.T System Board of Regents and supported by the Texas Legislature in 1972. UTHSC-H educates and trains health professionals and biomedical scientists, conducts cutting edge biomedical, behavioral and population research and provides primary care and highly specialized medical, dental, nursing and public health care and expertise.

Located in the internationally recognized Texas Medical Center, the University pursues its mission through a comprehensive approach to health. The UTHSC-H is composed of the Dental Branch, the Graduate School of Biomedical Sciences, the Medical School, the School of Public Health, the School of Nursing, the School of Health Information Sciences, the UT Harris County Psychiatric Center, and the Brown Foundation Institute of Molecular Medicine for the Prevention of Human Disease. In the fiscal year 2005 it had an operating budget of $589.6 million.

Since 2000, the leadership of UTHSC-H has been in the gifted hands of eminent cardiologist Dr. James T. Willerson. Dr. Willerson was interim president until March 2001, when he officially be-

The nationally ranked UT School of Nursing at Houston is helping to educate nurses for direct patient care, education and administration. Photo by Nash Baker

Internationally distinguished cardiologist James T. Willerson, M.D., is president of The University of Texas Health Science Center at Houston, where he emphasizes excellence above all in research, education and patient care. Photo by Nash Baker

came president of UTHSC-H. Among his many other notable titles, Willerson is Chief of Cardiology and the Robert J. Hall Chair of Cardiology at St. Luke's Episcopal Hospital in Houston. He is also the Alkek-Williams Distinguished Professor at UTHSC-H, and is president-elect of the Texas Heart Institute in Houston.

Dr. Willerson is the former editor of *Circulation*, the cardiology journal published by the American Heart Association. First published in 1953, Dr. Willerson became editor in 1993, taking the journal from a monthly publication

to the most widely read peer-reviewed, weekly cardiology journal in the world. Under Dr. Willerson the journal's ranking and impact factor continued to rise. Today its impact factor is 12.563—ranking number one among 70 journals in the Cardiac & Cardiovascular Systems category, number one among 62 journals in the Hematology category, and number one among 52 journals in the Peripheral Vascular Disease category (ISI, 2003) and has a circulation of 22,500.

Willerson got his exposure to medicine through his parents who were both doctors. By their example, he came to understand the great joy that comes from helping others. He would often go with his father, a general practitioner, on house calls, which was routine back in the 1940s. His mother was one of the first female anesthesiologists in Texas, and the young Willerson would go along with her to the hospital at night or on weekends and try to help. Though his parents never insisted or even encouraged him to go into medicine, Willerson knew from a very early age that he was going to be a doctor.

Today, Willerson's vision for UTHSC-H, the largest and most comprehensive health science center in the state of Texas and in the southwest, is to train future medical professionals to be leaders in the nation and the world, arming them with the tools and the education to make that vision a reality. He also believes that the translational research that will come out of the Institute for Molecular Medicine discoveries will be enormously helpful to these individuals as they practice and work toward creating advances in preventive medicine.

Through its current research programs and programs in the planning stages, Willerson hopes to make UTHSC-H into a world-class institute. He plans to do this by recruiting the world's best scientific minds; UTHSC-H already has one Nobel Laureate on campus and another two at Rice. He also recognizes the important roles the support of the Houston community, the State of Texas, and the country play in creating a great educational and research institution. To that end, Dr. Willerson has been instrumental in helping to raise more than $200 million of philanthropic donations in support of

this vision for a world-class institution.

One of the major elements in creating a world-renowned place of scientific research is in building a state-of-the-art facility that can continue to meet the scientific demands of the 21st century. The Brown Institute of Molecular Medicine for the Prevention of Human Diseases is on its way to being just such a facility. The institute is named after the Brown Foundation of Houston, which was founded in July 1951 by Herman and Margarett Root Brown and George R. and Alice Pratt Brown with a $20 million grant. The building itself, which will house the institute and is scheduled to open in the spring of 2006, is named after its other major benefactor and current patient of Dr. Willerson's, Fayez S. Sarofim, who personally donated $25 million to help build the new facility.

"Take a deep breath," Giuseppe Colasurdo, M.D., tells a young patient. Colasurdo is a specialist in pediatric pulmonary medicine and interim chair of the Department of Pediatrics at the UT Medical School at Houston. Photo by Marc Morrison

The wisdom of supporting the development of such an institute is evident in the research already underway at UTHSC-H. Perhaps the most impressive and groundbreaking research work to date at the Health Science Center is a study in which Dr. Willerson was one of the lead researchers. Beginning in 2003, Dr. Willerson and Dr. Emerson Perin at the

Texas Heart Institute worked with a Brazilian cardiologist at the Hospital Procardiaco in Rio de Janeiro, treating what would ultimately be 14 adult patients with very severe heart failure. The study took the patient's own bone marrow stem cells and re-injected them into the patients' hearts with a specially created catheter called a NOGA catheter. This device allows the doctors to measure electrical potential and to pinpoint areas in these patients' hearts where there was reversible injury, such as reduced blood flow and impaired function.

Each patient was injected with 2 million stem cells at 15 different sites in their hearts, for a total of 30 million cells. The results of the study showed that within

After a minimally invasive surgery procedure, Richard Andrassy, M.D., chairman of the Department of Surgery at the UT Medical School at Houston, checks on his patient's physical and mental well being. Photo by Marc Morrison

The Fayez S. Sarofim Research Building is expected to open in 2006 as the new home of the Brown Foundation Institute of Molecular Medicine for the Prevention of Human Diseases. Scientists at the institute pursue research into the fundamental mechanisms of common human diseases. Photo by Ester Fant

two months those patients had better blood flow and better cardiac function. This was the first study in the world in which a heart patient's own stem cells had been injected directly into their heart.

In 2005 Drs. Perin and Willerson were awarded the only FDA approved protocol in the United States to carry out the new procedure. This work began in 2004 at the St. Luke's Hospital at the Texas Heart Institute in Houston. To date, the Texas Heart Institute has treated 16 more patients with their own stem cells. The blind study includes 14 treated patients and seven controls in Brazil. The study will eventually include a total of about 30 subjects.

With the permission of the family of a participant in the study who died six months after treatment from a stroke, the researchers conducted a post mortem examination of the patient's heart and found there was a clear increase in blood vessel formation where the heart had been injected with the bone marrow stem cells. In addition, it appears that there was new cell growth. This is the first absolute confirmation that the research had, in fact, improved the blood flow and cell density at sites that were injected. The findings

of the study were published in *Circulation* in July 2005.

Dr. Willerson is also working in other ways to advance medical research. TexGen, in which the "Tex" stands for Texas Medical Center and "Gen" for genetic discovery, is the creation of Dr. Willerson and the University of Texas. Created in 2002, the organization is based on the notion that from gene and protein discoveries comes the ability to predict human diseases well before they occur and to ultimately prevent and cure them.

TexGen is an independent entity with a steering committee composed of one member from UT Houston, UT M.D. Anderson Cancer Center, Baylor College of Medicine, Texas Children's Hospital, and The Texas Heart Institute. Willerson brought together the presidents of the various Texas Medical Center institutions in an agreement whereby TexGen would be able to draw blood samples from consenting Texas Medical Center Hospital patients with a family history of heart or vascular disease, including heart attack, stroke, heart failure, sudden death, peripheral vascular disease, selective cancers of the nose or breast, colon cancer, and prostate cancer. From the Texas Medical Center's pool of 5.5 million annual patients, TexGen is creating a DNA database for genomic and proteomic research and discovery. They have been at work on the database for about two years

Interventional cardiologist Richard Smalling, M.D., Ph.D. conducts a routine examination of a patient. Heart disease is the number one killer of women in the United States. Smalling is the Jay Brent Sterling Professor in Cardiovascular Medicine at the UT Medical School at Houston. Photo by Marc Morrison

Victoria Leonhart, left, a fourth-year dental student, and Chantie Ploucha, coordinator of Special Programs for Patient Services, assist a Hurricane Katrina evacuee in the UT Dental Branch at Houston's well-equipped dental van. Photo by Ester Fant

and have more than 7,000 patients from which they have received blood samples. TexGen is now beginning to look carefully at each family's health history and is beginning to obtain blood samples from other family members to further the study. Donations that are made to TexGen are held independently of all the institutions and earmarked for this work.

Additionally, Willerson has been instrumental in creating the Gulf Coast Consortia (GCC). Six public and private institutions based in the Houston/Galveston region have launched the GCC, a new research and education initiative funded in part by a $3.5 million grant from the W. M. Keck Foundation of Los Angeles. Consortia member institutions are: Baylor College of Medicine, Rice University, the University of Houston, The University of Texas Health Science Center at

Among 10 faculty members from the UT Medical School at Houston named to the Texas Monthly 2005 list of Super Doctors, Thomas Clanton, M.D., chairs the Department of Orthopaedic Surgery. He holds the Edward T. Smith, M.D., Chair in Orthopaedic Surgery. Photo by Nash Baker

Theresa Koehler, Ph.D., right, professor of microbiology and molecular genetics at the UT Medical School at Houston, leads research into the deadly anthrax bacterium. Photo by Nash Baker

Houston, the UT Medical Branch at Galveston, and the UT M.D. Anderson Cancer Center.

Several UT-Houston schools and various faculty have already initiated efforts with the GCC, and Willerson anticipates

that the Brown Foundation Institute of Molecular Medicine for the Prevention of Human Diseases will be a very active player in the GCC in the future.

In addition to his research and institutional work, Willerson manages to teach and carry a full patient load. For his continuing passion for medical education, Willerson has been called "a teacher virtually without peer" by UT System Regent Pat Oxford. He leads a conference for residents at the University of Texas Medical School from 7 to 8 A.M. each Saturday morning. Residents and fellows regularly join him on his rounds and as he sees patients in the clinic every after-

Improving early childhood learning is a primary goal of Susan Landry, Ph.D., who has been tapped for national panels by the Department of Health and Human Services and the Department of Education. Landry is director of the State Center for Early Childhood Development at the UT Health Science Center at Houston and leads the UT Children's Learning Institute. Photo by Marc Morrison

noon for three or four hours. Willerson says that he gets great satisfaction from seeing young people commit themselves to becoming the best that they can be, which in turn compels him to share even more of what he's learned with these future leaders of medicine and medical research.

In other areas of research, UTHSC-H is number one among all public health universities in Texas in the areas of child health and human development. It has a student enrollment of more than 3,300 students, with a faculty of 1,247 and a staff of more than 3,100. In 2004 the Center provided more than $160 million in unreimbursed patient care to indigent citizens of Harris County.

Since its establishment in 1972, 27,418 graduates have gone on from UTHSC-H into the medical profession, Students participate in clinical training at over 200 affiliated sites across the state.

There are few people who can teach, do groundbreaking research, see patients, and run one of the largest medical teaching institutions in the world. Dr. James Willerson credits much of his success to his years learning to be a varsity swimmer. The physical and mental discipline and focus it takes to be the best you can be, as well as the essential lesson of teamwork, have served him well in his career.

Willerson also realizes that through failure one learns how to succeed. Outside his office is a plaque with a quote from President Theodore Roosevelt that reads, "Far better it is to dare mighty things, to win glorious triumphs, even though checkered by failure (and it will be), than to rank with those spirits who neither enjoy nor suffer much, because they live in the gray twilight that knows neither victory nor defeat."

That spirit lies at the core of everything Dr. Willerson does. Whether using his skills to create a world-class medical institution, or developing revolutionary procedures for treating patients with life-threatening heart ailments, or advancing the frontiers of science in stem cell research, he is truly daring to do mighty things. And he has never let the certainty of failure dim his faith in the promise of glorious triumphs.

In the newly developing field of pharmacogenetics, Lorraine Frazier, D.S.N., N.P., R.N., is an associate professor at the UT School of Nursing at Houston and director of TexGen (Texas Medical Center Genetics), a collaborative effort of many institutions at the Texas Medical Center. One of the TexGen projects is collecting DNA from thousands of cardiovascular and cancer patients each year with a view toward identifying genes that contribute to these diseases, analyzing treatment outcomes and tapping the potential of genetics to tailor therapies to individual patients. Photo by Marc Morrison

The environmentally friendly School of Nursing and Student Community Center building at the UT Health Science Center at Houston has won multiple awards from the American Institute of Architects. Photo by BNIM

HOUSTON A+ CHALLENGE

Houston A+ Challenge is a nonprofit educational organization that provides local teachers in 120 schools in six local districts with training, support and technical assistance to meet the diverse needs of each student. The organization directs the largest single amount of private funds ever dedicated to public school reform in the Greater Houston area and has raised more than $100 million to develop and fund school programs and educational leadership using the principles of Whole School Reform.

Whole School Reform is a philosophy that unites the "whole school," from the maintenance worker to the principal, in redesigning the school with the goal of improving student achievement. This three-tiered philosophy includes: quality professional development for the staff that targets specific areas needing improvement; a personalized environment, so that everyone from the cafeteria to the principal's office knows all students by name; and community engagement so that schools, communities, colleges, businesses, civic leaders, parents and business leaders all participate in redesigning the schools. Teachers work together across grade levels and across content areas; schools work with each other; and districts collaborate.

The decision to use "whole school reform" was born out of 18 months of community focus groups in 1995 and 1996 when a group of Houston educators, phi-

A Houston high school student works in a state-of-the-art Baylor School of Medicine research laboratory as part of a summer program to improve science teaching.

A father works with his son at Family Math Night to learn the instructional strategies he can use to help the boy with his homework.

lanthropists, business and civic leaders made it their priority to reform the area's urban public schools. The group received a $20 million grant for "whole school reform" from the Annenberg Foundation to become a National Annenberg Challenge initiative site, and raised an additional $40 million in matching funds from the Brown Foundation and Houston Endowment, among others.

Houston A+ works at all levels, from kindergarten to college using five educational models:

• Integrating fine arts with the core subjects of math and reading. Research shows that students engaged in the arts are more motivated to learn, are taught more easily and do better in school. Sustained involvement in particular art forms—such as music and theatre—is highly correlated with success in mathematics and reading.

• Designing the K-5 Mathematics Model with ExxonMobil to foster teacher understanding of mathematics in pursuit of improved student achievement. The centerpiece is the math specialist, who uses a coaching model for professional development to provide on-site leadership and expertise to teachers as they work to improve student achievement in mathematics.

• Developing local leadership abilities with a leadership academy, deans' group and central office training. It is a core premise of Houston A+ that quality leadership is essential to creating a successful school. The two-year "New Visions in Leadership Academy" gives principals and school leaders the tools to manage changing laws, board policy, current research, and best teaching and learning practices while providing opportunities for every child to learn and succeed.

• Redesigning large comprehensive high schools with the Carnegie Corporation of New York and the Bill and Melinda Gates Foundation for personalized, rigorous and relevant learning through creating smaller, theme-based academies. This system of high schools prepares students for post-secondary school success in college, in the workplace and in civic affairs in tomorrow's fast-paced, high-tech, global world.

• Changing teacher preparation by collaborating with higher education. This higher education model works to transform teacher preparation programs through university, school and community partnerships.

For more information about the Houston A+ Challenge visit the organization website at: www.houstonaplus.org.

A TIMELINE OF HOUSTON'S HISTORY

1823
Stephen F. Austin brought the "Old Three Hundred" to Texas.

1826
Harrisburg founded a few miles away from the future city of Houston.

1836
Texas Independence declared by the Washington on the Brazos Convention.

Augustus and John Allen purchase land to found the city of Houston which will become the capital of the Republic of Texas.

1837
Houston Mechanics Association, a pre-union organization, formed.

1838
Brazos and Galveston Railroad Company founded to facilitate trade between Galveston and Houston.

1839
Houston and Brazos Railroad Company established.

1840
First Chamber of Commerce founded.

1841
First Baptist Church of Houston formed.

1845
Texas' annexation approved by the United States Congress.

1848
Mexican-American War, fought over the annexation of Texas, ends with the Treaty of Guadalupe Hidalgo and set the current Texas borders.

1850
Houston, with a population of 2,397, becomes the third largest city in the state.

1853
The *General Sherman* locomotive, Texas' first, runs from Harrisburg to the Colorado River.

1861
Texas seceded from the Union following the election of Lincoln.

1863
At the Battle of Galveston and Sabine Pass, Texan troops fought back Union invasion forces.

1865
Emancipation Proclamation took effect in Texas two years after being penned.

1868
Black Texans granted voting privileges and the Klu Klux Klan appeared in

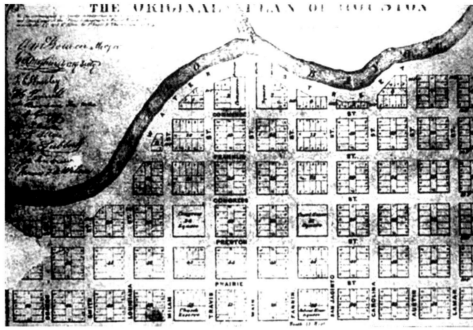

Original street map of Houston.

Houston.

1870
Texas readmitted into the Union.

1875
Hurricane hits Houston causing $50,000 in damage.

1876
Adoption of the Texas State Constitution officially ended Texas Reconstruction.

1880
Houston Post founded by Gail Borden Johnson.

1884
Negro Longshoremen's Association established following a strike.

Colored Teachers State Association formed.

1887
St. Joseph's Infirmary, today's St. Joseph Hospital, founded in Houston.

1900
Hurricane hits Galveston killing 6,000 persons and led to the supremacy of Houston.

1901
Spindletop discovered.

1909
Sharp-Hughes Tool Company, organized by Walter Sharp and Howard Hughes, Sr.

1911
Humble Oil Company formed.

1912
Rice Institute, later Rice University, began operations.

1914
Trenching of the Houston Ship Channel completed, poising Houston for economic prosperity.

1916
Texas State Federation of Labor and Houston Trades Council founded to unionize labor.

1917
World War I began and Camp Logan riot left fourteen dead.

1919
The Informer, a black newspaper, began printing.

1924
Museum of Fine Arts, the city's first museum, opened.

1926
Texas Southern University, a black college, established.

1927
University of Houston founded as a public institution and heavily funded by wildcatter Hugh Roy Cullen.

1928
Democratic National Convention held in Houston.

1930
Houston eclipsed Dallas and San Antonio in population.

1934
Local chapter of the League of United Latin-American Citizens started.

1936
Architect Alfred C. Finn commissioned to design the San Jacinto Monument.
1938
NAACP held state conference in Houston.
1941
Ellington Field received its first contingent of airmen.
1943
M.D. Anderson hospital, the first of the medical center complex, completed.
1947
Alley Theater founded.
1949
Shamrock Hotel opened for business.
1955
Houston Ballet established.
1960
Houston schools desegregated.
1961
Henry Gonzales the first Mexican-American elected to the United States House of Representatives.
1962
Houston designated as the site of the National Aeronautics and Space Administration (NASA).

Houston Astros, formerly the Colt 45s, began play.
1965
Astrodome construction completed at a cost of nearly $50 million.
1966
Barbara Jordan elected as state senator for Harris County.
1968
Houston Oilers opened their season in the Astrodome.
1968
Man's first walk on the moon.
1976
Houston International Airport renamed the William P. Hobby Airport.
1979
Metropolitan Transit Authority (Metro) formed to address Houston's transportation needs.
1980
The Houston CMSA (424,957 persons) has 14.4 percentare Hispanics, of whom 88 percent are of Mexican ancestry, the sixth largest Spanish-speaking region in the U.S.
1981
Urban Cowboy filmed in the outskirts of Houston.

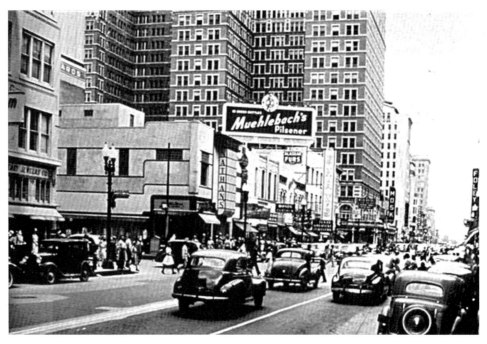

Houston downtown in the 1940s.

Houston elects its first female mayor, Kathy Whitmire, who will serve five consecutive two-year terms, tying Louie Welch for the longest executive tenure.
1982
Texas Commerce Tower, currently the JP Morgan Chase Tower, completed.

Houston encountered tremendous prosperity in the height of the oil boom; employment peaks at 1,583,400 in March, before onset of recession.

Ninfa a musical based on the life of restaurateur Ninfa Laurenzo opens in Houston.
1983
Transco Tower (Williams Tower) completed as the world's tallest skyscraper outside of a central business district; 155 office buildings built.

Houston officially becomes the nation's fourth largest city with a population of 1,775,000 people.

Hurricane Alicia (a category 3 storm) hits Houston August 21, 1983, ultimately causing 22 deaths and over $2 billion in property damage, primarily in the downtown business district.
1985
Compaq Computers headquartered in Houston.
1986
Houston fell into recession following the collapse of the oil industry resulting in the second highest number of foreclosures and bankruptcies in the city's history. Only the Depression saw

more.
Houston hosted the U.S. Olympic Festival.

Lillie and Roy Cullen Sculpture Garden opened at the Museum of Fine Arts-Houston.
1987
George R. Brown Convention Center, named after co-founder of Brown & Root, opened in downtown Houston.

Schlumberger heiress Dominique de Menil, alongside husband John, founded the Menil Collection.
1990
Rice University hosted the "G-8" Economic Summit.
1991
City's population reached 3,338,900.
1992
Republican National Convention held in the Astrodome.
1994
Houston Rockets, under the leadership of Hakeem Olajuwon, won the city's first NBA Title—the city's first professional sports title.

Voters rejected a zoning ordinance in one of the city's lowest voter turnouts for an election.
1995
Houston Rockets repeated as NBA Champions.

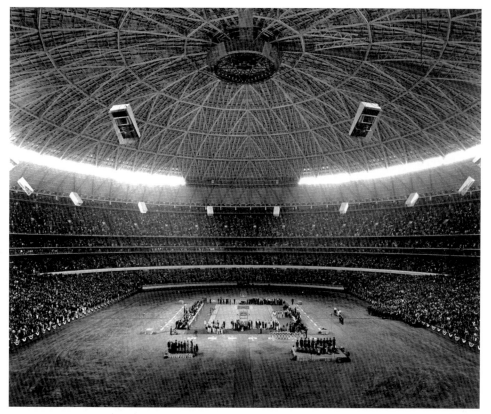

The Game of the Century took place between UCLA and the University of Houston at the Astrodome in 1968. The basketball game featured Lew Alcindor (Kareem Abdul Jabbar) for UCLA and Elvin Hayes for the University of Houston. Hayes lead the Cougars to a victory in front of a record-breaking crowd of 52,693. Courtesy, University of Houston Athletic Department.

1996
The Houston Oilers relocated to Tennessee as the Titans.
1997
Lee Brown, the city's first black chief of police, elected as mayor.
1998
Dr. Ferid Murad of the UT-Houston Medical School wins the Nobel Prize for medicine
2000
Enron Field, renamed Minute Maid Park following Enron's collapse, held its first Astros game.
2001
Enron declared bankruptcy sparking a large scale federal investigation of its financial practices.

Tropical Storm Allison hits Houston, paralyzing crucial areas such as the Medical Center while flooding major freeways and streets, bringing the city to a virtual standstill for several days.

Flooding caused $5 billion in property damage.
2002
Houston's newest NFL franchise, the Houston Texans, opened its inaugural season in Reliant Stadium.
2003
Toyota Center, home to the Houston Rockets, opened.
2004
Houston hosted the Super Bowl in Reliant Stadium.

Completion of the city's first light rail system.

Houston-Galveston diocese elevated to the tenth largest in the United States and largest in the South and Southwest.

Minute Maid Park hosted the Major League Baseball All-Star Game.
2005
Joel Osteen and his Lakewood Church congregation moved into the newly renovated Compaq Center. Osteen spent $95 million on converting the arena to a "church."

New Orleans victims of Hurricane Katrina are evacuated to Houston and temporarily housed at the astrodome.

Houstonians evacuate, fearing a Category 5 Hurricane Rita. The storm misses Houston but fleeing residents are caught in enormous traffic jams in record breaking heat, resulting in the deaths of some people and many animals.

Houston Intercontinental Airport opened in 1969 to serve as Houston's second airport. It was renamed George Bush International Airport in 1997 after the former president, a longtime Houstonian.

BIBLIOGRAPHY

Articles

Barker, Eugene C. "The United States and Mexico, 1835-1837," *Mississippi Valley Historical Review*, I (1914).

——. "Notes on Early Texas Newspapers, 1819-1836," *Southeastern Historical Quarterly*, XXI (1917).

Barr, Alwyn. "Sabine Pass, September, 1893," *Texas Military History* (1962).

——. "Texas Coastal Defense, 1862-1865," *Southwestern Historical Quarterly*, XXXVII (1961).

Drummond, Lorena. "Five Texas Capitals: An Account of the Seats of Government in Texas Since the Adop-tion of the Declaration of Independence," *Texas Monthly Magazine*, V (1930).

Gillette, Michael L. "The Rise of the NAACP in Texas," *Southwestern Historical Quarterly*, LXXXI (1978).

Hendricks, Pearl. "Builders of Old Houston," *Houston*, XII (1941).

Hine, Darlene Clark. "The Elusive Ballot; The Black Struggle Against the Texas Democratic White Primary, 1932-1945," *Southwestern Historical Quarterly*, LXXXI (1978).

Lang, Aldon S. "Financial Aspects of the Public Lands in Texas," *Southwestern Political and Social Science Quarterly*, XIII (1932).

Ledbetter, Nan Thompson. "The Muddy Brazos in Early Texas," *Southwestern Historical Quarterly*, LXIII (1959).

Looscan, Adele B. "Harris County, 1822-1845," *Southwestern Historical Quarterly*, XVIII (1914).

McCraven, William. "On the Yellow Fever of Houston, Texas, in 1847," *New Orleans Medical and Surgical Journal*, V (1848-1849).

Muir, Andrew Forest. "The Destiny of Buffalo Bayou," *Southwestern Historical Quarterly*, XLVIII (1943).

——. "Railroads Come to Houston, 1857-1861." *Southwestern Historical Quarterly*, LXIV (1961).

——. "Railroad Enterprise in Texas, 1836-1841," *Southwestern Historical Quar-terly*, XLVII (1943).

——. "William Marsh Rice, Houstonian," *East Texas Historical Journal*, II (1964).

——. "Diary of a Young Man in Houston, 1838," *Southwestern Historical Quarterly*, LIII (1950).

——. "The Free Negro in Harris County, Texas," *Southwestern Historical Quarterly*, XLVI, (1943).

——. "The Mystery of San Jacinto," *Southwest Review*, XXXVI (1951).

Oates, Stephen B. "NASA's Manned Spacecraft Center at Houston, Texas," *Southwestern Historical Quarterly*, LXVII (1964).

Porter, Eugene O. "Railroad Enterprises in the Republic of Texas," *Southwestern Historical Quarterly*, LIX (1956).

Reese, James V. "The Early History of Labor Organizations in Texas," *Southwestern Historical Quarterly*, LXXII (1968).

Stratford, James. "Behind the NASA Move to Houston, Texas," *Texas Business Review*, XXXVI (1962).

Suman, John R. "Importance of the Oil and Gas Industry to Houston," *Houston*, VI (1935).

Swenson, Loyd S. Jr. "The Fertile Crescent: The South's Role in the National Space Program," *Southwestern Historical Quarterly*, LXXI (1968).

Thompson, Charles H. "Separate But Equal; The Sweatt Case," *Southwest Review*, XXXIII (1948).

Winkler, Ernest W. "The Seat of Government in Texas," *Quarterly of the Texas State Historical Association*, X (1906).

Wooster, Ralph. "Foreigners in the Principal Towns of Ante-Bellum Texas," *Southwestern Historical Quarterly*, LXVI (1962).

Wrightman, Francis. "Alley-Theater Unusual," *Houston*, XXII (1948).

Books

Agatha, Sister M. *History of the Houston Heights, 1891-1918*. Houston: Premier Printing Company, 1956.

Alexander, Charles C. *Crusade for Conformity: The Ku Klux Klan in Texas, 1920-1930*. Houston: Texas Gulf Coast Historical Association, 1962.

Barker, Eugene C. *Mexico and Texas, 1821-1835*. Dallas: P.L. Turner Company, 1928.

Barna, Joel Warren. *The See Through Years: Creation and Destruction in Texas Architecture and Real Estate, 1981-1991*. Houston: Rice Univ. Press, 1991

Barr, Alwyn. *Black Texans: A History of Negroes in Texas, 1528-1971*. Austin: Jenkins Publishing Company, 1973.

Bartholomew, Ed. *The Houston Story: A Chronicle of the City of Houston and the Texas Frontier from the Battle of San Jacinto to the War Between the States, 1861-65*. Houston: Frontier Press, 1954.

Baughman, James P. *Charles Morgan and the Development of Southern Transportation*. Nashville: Vanderbilt University Press, 1968.

Beeth, Howard and Cary Wintz, ed. *Black Dixie: Afro-American History and Culture in Houston*. College Station: Texas A&M Univ. Press, 1992.

Brophy, William Joseph. *The Black Texan, 1900-1950*. Ann Arbor: University Microfilms, 1974.

Buchanon, James E. (ed.) *Houston: A Chronological and Documentary History, 1519-1970*. Dobbs Ferry, New York: Oceana Publications, 1975.

Chandler, Charles Ray. *The Mexican-American Protest Movement in Texas*. Ann Arbor: University Microfilms, 1968.

Conner, Seymour V. *Texas: A History*. New York: Thomas Y. Crowell Company, 1971

Culture and History Profile for Houston, Texas: A Technical Support Document for the Comprehensive Plan. City of Houston, Planning and Development Dept. 1992.

Daniels, Pat. *Texas Avenue at Main Street*. Houston: Allen Press, 1964.

Dauphin, Sue. *Houston by Stages: A History of Theatre in Houston*. Austin, Tx.: Eakin Press, 1981.

De Leon, Arnoldo. *Ethnicity in the Sun Belt: A History of Mexican Americans in Houston*. College Station: Texas A&M Univ. Press, 1989.

Dresel, Gustay. *Houston Journal: Adventtüres in North America and Texas, 1837-1841*. Trans. by Max Freund. Austin: University of Texas Press, 1961.

Frantz, Joe B. *Texas: A Bicentennial History*. New York: W.W. Norton & Company, 1976. Oklahoma Press, 1951.

Friend, Llrena. *Sam Houston: The Great Designer*. Austin: University of Texas Press, 1954.

Fuermann, George. *Houston: Land of the Big Rich*. Garden City: Doubleday, 1951.

———. *Reluctant Empire: The Mind of Texas*. Garden City: Doubleday, 1957.

Gallegly, Joseph. *Footlights on the Border: The Galveston and Houston Stage Before 1900*. The Hague: Mouton and Company, 1962.

Garwood, Ellen Clayton. *Will Clayton: A Short Biography*. Austin: University of Texas Press, 1958.

Giesberg, Robert I. *Houston Grand Opera: A History*. Houston: Houston Grand Opera Guild, Inc., 1981.

Gray, Kenneth E. *A Report on the Politics of Houston*. Cambridge, Massachusetts: Joint Center for Urban Studies for the Massachusetts Institute of Technology and Harvard University, 1960.

Hatch, Orin Walker. *Lyceum to Library: A Chapter in the Cultural History of Houston*. Houston: Texas Gulf Coast Historical Association, 1965.

Haynes, Robert V. *A Night of Violence: The Houston Riot of 1917*. Baton Rouge: Louisiana State University Press, 1976.

Hogan, William Ransom. *The Texas Republic: A Social and Economic History*. Norman: University of Oklahoma Press, 1946.

Holmes, Ann. *Houston and the Arts: A Marriage of Convenience That Became a Love Affair*. Houston: Houston Chamber of Commerce, 1970.

Houston: A History and Guide Compiled by Workers of the Writers Program of the Works Progress Administration in the State of Texas. Houston: Anson Jones Press, 1942.

Hurley, Marvin. *Decisive Years for Houston*. Houston: Houston Magazine, 1966.

Iscoe, Louise Kosches (ed.) *Ima Hogg: First Lady of Texas*. Houston: Hogg Foundation for Mental Health, 1976.

James, Marquis. *The Raven: A Biography of Sam Houston*. Indianapolis: The Bobbs-Merrill Company, Inc., 1938.

———. *The Texaco Story*. New York: The Texas Company, 1953.

Johnston, Marguerite. *A Happy Wordly Abode: Christ Church Cathederal, 1839-1864*. Houston: Cathedral Press, 1964. *of Texas, Its History and Annexation—Including a Brief Autobiography of the Author*. New York: D. Appleton & Company, 1859.

Justice, Blair. *Violence in the City*. Fort Worth: Texas Christian University Press, 1969.

King, John O. *Joseph Stephen Cullinan: A Study of Leadership in the Texas Petroleum Industry, 1897-1937*. Nashville: Vanderbilt University Press, 1970.

Larson, Henrietta M. and Porter, Ken-neth W. *History of the Humble Oil and Refining Company: A Study in Industrial Growth*. New York: Harper, 1959.

Lasswell, Mary. *John Henry Kirby: Prince of the Pines*. Austin: Encino Press, 1967.

Lipartito, Kenneth and Pratt, Joseph, *Bake & Botts in the Development of Modern Houston*. Austin: Univ. of Texas Press, 1991.

Lubbock, Francis R. *Six Decades in Texas*. Edited by C.W. Rains. Austin: Ben C. Jones & Company, 1900.

McComb, David G. *Houston: The Bayou City*. Austin: University of Texas Press, 1969.

Mann, Dene Hofheinz. *You be the Judge*. Houston: Premier Printing Company, 1965.

Maxwell, Robert S. *Whistle in the Piney Woods: Paul Bremond and the Houston East and West Texas Railway*. Houston: Texas Gulf Coast Historical Association, 1963.

Oates, Stephen B. *Visions of Glory: Texans on the Southwestern Frontier*. Norman: University of Oklahoma Press, 1970.

Powell, William Dylan. *Houston Then and Now*. San Diego, Ca.: Thunder Bay Press, 2003.

Reed, S.G. *A History of Texas Railroads*. Houston: St. Clair Publishing Company, 1941.

Rister, Carl C. *Oil: Titan of the Southwest*. Norman: University of Oklahoma Press, 1949.

Rose, Warren. *The Economic Impact of the Port of Houston, 1958-1963*. Houston: University of Houston, 1965.

Roussel, Hubert. *The Houston Symphony Orchestra, 1913-1971*. Austin: University of Texas Press, 1972.

Sibley, Marilyn McAdams. *The Port of Houston: A History*. Austin: University of Texas Press, 1968.

Siegel, Stanley. *A Political History of the Texas Republic, 1836-1845*. Austin: University of Texas Press, 1956.

———. *The Poet President of Texas: The Life of Mirabeau B. Lamar, President of the Republic of Texas*. Austin: Jenkins Publishing Company, 1977.

Spratt, John S. *The Road to Spindletop: Economic Change in Texas, 1875-1901*. Dallas: Southern Methodist University Press, 1955.

Thompson, Craig. *Since Spindletop: A Human History of Gulf's First Half Century*. Pittsburg: 1951.

Timmins, Bascom. *Jesse H. Jones*. New York: Henry Holt & Company, 1956.

Von Der Mehden, Fred ed., *The Ethnic Groups of Houston*. Houston: Rice Univ. Press, 1984.

Vu, Roy. "Rising from the Ashes of the Cold War: The Construction of a Vietnamese Community and Identity in Houston, Texas." Ph.D. Dissertation, Univ. of Houston, 2005

Warner, C.A. *Texas Oil and Gas Since 1543*. Houston: Gulf Publishing Company, 1939.

Webb, Walter Prescott. (ed.) *The Handbook of Texas*. 2 vols. Austin: Texas State Historical Association, 1952.

Weems, John Edward. *A Weekend in September*. College Station, Texas: Texas A & M University Press, 1957.

Winningham, Geoff, and Al Reinert. *A Palce od Dream: Houston, An American City*. Houston: Rice University

press, 1986.

Manuscript Collections

Archives Collection, University of Texas Library

Anson Jones Papers

Thomas Jefferson Rusk Papers

Ashbel Smith Papers

Newspapers

Houston *Chronicle*

Houston *Morning Star*

Houston *Post*

Houston *Telegraph and Texas Register*

Unpublished Papers

Berryman, Marsha G. "Houston and the Early Depression, 1929-1932." M.A. Thesis, University of Houston, 1965.

Carleton, Donald. "A Crisis of Rapid Change: The Red Scare in Houston, 1945-1955." Ph.D. dissertation, University of Houston, 1978.

Davidson, Chandler. "Negro Politics and the Rise of the Civil Rights Movement in Houston, Texas." Ph.D. dissertation, Princeton University, 1968.

Dishron, Joseph A. "A Population Study of Houston and the Houston Area." M.A. thesis, University of Houston, 1949.

Garcia, John Armando. "Mexican-American Political Leadership in Houston, Texas." M.A. thesis, University of Houston, 1968.

Greer, William Lee. "The Texas Gulf Coast Oil Strike of 1917." M.A. thesis, University of Houston, 1974.

Jager, Ronald B. "Houston, Texas, During the Civil War." M.A. thesis, University of Houston, 1974.

Lindsey, Walter. "Black Houstonians Challenge the White Democratic Primary." M.A. thesis, University of Houston, 1975.

Maroney, James C. "Organized Labor in Texas, 1900-1929." M.A. thesis, University of Houston, 1975.

Meltzer, Mildred H. "Chapters in the Struggle for Negro Rights in Houston, 1944-1962." M.A. thesis, University of Houston, 1963.

Merseburger, Marion. "A Political History of Houston, Texas, During the Reconstruction Period as Recorded by the Press, 1868-1873." M.A. thesis, Rice Institute, 1950.

Sapper, Neil Gary. "A Survey of the History of the Black People of Texas, 1930-1954." Ph.D. dissertation, Texas Technological University, 1972.

Schmidt, Ward Gary. "A History of the Desegregation of the Houston Independent School District, 1954-1971." M.A. thesis, University of Houston, 1972.

Timme, Kathryn. "A Medical History of Houston-Harris County, 1836-1918." M.A. thesis, University of Houston, 1965.

Young, William Alexander. "History of the Houston Public Schools, 1836-1965." EED. dissertation, University of Houston, 1967.

ACKNOWLEDGEMENTS

I wish to express my gratitude to the Harris County Historical Society for recommending me as the author of this book. As a longtime member of the society myself, I know of no group more dedicated to the writing and preservation of local history. Teaching courses in Texas history at the University of Houston and doing research in the field served only to quicken my interest in the history of my adopted city. Therefore, I was particularly pleased and grateful when through the agency of the society I was presented with the opportunity to do this project.

I also want to thank Pat Butler of the Harris County Heritage Society for the excellent choice of photographs depicting the history of Houston and Harris County. A conscious effort was made to blend the text and photographic reproduction, so that each would complement the other. In this effort, I believe we have succeeded.

My colleagues in the History Department at the University of Houston, Professor Robert I. Giesberg and John O. King, gave me the benefit of their counsel, and the staffs of the Anderson Library at the University of Houston and the Downtown Public Library have been unfailingly helpful and gracious in rendering assistance to me.

Finally, upon the completion of any work, the historian is made very much aware of those who have trod the same research path before him. In this regard, anyone writing about the city of Houston soon realized his obligation to the late Andrew Forest Muir. Professor Muir's articles on Houston and Harris County are literally gems of historical writing. The WPA writers' project book on Houston remains to this day an excellent compendium, perhaps still the best source for "what happened." On the other hand, Professor David McComb's *Houston: The Bayou City* emphasizes interpretation and qualified as a seminal, one-volume overview. If this book should in any way continue the tradition that the above-mentioned writers and others have commenced, the author will consider himself very happy indeed.

Stanley E. Siegel

A special thanks to Central College, HCCS librarians Ron Homick and Leo Cavazos for providing a wealth of invaluable resource links about where to find the most up-to-date information about Houston. Without their guidance and support, the writing about Houston from the 1980s to the present would not have been nearly as complete or as interesting. I would also like to thank Ms. Katherine Lopez, my wonderful graduate teaching assistant at the University of Houston for all her efforts in helping to procure pertinent and exciting photographs as well as for her work on the time-line chronology. The more personal and creative "shots" found in the modern Houston section of this book were taken by Ms. Kelly Durham.

Finally, I would like to thank my daughter Rachel and my wife Chris for all their support in this endeavor. Rachel's invaluable computer skills got me through some frustrating moments. Her exasperation with my ineptitude about computers resulted in me hearing regularly, "Dad, just let me do it," or "Dad, let me show you where to find that." At the end of a day's writing, they proved to be words of great relief and hope. Last, but most certainly not least, to my wife Chris, to whom I personally dedicate my portion of this book. From the moment I began writing she was always there—never hesitating to help in whatever way she could. She was, and is, my sharpest critic, most determined advocate, best editor, and closest friend and confidante.

John A. Moretta

INDEX

General Index

Italicized numbers indicate illustrations.